THE PORTRAIT PHOTOGRAPHY COURSE

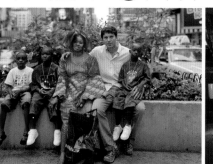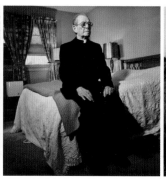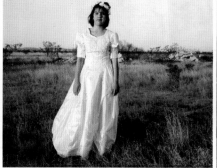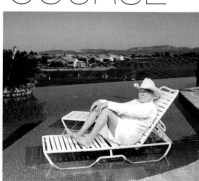

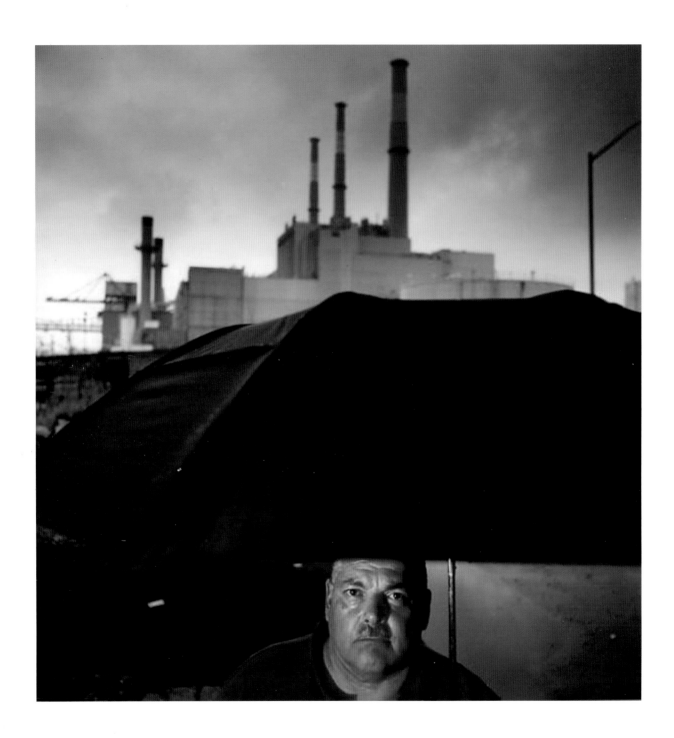

**USING LIGHTING TO
CREATE ATMOSPHERE**

This portrait of an environmentalist
was shot for a story on pollution in
New York. The sky is darkened by
two graduated filters that were
fitted over the lens at the time of
exposure. A small battery-powered
flash supplied the fill to his face.

THE
PORTRAIT
PHOTOGRAPHY
COURSE

Mark Jenkinson

Peachpit Press
1249 Eighth Street
Berkeley, CA 94710
510/524-2178
510/524-2221 (fax)

Find us on the Web at: www.peachpit.com
To report errors, please send a note to errata@peachpit.com

Peachpit Press is a division of Pearson Education
Acquisitions Editor: Nikki Echler McDonald
Production Editor: Hilal Sala
Proofreader: Liz Welch

A QUARTO BOOK
Conceived, designed, and produced by
Quarto Publishing plc., The Old Brewery,
6 Blundell Street, London N7 9BH

Project Editor: **Victoria Lyle**
Art Editor: **Jacqueline Palmer**
Art Director: **Caroline Guest**
Designer: **John Grain**
Picture Researcher: **Sarah Bell**
Illustrator: **Kuo Kang Chen**
Copy Editor: **Sarah Hoggett**
Proofreader: **Sally MacEachern**
Indexer: **Helen Snaith**
Quarto Creative Director: **Moira Clinch**
Quarto Publisher: **Paul Carslake**

ISBN 13 978-0-321-76666-3
ISBN 10 0-321-76666-0

10 9 8 7 6 5 4 3 2 1

Color separation by Modern Age
Printed in China by 1010 Printing International Ltd.

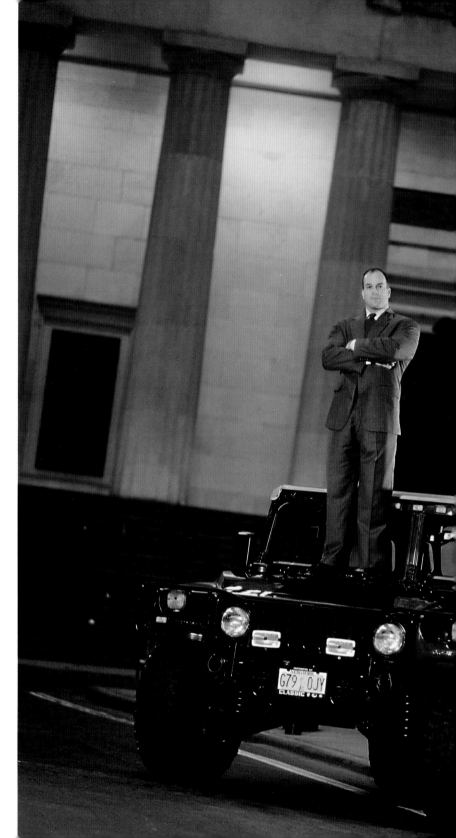

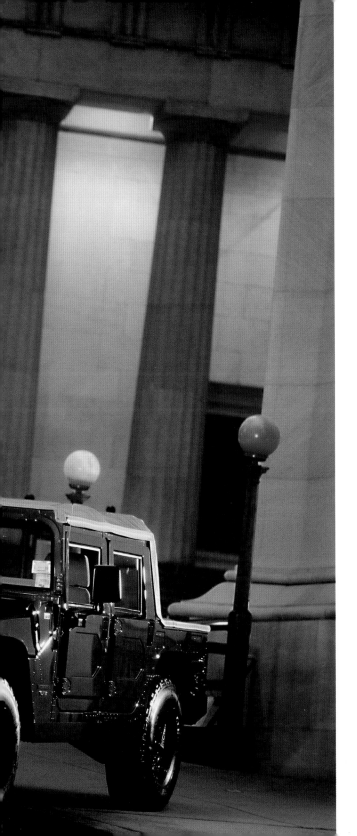

CONTENTS

FOREWORD

Simply put, I'm just a guy who still loves everything there is to love about photography. I love photographs, cameras, lighting gear, lenses, books, and, most of all, my fellow photographers. The list of photographers, living and dead, who have touched my life is huge and diverse; my personal world is a better place because of Diane Arbus, Richard Avedon, Larry Clark, Nan Goldin, Edward Burtynsky, and John Szarkowski, as well as many lesser-known photographers who are doggedly pursuing their vision without fame, fortune, or recognition. I've learned different things from all my heroes and colleagues, but one thing I've learned from all of them has been to trust the value of my own experience and my authentic voice.

I have been active in many different aspects of photography; I've been a professional photographer and photography teacher for over 25 years while pursuing personal fine art projects. Over the course of my professional career I've had the good fortune to work for major magazines on assignments spanning fashion, sports, photojournalism, architecture, automotive, and, of course, portraiture. I've had the chance to talk with a number of my heroes over a beer and work with some of the most celebrated art directors, photo editors, critics, and historians. I don't mention this to boast, but rather to explain my reasons for writing this book the way I have.

This book is designed to be a university-level textbook for students who are already committed to a career in photography. I've tried to address the issues that are pertinent to young photographers and often seem neglected by other books on photography. Many famous photographers have written autobiographies; these "how I got the shot"

memoirs can be very inspirational. But when a book uses a remarkable photograph by a supremely confident photographer with 25 years of experience, an army of assistants, and unlimited resources I wonder if it is useful or instructive to a 19-year-old student who is struggling to light a simple headshot. On the other hand, many photography teachers have written excellent instructional books that are extremely clear and concise. However, I don't know if they inspire students to greatness or reflect the reality and struggles of life as a young working photographer.

My hope was that by drawing upon both my professional career as well as my experience teaching young photographers I might create something that would be useful in a way I hadn't seen before. Most of the photographs in this book were made either by students or by professionals at the beginning of their career. I am indebted to all those who submitted photographs for their contributions. It is their work and their experience that has been the really distinctive element I could bring to this project.

Every student is unique, but many of the problems they face seem to be universal. Portraiture presents a particular set of problems for young photographers, if only because the subject is present and watching the photographer at work. Most books tend to concentrate on the psychology of putting the subject at ease, but in my experience it is usually the young, inexperienced photographer who is the most nervous person on the set. It is my hope that, by including the work and stories of real students as well as work by successful alumni and emerging professionals, this book can help young photographers bridge the gap between aspiration and accomplishment.

Mark Jenkinson

ABOUT THIS BOOK

This book offers a structured course in the art of taking portrait photographs, starting by exploring what a portrait is and finishing with how to get a job in the industry.

LIGHTING DIAGRAMS
Provide a quick-glance reference to the positioning of the photographer's equipment when the featured shot was taken.

TUTORIALS ▷

The tutorials lead you step by step through the key principles and techniques of portrait photography.

OBJECTIVES
A summary of the main teaching points of the tutorial and the skills you will acquire.

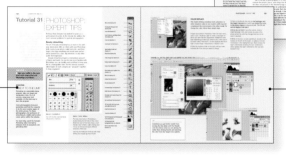

EXERCISES
Set the student practical assignments to enable the mastery of techniques and build portfolio content.

FEATURE PANELS
Expert tips, tricks, and information from inside the industry.

INTERVIEWS ▽

Interviews with six professional photographers specializing in different areas of portraiture, revealing their individual methodologies and philosophies.

PORTFOLIOS ▽

Showcase individual photographers' work and demonstrate techniques explored in preceding tutorials.

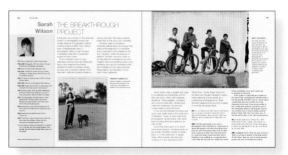

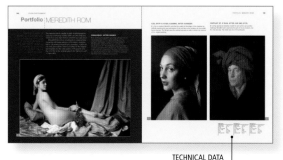

TECHNICAL DATA
Portfolio photographs are accompanied by the pictures' metadata: ISO, f-stop, focal length, etc.

KEY TO DIAGRAM SYMBOLS

	Camera
	Small light source front and back
	Small light source with grid
	Large light source
	Large light source with grid
	Soft light front and back
	Light
	Umbrella light
	Beauty dish
	Light stand
	Reflector
	Gobo
	Window

The photographic act is an event that occurs in real time with irrevocable consequences. The end result can be modified through post-production, but it is necessarily dependent upon, and influenced by, the image that was recorded in the camera.

Some areas of photographic specialization — still life, for example — afford the photographer comparatively longer amounts of time to think, modify, and edit the scene before the lens; but ultimately there is a moment when they have to commit. For portrait photographers "the moment" is ever elusive as they contend with the technical tools of their trade, the personality of their subject, and their own emotions, self-doubts, and artistic agendas.

Defining what a portrait is and what it means to you can help you know when this moment arrives. In this chapter we will attempt to come to a personal definition by looking at the history of portrait photography as well as some typical types and uses of portraiture.

POWERFUL PORTRAITS

At first glance, this photograph by Megan Fingleton appears to show an agricultural laborer out in a field. It is actually of a mine sweeper at work in Cambodia clearing the countryside of the millions of landmines that are the remnants of the brutality of the Khmer Rouge regime. The image suddenly has a greater impact when the viewer realizes that both the model and the photographer are putting their lives at risk.

chapter 1 | WHAT IS A PORTRAIT?

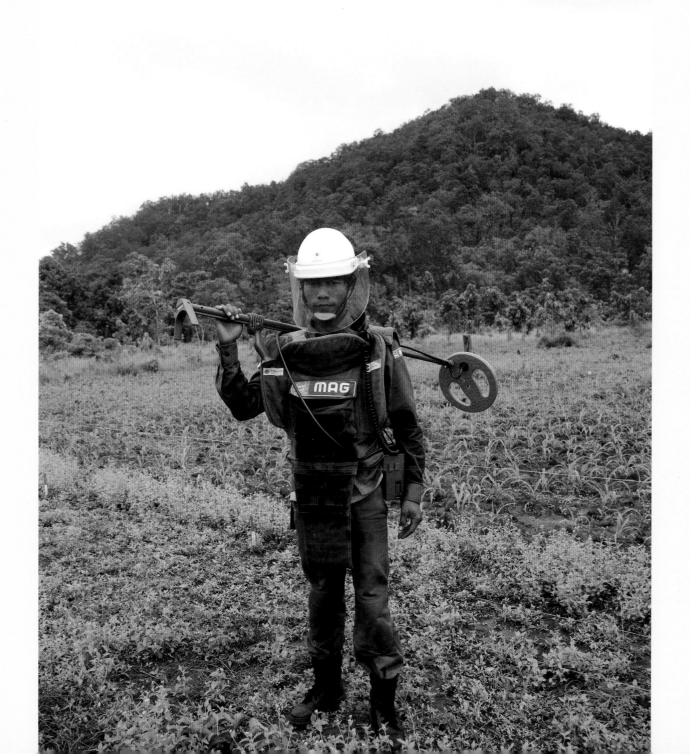

Tutorial 1 | PORTRAITS—A DEFINITION

What is a portrait? Is it merely a topographic map of tissue and bone? Or is it a collaboration between the photographer and sitter? Does a police mugshot count? What about a photograph of a model in a catalog?

Every artist comes to understand and define portraiture in his or her own way. This personal definition, in fact, is what makes us artists rather than technicians.

After many years of honing my skills in lighting and photography, I have come to the simplest definition of what I believe a portrait to be. For me, a portrait is defined as follows: the evidence of a series of quantum possibilities (choices) between a photographer and subject that results in a particular likeness of the outward appearance or manifestation of a specific soul at a particular point in time.

Finding your personal definition is the purpose of this book. In the coming pages we will spend a great deal of time and energy honing skills to make people look their best. These are cosmetic tools for us to master, but they are not the essence of the problem. Our real problem, and mission, is to create an authentic human moment between the sitter, photographer, and the audience that transcends time and the vagaries of flesh, providing insight and clarity into the lives and times we share.

Pretty doesn't last, but truth endures.

OBJECTIVE >>

☐ **To identify your own goals by looking at the history of the portrait genre.**

A CHANCE ENCOUNTER

I once gave a lecture in one of my lighting classes about how the consistent use of light is the principal vehicle for a master photographer to define and illustrate his or her view of time and the physical universe.

To illustrate my point I discussed the famous Diane Arbus photograph of the boy holding the hand grenade in Central Park. "Look at how specific it is," I explained. "We could go to the park right now and find the exact spots where they each stood. Look at the light; with a little work we could actually calculate what time of year it was and the exact time of day. Arbus was a master of the specific; she was truly interested in the individual she was photographing. This kid wasn't a symbol or an archetype for her; he was a unique soul and she was interested in describing an exact moment extracted from her interaction on a specific day with this specific kid."

I went on, "There has been a lot of speculation about this little boy. Some people think he was autistic because he looks a little deranged in the photo, but I think he was just acting out for a moment, and that was the moment that Arbus connected to. This was when the specific became something universal."

I mused out loud, "I wonder about that kid sometimes. This is one of the most famous photographs in the history of photography. What was it like for him to grow up as an icon? How did that brief moment of frustration and drama influence the rest of his life?"

Later that evening, while I was having dinner with a friend, an old acquaintance of hers came over to say hello. He looked very familiar.

"Excuse me, but don't I know you?" I asked.

He shrugged it off. "I don't think so."

It was gnawing at me and I wouldn't give up. "No, I'm sure I remember you, but I think it was from when we were kids. Did you grow up in Rochester, New York?"

"No, I grew up in New York City. You can't possibly know me." My questions seemed to make him uncomfortable so I let it slide, but I was certain I'd known him from our childhood.

When he left, my dinner companion clued me in. "I went to college with him. I think you recognize him because he's the little boy with the hand grenade from the Arbus photo."

Diane Arbus had always been one of my favorite photographers, but this incident seemed to validate everything I had suspected about both the boy and her approach to photography: The boy was, in fact, completely normal and had grown into a successful, outgoing man, but, more importantly, her image was so specific that I was able to recognize the individual 40 years later.

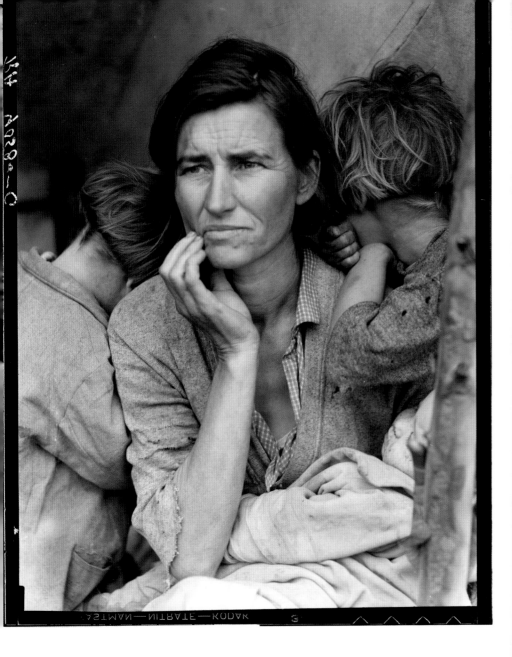

ΠΑΤΜΑΝ—ΝΙΤRΑΤΕ—ΚΟDΑΚ

PRECONCEPTIONS AND INTERPRETATIONS

Compare the photos below and discuss how your prior knowledge or ignorance of the person's life changes your interpretation of the images. What about how the people are dressed, posed, and lit?

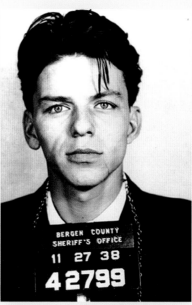

BERGEN COUNTY
SHERIFF'S OFFICE
11 27 38
42799

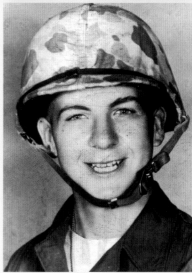

Key: Frank Sinatra (top), Lee Harvey Oswald (bottom)

INDIVIDUAL OR ICON?

This image by Dorothea Lange is popularly known as "The Migrant Mother." However, the photograph is a portrait of Florence Owens Thompson, who was 32 years old and had real concerns for her family of seven—very real—children.

Who could have planned the confluence of events to create this timeless masterpiece? What photographer could have imagined the perfect, shadowless light that renders her beautiful facial architecture as impartially as every furrow? Or the perfect amount of dirt under her fingernails that touch her cheek with such apprehension? What act of fate prompted her children to look away from the camera at just that moment, allowing their mother a private moment to indulge her feelings?

Lange took five other photographs of the Thompson family that day; two were terrible, three were passable, but one would become the *pietà* of its age, expressing the sorrow, tragedy, and fortitude of a nation's despair.

Tutorial 2 | AN APOCRYPHAL HISTORY OF PORTRAITURE

It is impossible to present a comprehensive history of either photography or portraiture in these few pages, but we can look at some of the more significant moments that have influenced the way we perceive portrait photography today.

exercise:

LOOK AND LEARN

Go to any museum and look at any portrait. Write 200 words on what the subject might have wanted to achieve by sitting for the portrait. Then write 200 words on what the artist hoped to achieve in making the image. Writing about art hones an artist's critical skills and can fast-track your development as a photographer by refining your personal goals, mission, and style.

What is our impulse to create likenesses of other humans? Why would we do this?

One obvious reason, as any parent with a camera will tell you, is to preserve our memory of people we love. The fact that this is obvious has not dissuaded an army of learned scholars and theoreticians, from Roland Barthes to Susan Sontag, from embracing this rather simplistic notion, proclaiming that photography's main purpose is to serve as a handmaiden to either voyeurism or memory, while neglecting the medium's ability to reveal and describe the unseen.

This idea of using photography as a mnemonic device is, of course, valid as a way of understanding the medium's impact on our culture, and many photographers are interested in photography as a way of documenting their own lives. Of course, family snapshots also fall into the category of photographs that serve as an aid to memory.

However, for many practicing photographers, this idea of reducing photography to such an interpretation is antithetical to everything they understand and love about the medium. Most working photographers/artists approach the medium from a slightly different perspective, using it as a way to engage with the world. They know that as photographers they are not simply observers; they are participants in the events and lives they witness. They know that they are not objective, and they know that no image represents the complete truth, or even a memory of the truth.

Looking at art from an artist's point of view

If we go to a magic show and watch a magician perform, we expect to be amazed and enjoy the show. If we are aspiring magicians we also hope to enjoy the show—but our own personal growth depends on our ability to see beyond the smoke and mirrors. We want to learn how the trick was done.

CAVE PAINTING FROM ANGOULÊME, FRANCE, C. 25,000 BC

As of this writing, this cave painting is thought to be the earliest known example of a portrait, a simple likeness of a human face.

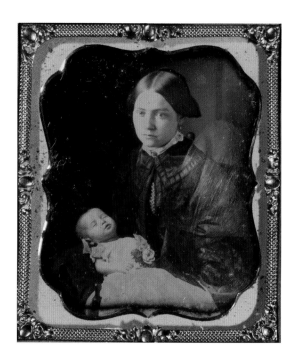

POST-MORTEM PORTRAIT, C. 1855

Post-mortem portraits, such as this one, were popular in the 19th century as a way of preserving the memory of the deceased.

When we look at portraits we want to put ourselves in the shoes of the artist and there are some key questions we want to ask:

■ What is the artist's goal in creating a portrait?
■ What is the subject's goal in allowing a portrait to be made?
■ Who is the intended audience for the portrait?

For aspiring professional photographers, the last two questions are probably more interesting, and are likely to shed light on the first.

Before the advent of the snapshot camera, virtually all portraiture was commissioned; a professional artist/ photographer was hired to create a likeness of a specific person. I'm not an art historian but I would hazard a wild guess that more than half of the Western art created before 1910, from passport photos to Renaissance altarpieces to the Mona Lisa, has been some form of commissioned portraiture. This makes portraiture a very interesting and distinct problem for the artist, because when someone (even a third party) commissions a portrait, or agrees to sit for one, they have a vested interest in its outcome and message.

The subject's point of view

One of the most fascinating relationships in the history of art was between the painter Diego Velázquez and Prince Philip IV of Spain. In 1623 Prince Philip IV sat for a portrait by Velázquez; this first portrait pleased the Prince so much that he ordered all other likenesses of himself to be collected and withdrawn from circulation. The Prince then ordered Velázquez to move his family to Madrid, where he remained as the official court painter for the rest of his life. He painted many other dignitaries over the course of his life and the Prince allowed him free rein over many subjects, but Prince Philip IV would eventually commission over 40 more portraits, all from Velázquez. What did Velázquez see and portray that Philip found so compelling?

By modern standards, Velázquez's paintings are not purely flattering to Prince Philip: the famous Habsburg jaw is extremely prominent (though as genetic proof of his royal lineage he was probably proud of it) and he looks stiff (but of course Philip believed in maintaining a regal bearing). Yet I believe that Philip saw his best reflection in these mirrors painted by his friend Velázquez. These are paintings that were calculated to convince people that Philip was worthy to be king and possibly even to assuage Philip's own doubts about his qualifications. They are mirrors that were true, but also a bit better than true.

This is really a different idea from the oft-cited desire to preserve memory; this is really a desire on the part of

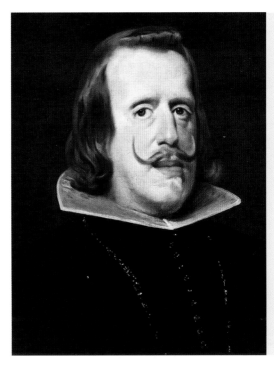

the subject to be remembered in a particular way. This is one way in which the sitter attempts to cheat death, by crafting an image for eternity.

We see this pattern repeated many times over history; the pop singer Madonna, for example, is as much a creation of her most frequent photographer/ collaborators (Herb Ritts, Steven Meisel, and Steven Klein) as she is her own. This is because commissioned portraits are unique entities in the history of art, quite distinct from all other genres. They are works of art created from two points of view—the artist's and the subject's. Both people are trying to communicate (to yet another person/audience) something essential. This why the common wisdom is that a portrait is "a collaboration between the artist and the subject." However, as you will see, this oversimplification does not take into account the times when the artist and the subject may have different agendas.

The advent of photography

When photography was invented, it changed everything. Portraits were still commissioned, as photographs required a highly trained craftsman, but the cost was within the reach of the middle class.

One of the most common forms of 19th-century photographic portraiture was known as a *carte de visite*; these were literally calling cards, which were often

"All photographs are accurate, none of them are true."

Richard Avedon

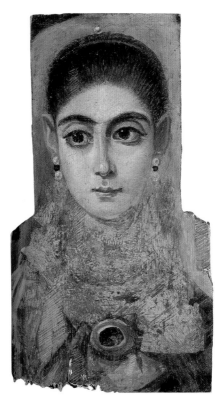

EGYPTIAN BURIAL PORTRAITS

Egyptian burial portraits are interesting because they were created specifically to be buried with the subject they depict: What audience were they created for?

presented to a servant when calling upon a prospective business or social contact. They were designed to introduce a visitor by both showing what they looked like and by providing visual clues to their profession, aspirations, and social status. These were very important photographs because, in an age before telephone and emails, they were often the first impression one had of a prospective suitor or business associate. For this reason, the *carte de visite* sought to mimic the visual style and references of the most expensive portrait medium of the day, which was painting. It was common for studios to rent clothes to patrons in order to present an affluent image. Again we see the desire not simply to remember, but to actively influence one's memory or legacy.

The invention of the snapshot camera

Until the invention of the first Kodak camera, photography and portraiture remained almost entirely in the hands of professional photographers. George Eastman changed everything in 1888 with the introduction of gelatin roll film and the first practical handheld camera for the untrained amateur.

The handheld camera created a revolution in image making that was not to be equaled until 100 years later, with the introduction of Photoshop editing software in 1990. Although it was still expensive (each photo cost about $12 in modern currency), the Kodak literally put cameras and photography into the hands of the masses. Parents could use photographs to preserve and share memories of their children and family trips and to mark special occasions. Because early emulsions were so slow, most amateur photography moved outdoors, finally liberated from the stuffiness of the photographer's studio.

Portraits were now made primarily by friends and family members with simple cameras. This fundamentally changed the psychological relationship between the sitter and the photographer. Portraits became less formal in attire and pose, with an emphasis on depicting a moment in time rather than attempting to create a portrait that represented the totality of a person's existence.

Compared to painting, photography had always been perceived as an expedient way to create a portrait. However, the first Kodaks, and the more sophisticated roll film cameras that came later, truly made photography into the spontaneous, time-based, "decisive moment" medium that we now consider to be one of its defining attributes.

When we look at the history of photography we see that that "the moment" gets progressively shorter. Exposures for the earliest photographs were measured in minutes, but were still considered moments in time;

"SELF-PORTRAIT IN SHARPSHOOTER'S UNIFORM," ALEXANDER SEIK

This *carte de visite* is interesting because it is a self-portrait by pioneer Czech photographer Alexander Seik, who had a thriving business photographing soldiers during the Prussian invasion in 1866. In his dual roles as both photographer and subject, what do we imagine Seik was trying to achieve in this image?

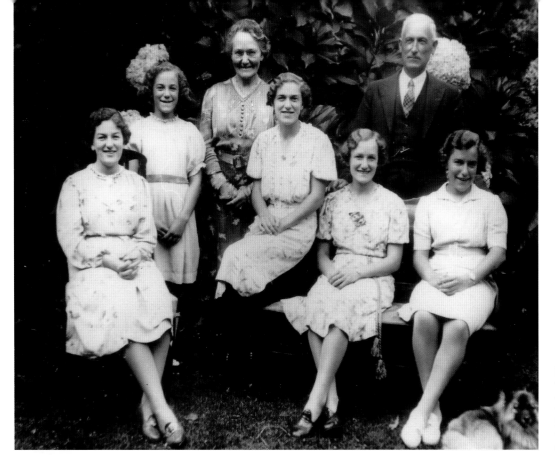

RELAXED FAMILY PORTRAIT

The individuals in this family portrait from the 1930s look comfortable and at ease. This is because the invention of the handheld camera meant that subjects were usually photographed by a friend or family member.

"SNAPSHOT" AESTHETIC

This photograph uses a "snapshot" aesthetic that capitalizes on the intriguing "mistakes" of amateur photography to create a unique and humorous portrait.

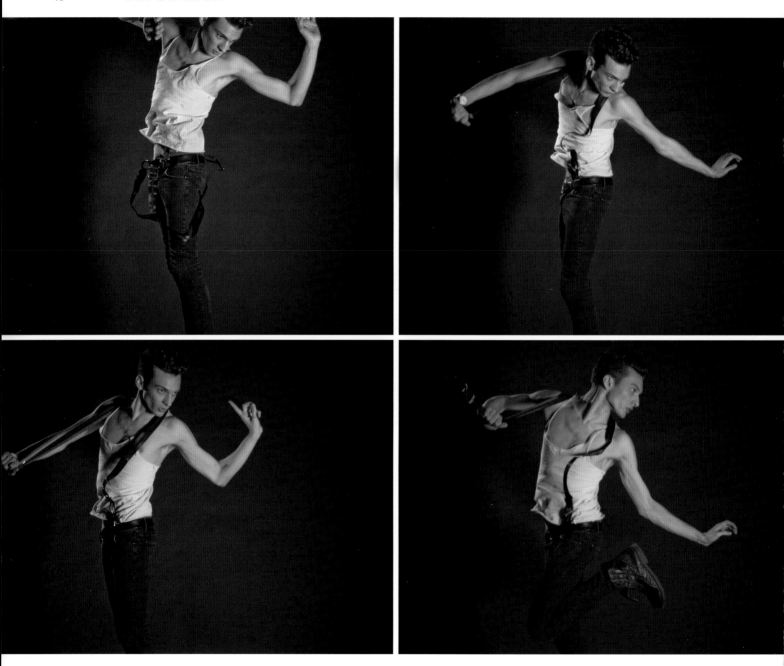

COMPOSITE PORTRAIT

This composite portrait by student Rachel Ceretto uses electronic flash to slice time into milliseconds, describing the subject in a way that would be impossible without the aid of photography.

by the 1960s, electronic flash had reduced the moment to milliseconds.

As the snapshot camera evolved with smaller, less expensive formats, faster films, and more sophisticated cameras, it completely redefined what a portrait could or should be: As amateurs made "mistakes," professionals and artists interested in pushing the boundaries of the medium would refine these miscues in lighting, composition, and timing into a new visual language that freed photography from the conventions of painting. The photographic portrait devised a new set of rules based on the idiosyncrasies that were unique to the photographic medium; spontaneity, description, and (until recently) the unquestioned veracity of the photographic document.

Digital comes alive

There's a lot of talk about how Photoshop has changed the way we see the world and view ourselves, about how unrealistic images of computer-assisted fashion models are damaging a generation of teenage girls. But anyone with a casual interest in the history of photography or art knows that the human body has never, ever, been portrayed realistically. People are quick to point to Greek sculpture as the zenith of naturalism, but are we to believe that the average Greek citizen spent more time sculpting his body than a modern Olympic athlete? Even anatomical necessities such as the sternum and coccyx are routinely removed in Greek statuary in order to idealize the body. Virtually every tool in Photoshop has been part and parcel of photography from the beginning, and photographers have been retouching, colorizing, slimming, airbrushing, cutting, and pasting all along.

What Photoshop and digital photography did that was revolutionary was to put these tools into the hands of amateurs. Professionals were always aware of how images could be manipulated. Digital photography,

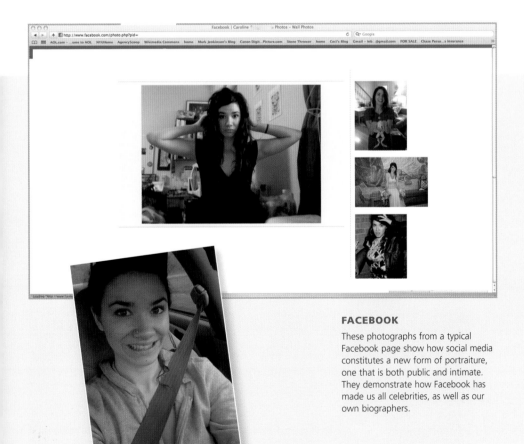

FACEBOOK

These photographs from a typical Facebook page show how social media constitutes a new form of portraiture, one that is both public and intimate. They demonstrate how Facebook has made us all celebrities, as well as our own biographers.

social networking, and image editing mean that any teenager can publish an idealized likeness on his or her own Facebook page or blog, presenting themselves to the world as they would like to be seen, slimmed down, pumped up, and acne free. We have become our own, and each other's, Velázquez.

Looking to the future

Recent innovations in broadband communications technology might be the biggest game changer for the next generation of photographers. As the distribution of images via paper, ink, and print fades into the past, the Web will require photographers to acquire a whole new set of skills.

Photosynth This is a software application developed by Microsoft and the University of Washington. Photosynth creates a virtual three-dimensional model from a group of photographs, which can be created by a single photographer or from many photographs by many photographers. The accumulated photographs that are gathered by the Photosynth software create an "image cloud" that allows the viewer to access and view the photographed object from any point in space with extreme detail. This allows for a single photograph and point of view to be rendered by an individual (who need not be present) from the collective consciousnesses, descriptions, and experiences of many people. The possibilities for both artistic and commercial uses of this technology are beyond comprehension, but the next generation of photographers will be as conversant and comfortable with it as the current generation is with cell phone cameras and Photoshop.

Animation and three-dimensional imaging The ability to animate and produce three-dimensional views of an object has enormous implications in the area of product photography. Within two years, all online product photography for major retailers will be animated through QuickTime VR and other technologies.

New technologies in three-dimensional printing that were originally designed to produce rapid prototypes for industrial designers now allow photographers to create sculptures from 360-degree views of a subject. The possibilities of this technology are endless for portrait photographers.

Handheld communication devices The emergence of the iPad, Nook, Kindle, and other handheld communications is a revolution. Online storytelling and sharing with video has been around for a few years, but tablet-style communication devices will usher in the next great age of editorial photography and photojournalism. With tablet devices, the viewer regains the intimate

THREE-DIMENSIONAL PORTRAITS

Professor Wafaa Bilal created this three-dimensional photographic portrait of his colleague Professor Thomas Drysdale. First the subject was photographed in about 20 different views to create a 360-degree record of Drysdale's appearance. Then Professor Bilal used Maya software to create a computer-generated three-dimensional model. The computer model was then uploaded to a three-dimensional rapid prototype printer at NYU's Advanced Media Services Laboratory. The rapid prototype printer "printed" the sculpture, layer by layer (each layer is about 1/360 inch deep), in full color. A close look at the detail photograph reveals the individual layers. While the image is three-dimensional it is still (technically) a photograph since the images were captured photographically and rendered with photographic technology.

experience of reading a story, looking at photographs, and viewing video. Hyperlinks embedded within photographic imagery will allow for further investigation and research. Eventually, magazine publishers will find a way to meaningfully monetize online content and photographers/videographers and writers, will once again be fairly compensated for the invaluable content we provide.

Hybrid DSLRs like the Canon 5D Mark II allow photographers to create complete multimedia stories within a single capture device. The quality of HD video from the current generation of hybrid cameras is already better than most purpose-built video cameras under $40,000. The next generation will continue the trend with upgrades in sound quality, motorized zoom lenses, and (eventually) RAW video capture.

This puts amazing capabilities in the hands of photographers, allowing complete editorial control over the production and distribution of their work independently of traditional outlets.

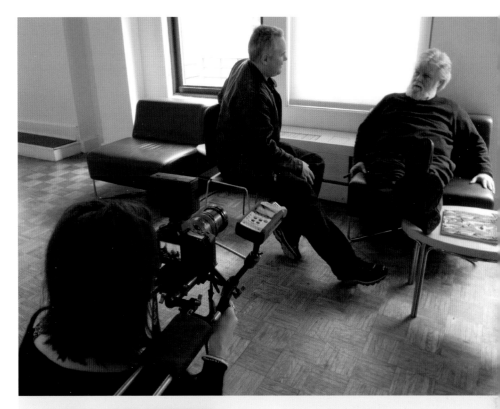

COPYRIGHT ISSUES

Nothing threatens the next generation of photographers more than the steady erosion of their rights to their work. In the past, photographers were able to retire on the intellectual property they had created over their lifetime. Over the past ten years, photographers have paid little attention to people appropriating imagery for use on the Web because we considered the Internet to be transitory and a minor use compared to print. However, as print dies and screen-based distribution of images becomes the norm, photographers will have to become savvy about how to find and enforce copyright abuse. In the past photographers have watermarked their images to prevent this kind of abuse, but new technologies such as "Content Aware Fill" in Photoshop CS5 have made watermarks fairly useless.

The next time you illegally download a song by a recording artist, remember that someone is probably doing the same to one of your images. It might not seem like much, it may even be flattering—but it is theft, pure and simple.

IMAGE AND SOUND

This student is recording an interview using a hybrid DSLR; the device mounted to the side is a dedicated sound recorder. Use of a separate recorder greatly improves sound quality and allows the use of better quality microphones.

exercise:

DO A LITTLE READING

The definitive book on the future of imaging was written by Fred Ritchin. His book *After Photography* (W.W. Norton) is a must-read for any serious photographer.

Tutorial 3 | TYPICAL TYPES AND USES OF PORTRAITURE

As professional photographers most of our assignments will (we hope) be commissioned portraits. With the exception of fine art and personal family portrait photography, almost all other forms of photographic portraiture are of a person who is trying to project an image that will somehow engage an otherwise disinterested stranger or audience.

exercise:
USE THE PATHS OF OTHERS TO MAP YOUR OWN ROUTE

Go to the library and look through at least 30 general-interest magazines, across a range of topics—fashion, business, sports, and so on. Every time you see a photograph you like, jot down the name of the photographer. Keep an eye out for names that keep coming up. Research these photographers more thoroughly on the Internet.

Here are a few typical uses of professional portraits:

Headshots and publicity photos

Headshots are essentially a marketing tool for professional musicians, actors, and television hosts. They are perfect examples of how photographers help other people present themselves to the world. As in all portraiture, the ingredients for an effective headshot take into account their intended audience, who are typically casting directors, agents, and film and television directors. Headshots for actors and television hosts need to clearly show an individual's physical attributes, but also to convey the emotional spark that an actor can bring to a performance.

Typically, headshots should make the entertainer look as attractive as possible while staying truthful. Computer manipulation may be used minimally in order to change transitory cosmetic problems (such as a pimple), but should not drastically alter the overall appearance of the subject. They should be updated frequently, as hairstyles and other features change with time. Frequent, fresh, updated headshots also help keep casting directors interested, since the same actors may be presented many times for different projects.

Financial/business portraiture

Photographs of executives and employees for company brochures, websites, and financial reports are usually done in collaboration with a team of business communication professionals (writers, designers, art directors). This team maps out an overall strategy for what the company is trying to communicate and the photography is tailored to fit into this larger set of corporate concerns.

Did the company expand operations or curtail them? Does the company want to project an image of staid solidity or of dynamic innovation? Should the sitter be in shirtsleeves or jacket? Should the location be in the boardroom or on a factory floor?

All of these questions are discussed beforehand and the answers can drastically affect the general approach to the project as well as the details of the shoot. Each decision conveys a slightly different message, and the process of creating a photograph that sends the right signals is really far more interesting than most people would imagine.

Portraits of celebrities and public figures

Portraits of people who are in the public eye pose a unique problem: In almost all other portraits, the photographer is trying to interest the viewer in a stranger; celebrities, however, already have a public persona that has typically been very well crafted by teams of agents, stylists, and publicists.

This means that celebrities should be among the most interesting and easiest subjects for the portrait

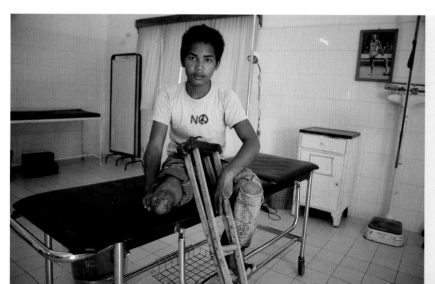

PHOTOJOURNALISM

Megan Fingleton is a photojournalist who works with medical relief agencies around the world. This photograph, "Battambang, Cambodia, 2007," is from an extended project on the 35,000 victims who have lost limbs due to the estimated 4,000,000 landmines that still litter Cambodia.

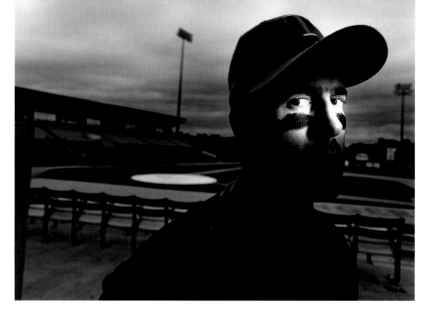

EDITORIAL PHOTOGRAPHY

Editorial portraiture is driven by the magazine's spin on a particular story. It needs to be striking, fresh, and appropriate to the written content of the story. Nick Carillicchio was assigned to shoot about 20 ball players for a *Sports Illustrated* feature story. The concept was that each player made exceptional use of one of his body parts. Will Clark, shown here, could both hit and field better than most due to his extraordinary vision, so Nick built the shoot around highlighting his eyes.

photographer, but they are actually often the most difficult—not because they are prima donnas but because they, and their entourage, are loathe to risk any attempt by the photographer to create a photograph that isn't in keeping with their established image. Celebrities often insist on their own approved list of stylists and photographers, and will typically insist on approving a shoot before it can be published, for good reason: A bad photograph can damage their career.

Editorial portraiture

Working for magazines is actually a subset of all the above categories, with one important difference: The magazine is commissioning the shoot for a specific story and usually wants the photograph to convey a very specific message. Most magazine stories present the featured individual in a positive light and are beneficial to the career and public image of the subject. However, there are many instances where magazines are in the process of breaking a story that exposes a public figure's misdeeds; here, the photographer's assignment may be at odds with how the subject wants to be portrayed.

Examples might be a men's magazine doing a story on an athlete who has a reputation for cheating on his wife, or a CEO whose lavish lifestyle conflicts with his responsibilities to his shareholders. This can present a complex set of problems for the photographer in trying to coax a subject to pose for a photograph that may be damaging or detrimental to their image. The photographer may also find him- or herself at odds with a writer who is not being fair to the subject.

Photojournalism

Portraits that put a face to global conflict and tragedy have power. In many cases these images have so

influenced public opinion that they have literally changed the world.

Private clients

Shooting for any private client is a real challenge. The client/subject or family is also often the intended audience, which puts an added burden on the photographer to match and flatter the client's preconceptions.

Wedding photography is one of the most demanding and difficult fields in all of photography. Typical fees for wedding photographers range from about $5,000–10,000+ per day; typically the family will hire one photographer in their entire life at a fee that is (or seems) exorbitant to a family budget.

The bride and groom have the right to expect a lot for their money; they also have the right to a memorable wedding day. Wedding photographers have the difficult challenge of shooting something as beautiful as one would expect to see in a magazine while still allowing the party to go on with as little intrusion as possible. It all has to look and feel effortless. The professionals who balance it well are some of the most skilled, and under-rated, photographers in the field.

Fine-art photography

Fine-art photographers who specialize in portraits might have the most demanding and rewarding challenge in all of photography—making a photograph of a person that is so engaging that the viewer feels an emotional communion with a stranger.

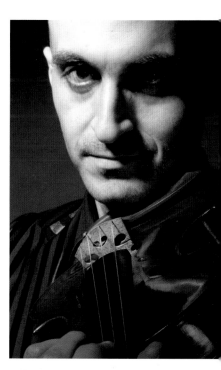

HEADSHOTS

Portraits for musicians, like this one by Meredith Rom, are influenced by the styling cues and clichés associated with different genres of music. Like the *carte de visite*, the headshot or publicity still must communicate a great deal about an artist/entertainer very efficiently.

Tutorial 4 | CLICHÉS AND CONVENTIONS

Successful photographers tread a fine line between communicating clearly, without creating clichéd images, and staying true to their artistic vision, without being elitist.

How many times have we encountered a disheveled man on a street corner screaming in an angry voice, incoherently imploring the world to listen to his proof that aliens exist? Our reaction is probably to cross the street and keep our distance. Yet if we hear the same man singing a soulful Italian aria, we might stop to listen and even throw some change in his hat.

What's the difference?

In the first instance the man is emotional and expressive but he is probably not communicating. In the second instance, although he is singing in a language we might not understand, he is communicating through the commonly accessible language of music. More important; by singing beautifully he has drawn us in and invited us to pay attention.

Artists are always struggling to find the perfect balance between clear communication and innovative expression. Communicative art relies on conventions that are well understood. Conventions are the common language between the artist and the audience: Renaissance painting, for example, was built on the conventions of chiaroscuro and two-point perspective, while movies use certain motifs of cinematography, editing, and background music to build tension and suspense (the plaintive notes of a cello tell us when to feel sad).

But when does an accepted convention turn into a meaningless cliché with no substance?

OBJECTIVE >>

■ **Learn how to use conventions, but avoid cliché.**

exercise:

SUPERIOR AND DIMINUTIVE

Using a video camera, have a friend simply repeat the line, "I love you" monotonously while looking straight into the lens. Start with the camera 2 feet (60cm) above them and slowly lower it until you are at knee level, with the subject maintaining eye contact and repeating the line all the while. Note how the camera position changes both the meaning of the phrase and the implied age from the viewer's perspective. Experiment: Try different angles and lines of sight for the subject, looking away and up or off to the distance as well.

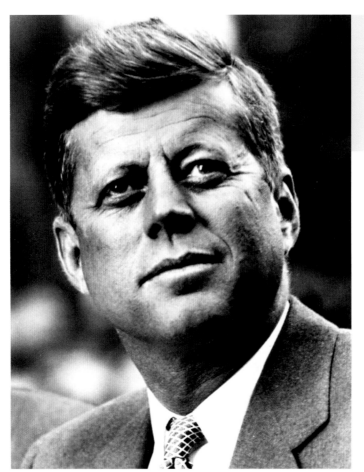

CLICHÉ OR AN EFFECTIVE USE OF VISUAL LANGUAGE?

How does this photograph reaffirm our preconceived ideas about John F. Kennedy? Is it a cliché? If so, was it also a cliché in 1961?

KEEP YOUR WORK FRESH

Photographers become victims of their own success when they fail to update their portfolios and websites frequently and stop experimenting. If you are a success, it is because you are having fun and experimenting. It is natural for clients to ask us to repeat ourselves and "do something like that shot in your book." There's nothing wrong with satisfying a client, but you should also make certain that every shoot satisfies your own creative instinct as well. Treat every shoot as if it's a chance to create a new portfolio piece.

Art that is truly innovative runs the risk of being elitist because it only communicates to the intellectual cognoscenti. In 1910 Cubism was an obscure mode of attempting to depict the totality of an object or person by rejecting the hitherto accepted convention of rendering a scene from a singular point of view in time and space (classical perspective). At its inception it was not widely understood and communicated only to the elite who "knew the code."

Now, almost anyone can understand and appreciate a Picasso. Does that mean that Cubism has become a cliché—or is it now simply an alternative convention for a modern artist?

CONVENTIONAL VS UNCONVENTIONAL

Formulaic This photograph is an example of a wedding photograph that is part and parcel of almost any wedding album. It's important to get photographs like this because the client will expect them, but it is equally important to stay ahead of trends and not rely on formulas.

Offbeat While a client might not know to ask for something as offbeat as this (below), it's a pretty good bet that this photo by Karen Cunningham ended up as a 16 x 20-inch (40 x 50-cm) framed print that is displayed prominently in the couple's home, while the wedding album full of cookie-cutter portraits sits on a shelf.

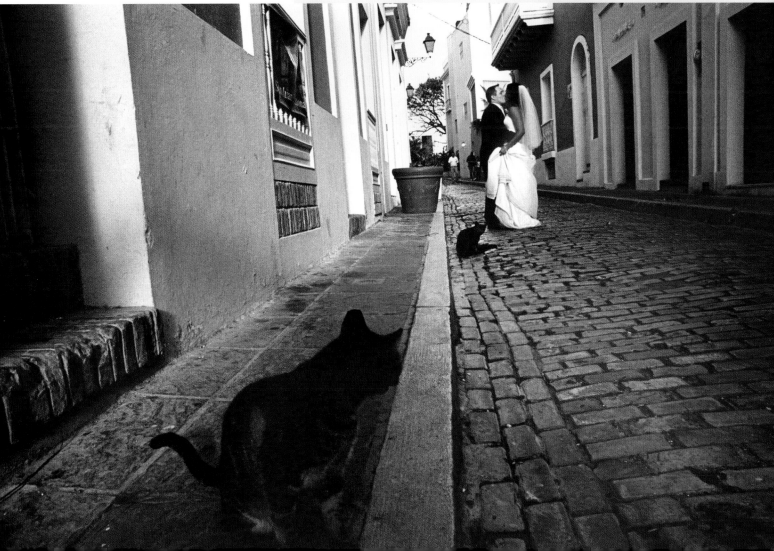

If you have purchased this book, then there's a good chance you have aspirations to become a professional photographer. It's also a good bet that you already own a digital camera and know at least how to use it in program mode. You might even shoot RAW files.

As this chapter demonstrates, there are a wealth of other choices out there and, whether it's a large-format film camera or a digital point-and-shoot, every camera will have an influence on the way you work, how you see, and what you photograph.

UFO RESEARCH CENTER, ROSWELL, NEW MEXICO, 2005
This photograph by Norwegian photographer Haakon Harris was shot as part of a personal project/road trip that focused on the oddities of American culture. Harriss used a Mamiya 7 rangefinder camera and lit the scene with a single Norman 400 battery-powered flash to photograph this dedicated caretaker of documents that prove the fact or fiction of UFOs.

chapter 2 | CHOOSING AND USING EQUIPMENT

Tutorial 5 | FILM OR DIGITAL?

At NYU's Department of Photography and Imaging, most prospective freshmen apply with a portfolio that was shot digitally; by the end of their freshman year, over 75 percent of them are shooting film exclusively. But isn't digital photography state of the art, cheaper, and far more convenient? Why would anyone want to shoot film in this day and age?

OBJECTIVE >>

■ **To understand the pros and cons of film and digital cameras.**

exercise:

TRY SOMETHING NEW

If you have never tried shooting film, then borrow a camera and try it. If you have never shot digitally, then borrow a camera and try it.

The easiest way to break out of any creative rut is to do something that breaks the routine of your established work habits. Even if you return to your original camera, your work will improve because of the experiment.

The main advantage of film is simply the variety of cameras and films available. Every camera and every film has a unique fingerprint. While (skillful) digital post-production can duplicate the look of any film, the unique signature of a particular camera/lens combination is a far more elusive quality to define. For example, medium- and large-format cameras depict space differently than small cameras because the lenses are inherently longer for a given field of view.

Different cameras also influence the work habits and perceptions of photographers. The small-format digital camera encourages an almost athletic approach to photography. The 4 x 5-inch camera requires a far more contemplative approach, with the photographer working on a tripod and making one or two carefully thought-out exposures. Cameras with waist-level finders allow the photographer to maintain eye contact while shooting and engage the subject directly. And viewing the scene through a square-format camera (for example) also influences composition and perception during the shooting process. In the past photographers chose the right camera for the task. This is still true; there are times to shoot digital and times when film still rules.

Most prosumer-level digital cameras are designed to be easy to use. They come with a standard "kit" zoom lens, they have a variety of "picture styles" built into the camera, and they work extremely well in fully automatic mode. They also allow and encourage the photographer to edit in the field (a big no-no!). All of this is great and allows amateurs to make good spontaneous photographs with minimal effort. It also means that Flickr is filled with millions of pictures that all look the same.

Make no mistake, digital cameras are the greatest photographic invention since the 35mm camera. Working well digitally requires just as much craft as analog, but digital photographs don't encourage craft as well as film cameras. Can one make a great photograph with the camera built into a cell phone? Of course—but to make serious work with a camera phone requires the same level of commitment from the photographer as shooting with an 8 x 10-inch camera.

CAMERA CHOICES

Any camera, from the tiny cell phone shown in the foreground to a vintage and cumbersome rangefinder, can be used for portraiture. However, the portability, lens, and rangefinder (for example) of your choice of camera will influence how you perceive the world and thus how you present your vision.

CAMERAS IN EXTREME CLIMATES

Simple mechanical film cameras keep working in sub-zero temperatures long after the batteries in digital cameras have frozen to uselessness.

FILM VS DIGITAL: PROS AND CONS

FILM

Pros

- Mechanical cameras work better in extreme environmental conditions than digital/electronic cameras.
- Dollar for dollar, film cameras are still more capable of higher quality than their digital counterparts (especially if one considers the used market).
- Color-negative film is still the most forgiving capture medium. It has more exposure latitude and dynamic range than digital capture.
- Every film type has a unique way of rendering the world.
- With proper storage, negatives can be easily and reliably archived.
- Color transparency film renders colors without interpretation, an invaluable aid to learning how the camera responds to different light and color temperature.
- Medium- and large-format cameras require and encourage slower, more thoughtful photography on the part of both the photographer and the subject.
- There's still something special about prints made in a darkroom by a master craftsman.

Cons

- In our electronic society, photographs are increasingly viewed on some kind of monitor or screen, and most clients prefer electronic delivery of commercial shoots. This requires that photographs shot on film be scanned, adding additional time, expertise, and expense to every shoot.
- The direct cost of film per shot is more expensive (although the peripheral costs of computers, software, digital storage, and so on make digital a "false" economy for many photographers).
- Reliable processing, especially for black-and-white film, is becoming scarce even in large urban areas.
- There is no simple way to preview complex lighting scenarios.
- It is necessary to change film in order to use emulsions with a different ISO.

DIGITAL

Pros

- Fast and convenient workflow.
- There is no need for a separate instant camera in order to preview complex lighting situations.
- The lack of short-term film/processing expenses encourages personal projects, experimentation, and testing.
- For small-format digital cameras, there is a vast array of lenses available at comparatively low cost.
- Huge-capacity memory cards do not require frequent reloading in fast-paced situations. (However, losing one card can mean losing an entire shoot.)
- Digital editing of RAW files allows for unlimited options in the way photographs can look and be presented.
- Quick-and-easy camera controls allow for spontaneous photographs.
- Recent advances in high ISO/low noise sensors are enabling available-light photography in situations that were not previously possible.
- Working digitally allows you to conveniently change the ISO setting of your camera to find the ideal aperture and shutter speed combination.
- Modern digital cameras are often superior to film in low light situations.

Cons

- The limited choice of camera formats can be restrictive.
- Short focal length lenses allow for fewer options for "in-camera" control of depth of field.
- Quick-and-easy camera controls can encourage sloppy technique and conventional thinking.
- High-resolution medium-format cameras are so expensive that they can be restrictive for location/field use.
- The long-term costs associated with computers, digital archiving, and printer maintenance are high.

FIND THE TOOLS THAT FIT YOUR VISION

Sorry to disappoint, but there is no magical camera, lens, light, or computer program that will make every photograph a work of genius. However, there probably is a set of tools that will fit you like a glove. The best photographers have highly idiosyncratic styles and equipment preferences. Finding your personal toolbox may require quite a bit of experimentation.

Having the opportunity to experiment and play with many different cameras is probably one of the main advantages of studying photography at a university, where there are rooms full of equipment that you can borrow for a day or two before committing to a major purchase.

Renting is also a terrific way to try before you buy. Renting used to be an option only for photographers in large urban areas close to professional stores, but online and mail-order rentals such as www.lensrentals.com have opened up the option of renting gear to photographers in remote or rural locations.

PREVIEWING IMAGES

Of course, the single greatest advantage to digital cameras is their ability to preview every image instantly in the field.

Tutorial 6 | 35MM AND SMALL-FORMAT DIGITAL CAMERAS

The portability, affordability, and versatility of the 35mm camera revolutionized photography.

OBJECTIVE >>

■ **To compare and contrast the options available in small-format digital and film cameras.**

The phrase "the decisive moment" would never have been coined without the invention of the Leica. These small cameras could be shoved in a pocket or dangled from a neck, allowing them to go anywhere. Film costs were a fraction of the price compared to larger cameras of the day. Lower expense per shot allowed photographers to experiment wildly, capturing photographs that had never been seen before. The invention of digital photography amplified these traditional benefits to an untold level.

In many ways, the small camera has always been the perfect blend of size and resolution. The small size of the traditional 35mm format meant that lenses could have short focal lengths and very fast apertures. Because the focal plane shutter is built into the camera, lenses can be relatively inexpensive compared to lenses associated with medium-format cameras, which require a separate shutter for each lens. Small-format 35mm and digital cameras are probably the most versatile image-making devices ever created. Modern electronic features such as autofocus and programmed exposure make them easy to use and allow for remarkable spontaneity in both situation and composition.

Even inexpensive digital single lens reflex (DSLR) cameras are capable of professional quality for prices under $1,000 complete with a zoom lens, a package that offers more focal length range and digital resolution than most serious amateurs will ever need. Pro-level, small-format digital cameras are capable of greater resolution than 35mm (and even medium-format) film cameras. The latest hybrid video/still models also incorporate HD video capabilities with image quality that even professional video cameras can't match, and are now routinely used to shoot high-budget episodic

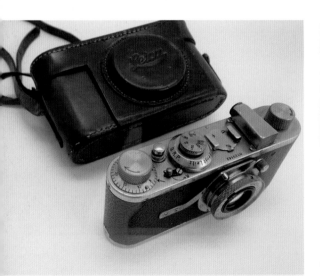

HENRI CARTIER-BRESSON'S FIRST LEICA

Henri Cartier-Bresson was one of the few photographers to take the 35mm format seriously when it first appeared. However, the Leica fitted his creative vision perfectly; he used it to take candid photographs of people on the street. In doing so he revolutionized the medium of photography and is considered the father of modern photojournalism.

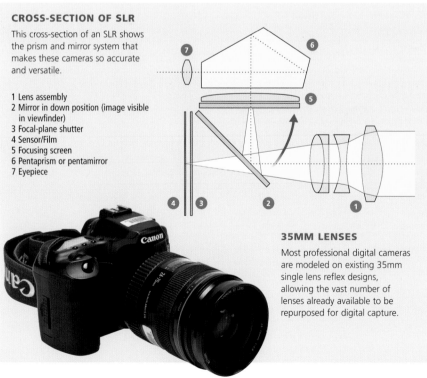

CROSS-SECTION OF SLR

This cross-section of an SLR shows the prism and mirror system that makes these cameras so accurate and versatile.

1 Lens assembly
2 Mirror in down position (image visible in viewfinder)
3 Focal-plane shutter
4 Sensor/Film
5 Focusing screen
6 Pentaprism or pentamirror
7 Eyepiece

35MM LENSES

Most professional digital cameras are modeled on existing 35mm single lens reflex designs, allowing the vast number of lenses already available to be repurposed for digital capture.

TV dramas that were shot with $200,000 35mm motion-picture cameras just a few years ago.

However, the biggest advantages of the digital small-format camera over its film equivalent are the lack of expense associated with film costs and the ability to review results instantly.

Small camera types

Single lens reflex (SLR) The small-format SLR, in either its digital or analog (film) variants, is probably the most versatile imaging device ever made. By using a prism and mirror system, the photographer is able to view and focus through the lens that will be taking the photograph, allowing the photographer to view the composition and depth of field with a very high degree of accuracy regardless of the lens being used. All modern SLR cameras employ though-the-lens (TTL) light meters that precisely measure the light being transmitted by the lens. In most circumstances, TTL metering is extremely accurate.

One of the primary features of the SLR design is the vast array of lenses available, running the gamut from 8mm fisheyes capable of 180-degree views to 2,000mm telephotos that can capture the grimace of a single athlete from across a stadium.

Most DSLRs use a digital sensor that is smaller than the traditional 35mm format; these sensors are commonly referred to as APS chips, because they are approximately the same size as an obsolete film format from the 1990s known as Advanced Photo System. Although no one makes APS film cameras any more, the size of the format (25.1 x 16.7mm) enabled camera manufacturers to produce digital sensors that were affordable to consumers yet retained most of the optical advantages of preexisting lens designs for 35mm cameras. As you will see, this has implications on focal lengths for portraiture and depth of field.

Many of the professional digital cameras currently on the market use a sensor that is the same size as 35mm and are referred to as "full-frame" cameras.

Rangefinder cameras Rangefinder cameras use a series of triangulated mirrors to focus the camera. As the lens is turned, it moves a cam inside the film/sensor chamber, which in turn rotates a mirror in the viewfinder. What the photographer sees is a clear view of the entire scene with a small, superimposed, double image in the center. As the lens is focused, the image merges and the camera is properly focused.

Rangefinder cameras are an acquired taste; they are small, light, quiet, and unobtrusive. They work very well with lenses in the 28–90mm range. The joy of shooting with rangefinder cameras is due in part to the clarity of the scene through the viewfinder, which is crisp and clear with virtually no obstruction between your eye and the scene. Rangefinders might be an acquired taste, but they are very addictive.

Zeiss Ikon, Voigtlander, and Leica make rangefinder cameras that shoot film. Leica is currently the only manufacturer making a rangefinder camera that can capture digitally.

Micro four-thirds mirrorless cameras These are a new breed of camera. As consumers have become more and more accustomed to using point-and-shoot cameras that rely solely on an LCD screen to compose and focus, manufacturers such as Panasonic and Olympus have introduced a new type of interchangeable lens camera that only uses electronic viewfinders. By dispensing with the mirror and prism of the traditional SLR, the new mirrorless cameras are able to be extremely small and light.

The mirrorless systems do currently have some fairly severe limitations, because there are so few lenses made for the cameras and most of the lenses are quite slow. However, they are great "carry-around" cameras for professional photographers and are completely capable of professional results.

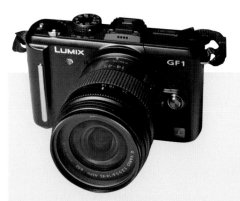

MICRO FOUR-THIRDS CAMERA
The new micro four-thirds cameras dispense with the bulky mirror and pentaprism of the single lens reflex design to create a camera that is almost as small and light as a rangefinder but as versatile as the SLR.

RANGEFINDER CAMERA
Rangefinder cameras are still a favorite for professionals and advanced amateurs as they offer a crisp, clear scene through the viewfinder.

Just tell me what to buy!

In this day and age, film cameras are best viewed as advanced tools for photographers who already have a good idea of what they want to achieve. For most students and advanced amateurs, the camera of choice is an SLR with an APS-sized sensor capable of at least 10 megapixels. There are a plethora of manufacturers to choose from and many of the newer names (such as Sony) make very capable cameras with stellar optics.

In the early days of digital photography, many pros switched from Nikons to Canon brand cameras because Nikon only made APS-sized cameras. Now, both manufacturers make very capable cameras so you can confidently buy either based on personal preference. However, it's a good idea to stick to either Canon or Nikon. Very few photographers can afford to own every lens they will ever need; owning a camera made by either Nikon or Canon will enable you to easily borrow or rent accessories and lenses for special situations. Most university photo programs have lenses and accessories for students to borrow, so it's a good idea to buy a camera that is supported within the program. Within the major brands there are basically three tiers of choice:

Sub $1,000 consumer level Most consumer-level DSLR cameras are capable of professional-level work, especially if the "kit" lens that typically comes with the camera has been replaced with a pro-level lens. Lenses are still the most important determining factor in image quality. Consumer-level DSLR cameras resolve between 12 and 18 megapixels as well as HD video on smaller APS-sized sensors. Many pros carry these as lightweight backup cameras.

PHOTOGRAPHY REINVENTED

Henri Cartier-Bresson was 26 years old when he made this portrait of Mexican prostitutes with a 35mm Leica. He had only been photographing seriously for a few years, yet the graphic and philosophical elements that would become the hallmarks of his work are already evident.

The women are framed in classic Bresson fashion; but the unique power of this photograph comes from the aggressive salesmanship of the woman on the left who appears ready to climb right out of the photograph—she is captured attempting to entice a young, attractive man to put his camera down, go inside, and relax a bit.

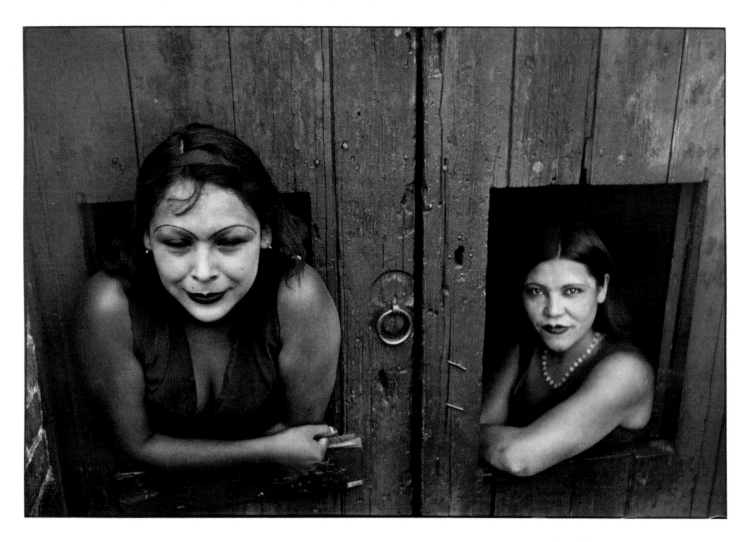

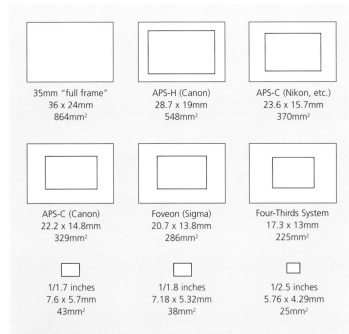

35mm "full frame" 36 x 24mm 864mm²	APS-H (Canon) 28.7 x 19mm 548mm²	APS-C (Nikon, etc.) 23.6 x 15.7mm 370mm²
APS-C (Canon) 22.2 x 14.8mm 329mm²	Foveon (Sigma) 20.7 x 13.8mm 286mm²	Four-Thirds System 17.3 x 13mm 225mm²
1/1.7 inches 7.6 x 5.7mm 43mm²	1/1.8 inches 7.18 x 5.32mm 38mm²	1/2.5 inches 5.76 x 4.29mm 25mm²

SENSOR SIZES COMPARED

This diagram shows the relative size of some of the most popular digital sensors on the market. The size of the camera's sensor influences many factors in both the design and price of a camera. Larger sensors are far more expensive to manufacture, and require longer lenses (with less inherent depth of field) for a given field of view.

Equal resolution for different sensors does not mean they are equal. Two sensors (a 35mm full frame and four-thirds sensor, for example) might be rated at the same resolution and have the same number of photosites. However, in the smaller sensor the photosites will be much closer together, resulting in increased digital "noise."

The only real disadvantage to these cameras is the less rugged build quality, and the viewfinders, which tend to be small and squinty.

$1,500–2,000 prosumer level Optically and electronically, these cameras are very similar to their lower-priced consumer-level brethren and also use APS-sized sensors. However, they are much better built, have much better viewfinders, and are better sealed against dust and moisture. These cameras are an excellent choice for students and aspiring professionals.

$2,500–8,000 professional level Professional-level cameras usually use much more expensive "full-frame" sensors, which are the same size as 35mm film. These sensors allow the photographer to shoot at extremely high ISOs with very little digital noise and are capable of resolving in the 22–25 megapixel range. We can expect 30–40 megapixel DSLR cameras with even higher available ISOs in the very near future.

Pro-level cameras are fully weatherized and rugged enough to be considered military spec. They also have huge electronic "buffers" to allow many frames to be shot at very high rates per second. These buffers hold the electronic data until it can be written to the removable SD or CF card. The most expensive pro-level cameras are also capable of storing photos to two memory cards simultaneously, so that all images are securely backed up.

The most advanced pro-level cameras are also capable of full HD video. This is a very significant development as more magazines and newspapers create stories specifically for multimedia presentation via websites and handheld devices such as the iPad and Kindle. The line between photographer and videographer is quickly disappearing. Most top pros are comfortable shooting both, and know how to build a story using a mix of still photos and moving images.

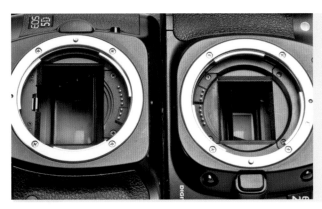

FULL FRAME CAMERA VS APS-C CAMERA

Removing the lenses from two cameras made by the same manufacturer clearly shows the difference in sensor size.

AVOID CHIMPING

The phrase "chimping" derives from photographers who habitually review every photo right after taking it, then oooh and ahhh like a chimpanzee over the results. Chimping breaks the creative flow of the shoot and encourages the photographer to stop thinking once a preconceived result has been achieved. Shoot digital as if you were shooting film, and keep exploring until you've exhausted all the possibilities.

Tutorial 7 | MEDIUM-FORMAT CAMERAS

Over the last 40 years, medium-format cameras have reigned as the ultimate tool for portraiture. Cameras such as the Rolleiflex, Hasselblad, and Mamiya RZ67 have been the chosen tool for legions of legendary photographers such as Bruce Weber, Nadav Kander, and Annie Leibovitz.

Medium-format cameras dominated the professional arena because of their unique attributes:

- The superb optical quality of available lenses.
- Most medium-format cameras offer interchangeable backs allowing for switching film types mid-roll, as well as the ability to shoot instant films for previewing complex lighting setups.
- Interchangeable backs allow for preloaded magazines to be quickly exchanged during fast-moving situations.
- Most medium-format cameras employ leaf shutters in the lens, allowing for synchronized flash at all shutter speeds (almost always a necessity when using flash outdoors).
- Large negatives/transparencies ensure high-quality prints and magazine reproduction.
- The build quality of most medium-format cameras is so high that they are as reliable as an ax. They remain an ideal tool for field use.
- The inherently longer focal lengths of medium-format camera lenses have a unique way in which they describe space.

Today, due to the influx of digital, thousands of these amazing cameras are available on the used market at

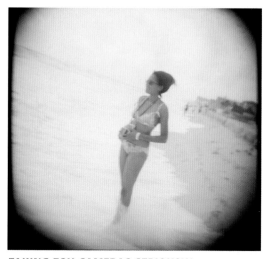

TAKING TOY CAMERAS SERIOUSLY

The Holga is revered for the unique quality of its lens, which is sharp in some places and blurry in others. In this photograph, by Aaron Lee Fineman, you can see how the lens is flaring in the center and vignetting at the edges. Fineman is one of many professionals who have embraced the unpredictable nature of the Holga and uses it frequently on professional assignments.

OBJECTIVE >>

- **To compare and contrast the medium-format cameras available.**

exercise:

HOW DOES FORMAT AFFECT YOUR PHOTOS?

Try shooting with a digital SLR camera one day and a medium-format camera the next. Pay attention to the subtle ways in which your photographic behavior is influenced by the different cameras. Are some formats easier to compose in? Do you notice a difference in what you shoot because of different viewfinders? Are you more careful when you shoot film or does the expense make you less likely to experiment?

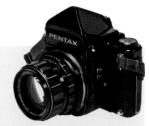

PENTAX 67

The Pentax 67 handles like a 35mm and has been a perennial favorite among fashion photographers because it excels in fluid, fast-moving situations. However, it is hampered for studio shooting by the lack of interchangeable backs and the slow synch speed of its focal-plane shutter.

HOLGA

Cameras like these Holgas and other "toy" cameras produce unique images on medium-format 120 film. Cameras like these have been embraced by photo students as a way of experimenting and breaking away from the tradition of predictable, sharp-focus photographs. Even a few pros have found ways to harness the unique qualities of these cameras and use them professionally.

fractions of their original price and they are every bit as good as they ever were. Negatives and transparencies scanned at the highest resolution are typically around 250–400 megabytes, allowing for huge exhibition-sized prints and extremely fine control when retouching digitally. Photographs shot on color negative film also offer greater tone control than most digitally captured files.

For many of us, the biggest advantage of the medium-format camera is also psychological: People who are used to having snapshots taken with small cameras sense that the photographer with a medium-format camera is a serious professional. A subject seems to understand instinctively why it might take an hour (or more) to set up and light a shot. Photographers slow down as well, and make every shot count.

Modern medium-format digital cameras continue this tradition. Large digital sensors are so "clean," smooth, and free of digital noise that virtually no discernable evidence of digital artifacts is visible, allowing for unparalleled levels of retouching in post-production. However, the extreme expense of both purchasing ($20,000–$40,000) and insuring high-end digital models makes them prohibitive for most field and/or fine-art applications. These cameras are typically used in studios while tethered electronically to computers for instant preview on a monitor.

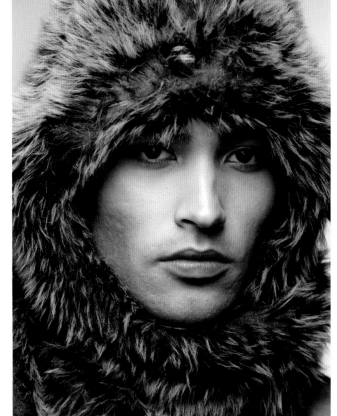

MEDIUM-FORMAT DIGITAL

New York-based fashion photographer Kevin Link uses a medium format camera with a 39 megapixel digital back for his studio portraiture. Tethering the camera directly to a computer allows him to fine tune his lighting and styling by previewing the image at full resolution.

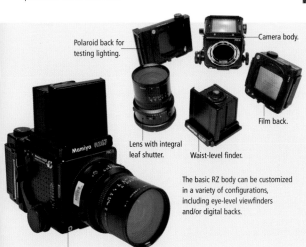

Polaroid back for testing lighting.

Camera body.

Lens with integral leaf shutter.

Waist-level finder.

Film back.

The basic RZ body can be customized in a variety of configurations, including eye-level viewfinders and/or digital backs.

The RZ uses a bellows/rack and gear focusing mechanism, which allows all of its lenses to focus extremely close.

MAMIYA RZ67

The Mamiya RZ67 is remarkably versatile, offers interchangeable backs, viewfinders, fast synch speeds (to $\frac{1}{400}$ second), and extremely close focusing. However, it is cumbersome and slow, especially for photographers who are new to the camera.

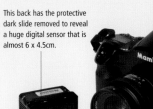

This back has the protective dark slide removed to reveal a huge digital sensor that is almost 6 x 4.5cm.

This back is a traditional film back. The ability to switch from film to digital in an instant makes the 645 a popular format with fashion photographers.

MAMIYA 645

The Mamiya 645 attempts to be all things to all people, offering 35mm-like handling, autofocus, and autoexposure. One advantage of this particular camera is the ability to easily adapt it for both film and digital use through the use of interchangeable backs.

MAMIYA 7

A favorite among photojournalists and landscape photographers, the Mamiya 7 is an oddity in medium-format cameras. While it is limited due to its inability to focus closer than about 3 feet (90cm) and does not have interchangeable backs, it does have interchangeable lenses and is extremely portable and quiet. Leaf shutters in each lens allow for high shutter speeds with electronic flash. The lenses are remarkable.

Tutorial 8 | LARGE-FORMAT CAMERAS

Why would anyone choose to lug around these large, heavy, antiquated beasts?

A 4 x 5-inch camera with a tripod weighs about 15 pounds (6.5kg) and a similar 8 x 10-inch camera about 30 pounds (13.5kg). Add the weight of ten film holders and a per shot expense of $6–20, depending on the film choice and processing, and it becomes easy to understand why large-format photography is a dying art.

However, if you have ever seen an original print (not a reproduction in a book or on a computer) by Stephen Shore, Sally Mann, Edward Weston, or Richard Misrach, it is very clear that the way large-format cameras see and render the world is nothing short of magic. Large-format cameras seem to be able to describe the air around things as well as the things themselves.

If one of the advantages of medium format is that it slows things down, then large-format cameras are positively glacial by comparison. This slowness is one of the best reasons to use large-format cameras for

portraiture. The difference between a good photograph and a great one is in the subtlety of expression in the subject. People can't hold their "happy face" masks for long. There is no better example of this than Richard Avedon, who used his 8 x 10-inch Deardorff cameras like an X-ray machine to see below the surface and into the soul of his subjects.

Could we achieve the same effect by simply slowing down with a high-resolution digital camera? Probably—but the large-format camera also allows the photographer to selectively control depth of field and composition by manipulating the placement of the lens planes and film planes independently.

It's interesting: as large format becomes less and less relevant as a commercial tool, it becomes more and more relevant as a fine-art tool.

OBJECTIVE >>

■ **To understand the unique challenges and qualities of large-format cameras.**

exercise:

LOOK AT REAL PHOTOGRAPHS

Go to a gallery or museum and look at original prints by photographers. Viewing work online and in magazines reduces all photographs to the "lowest common denominator" resolution of a computer screen or the quality of the printing. For photographers, this is the visual equivalent of only listening to music through a set of $5 headphones. Great photographs are subtle: Get out and see the real thing every once in a while.

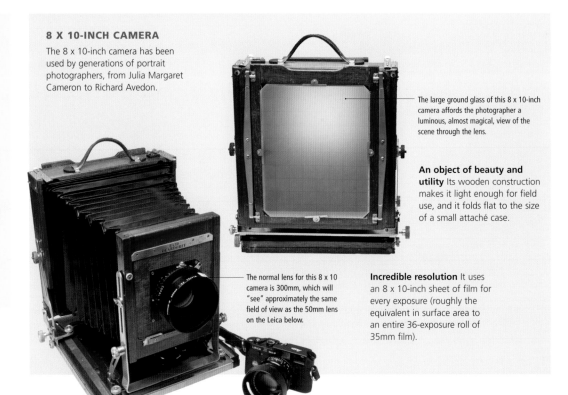

8 X 10-INCH CAMERA

The 8 x 10-inch camera has been used by generations of portrait photographers, from Julia Margaret Cameron to Richard Avedon.

The large ground glass of this 8 x 10-inch camera affords the photographer a luminous, almost magical, view of the scene through the lens.

An object of beauty and utility Its wooden construction makes it light enough for field use, and it folds flat to the size of a small attaché case.

The normal lens for this 8 x 10 camera is 300mm, which will "see" approximately the same field of view as the 50mm lens on the Leica below.

Incredible resolution It uses an 8 x 10-inch sheet of film for every exposure (roughly the equivalent in surface area to an entire 36-exposure roll of 35mm film).

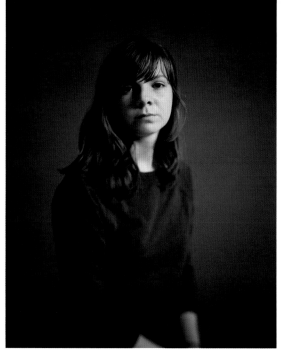

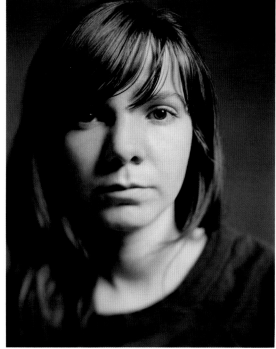

◁ **EMMA, 2009**

David Macedo uses 4 x 5-inch cameras to create diptych and triptych portraits marked by a timeless, still quality. Note the use of lens swing to subtly throw the left side of the face out of focus.

▽ **DEATH ROW PORTRAITS**

For my personal project on Death Row Portraits I chose to use a Sinar 4 x 5 (see left) because the slowness of the camera made the process more formal and requires a greater level of participation on the part of the subject.

4 X 5-INCH CAMERA

This monorail camera is designed primarily for highly technical applications, but many portrait photographers use them as well because they are so versatile and solid.

Tilting the lens like this allows the photographer to control the depth of field independently of the aperture setting. The lens can also "swing" (rotate + or - 20 degrees) around the axis, creating the effect in the portrait above.

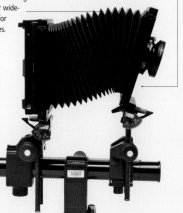

The bellows can be interchanged, allowing a greater degree of movement for wide-angle lenses or a longer bellows for extreme close-ups with long lenses.

A grid etched in the ground glass can be used to aid precise framing.

Extensions can be added to the rail for longer lenses.

Monorail view camera This is a 4 x 5-inch camera. It uses a rail to hold the lens and film planes, which offers more flexibility in camera "movement." However, the camera is not as easy to carry because it does not fold flat.

Versatile and flexible The use of an accordion-style bellows allows the lens and film stages to move independently on large-format view cameras. While these movements are primarily designed for architectural and product photography, they are also used to control composition and give the portrait photographer the option of choosing the plane of focus.

Tutorial 9 | BASIC LENS SELECTION

Is the basic wide-angle to moderate telephoto kit lens all anyone needs? Or is it a piece of junk that is incapable of professional work?

OBJECTIVE >>
■ **To work out which lenses you really need.**

exercise:

USE METADATA TO LEARN ABOUT YOURSELF

Look though the EXIF metadata (exposure information) of a few hundred of your favorite or typical photographs. See if there's a focal length that you seem to shoot with more often than others. If you see a pattern, try shooting for a few days with your zoom lens taped to that focal length. If you notice that you don't really need to zoom very often, then it is probably worth owning a prime lens in that length.

For many photographers, the kit lens sold with the camera is all they'll ever need. It's intended as a relatively compact, light, do-everything lens for walking around, and in this regard kit lenses are pretty terrific. They are slow, but most offer image stabilization. When combined with the high ISOs of modern digital cameras, they are more capable in low light than film cameras of just a few years ago.

That said, almost every photographer needs a fast, fixed focal length prime lens or two for low-light situations. Prime lenses are usually much faster than zoom lenses, so they offer more flexibility and control over depth of field, as well as being able to stop subject motion in available-light situations. Your personal preference will be largely based on the kind of photography you find yourself specializing in: A wedding photographer who has to shoot in dark churches and wants razor-thin depth of field for portraits might opt for a pricey f/1.2 85mm, while a photojournalist might choose an f/1.4 24mm. In fact, many professionals and fine-art photographers find themselves drawn to a particular focal length and never use anything else.

Another option is to upgrade the kit zoom lens to a pro-level zoom with a constant aperture. Kit zoom lenses try to do a lot with one lens, zooming all the way from extreme wide angle to moderate telephoto.

Designing a lens like this always involves compromises. Pro-level zoom lenses are generally more moderate in what they attempt to accomplish by staying within a narrower zoom range such as 16–35mm or 24–70mm. The optical quality of pro-level zooms is on par with that of prime lenses.

The great news for photographers who use APS digital cameras is that the fixed focal length 50mm prime that is a normal on full-frame cameras is a perfect portrait lens for an APS camera, and even the f/1.4 version is affordable.

Image stabilization and vibration reduction lenses

The rule of thumb for shutter-speed selection is that the handheld shutter speed should never be less than the focal length of the lens, because any motion in the photographer's hand is amplified in longer focal length lenses. It is considered safe to (carefully) handhold a 28mm lens at $\frac{1}{30}$ second, but a 100mm lens would require a shutter speed of about $\frac{1}{100}$ second. This rule of thumb applies to full-frame cameras; for APS-sized cameras the crop factor of 1.5 applies—so if you are handholding a 50mm lens, the minimum recommended shutter speed would be $\frac{1}{75}$ second or faster.

Image-stabilized lenses use a floating element that is controlled by gyroscopic sensors to minimize handheld camera shake. With care, this can enable sharp photos to be taken handheld at shutter speeds four times longer than the rule-of-thumb recommendations. However, while image stabilization allows a photographer to shoot at extremely low shutter speeds, it is no help at all if the subject is moving.

TEST IT!

The chances are your zoom lens is great at certain focal lengths, but not throughout the entire zoom range. Typically, most kit zooms are quite good as long as you stay away from the extreme limits of the lens's total zoom range. A lens might be great at a 20mm setting, but turn to mush at 17mm.

A simple test is to photograph a newspaper taped to a wall. Frame the newspaper in the viewfinder at a few different focal lengths, including the widest and longest. Examine the results on a computer at full size to find the sweet spots, then try to stay within the limitations of the lens when you shoot. It's a good idea to test all your lenses every year to make sure they are still functioning optimally.

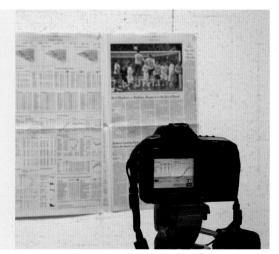

LENS HOODS

Lens hoods are not an optional accessory; they are essential to getting the most out of your expensive lenses.

Without lens hood Most of us are familiar with the brightly colored flare of a light shining into the lens, but flare can also be subtle. Here the flare is evidenced by a lack of contrast because the flare is being caused by an unshaded protective filter.

With lens hood Flare is dramatically decreased with a lens hood in place.

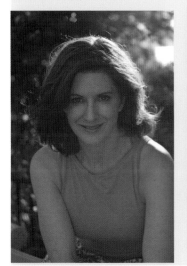

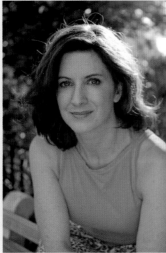

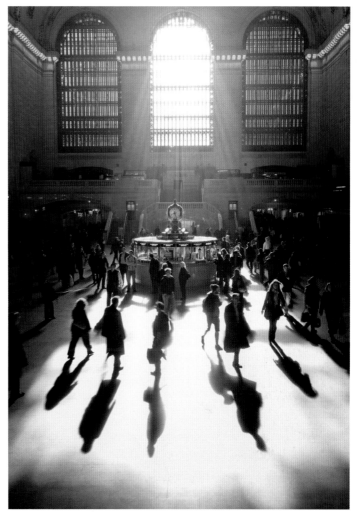

Shot on kit zoom lens at 85mm, f/5.6

Shot on 85mm prime lens, f/1.8

STICK WITH THE KIT OR INVEST IN A PRIME?

The photo on the left was shot on an APS-sized camera with a kit zoom at 85mm and the lens open to the maximum aperture of f/5.6. The photo on the right was shot with a good, but inexpensive, consumer-level 85mm prime lens at f/1.8. Note how much less depth of field there is.

Each lens has advantages: The zoom is versatile but slow. The prime lens is fast but may not be as versatile.

MOTION BLUR

Using an image-stabilized lens allowed this photo to be handheld at ⅛ second, giving the rushing commuters just the right amount of motion blur while keeping the architecture tack-sharp.

Tutorial 10 | DEPTH OF FIELD

If you ask the average professional photographer what depth of field is, they will say something like, "It's how much of the foreground or background is in focus. If you make the aperture bigger, you get less depth of field; if you make it smaller, you get more." If you ask them how it works, fewer than one in ten will be able to explain it.

exercise:

TRY IT

Set your camera to aperture priority and your kit zoom to a short focal length and the widest possible aperture. Now zoom to a telephoto setting and watch the maximum aperture change (usually from f/3.5–f/5.6) in the light meter readings.

For a lot of photographers that's all they need to know, because certain photographic specialties (such as architectural photography) consistently need all the depth of field the photographer can get, whereas in others (such as sports photography) action-stopping shutter speeds are more important, so photographers learn to work with very limited depth of field.

"Old-school" prime lenses (fixed focal lengths) have a depth-of-field scale engraved on the barrel. The problem for many young photographers who came of age shooting with zoom lenses is that there is no easy way to calculate depth of field on a modern zoom lens.

Portrait and fashion photographers, as well as cinematographers, have to really understand and use depth of field. If you look at most portraits, most of the image area in a typical portrait is actually background. Portrait photographers are constantly evaluating the background in relation to the subject. Does the surrounding environment contribute to our understanding of the subject or is it distracting?

The importance of aperture

Most photographers understand the lens apertures, or f-stops, as a way of controlling exposure. An aperture of f/2 lets in twice as much light as f/2.8 and four times as much light as f/4 and so on.

What those numbers actually signify is a ratio between the diameter of the aperture and the focal length of the lens: A 50mm lens with an opening (aperture) 25mm in diameter has an f-stop of f/2.

This is why "kit" zoom lenses have variable maximum apertures. As the lens is zoomed in or out, the ratio between the diameter of the lens (the aperture) and the focal length changes.

This is also the Achilles heel of most kit zoom lenses: As the photographer attempts to lessen depth of field by using a longer focal length, the depth of field is simultaneously increased by the proportionately smaller maximum aperture. Most amateurs don't care or notice, but it is extremely important to professionals. This is one of the reasons why pro zoom lenses maintain a constant f-stop throughout the zoom range.

How depth of field works

A lens is only truly focused on one particular plane of focus. Objects slightly in front of or behind the plane of focus are not as sharp and show up as unfocused pools of light. These areas are called "circles of confusion."

When the lens is closed down, less light is admitted into the camera. However, the rays that do get in are more parallel to each other, resulting in much smaller circles of confusion. The photo looks sharper from front to back. When the circles of confusion become small enough (relative to the size of the final image), they are considered to be as "in focus" as the primary plane of focus.

This is how Ibn al-Haytham was able to project an image in his prison cell without a lens (see right). The aperture was so (proportionately) tiny compared to the focal length that it had great depth of field.

All lenses have a certain amount of depth of field due to their focal length, regardless of their field of view. A 50mm lens on an APS camera is a moderate telephoto, on a full-frame camera it is a normal lens, and on a 6 x 7 format camera it is an extreme wide angle. However, the depth of field for any 50mm lens at any given f-stop is constant because depth of field is inherent to the focal length of the lens and not its field of view or the format of the camera.

Once you understand that the camera format, depth of field, and lens selection are all interrelated topics, you can better understand why many photographers still prefer medium- and large-format film cameras to digital cameras, regardless of resolution.

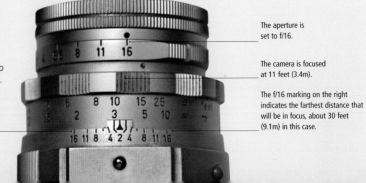

SETTING DEPTH OF FIELD ON YOUR CAMERA

This 50mm prime lens is focused at 11 feet (3.4m) and the aperture is set to f/16. The depth-of-field scale indicates that the photo will be sharp from 7 feet (2.1m) to 30 feet (9.1m).

The f/16 marking on the right side indicates the closest point that will be in focus, about 7 feet (2.1m) in this case.

The aperture is set to f/16.

The camera is focused at 11 feet (3.4m).

The f/16 marking on the right indicates the farthest distance that will be in focus, about 30 feet (9.1m) in this case.

A BRIEF HISTORY OF OPTICAL SCIENCE

It seems ridiculous to us now, but until the 10th century the commonly accepted explanation for how vision worked is that some kind of ray emanated from the eye and reflected back to the viewer.

That all changed when a supposedly insane Islamic scholar/philosopher named Ibn al-Haytham was imprisoned by an Egyptian Caliph. Haytham wasn't really insane; he was one of the most brilliant men to ever walk the earth. He had spent his life studying and translating Greek philosophers into Arabic and dreamed of reunifying Islam through the study of natural science.

For 10 years, Ibn al-Haytham sat in his room with one window. He looked at light and investigated how we see. It was in his room that he built the first documented camera obscura (Latin for "darkened chamber") by

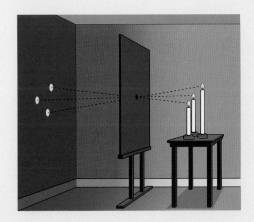

covering the window and letting a small beam of light enter the room through the hole (aperture). He used a bed sheet to form a projection screen on the opposite wall (the focal plane).

Ibn al-Haytham used his knowledge of Euclidean geometry and deduced that when light came from the sun it was reflected in all directions. However, only a very small percentage of the rays were at the proper angle to enter the small hole in the window (aperture) and these were the rays that formed the apparition on the screen.

In one experiment he observed that the projected image of varied light sources was inverted and correctly deduced that our eyes must do the same thing, with our brains correcting the image.

One day, the Caliph who had imprisoned Ibn al-Haytham went out for a walk and disappeared; suddenly Ibn al-Haytham was completely sane. He went home and wrote the first book on optical physics. He is considered to be the first true scientist. Later, his work would be rediscovered by a Franciscan monk named Roger Bacon, translated into Latin, and form the basis for the Italian Renaissance.

How can a pinhole with no lens form an image? The answer is that, because the hole is so small, it has extreme depth of field.

IBN AL-HAYTHAM'S CAMERA OBSCURA

This diagram illustrates the principles dicovered by Ibn al-Haytham when he built the first documented camera obscura. It shows how rays of light pass through a small hole and project upside down on the opposite wall.

APERTURE AND DEPTH OF FIELD DEMYSTIFIED

The aperture setting of any lens is a ratio between the size of the lens opening and the focal length.

Aperture is particularly important when we use inexpensive zoom lenses because the ratio between the maximum aperture of the lens changes as the focal length changes.

f/2 In this case the lens opening is 25mm wide and the lens is 50mm long, resulting in an effective aperture of f/2.

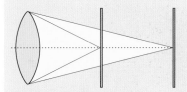

f/4 When a 25mm lens opening is applied to a 100mm lens, the effective aperture is f/4.

PINHOLE CAMERA ROOM

In this experiment a window was completely blocked off except for a small opening about ⅓ inch (1cm) in diameter (no lens is used). This effectively turned the entire room into a giant pinhole camera, with the building across the street being projected onto the opposite wall of the darkened room.

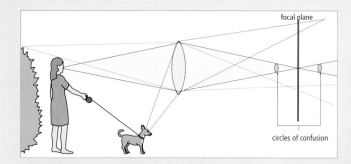

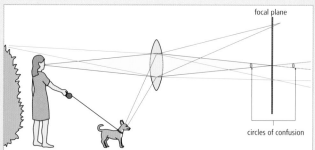

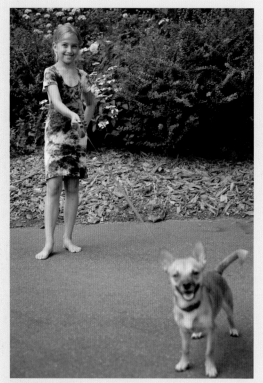

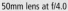
50mm lens at f/4.0

50mm lens at f/16

DEPTH OF FIELD AND CIRCLES OF CONFUSION

A lens is only precisely focused at a particular distance, but judicious use of the aperture can make it seem to have more or less focus in front of or behind the main subject.

There is no "correct" depth of field. There are times when it should be deep and times when it should be selectively shallow.

Far left When the lens is opened to its widest aperture, the light from the plane of focus is precisely focused on the little girl. However, much of the light from objects in front (the dog) and behind (the bushes) is either converging in front of or diverging behind the film plane, creating "circles of confusion"—blurry pools of unfocused light.

Left When the aperture is closed slightly, fewer rays of light enter the lens. However, the rays that do enter are more parallel, resulting in smaller circles of confusion and greater depth of field.

Although, technically, only the girl is truly focused, when the circles of confusion are small enough, the effect is the same as if the lens were focused on both the foreground and the background.

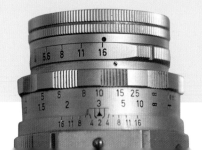

DIFFERENT CAMERA, DIFFERENT DEPTH OF FIELD

These photographs were taken with five different cameras; however, they all have the same approximate (normal) field of view. They are all shot at ⅟₆₀ second at f/6.3. They are all focused at exactly 10 feet (3m). In order to achieve the same effect on an APS-sized Canon 50D as the 300mm lens on the 8 x 10-inch camera, we would have needed to shoot on a 30mm lens with an f-stop of f/.07. Of course, no such lens exists; however, we could get the same effect with a 50mm f/1.2 lens on a full-frame (digital or film) camera or a 90mm f/3.5 lens on a 6 x 7-inch film camera.

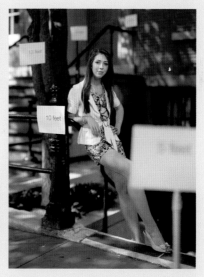

Panasonic Lumix (approximately a 7 x 9mm sensor) with a focal length of 9.3mm The depth of field with this lens and f-stop is extremely deep—from 3 feet 9 inches (1.1m) to infinity.

Canon 50D (APS sensor) with a 30mm lens The depth of field is from 7 feet 1 inch (2.2m) to 16 feet 6 inches (5m).

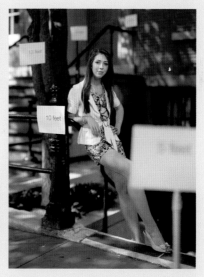

Canon 5D Mark II (full-frame sensor) and a 50mm lens The depth of field is now from 8 feet 1 inch (2.5m) to 12 feet 11 inches (3.9m).

Mamiya RZ67 with a 90mm lens The depth of field is now from 8 feet 8 inches (2.6m) to 11 feet 9 inches (3.6m).

8 x 10-inch Deardorff and a 300mm lens The depth of field is now extremely narrow—from 9 feet 5 inches (2.8m) to 10 feet 7 inches (3.2m).

Tutorial 11 | FOCAL LENGTH

The focal length of a lens is simply how far away the lens has to be from the film or sensor surface (henceforth referred to as the "focal plane") in order to focus sharply on an object at "infinity" (30–100 feet, or 9–30m, for most photographic lenses).

exercise:

SHOOT EXTREMES OF FOCAL LENGTH

Shoot the same subject with different extremes of focal length but keep the main subject the same size in all of the photos. How does a simple "head and shoulders" portrait change when it is shot with a 200mm lens from 20 feet (6m) away or a 24mm lens from 3 feet (90cm) away? What about the background? How does it change?

Back in the days when 35mm film cameras ruled amateur photography, all cameras came with a fixed focal length "normal" lens (50mm). These normal lenses had a lot going for them; they were quite fast (more on this later), very sharp, compact, simple, and inexpensive. In fact, the only disadvantage of the 50mm normal lens was the fact that it couldn't change its focal length and "zoom" from wide-angle to telephoto views. The 50mm normal was the standard, because it most closely reflected the normal angle of view seen by the human eye.

Focal length and angle of view

All lenses create and project a circular image. Photographs are rectilinear because the chamber that covers the film or sensor of the camera is shaped in a rectangle that "crops" a section out of the circle.

The "normal" lens for a particular camera or format is approximately the diagonal of the film, or sensor size:

■ 1/25 type digital sensor (many point-and-shoot cameras) = 7.1mm
■ APS C and H cameras (most prosumer Canon and Nikon cameras) = 30mm
■ 35mm film and full-frame digital cameras = 50mm
■ 6 x 4.5-cm film and digital sensor medium-format cameras = 75mm
■ 6 x 6-cm film cameras (Hasselblad, Rollei, etc.) = 80mm

■ 6 x 7-cm medium-format film cameras (Mamiya RZ67, Mamiya 7, etc.) = 90mm
■ 4 x 5-inch large-format cameras = 150mm
■ 8 x 10-inch large-format cameras = 300mm

All of these different focal lengths will actually yield almost exactly the same framing or "field of view" when matched to the corresponding film or sensor size.

Because 35mm film was the photographic standard for so long, many photographers have come to instinctively think and pre-visualize in the focal lengths that were common to the 35mm format: 50mm = normal, 28mm = wide-angle, 135mm = telephoto, and so on. This is why manufacturers of digital cameras often refer to "equivalent" focal lengths in sales brochures. Because the sensor size on APS DSLRs is smaller than the traditional 35mm frame, a 30mm lens yields approximately the same angle of view as the 50mm on a full-frame 35mm camera. This is often referred to as the "crop factor," because the smaller sensor is "cropping" a smaller section of the lens's projected image. This crop factor means that photographers using APS-sized sensors multiply the actual focal length by 1.6 (for Canon) and 1.5 (for Nikons) to get the equivalent in a traditional full-frame camera.

Modern digital cameras almost always come with an inexpensive "kit" zoom lens (usually about 18–85mm)

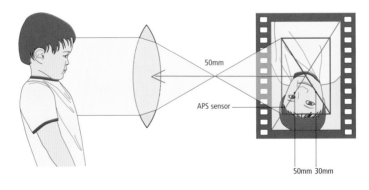

50mm

APS sensor

50mm 30mm

50MM LENSES

The "normal" focal length of the 50mm lens in 35mm photography (or on a full-frame digital camera) corresponds to the diagonal of the frame. This yields an image magnification and angle of view that closely approximates the human eye.

The diagonal of prosumer cameras with smaller APS sensors is about 30mm (as marked by the smaller blue frame), so an equivalent "normal" lens would have a focal length of about 30mm.

The good news for portrait photographers is that there are lots of very fast, sharp, and inexpensive 50mm lenses on the market that were originally made for film cameras. The 50mm focal length becomes a great portrait lens on cameras that use APS sensors.

that enables the photographer to change focal lengths from wide-angle to telephoto. When we take the crop factor into consideration, we see that these zoom lenses have approximately the same field of view as a 29–135mm zoom lens for a full-frame 35mm camera.

With a few caveats, the zoom lenses that come with digital cameras are fantastic.

Why some lenses distort and/or foreshorten

Lenses really don't distort or foreshorten; they render what's in front of them with geometric precision. However, they can see a wider view than our eyes are capable of and this can have the effect of emphasizing the distance between objects. Conversely, they can also magnify distant objects (telephoto) and this can tend to minimize the distance between objects.

Knowing how to use lens length is one of the most effective tools in any photographer's bag of tricks, and it can have a dramatic effect when shooting portraits.

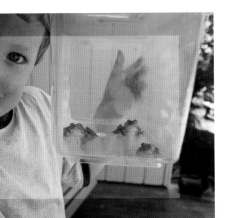

CROP FACTORS FOR DIFFERENT SENSORS

This photo above was shot with a 24mm lens on a full-frame camera. The center area shows what the camera would see with the same lens on an APS DSLR. In order to get the same framing with an APS camera, I would have needed to shoot with a 15mm lens.

THE EFFECT OF FOCAL LENGTH AND RELATIVE DISTANCE ON PERSPECTIVE

While photographers commonly refer to the wide-angle or telephoto lenses distorting, this isn't really the case. The camera's distance to the subject and to the objects in the background is what creates the effects of distortion or compression.

24mm lens on full-frame camera
The figure in the foreground is 9 inches (22.5cm) away from the lens and the figure in the background is 9 inches (22.5cm) farther away (18 inches/ 45.5cm from the lens). The figure in the background appears half as big as the figure in the foreground, because it is twice as far away. This is commonly referred to as wide-angle distortion, but it is actually a perfectly accurate description of the relative distances between these objects.

50mm lens on full-frame camera
The camera is now 18 inches (45.5cm) away from the foreground subject and 27 inches (68.5cm) from the figure in the background. The figure in the background is now 66 percent of the size of the subject in the foreground.

100mm lens on full-frame camera
The camera is 36 inches (91.5cm) away from the figure in the foreground and 45 inches (114cm) away from the figure in the background. The figure in the background is now 80 percent as large as the figure in the foreground. This is commonly referred to as telephoto "compression" or flattening, but it is really a mathematically accurate description of how the lens renders the relative distances between objects when the viewer/camera is farther away.

Tutorial 12 | PORTRAIT LENSES

People often say, "Please don't take my photo. I hate the way I look in pictures!" They don't say, "I hate the way I look," but rather, that they hate the way the camera makes them look.

OBJECTIVE >>

■ **To understand why people look different in photos as opposed to in the mirror, and to use this knowledge to create flattering portraits.**

exercise:

EXPERIMENT WITH SELF-PORTRAITS

Use a self-timer to photograph yourself using your lens at different focal lengths to determine which most clearly fits your self-image.

Why is there a common disparity between the way we perceive ourselves and the way the camera describes us?

The answer is in large part due to the device that we use to see ourselves daily—the bathroom mirror.

An average bathroom mirror measures about 20 x 24 inches (50 x 60cm). When we look at our reflection, we typically frame ourselves for a "head and shoulders" view and we stand about 3–4 feet (90–120cm) away from the mirror. If we stand much closer, our eyes will be forced to scan the reflection and we will be zeroing in on details instead of looking at our overall appearance, so 3–4 feet (90–120cm) seems to be optimal.

When we examine the optics of the bathroom mirror, we see that when we stand 3 feet (90cm) from the mirror we are actually standing 6 feet (1.8m) from our reflection. This is very easy to test. Put a piece of tape on a mirror, stand about 3 feet (90cm) away, and use a camera to focus on the tape; the tape will be sharp but your reflection will be out of focus. If you focus on your reflection, the tape will be out of focus.

At this distance the bathroom mirror is actually behaving like a moderate telephoto lens, because it is minimizing the distance between the tip of our nose and our ears. It is "flattening" our face like the photos with the toy soldiers that were shot with the 105mm lens.

Using lenses

What happens when we take a snapshot portrait of another person with a point-and-shoot camera?

When we turn the camera on, it opens up with a wide-angle lens setting of about 35–50mm or the equivalent; then we step forward to about 3 feet (90cm)

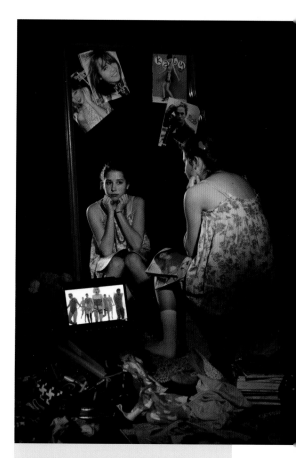

MIRRORS CAN BE MISLEADING

Andrea Bejarno based this modernized photograph of a young woman looking in a mirror on a Norman Rockwell painting from the 1950s. Note that the reflection seems farther away than the surface of the mirror.

THROUGH THE LOOKING GLASS

When we look in a mirror we are farther away from ourselves than we think. In this diagram the mirror is just 3 feet (90cm) away, but the reflection is 6 feet (1.8m) away.

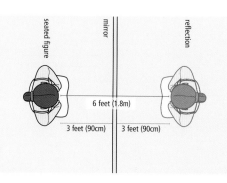

seated figure | mirror | reflection

6 feet (1.8m)

3 feet (90cm) | 3 feet (90cm)

away from the subject and frame the photo for a "head and shoulders" portrait. The subject looks terrible and they hate the photo.

Six feet (1.8m) is the commonly accepted conversational distance. When someone gets much closer we tend to back up; if they get much farther away we feel as though they are avoiding us. Six feet (1.8m) also happens to be the distance where we can look someone in the eye without having to scan back and forth between the two eyes.

Manufacturers often advertise lenses in the 85–135mm range as portrait lenses for 35mm or full-frame cameras. What this usually means is that the lens will frame a head and shoulders viewpoint at about 6–10 feet (1.8–3m).

Could we shoot with a wider lens? Sure. As long as we stay farther away than the 5–6 foot (1.5–1.8m) range, the subject's face will still be rendered naturally. Of course, the lens will include more of the surrounding environment, and body parts such as hands and feet that are closer might look too large.

Could we shoot with a longer lens? Yes, if we have enough distance to back up. In fact, the farther back you go (with a longer lens), the better the subject will usually look. Longer lenses also have the added advantage of having less depth of field, providing a greater separation of visual space between the subject and the background. Many fashion photographs are shot with lenses in the 200–300mm range with the photographer yelling to the model.

This also explains why some people seem more naturally photogenic than others. Top models often look a bit odd when we first meet them. They can look gaunt and have very exaggerated features. However, when they are photographed with long lenses their faces flatten out and they look amazing.

The advantages of APS-sized cameras

The great thing about APS-sized prosumer cameras is that, when we consider the crop factor, one of those fast, simple, sharp, and inexpensive 50mm prime lenses becomes a perfect moderate telephoto portrait lens. Of course, we can simply shoot with the kit zoom—but the fixed focal length 50mm lens usually has a maximum aperture of f/1.8 or f/1.4, allowing us to shoot in less light, and with far less depth of field, which is often desirable in this kind of portrait.

IT'S NOT THE LENS, BUT THE DISTANCE THAT MATTERS

Look at the two photos below. The subject's head is exactly the same size but his features are described differently because the photos were shot at different distances (with the focal length changed to maintain the same magnification). Changing to an even longer lens and backing up further might have been even more flattering.

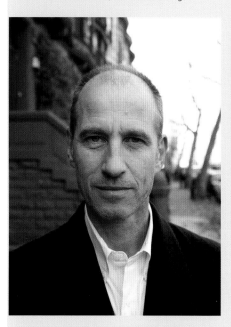

30mm normal lens on APS size camera at f/3.5 The subject looks a bit gaunt, with an exaggerated nose and thin neck. Note how much more of the background is included.

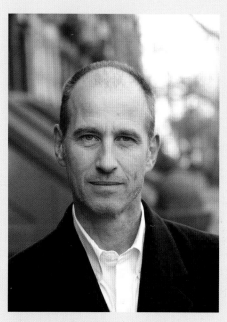

70mm lens at f/3.5 Stepping back and then zooming in with a 70mm lens brings the features into better proportion. Note also how much less of the distracting background is included and how much more the background is thrown out of focus.

IS THERE A TRUE PORTRAIT LENS?

Unique "portrait" lenses, such as this Imagon, provide the photographer with the ability to vary the degree of sharpness/diffusion within the image. The lenses come with a series of disks with multiple smaller apertures that are inserted into the lens to create a series of diffuse layers that "overlay" the primary image. Without the disks these lenses are extremely sharp.

This particular lens is made to be used on a 4 x 5-inch camera, but some manufacturers have made similar lenses for use on both medium-format and 35mm cameras.

Tutorial 13 | METERS

In an age when virtually every camera has a meter built in as well as an instant playback of the image, do you still need a handheld meter? Maybe not. If you always shoot in available light with a digital camera, you might never need a handheld meter — but it will be very hard to build a career on such a modest level of skill.

OBJECTIVE >>
■ To break your reliance on your camera's program mode.

exercise:

CAN YOU LIVE WITHOUT THE METER?

Carry an incident meter around for a week or two and take a reading every time the light changes or you find yourself in a new situation. It will help you look at light more carefully and break the habit of using your camera in program mode all the time.

Meters can help to analyze problems in complex lighting setups, and keep you out of trouble in tricky available-light situations. Most modern meters can also be used to measure the light from electronic flash. Of course, a handheld meter is a necessity when working with almost any medium- or large-format camera.

Light meters are dumb

The most important thing to remember about light meters is that they only do one thing: They measure the amount of light necessary to make everything exactly the same shade of gray.

If you point a reflected light meter at a snowman, it will tell you the exact exposure to render the snowman gray (underexposure). If you point it at a black cat in a coal bin, it will tell you exactly how to make it look gray (overexposure). If you point it at a gray card, however, it will expose the gray card perfectly. If you point it at a black-and-white checkerboard, it will also expose it perfectly, because it averages the two tones together to "make" gray. Your light meter is perfectly accurate, as long as you use it correctly.

The meter in your camera

The meter in your camera reads the light reflected from the scene that you are photographing. Most scenes have enough of a range of tones for the reflected light to average out at middle gray.

Most modern cameras have three metering modes. They are all excellent, but there are times when one mode is better than others:

Average/center-weighted metering In this mode the meter looks at the reflected light from the entire scene; the shadows under cars (black), the clouds (white), the foliage (two stops darker than middle gray), Caucasian flesh tones (one stop brighter than middle gray). The meter averages all these tones to expose for the average of middle gray. Center-weighted metering works quite well as long as the scene has a good range of tones. If you are taking a photo of a black cat in a coal bin or a snowman, it will always make a bad exposure.

Spot metering In this mode the meter only looks at a very small section (usually indicated by a circle) in the center of your viewfinder. This mode is useful when most of the scene is such that it would "fool" the meter, such as a person standing in a snowfield. By using the spot meter, you can see what the camera is metering and evaluate whether it is close to middle gray.

DIFFERENT METERS

Meters come in many different types and every photographer has a different preference. Buy the best you can afford—you will probably own it for the rest of your life.

Classic and reliable This selenium cell meter has been an industry standard for over 40 years and they are still being manufactured. Because selenium cell meters don't need batteries (they are powered by a photo-electric cell) they are great backup meters. This meter can measure both incident and reflected light but not flash.

Tiny and simple This meter will also measure both reflected and ambient light, yet it's small enough to fit in a pocket and has scales for both analog and digital readings.

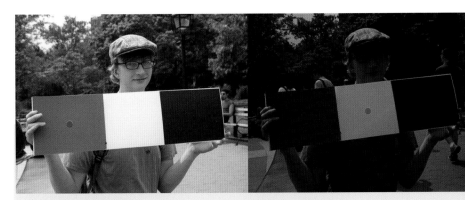

PERFECT EXPOSURE
Using a spot meter to read the calibrated 18 percent gray card on the left yields a perfect exposure.

UNDEREXPOSURE
If we use the white middle area, the meter will give a reading to make it gray, resulting in underexposure.

OVEREXPOSURE
Reading the black card on the right results in the black card being rendered as gray, overexposing the rest of the scene.

Spot meter mode is also handy when you have a gray card from which to meter.

Evaluative or matrix metering

This is the most sophisticated metering available to the meter in modern cameras and the mode you should use most often. In this mode, the camera meters many different segments of the scene and uses the manufacturer's software to evaluate and compare the segments. Then it compares the data to typical scenes stored within the camera's software. Essentially, the camera looks at a scene—a person standing by a lake with a lot of sky behind them, for example—and recognizes that the person is probably more important than the sky and adjusts the exposure slightly to favor a proper exposure for the person instead of the landscape. Evaluative/matrix metering is harder to fool, but it is not foolproof.

Handheld/auxiliary meters

Handheld meters measure either the reflected light from the scene (in the same way as your built-in camera meter) or the incident light—the light that is falling on the subject.

Zone system tool A 1-degree spot meter like this allows the photographer to isolate and read very small areas of the scene in order to analyze the entire tonal range. This meter is very popular with photographers using large-format cameras and the "zone system" technique popularized by Ansel Adams.

Versatile and handy This meter will measure incident light from both ambient and flash-light sources. The dome can also be interchanged to allow reflected light readings or a spot meter attachment. As a compromise of infallibility, size, price, and versatility, a meter like this is hard to beat.

Do it all The meter can be used to measure ambient light, electronic flash, or a combination of both. It has a built-in incident dome as well as a 1-degree spot meter capability.

Color meter Color meters are specialized tools that precisely measure the color temperature of incident light in order to ensure accurate color. With the RAW files and the ability to change light balance in post-production, meters like this aren't quite the necessity they were in the past. However, they can be invaluable as an aid in balancing light from different sources (like fluorescent and tungsten).

HOW TO USE A METER CORRECTLY

Incident meters use a translucent dome to measure the light. The dome is made to approximate the depth and shape of a human face. Care should be taken to make sure that the shadows on the dome look about the same as the shadows on the face. For beginners, this means that you have to walk to the subject and put the meter near your subject's face. Eventually, you can learn to use the meter from the camera position—as long as the light is the same in both positions

The white dome can read the incident light for either the flash or the ambient, or it can combine the flash/ambient combination. On this meter the dome can be retracted, allowing the photographer to measure each of the lights in a multiple flash setup individually.

The meter gives you the optimum aperture/f-stop for the specific light you are working with.

The ISO 2 button enables you to set a second film speed.

Connect your synch cord here.

Enter your working shutter speed here.

SEKONIC METER

One of the most versatile meters on the market is this Sekonic. It can be used to measure flash or ambient light. It can also be used as either an incident or a spot meter, even with electronic flash.

The ability to measure incident light is useful because an incident light meter is never confused by the amount of light that is being reflected from a predominantly light or dark object or scene. It gives the same perfect exposure for both the black cat and the snowman because it is measuring the incident light that is falling on the objects, not the light that the objects are reflecting.

In fact, the only handicap to the incident meter is the fact that the light falling on the meter must be the same as the light falling on the subject. This means that sometimes the photographer will have to leave the camera position (if the camera is in the shade) and meter at the subject's face (in the sun or vice versa).

Incident meters are also great in the studio. When you change the metering mode to "flash," they can be used to measure the amount of light each flash unit is putting out without being fooled by the subject's light/dark skin tone or the background.

Spot meters

In a way, spot meters are a throwback to the days when black-and-white photographers selectively processed their film in order to expand or contract the tonal range of the scene.

Photographers who shoot digitally or with color film don't have this option (at least not in the darkroom). However, spot meters can be helpful in determining the contrast range of a scene. Photographers who know how to use them swear by them.

One caveat to photographers shooting portraits is that using a spot meter to measure the light coming from your subject's face is never a good idea. Most Caucasian skin is about one stop brighter than middle gray, while African skin can be anywhere from middle gray to almost three stops darker. Skin tone is a very unreliable guide for using a meter. Have your subject hold a gray card to meter the reflected light or use an incident meter to get perfect exposures.

ISO

The ISO (International Organization for Standardization) is a numerical designation that indicates the relative sensitivity of a film emulsion or digital sensor to light. Doubling the ISO increases the sensitivity of the film or sensor by one stop enabling a smaller aperture or faster shutter speed. Conversely, selecting a lower ISO requires a larger aperture or slower shutter speed. Higher ISO ratings will result in increased digital noise, which can degrade image quality. Most modern digital cameras can be confidently set to an ISO of about 800 before the adverse effects of a high ISO rating become objectionable.

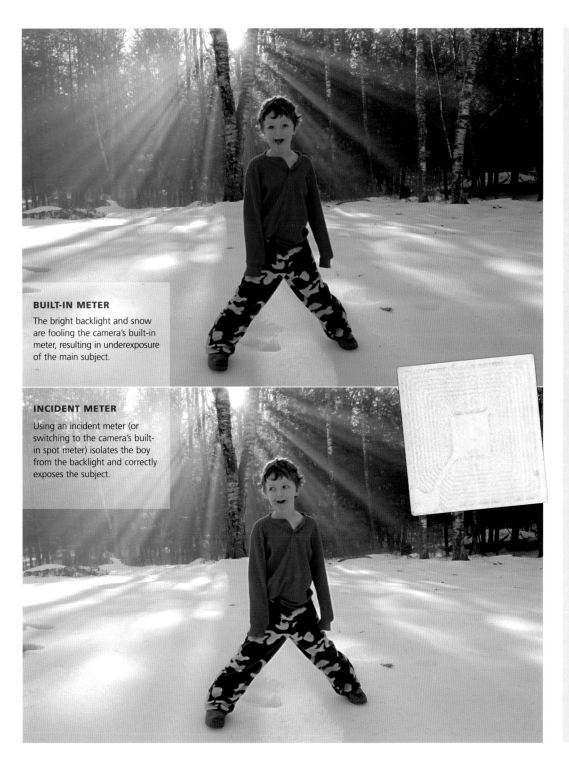

BUILT-IN METER

The bright backlight and snow are fooling the camera's built-in meter, resulting in underexposure of the main subject.

INCIDENT METER

Using an incident meter (or switching to the camera's built-in spot meter) isolates the boy from the backlight and correctly exposes the subject.

THE SUNNY 16 RULE

The sunny 16 rule can be very helpful when your camera's light meter doesn't seem to be making sense because it is being fooled by a scene that contains very large bright areas (such as a snowfield or white wall), or large dark areas (such as a forest) in the background.

Simply put, on a sunny day when the sun is behind you, the ISO you are shooting at becomes the shutter speed, and the f-stop is determined by looking at the shadows that are being cast by the sun.

For example, if you are shooting on a sunny day at ISO 100 (film or digital) you set the shutter speed to $\frac{1}{100}$ second and the f-stop is set to f/16—hence the phrase "sunny 16."

The rule continues under the following conditions:

Bright sun with sharp distinct shadows = f/16 at a shutter speed equivalent to the ISO
Slightly overcast/hazy with softer shadows = f/11 at a shutter speed equivalent to the ISO
Cloudy bright (no shadows but still bright) = f/8 at a shutter speed equivalent to the ISO
Overcast or shade = f/5.6 at a shutter speed equivalent to the ISO

Of course, you don't actually have to shoot at the exact shutter speed/f-stop combination: you can extrapolate the sunny 16 rule to choose different combinations of the same exposure. For example, $\frac{1}{100}$ second at f/16 is the same as $\frac{1}{400}$ second at f/8.0, or $\frac{1}{50}$ second at f/22, and so on.

Knowing the sunny 16 rule can help to alert you to potential problems when your camera's meter seems be giving you erroneous information. It will also help you to set up mixed flash and available light portraits outdoors (more on this later).

Tutorial 14 | TRIPODS AND MONOPODS

Tripods are another highly personal bit of gear, and you should borrow or rent as many different ones as you can before you spend a lot of money on one. If you buy one that is too heavy, you will never use it; if you buy one that is flimsy, you will swear at it.

OBJECTIVE >>

☐ **To understand the various features of different tripods in order to decide which is right for you.**

exercise:

SHOOT WITH A TRIPOD FOR A WEEK

Spend a week shooting every photo with a tripod, even in the sun. Using a tripod teaches you to see precisely. This exercise will actually quicken your reaction time when you shoot handheld.

Most pro-level tripods are sold as two separate pieces: a leg set and a tripod head. This is good news, because it will allow you to mix and match components as your career and specific interests develop.

Tripod legs

Tripod leg sets constitute the heaviest part of the tripod. Modern carbon fiber legs are expensive, but they are half the weight of aluminum leg sets. They also help to dampen vibration. Photographers who work alone should always spend the extra money for a carbon fiber leg set, because a tripod that is always left in the trunk of the car or at home because it is too heavy is useless. Many pros work with assistants who do all the heavy lifting, and prefer the solidity of a heavier aluminum leg set because carbon fiber tripods can be so light that the tripod can be blown over in gusty wind conditions.

Unless you need something extremely small and light (for backpacking or photojournalism), make sure that the legs are long enough to bring the camera to eye level without using the center post of the tripod. The center post is the weakest part of the tripod and should only be used to fine-tune compositions by a few inches.

Tripod heads

Tripod heads fall into two broad categories: ball heads and pan-and-tilt heads.

Ball heads are preferred by photographers who like to work fast and need a tripod that allows for quick changes in composition and the ability to react to the movements of the subject or model. Ball-head tripods also travel well, because they are compact and have no protruding handles that can be broken or bent by airline baggage personnel.

Good ball heads have a separate adjustment for the friction/tension of the ball and will also allow the camera to be panned while still having the ball and socket locked. These features are well worth the additional expense.

The downside to ball heads is that photographers who compose very precisely can find them frustrating because the entire camera/head assembly moves freely, making it difficult to align each axis independently.

Pan-and-tilt heads allow the camera to be moved and/or locked separately in each axis; horizontally, vertically, and when panning. This makes them much faster when precise composition is necessary.

TRIPOD HEADS

A pan-and-tilt tripod head (left) and a ball head (right).

PRECISE TO THE MILLIMETER

This specialty tripod head by Manfrotto is gear driven and self-locking, allowing for extremely precise framing. Heads such as this are delicate and should never be transported in a case that would rattle around with other light stands or gear.

Pan-and-tilt heads are the perfect solution for environmental portrait photographers who need to compose backgrounds carefully.

Monopods

Monopods are handy for photographers who need to work quickly or need a little extra stability. However, they are not a substitute for a proper tripod. An inexpensive ball head will allow quick changes to vertical compositions.

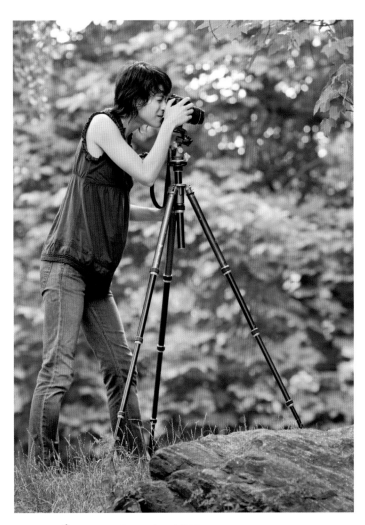

QUICK RELEASE

A quick release allows the camera to move from handheld to a secure tripod mount in less than a second, with no fumbling. Buy one that uses mounting plates that are small enough to be left on your camera semi-permanently.

MONOPODS

Monopods are especially useful for photographers who work with long/ heavy lenses but need to move and recompose quickly, making them one of the favorite tools of fashion and sports photographers.

GOOD TECHNIQUE

You would think that using a tripod is simple, but many beginners make some basic mistakes:

- Make sure one leg is aligned with the lens; otherwise you will trip over or kick the legs. When you use very long lenses, it adds stability.

- With pan-and-tilt heads, point the long handle to the rear; otherwise it will be difficult to switch to vertical compositions.

- Try to use as little of the center column as possible.

- Hanging your camera bag (or any heavy object) from the center column can help to stabilize a tripod that is a bit too light. A mountaineer's carabiner in your camera bag is a handy device to quickly clip the bag to the tripod.

Portfolio | CIRCLE RULES FOOTBALL CALENDAR

This tongue-in-cheek send-up of the popular "beefcake" calendar genre was created as a collaborative project by three NYU students (who all participate in the co-ed sport) as a fundraiser.

Blaine Davis and Sasha Arutyunova were responsible for the photographs, while Bonnie Briant designed the calendar. The team collaborated on the production and logistical aspects of the project; casting models, scheduling shoots, planning wardrobe, styling, and location scouting to create a project that would become an integrated whole, as well as a portfolio piece for each of the artists.

While this project trades on the traditional pin-up calendar genre, its lighthearted approach never falls into the trap of parody or satire. Each of the models is treated with respect. Though each portrait flatters and portrays the subject as physically attractive, they are all depicted as unique individuals who are both athletes and intellectuals.

Like any real-world assignment, this project came with certain time and budget constraints. One obvious consideration was the vertical format of the calendar, which dictated that all photographs be vertical with enough clear space at the bottom to accommodate the text.

In all, this is a fantastic example of a self-generated, collaborative exercise for three emerging professionals that mirrors and prepares them for many of the real-world problems they will face in their careers.

CONTEMPORARY DESIGN

Bonnie Briant did the design and layout for the calendar using bold colours and contemporary typography. She made the decision to eliminate the traditional boxes for the days of the month in order to showcase the photographs more fully.

METADATA 1	
Make/Model	Canon EOS 5D Mark II
Shutter speed	1/250 sec
F-stop	f/2.8
ISO speed rating	100
Focal length	70mm
Lens	24–70mm
Flash	Did not fire
Metering mode	Evaluative

METADATA 2	
Make/Model	Canon EOS 5D Mark II
Shutter speed	1/80 sec
F-stop	f/8
ISO speed rating	50
Focal length	85mm
Lens	85mm
Flash	Did not fire
Metering mode	Partial

METADATA 3	
Make/Model	Canon EOS 5D Mark II
Shutter speed	1/250 sec
F-stop	f/5.6
ISO speed rating	800
Focal length	35mm
Lens	35mm
Flash	Did not fire
Metering mode	Spot

LATE AFTERNOON SUN

1 Here Sasha uses late afternoon sun and tight cropping to emphasize and define the physique of her subject. A full-frame camera combined with a medium telephoto lens and wide-open aperture visually separate the subject from the background, echoing an established visual convention commonly seen in *Sports Illustrated*'s swimsuit calendars.

SHALLOW DEPTH OF FIELD

2 Here Blaine uses a full-frame camera with a 85mm lens in conjunction with a high shutter speed/medium aperture exposure to freeze the subject's motion and use the resulting shallow depth of field to minimize the distracting fence in the background. A 4 x 6-foot (1.2 x 1.8-m) white silk was used as a reflector to bounce light for fill.

"MAGIC HOUR"

3 Because Circle Rules Football is a co-ed sport the team felt it important to include at least one of the female participants. Blaine Davis arranged to photograph Luci during "magic hour"; the time just after sunset when the world is bathed in the warm, soft, residual sunlight that is reflected from the clouds and the earth's atmosphere.

Luci circled the photographer on her vintage bicycle as Blaine panned with her using a relatively slow shutter speed to create a photograph that is as dynamic as it is charming.

Light is everywhere, yet (while this might seem contrary to common sense) we can't actually see it. We can only see the effect of light on other objects.

The use of light is also part of the fingerprint of every great photographer. Lee Friedlander's work is defined by light that is astringent and dry; the light in a Sally Mann print is romantic in its silver liquidity; Nan Goldin uses light as an embrace to anyone she has loved, light more tender than a kiss.

There are photographers who have built their careers on using only available light, but for most of us there are times when this simply isn't an option. In this chapter, we'll review some of the most basic concepts, instruments, and principles of using light to build up skills and confidence.

chapter 3 | LIGHT AND LIGHTING

Tutorial 15 | LIGHT INTENSITY AND DISTANCE

As a light source gets closer, the light becomes brighter—and as it is moved away, it becomes dimmer.

exercise:

PLAY WITH LIGHT AND DISTANCE

Using only one simple light, experiment with how changing the distance affects the light's fall-off.

This is a commonsense revelation that we had as children. Then we learned a formula in our high school science class: A light's intensity diminishes in inverse proportion to the square of the distance. This is because the light is illuminating a greater surface area with the same number of photons. Like many things we learned in high school, this information was useful for passing the test and then relegated to a dusty corner of our consciousness.

The inverse square law made simple

The numbers that photographers commonly use to determine f-stops (2, 2.8, 4, 5.6, 8, 11, 16, 22, etc.) also correspond to the distances in feet at which light increases or decreases by approximately one stop. This rule only works perfectly in spaces where the light can't reflect off other surfaces, but it is a useful guideline in most photographic situations.

So, imagine that you are in a large black room: A single light 11 feet (3.3m) away from your subject gives your light meter a reading of f/8.0 at ¹⁄₆₀ second. If you want to reduce the amount of light hitting your subject by exactly 1 stop (to f/5.6 at 1/60th), how far away should the light be from the subject? The answer is

16 feet (4.8m). If you want the light to be brighter by exactly 1 stop (f11 at ¹⁄₆₀), the light has to move closer. Moving the light to 8 feet (2.4m) from the subject will make it brighter by one stop. If you need it even brighter you would move it to 5.6 feet (1.7m) from the subject. Another stop brighter? Move it to 4 feet (1.2m) from the subject.

Light fall-off

This also explains why, when you use the flash on a point-and-shoot camera, parts of the scene may be underexposed.

Photographers commonly refer to this phenomenon as "fall-off." Light falls off drastically at close distances and very little at great distances. Moving a light from 2 feet (60cm) to 3 feet (90cm) away from a subject will affect the light by more than 1 stop; however, moving a light that is 22 feet (6.7m) away by the same amount of 3 feet (90cm) will have a negligible effect on the exposure.

Keeping the "f-stop as distance" rule in mind will help you to manage lights in complex situations.

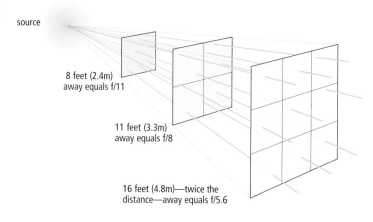

source

8 feet (2.4m) away equals f/11

11 feet (3.3m) away equals f/8

16 feet (4.8m)—twice the distance—away equals f/5.6

THE INVERSE SQUARE LAW MADE SIMPLE

The intensity of a light source is inversely proportional to the square of the distance to the source. This means that an object twice the distance away receives a quarter of the amount of energy (equaling 2 stops less light) compared to an object that is closer.

In this example our light source yields an exposure of f/11 at 8 feet (2.4m), doubling the distance to 16 feet (4.8m) yields a quarter of the intensity (f/5.6).

AN EXPERIMENT

For this demonstration I created five targets that were all printed with the same 18 percent gray field.

The targets were placed at 5.6 feet (1.7m), 8 feet (2.4m), 11 feet (3.3m), 16 feet (4.8m), and 22 feet (6.7m) away from the light source. The light source was adjusted to yield a perfect exposure at the target marked "F 8.0," which was 11 feet (3.3m) away from the light source. The targets were positioned so that none cast shadows onto the one behind.

Targets that are closer to the light are overexposed by 1 and 2 f-stops relative to their distance. Targets that are farther away are underexposed by 1 and 2 stops relative to their distance.

A light meter confirmed that the actual variance for each target was less than $\frac{2}{10}$ of a stop from the theoretical result.

Perfect exposure This target is 11 feet (3.3m) away from the light source. It is perfectly exposed at f/8 at ⅟₆₀ second.

Over- and underexposure As the exposure was a constant at f/8 at ⅟₆₀ second, targets that were placed closer or farther away from the light source were over- or underexposed depending on the distance.

USING FALL-OFF

Using your knowledge of how light falls off can also be useful in tailoring to the facial structure of a particular subject. The only difference between the two photos shown right is the distance of the light from the subject. By using fall-off to our advantage, we can often bring out more of the model's facial structure. We'll look at this in more depth later.

Light 6 feet (1.8m) away The light falling on the model's ears and shirt is almost the same as the light falling on her face and there is no appreciable difference in the light anywhere on her face.

Light 3 feet (90cm) away The model's forehead and cheekbones are getting appreciably more light than her shoulders, ears, and shirt. Her dimples, cheekbones, and overall facial structure are significantly enhanced through the intelligent use of the light's fall-off.

Tutorial 16 | UNDERSTANDING SHADOWS

Sometimes it seems as though photographers have more ways to describe light than the Inuit people have words for "snow."

We hear terms like "hard light" or "soft light"; these can be confusing, because every photographer may have a slightly different image in mind when he or she uses the terms. For the purposes of this book, we are going to use the term "soft" to describe light that creates a shadow with a relatively feathered edge, and the term "hard" to describe light that produces a shadow with a sharply defined edge.

In the coming tutorials, we'll be looking at a variety of tools that can all be classified as "light modifiers" and used to create shadows with exactly the quality of shadow we desire. All light modifiers do one of two things: They make the size of the light source bigger or smaller. Large light sources are diffuse and create soft shadows; small light sources create hard shadows.

OBJECTIVE >>

☐ **To learn to create shadows that have the definition and quality you desire.**

exercise:

PLAY WITH THE SIZE OF A LIGHT SOURCE

Using only one light, experiment with light sources of different sizes and distances to create different qualities of shadow.

exercise:

PLAY WITH DIFFERENT TYPES OF LIGHT SOURCE

Pick a few different light sources ranging from very small (flashlights, for example) to very large. Using only one at a time, experiment with them at varying distances.

SIZE AND DISTANCE COMPARED

When a light source is either very small or far away, it produces a defined "hard" shadow. When a light source is either very close or very large, relative to the size of the object it is lighting, it produces a shadow that is feathered or "soft" because the light begins to "wrap around" the object.

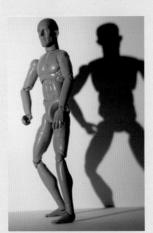

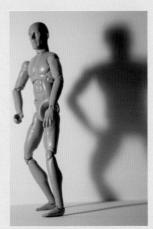

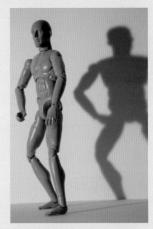

Small light source close by In this photo the light source is 1 inch (2.5cm) in diameter and positioned about 2 feet (60cm) away from the artist's mannequin. The very small source creates a hard-edged shadow.

Large light source close by At the same 2-foot (60-cm) distance, by using a small 9 x 5-inch (15 x 22.5-cm) soft box (almost as large as the mannequin) we create a very soft-edged shadow.

Large light source farther away When the same soft box is now moved to 6 feet (1.8m) away, the result is almost as hard edged as the very small 1-inch (2.5-cm) light source. The difference in contrast is attributable to the stray light scattering around the white room and "filling" the shadows.

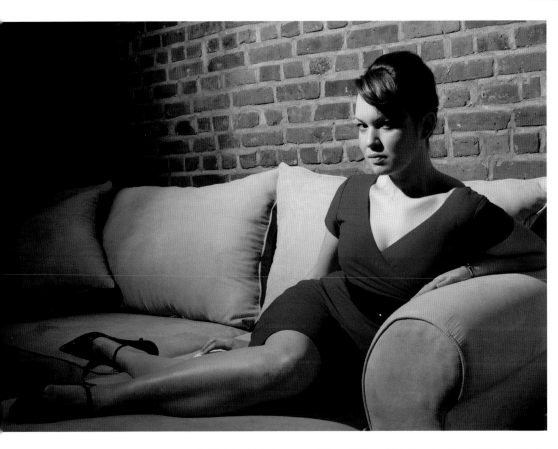

SMALL SOURCE + DISTANCE = HARD SHADOWS

Erin Erwin used a small light source (a grid on a strobe head) about 10 feet (3m) away to create this self-portrait with a hard-edged film noir look that is in keeping with her wardrobe and styling.

LARGE SOURCE + CLOSE PROXIMITY = SOFT SHADOWS

In this photograph Erin Erwin used a larger source (medium soft box) closer to her face, creating softer-edged shadows. Note that both photographs have about the same levels of contrast. Whether a light is "contrasty" or "flat" is independent of it being soft or hard.

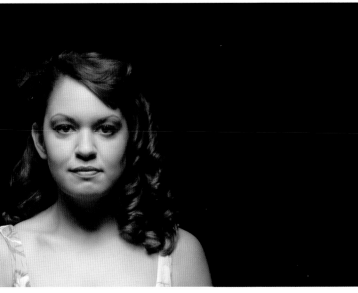

DISTANCE AND SIZE ARE RELATIVE

The sun is, of course, a very large light source, but it produces shadows that are hard edged because it is so far away. When the sky is overcast the entire sky becomes the light source and the result is shadows that are far less defined (or nonexistent) because the light source is so large in relation to objects on the ground. Matching the size of the source to the relative distance of the object we are photographing is one of the most basic problems in any lighting scenario.

Assignment | ONE LIGHT, EXPERIMENT WILDLY

To really understand and use light creatively break the rules and have some fun.

In this assignment, your task is to use one light for each shot, and experiment wildly. This means that you should use unusual lights, and use them in an unusual way. Think outside the box and try to reinvent light in a way no one could dream of. Anything that produces light should be considered a photographic light source: flashlights, laser pointers, desk lamps, slide projectors, candles, bare fluorescent tubes, glow sticks, anything at all. These sources can be reflected into mirrors or pie pans; they can be directed through shattered glass or bed sheets; they can be moved during the exposure.

Becoming really good at lighting (or photography for that matter) is a mix of letting yourself go wild and then bringing what you have learned back to a disciplined and controllable way of working. It's a never-ending process that can occupy your entire life and keep you engaged for ever.

None of the photographs in this portfolio has been digitally altered; all of the effects are purely through the use of light.

ETHEREAL BEAUTY

Sam Heesen achieved this striking portrait by placing his model on a sheet of white Plexiglass and shining the light through the Plexiglass from the back. He used a simple piece of white poster board to reflect a bit of light back onto the model's face.

INCORPORATING THE UNPREDICTABLE

Andres Vargas shoots through a piece of glass placed over a boiling tea kettle, which creates ever-changing levels of transparency and opacity.

SMALL FLASH UNITS

Alexandra Shabti and Mike Finkelstein collaborated in an experiment with one small flash unit being triggered multiple times over the course of a long exposure.

ONE LIGHT IN A SIMPLE REFLECTOR

Daisy Briceno used one studio strobe head for this classic portrait. A fine 10- or 20-degree grid mounted on the flash controls the amount of spill and creates a pool of light for the subject.

TOY LIGHTS

This snapshot uses only the child's toy as the light source. Note how drastic the fall-off is from her face (about 2 inches, or 5cm, from the source) to her elbow (about 8 inches, or 20cm, from the source).

DISCO LIVES

For this shot, several students experimented with a motorized projector ball used for lighting parties and nightclubs.

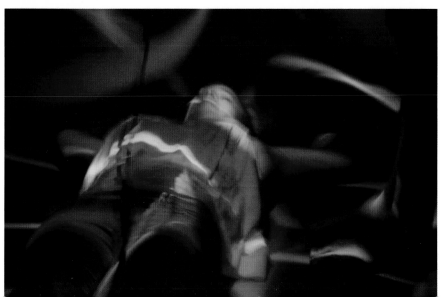

Tutorial 17 | KEEP IT SIMPLE

You can't establish an emotional connection with your subject if your overly complex lighting setup is constantly tripping you up. Keeping things simple will enable you to gain more confidence as a photographer.

OBJECTIVE >>

■ **To find simple lighting solutions to making your subject look better.**

One of the distinct problems with learning to make better photographs is that photography is so inextricably linked to constantly evolving technologies and a seemingly endless array of equipment. In portraiture it is even more difficult, because young photographers (and even seasoned pros) can often feel that the subject is nervously tapping their foot like a time bomb while the photographer is being pressured to solve a technical or aesthetic problem. It is always when the CEO or movie star arrives on set with a short 15-minute window of availability that the strobes explode, the camera jams, or the computer crashes.

Being a good photographer is easily as difficult and intellectually demanding as being a good lawyer, writer, or doctor—except that our workspace is often in the middle of a crowded sidewalk and there are always ten people surrounding us wondering when we will be done, or asking, "Are you sure you are doing that correctly? Wouldn't it be better if you just moved the light a bit?"

In the most basic portrait we have a myriad of problems to solve. Here are just a few examples:
■ Making the subject feel at ease
■ Finding a location or background that is appropriate
■ Finding a lighting solution that is flattering
■ Finding a focal length and pose that suits the subject
■ Watching for details in hair and makeup
■ Satisfying our own standards (which is always the hardest part)

The trick is always to break these problems down into manageable chunks. Trying to concentrate on everything at once is impossible.

Many young photographers are anxious to "go big time" and arrive on set with a kit full of lighting gear and lenses, but this is usually a disaster in the making. While Annie Leibovitz might travel with a truck full of gear, she has an entire crew of assistants and stylists to manage it all. Many of the world's best photographers—Terry Richardson, Bruce Weber, Herb Ritts, and Helmut Newton—worked with very simple equipment, relying on their vision and an emotional connection to the subject to make the photograph sing.

In this section we are going to look at some simple portrait scenarios and equipment that can add some "production value" to make your work look more professional but won't turn a simple portrait into something resembling a Hollywood feature. Pay particular attention to the hot light assignments and tutorials before you start working with strobes. Nothing teaches lighting as well as a few months (or a year) of working with continuous source lighting before jumping into electronic flash.

ONE-LIGHT WONDER

Sam Heesen created this striking self-portrait using some cloth and one light suspended high above to simulate moonlight in a night sky. A 30-degree grid controls the spill to keep the surrounding studio dark.

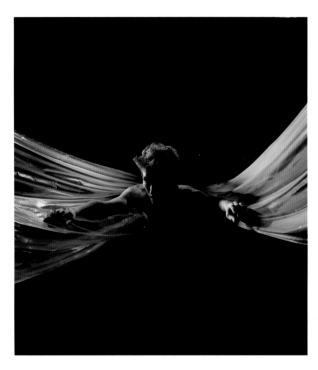

exercise:

BUILD SKILLS WITHOUT PRESSURE

It's no accident that most of the student photographs in this book use other students as the subject. It's difficult to learn any new technique if you feel pressured. Get a patient friend, or even a mannequin head, to experiment with lighting so you can concentrate on lighting without all the other problems of portraiture. Solve problems and build skills one step at a time.

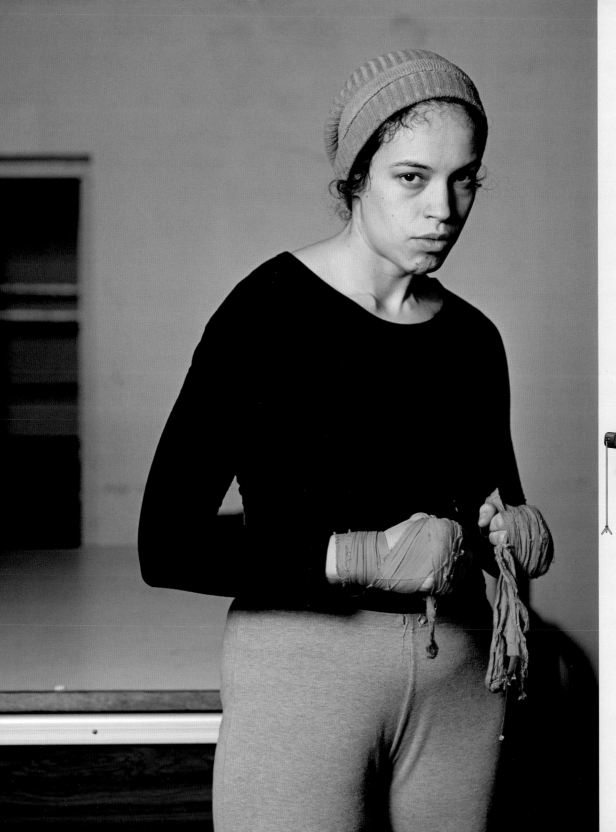

SIMPLE SOFT BOX

Inzajeano Latif used a small soft box for his series of portraits on female boxers. This photograph, "Female Boxer No. 3," was the signature image for the 2010 Taylor Wessing Photographic Portrait Prize at the National Portrait Gallery in London, proving that you don't need complicated lighting setups to create internationally revered images.

Portfolio | JULIA PENCAKOWSKA

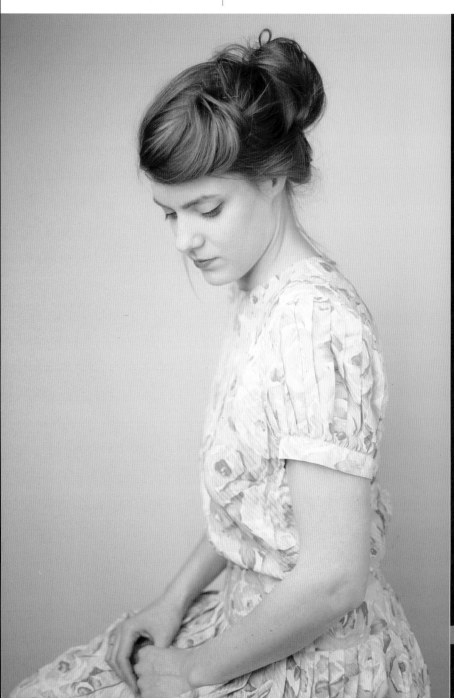

1

Julia Pencakowska is a fan of vintage fashion who often scours London's thrift stores.

She says, "Borrowing past fashions is a way to express one's individuality. It avoids all the similar fashion dictated by the high street and allows one to look unique."

As a portfolio by a young pre-professional it is beneficial that the lighting and styling isn't in step with current fashion trends. Emulating another period will enable her to use these photographs in her portfolio for quite a while without looking dated. However her attention to the historical accuracy of the project also inspires confidence that she has the skills to take on other, more modern projects.

SOFT AND SIMPLE LIGHTING

1 Julia kept her lighting soft and simple for the entire series using one light in a large soft box (with some extra diffusion added) and a large reflector as fill.

VINTAGE STYLING

2 The colors of commercially available seamless backgrounds didn't have the vintage palette Julia was looking for so she simply painted a piece of 4 x 8-inch (10 x 20-cm) plywood to complement each model and ensemble. The soft mint green in this photo contrasts beautifully with the model's red hair and fair complexion but still feels soft.

3 The models are all either Julia's friends or random girls she spotted who had the look she sought.

4 The makeup and styling were all collaborations between the photographer and the models.

5 Shooting digitally allowed Julia to streamline her workflow, preview her lighting, and easily retouch the images in post-production.

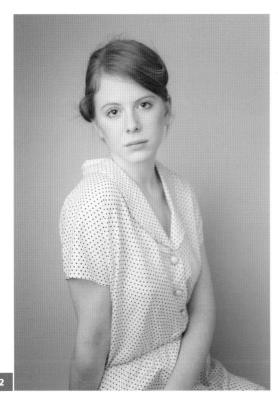

2

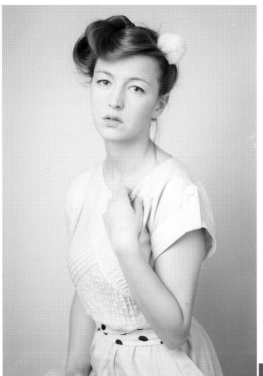

3

METADATA 1, 2, 3, 4, 5

Make/Model	Canon EOS 5D
Shutter speed	1/250
F-stop	f/2.8
ISO speed rating	160
Focal length	50mm
Lens	50mm
Flash	Did not fire
Metering mode	Pattern

4

5

Tutorial 18 | HOT LIGHTS AND CONTINUOUS LIGHT SOURCES

Lighting with hot lights is simple and direct. They are the ideal instruments for learning how to light. You can see exactly the effect of moving a light a few inches without the need for shooting and examining a test shot. They also mix well with most forms of common household lights because the color temperature is close.

Hot lights have traditionally been used for architectural shoots. As a young photographer I assisted many architectural photographers and worked primarily on interior design shoots for magazines such as *Architectural Digest*. Almost all of these relied on using "hot lights"—either special quartz halogen lighting made for photography or simple incandescent lightbulbs in aluminum reflectors (also known as "scoops"). This was a necessity given the scale of the spaces we were photographing: Many of our shoots were huge complex spaces that took many hours to light. It was common to use 15–25 (or more) lights in a shot. Electronic flash is often not practical when you are lighting very large spaces or need this many lights. This is also why most cinematographers still use some form of tungsten lighting on film sets.

Hot lights weren't optimal for portraiture in the days of slow film speeds as they produce far more heat than

light. As a result, they have been largely replaced by electronic flash for photography for the last 40 years. However, with the exceptional high ISO performance of modern digital cameras, combined with the increasing requirement of shooting video simultaneously, hot lights are making a comeback.

Types of continuous lighting

Most of the lights we see in our everyday life are continuous sources: common lightbulbs, track lights, etc. Fluorescent lights are not actually continuous, but they flicker on and off so quickly that we don't notice it.

Fresnels The Fresnel lens was invented by Augustin-Jean Fresnel (pronounced "Fray-nel") in 1823 to increase the efficiency of lighthouse lanterns. The Fresnel light has been the mainstay of Hollywood lighting since the

exercise:

MAKE LIGHT THE SUBJECT

Spend one day trying to make a series of photographs that use light itself as the subject of the photo.

CONTEXT AND INTEREST

Most of us would assume that the subject of this photograph is the little boy, but in fact we could also say that the light itself is the true subject because it is the light that supplies the context and interest in the photo.

beginning. Every movie star from Dietrich to Angelina Jolie has been lit with a Fresnel.

Fresnels produce a variable and focusable beam of light by moving the tungsten bulb back and forth in relation to the lens on the front and a polished parabolic reflector in the rear. They are classified and used according to the size of the lens, with a 10- or 12-inch (25- or 30-cm) lens being the standard for lighting a face in traditional Hollywood lighting (note that this is about the same size as a human face).

While Fresnels are fantastic, they are very large, heavy, and hot, so they are seldom used for still photography any more. This is too bad: When Fresnels are used well, they have a unique beauty and versatility that is hard to duplicate.

That said, many university photo departments will have a couple of old Fresnels gathering dust in a closet. Pull them out and experiment with them. While they are best suited to film productions with large crews, the unique "look" of a Fresnel is part and parcel of what we expect when we see great lighting. Many fashion and portrait photographers have had modern electronic strobes installed into old Hollywood film Fresnels in order to combine the qualities of the classic Fresnel light with the consistency and convenience of a modern flash unit.

As you will see when we begin working with strobes, there are other ways to emulate the look of the Fresnel by using lightweight honeycomb grids.

Scoops They may not look like pro equipment, but these simple, inexpensive, aluminum reflectors, available at any hardware store, may be the single most useful piece of lighting equipment you can own.

Scoops are fantastic because they are so straightforward. If you need a light to be brighter, just move it closer or change to a brighter bulb. If you need to create a shadow or block light from a certain area, simply use a piece of cardboard as a "gobo."

When you move up to strobes, you can trade the lightbulbs in the fixture for inexpensive electronic flash units that screw into the socket. These are very useful as easily hidden accent lights when lighting an environmental portrait.

Open-faced quartz halogen lights The most popular open-faced quartz lights are made by Lowel Lights. Ross Lowel was a documentary cinematographer who wanted a set of simple, light, and powerful lights that could go anywhere and do anything without the weight and bulk of traditional Fresnel fixtures. The Lowel line of lighting equipment is incredibly comprehensive and versatile. It is a mainstay for videographers and TV news crews.

CAUTION! Never touch any quartz bulb with your fingers, even when it is off. The residual oil from your skin will boil the instant the light is turned on and cause the bulb to shatter.

LEDs Sources that use light-emitting diodes (LEDs) are the coming trend in photography. LEDs are cool to the touch and they can be dimmed on a rheostat without affecting color temperature. They last almost forever and they also have the advantage of usually being manufactured with a color temperature that matches daylight. In fact, the most sophisticated LED lights can be controlled to reproduce any spectrum the photographer desires.

As of this writing, LEDs aren't quite powerful enough for most portraiture. They can't match strobes for efficiency, or traditional hot lights for price. However, LED technology is evolving fast; it is likely to become the predominant photographic light source in the very near future.

CLASSIC 10-INCH FRESNEL
Here the subject is lit with a classic 10-inch (25-cm) Fresnel light (there's another one in the background for reference). There's no fill light in the photo. While this light looks harsh, and it is, it also does a great job of defining the volume and facial structure of the subject.

Fresnels are still tough to beat for versatility; with skill and practice they can be made to mimic any other light source, from the sun, to a street lamp. By bouncing them into another surface or shooting through a diffuser they can become soft-edged sources for use as a fill light. Many photographers have had electronic flash heads modified for use in old Fresnels because they love the look of these classic sources.

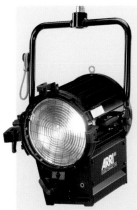

Fresnels The mainstay of Hollywood lighting, they produce a variable and focusable beam of light.

Scoops These simple lights are great to use because they are so straightforward.

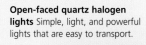

Open-faced quartz halogen lights Simple, light, and powerful lights that are easy to transport.

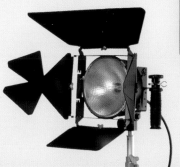

LEDs These lights are likely to dominate photographic lighting in the future.

Tutorial 19 | REFLECTORS AND SILKS

Once you understand the simple basics of how the qualities of shadows are influenced by the size and distance of the light source, you can start to experiment with ways to control and modify lights, for example with reflectors and silks.

OBJECTIVE >>

■ **To add some polish to your portraits with silks, reflectors, and hot lights while keeping your early shoots from becoming too technical.**

Shoot-through silks

Collapsible reflectors

Collapsible reflectors

Based on the ever-present "shiny boards" seen on Hollywood film sets, collapsible, spring-loaded, fabric reflectors came on the scene in the late 1980s and were an instant hit with photographers. They come in a variety of surfaces from shiny gold or silver metallics to matte white and even black to create "negative fill," and they are so simple to use that there is little you can do wrong.

When you use a reflector, you are using it to bounce light back into the scene. This means that you are usually using the sun (or other main light source) as a back or sidelight, and the reflector is filling in from a 180-degree position, either mounted on a stand or being held by an assistant.

Often, inexperienced assistants simply rest the reflector on the ground and angle it up at the subject. However, reflected light from a low angle that is uplighting the subject can look quite unnatural. When using a reflector it is always good to remember that we expect light to come from an angle overhead. Don't let your assistant get lazy. As a rule of thumb, reflectors are usually best used slightly above the eye level of your subject.

If possible, you should experiment with some borrowed or rented reflectors before buying. The very shiny, metallic types are very efficient and reflect a lot of light, but they can make people look sweaty because they create so many specular reflections or "hot spots." Gold metallic reflectors can impart a warm, healthy glow with fair-skinned Northern European subjects, but they can make olive-skinned Mediterraneans look quite

jaundiced. People of African or Far Eastern descent are usually served best by a plain white reflector or a silk.

Silks for diffusing available or artificial light

Collapsible silks are another simple, but versatile, lighting tool. Diffusing light through a piece of cloth is really just another easy way of making a hard, small light source into a large, soft light source.

On big production shoots, large silks (sometimes called butterflies) are pretty cumbersome. They are large pieces of nylon that are tied onto frames and require special stands. On big-budget films, it is not uncommon to see an entire city block draped in silk to simulate an overcast day.

For shooting smaller-scale portraits, a collapsible silk is like carrying a portable cloud around in your camera bag. With it you can create shade anywhere, you can turn the sun into a soft box, and when using it with artificial light you can create a soft source of exactly the right size and shape. If you have a metallic reflector, you can use a silk over it to create a very efficient reflector that is less specular.

Silks come in different levels of translucency, so if possible you should experiment a little before you buy. Silks are subtle, and so is their use.

Silks and reflectors outdoors

While silks and reflectors are great tools in the studio, they really come into their own when used outdoors. Silks can be used to transform harsh sunlight into a soft source, and reflectors can bounce light into shady areas or kick back the sun to create a secondary source.

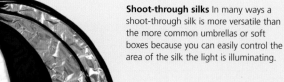

Shoot-through silks In many ways a shoot-through silk is more versatile than the more common umbrellas or soft boxes because you can easily control the area of the silk the light is illuminating.

Collapsible reflectors These light, simple, and versatile light modifiers are available in a variety of sizes from 1 foot (30cm) in diameter to 4 x 6 feet (1.2 x 1.8m). They open up to full size with a flip of a wrist yet collapse down to a package less than 2 feet (60cm) in size making them a great accessory for location photographers shooting fashion, weddings, or portraits.

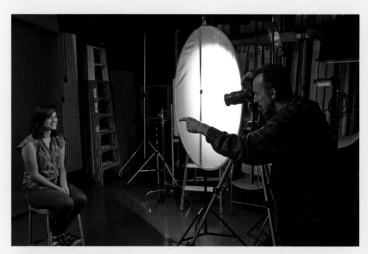

Incandescent scoop, shoot-through silk; no fill

White fill

Silver fill

Gold fill

△ SUBTLE BUT SIMPLE

Silks can be a little more difficult to position than the more commonly used umbrellas because you'll need a separate stand or an assistant, but in many cases they actually offer more options. In many ways, a shoot-through silk is more versatile than the more common umbrellas or soft boxes because you can easily control the shape and area of the silk the light is illuminating. In this case, the photographer has found the optimal size for lighting the subject by simply moving the light in relation to the silk. Silks are also very useful for shaping the reflections in shiny objects and eyes.

▷ REFLECTORS

Changing the type of reflector (gold, silver, or white) changes the amount, color, and quality of the reflected fill for the shadows.

WATCH A MOVIE

For a great example of someone breaking the rules on reflectors, watch *Do the Right Thing,* directed by Spike Lee. Director of Photography Ernst Dickerson used silver shiny boards throughout the film to impart a sweaty specularity to all the actors, because the film is set on the hottest day of the summer when racial tensions flare.

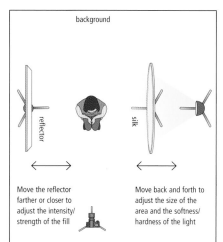

background

reflector

silk

Move the reflector farther or closer to adjust the intensity/strength of the fill

Move back and forth to adjust the size of the area and the softness/hardness of the light

CAUTION!

Be careful not to get the light so close that it burns the silk!

EASILY MODIFIED

In this example the single light source was set up to shoot through the silk. This diagram shows that, by varying the distance from the silk to the model or the source to the silk, the size of the light source is easily modified to control the shadows from the light.

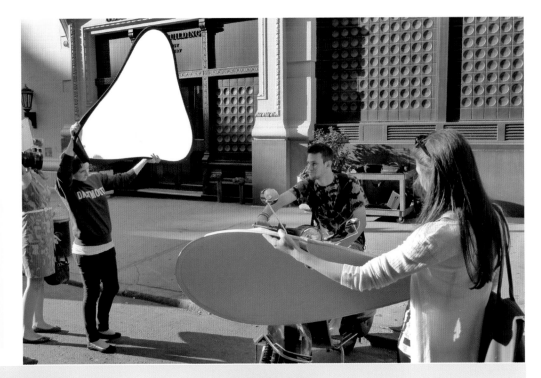

exercise:
RECRUIT SOME HELP

Experiment with using reflectors and silks with a group of friends. Swap roles and be daring in your choices.

EXTRA PAIR OF HANDS REQUIRED

The biggest problem with working with silks and reflectors outdoors is that you really need the extra hands of an assistant or two. Most professional photography is done with at least one assistant. Here a group of students are helping each other experiment.

Far left and above Here the sun is being diffused by the silk on the left while another student bounces light from a silver reflector on the right.

Left In this photo the sun is coming from behind the photographer but is being diffused by a silk held high over her head. Another assistant uses a gold reflector to "catch" the diffused light and bounce it onto the left side of the subject's face.

CONTROLLING THE SUN

These photos were made with the same collapsible silk and reflectors that we used in the studio.

Direct sun with no modification The shadows completely obscure the subject.

With a gold reflector Using a white translucent silk softens the contrast, while a gold reflector bounces some warm light onto the right side of her face.

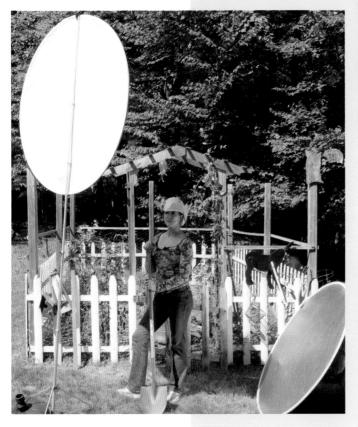

Shoot setup The diffusion disk lets some sunlight through, but softens the shadows. The reflector opens up the opposite side.

With a white reflector Here the light is diffused through a silk while a white reflector defines her facial structure by adding soft highlights to the right side of her face.

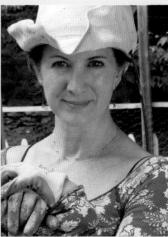

With a silver reflector The translucent diffuser is still in place but a silver reflector is being used as a bounce. Note how shiny her face looks due to the more specular reflections created by the silver bounce.

BE RESOURCEFUL

While the collapsible reflectors that are made for photography are portable and convenient, you can use anything to reflect or diffuse light. Cheap foamcore or poster board makes a great reflector, and the sheer fabric used for drapes can be used in place of silks.

Tutorial 20 | ELECTRONIC FLASH IN THE STUDIO

Working with electronic flash for the first time is often pretty exciting for young photographers. The gear is cool, lights pop, fans whir, and capacitors hum: there's a certain sense that this is photography the way the pros do it.

The invention of electronic flash was a significant moment in the history of photography. Flash allowed Avedon's women to achieve their full power and grace through movement. Bernice Abbott used it to study the poetic truths that could be displayed by the simple physics of a bouncing ball. Martin Parr uses it like an X-ray machine turned on modern society.

They are the most versatile lights available to a still photographer. They are difficult to master, but they can do things that no other light source can.

What is a studio flash unit?

All flash units, even the small flash that you put on your camera, consist of two basic parts, even if they happen to be housed in one package:

The capacitor draws power (usually from a wall outlet) slowly and stores it until the flash unit is triggered by the camera. When the capacitor is triggered by the camera, it sends a high-voltage pulse to the flash tube. The flash tube is filled with xenon gas, which is instantly ionized by the high-voltage pulse, and this creates a very bright, very short, flash of light. Typical durations for the flash are about 1/500 second on the long side but can be as brief as a few milliseconds. Flash tubes last for many thousands of flashes and are extremely consistent.

Synchronizing the flash to the camera

The flash unit is triggered by attaching a synch cord to the camera. An electronic connection fires the flash at

OBJECTIVE >>

■ **To begin to master electronic flash.**

exercise:

EXPERIMENT WITH ELECTRONIC FLASH

Borrow or rent some electronic flash units. Read the instructions carefully or have a technician give you a tutorial on them—you'll need to learn how to set the power correctly for each flash head.

Get a friend or classmate to model for you. You don't want to learn flash in a pressured situation.

ELECTRONIC FLASH: PROS AND CONS

Pros
• Extremely short durations can stop a jumping model or a speeding bullet in midair.

• A huge array of light modifiers is available for purchase or rental because electronic flash is so popular.

• Strobes produce consistent color temperature regardless of the power setting or intensity.

• Changing the intensity of a light is as simple as turning a dial or flicking a switch.

• They are safer than hot lights, producing far greater amounts of light while burning cooler.

• Daylight balanced, they mix easily with existing daylight.

Cons
• It is very difficult to previsualize the final result without some form of instant proofing (either instant film or digital display).

• They are expensive to purchase.

• Light modifiers (grid sets, soft boxes, and so on) are also expensive.

• They are heavy and cumbersome.

PROFESSIONAL ELECTRONIC FLASH GEAR

Here we take a closer look at the equipment the pros use.

Flash generators and flash heads Professional studio flash units typically come as two separate units, with the capacitors being housed in a flash generator or power pack. The flash tube is in a separate flash head connected by a cable. The power pack has multiple outlets, enabling it to power three flash heads simultaneously. The output of each head can be controlled individually by adjusting the power pack's settings.

This particular unit is rated at 2,400 watt seconds total, which means it is capable of powering a single head at the maximum of 2,400 watt seconds, or it can split the power between the three separate heads for 2,400 watt seconds total.

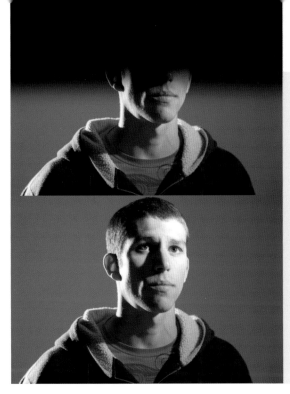

**SHUTTER SPEED
TOO FAST**

Using a shutter speed
that is beyond the
camera's fastest synch
speed will result in the
shutter blocking part
of the exposure.

**SHUTTER SPEED
CORRECT**

At the proper synch speed
(or slower), the shutter is
fully open.

exactly the moment that the camera's shutter is fully
open. The synch cord is a crucial connection; you can't
work without it, so always carry spares.

Cameras with focal-plane shutters (all digital SLRs
and 35mm cameras) do not synchronize with flash at all
speeds because at very high speeds (typically 1/125 second
or higher for modern cameras) the shutter does not
completely open for the entire exposure.

Metering with flash

Because the duration of the flash is so short, you'll need
to use a separate handheld meter.

Set the ISO and shutter speed correctly on the meter
(remember that you can't exceed the highest possible
synch speed), then plug the synch cord into the meter.
Many modern meters have wireless transmitters built in.

Bring the meter close to the subject and make sure
the light hitting the translucent dome approximates the
light hitting the subject. Press the button and the flash
will fire. The meter will display the appropriate f-stop to
set your camera to.

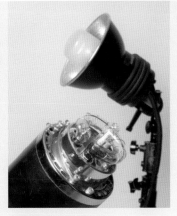

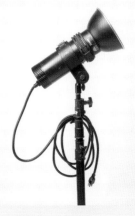

Inside a flash head With its reflector
and protective dome removed, you can
see that the flash head actually has two
lights inside. The one that is glowing in
the photo is the modeling light. This is
just a fairly weak incandescent light to
aid the photographer in focusing and
previsualizing. The actual flash tube is
the ring-shaped glass tube around the
modeling light. This is the light that the
camera uses to make the exposure. There
is usually a small fan located in the head
to aid in keeping the flash tube cool.

Monohead In this type of unit there is
no separate power pack; instead, it plugs
directly into an AC outlet. The capacitors
are located inside the (larger and heavier)
flash head. Monoheads are less powerful,
but they are often preferred by
photographers who work by themselves
or with smaller crews because there is
less setup involved. Another advantage is
that multiple light setups don't require all
the heads to be connected to a single
power pack.

Safe synch cord Though the voltage
passing through the synch cord is low,
it's possible for a faulty flash unit to
fry the circuitry of digital cameras. In
this photo, a "safe synch" circuit-
breaker protects the electronics of the
digital camera. Always use a safe
synch or wireless radio transmitter
(more on these later) between any
digital camera and studio flash units.

POWER RATINGS

Electronic flashes are rated
according to the amount of watt
seconds or joules they generate;
however, this is like saying that
cars are rated according to
horsepower. From one manufacturer
to the next, watt second ratings
are largely meaningless because
there are many other factors (such
as the shape and efficiency of the
reflector) that have a greater
effect on the total output of an
electronic flash. The actual output
of manufacturer A's 1,000 watt
second unit might be two or three
stops different from a unit made
by manufacturer B.

However, the concept of watt
seconds as relative power settings
will be useful later on when you
learn to use multiple flash heads.
Within any strobe system or brand,
the relative power ratings of
different heads are consistent.

Tutorial 21 | LIGHT MODIFIERS FOR ELECTRONIC FLASH

All of the same principles that we used to control continuous lighting apply equally to flash. Light is light, no matter what technology was used to create it.

Because of the unique qualities and popularity of strobe lighting, some special tools have been developed specifically for use with electronic flash.

Parabolic reflectors

Unless you are using a soft box, almost all flash units will either have a parabolic reflector built into the head or require you to mount one onto the flash head.

The most common size is about 7 inches (17.5cm) in diameter because they represent the best compromise between portability and size for location photographers.

Soft boxes and umbrellas

Soft boxes and umbrellas are two of the most popular ways to create large light sources with diffuse soft-edged shadows. Photographers always seem to have a distinct preference for one or the other: if they love soft boxes then they seem to hate umbrellas, and vice versa.

Soft boxes Soft boxes can vary in size from small 6 x 9-inch (15 x 22.5-cm) boxes that are designed to be used with flash units mounted on the camera to the huge 40 x 60-foot (12 x 18-m) monsters that are used

in automotive photography. They produce a similar effect to shooting through silks, except they are more efficient and easier to control because there is very little spill or reflected light lost. Of course the exact size of the source is less easily controlled, so photographers who prefer soft boxes usually own a few in different sizes.

Soft boxes can be made with a variety of interior surfaces to increase or decrease their efficiency, color temperature, contrast, or specularity. The best ones also have interchangeable fronts and/or interior baffles and can be used to create different levels of diffusion.

Transportable fabric soft boxes are a type of light modifier that was originally invented specifically for use with strobes. Now there are specially designed soft boxes made for hot lights that have vents and metallic interiors to protect them from the excessive heat that hot lights produce. Never use hot lights with a soft box that hasn't been designed and manufactured specifically for them.

Umbrellas Umbrellas are very fast and easy to set up. They can also vary in size, from about 1½ feet (45cm) to over 8 feet (2.5m) in diameter. They can be made with

OBJECTIVE >>

■ **To explore ways to control and enhance electronic flash, while still keeping things simple.**

exercise:

ONE LIGHT WITH ELECTRONIC FLASH

Before you try complicated multiple flash setups, master the use of simple one-light setups using the size and shape of the reflector or soft box to hone your skills.

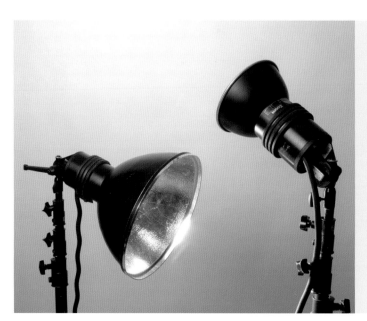

LOOK FOR A COMPREHENSIVE SYSTEM

The best electronic flash systems comprise a comprehensive set of accessories for shaping and modifying the quality of light including: soft boxes, beauty dishes, and grids, as well as different sizes of parabolic reflectors.

The small reflector is about 7 inches (17.5cm) in diameter, the standard size that is supplied with most flash units.

Larger reflectors can be very useful for direct lighting in portraiture but can be a bit bulky and delicate for location assignments.

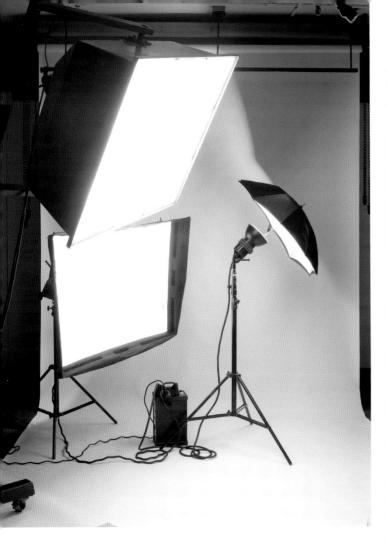

SIMPLE SOFT BOX PORTRAIT

Meredith Rom used one light mounted in a soft box for this striking portrait defined by soft-edged shadows, a direct gaze, and the beautiful description of the model's skin.

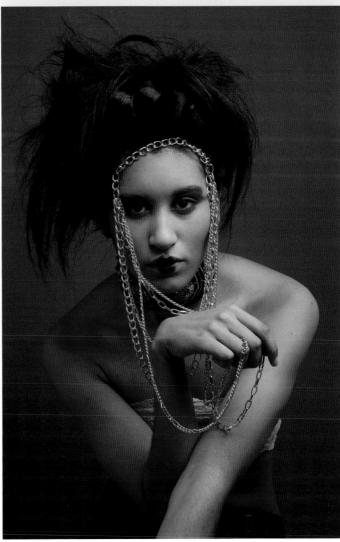

MAKING THE SOURCE LARGER

The large soft box above is a rigidly built studio unit that is permanently mounted to a large rolling stand. It produces perfectly even illumination across the entire surface. The lower one is made of fabric and breaks down like a camping tent, allowing it to be used on location. The umbrella on the right is being used as a reflector umbrella; by removing the black cover it can be reversed and used as a "shoot-through" umbrella.

ZOOMABLE REFLECTOR

This light has a movable parabolic reflector that can be "zoomed" to quickly adjust the area that will be illuminated.

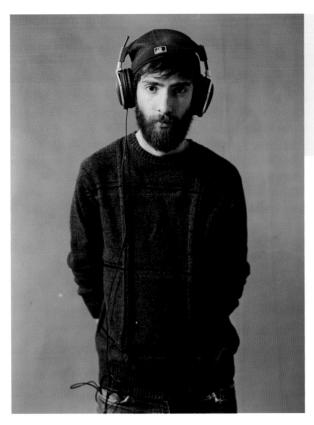

SIMPLE AND SOFT

David Macedo used one umbrella from the left for this portrait with a large reflector on the right to open the shadows.

TIP

A simple way to check whether the grid is aimed correctly is to stand in the position of the subject and look at the grid. If you can see through the grid, then light will reach the subject; if not, you need to reposition the light.

different surfaces—silver, gold, translucent, or opaque white. One distinct advantage of umbrellas is that, as long as some caution is exercised, they can be used with hot lights: just be careful not to get the umbrella too close.

An umbrella is really a parabolic reflector, so at close distances it can wrap around the subject and at farther distances it actually has a (soft) focus. The depth and overall shape of the umbrella can have a significant impact on the quality of light. The surface area that is being used can be adjusted easily by moving the umbrella nearer or farther from the flash head.

Umbrellas are harder to control for photographers who have to work on location, because there is so much spill and their distinctive shape is harder to hide in reflective surfaces such as eyeglasses and windows.

Grids

Honeycomb grids are another type of light modifier that has been developed specifically for electronic flash. Grids are used to enable flash heads to mimic the distinctive qualities of focusable Fresnel lights, and they do a pretty good job.

Fresnels work because the lens enables the divergent light rays to be focused into streams of parallel rays. Grids do much the same thing by absorbing light rays that are not parallel to the structure of the grids.

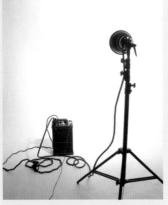

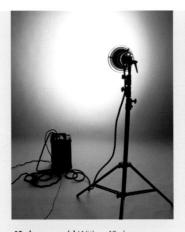
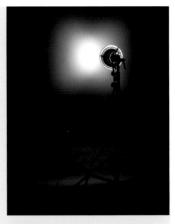

THE EFFECT OF GRIDS

This sequence of photographs shows the effect of different degree grids on the illuminated area.

Parabolic reflector With the standard parabolic reflector mounted, the light covers a range of 65 to 110 degrees, depending on how the reflector has been set.

40-degree grid With a 40-degree grid in place, the beam is much smaller than with the standard parabolic reflector.

10-degree grid With a 10-degree grid in place, the illuminated area is smaller still.

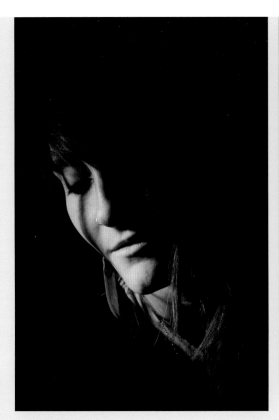

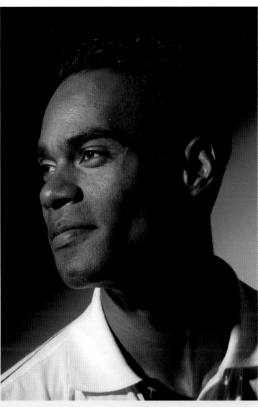

SIMPLE AND HARD

These photos were shot using only one light with a grid, no diffusion or fill. Small sources with grids can be used to mimic the hard-edged shadows created by direct sunlight.

Far left Janice Gilman used one light (a small 7 inch/17.5cm reflector with a narrow spread 20 degree grid mounted) for this portrait of her classmate.

Left For this portrait I used one light to illuminate the face and a background light to define the space behind the subject.

HOW GRIDS WORK

Light rays that line up with the structure of the grid will pass through, but light that is not at the correct angle is absorbed by the black grid.

GRID SETS

Grids are usually sold as sets with the angles of coverage determined by the tightness of the honeycomb pattern. This is a set that will vary the beam in 40-, 30-, 20-, or 10-degree increments.

MOUNTING A GRID

The grid is mounted to the front of the light. Most lighting systems will use reflectors that allow the grid to be mounted directly onto the reflector, but some will require an adapter ring.

Photography is all about choices: what to look at, when to push the button, where to stand, and, ultimately, who to photograph. The decisions all influence each other, and you as well, because the ultimate decision you are making is who you want to be and what you want your work to stand for. The work you create will be a direct reflection of who you are. We are forged by our experiences; the people and things we photograph fundamentally change us—and that's the exciting part.

In this chapter, we'll break down some of the most basic choices we have to make.

chapter 4 | COMPOSITION AND CONTEXT

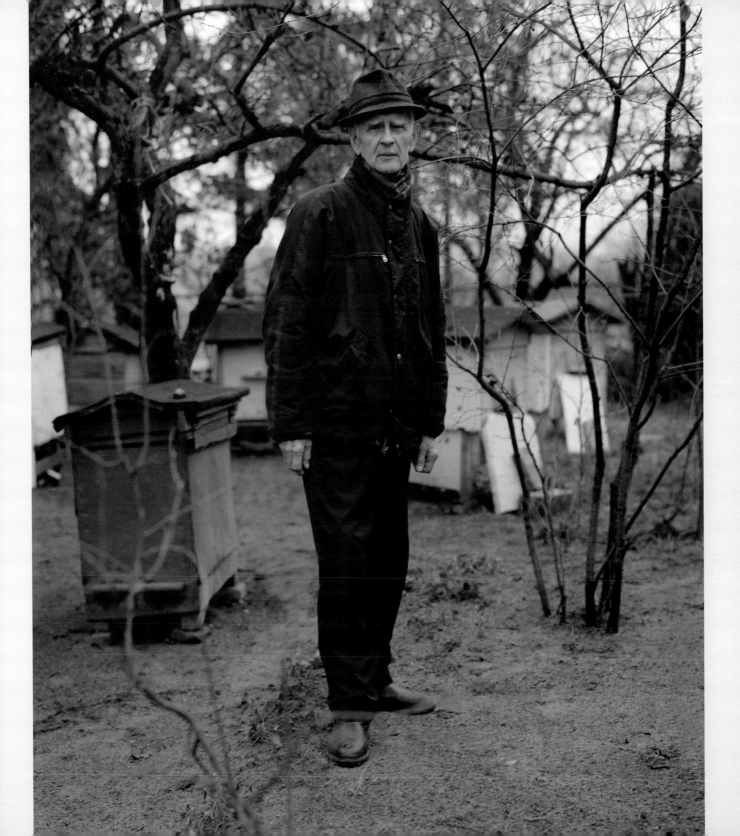

Tutorial 22 | COMPOSITION AND FRAMING

The frame is a basic concept in all art, but it is one of the most central in photography.

exercise:
COMPOSITION ANALYSIS

Look through your favorite photographs (either your own or those of other photographers) and see how many of them employ the classic compositional devices featured here.

DOMINANT ASPECTS

When we apply the rule of thirds to portraiture, we find that many strong portraits place the dominant eye of the subject at one of the intersections. This photo by Samantha Adler places both the dominant eye and the subject's hand at diagonally opposed locations within the "rule of thirds" grid to create dynamic tension.

Most art, painting and drawing in particular, uses the frame as a staging area; graphic elements (line, shape, color) are brought onto the stage by the artist. Paintings are built from the "inside out" within the frame. The scale of the frame (the canvas) is determined by the artist before the work is created, in anticipation of the elements it will be required to contain.

In photography theory, the area that the camera's field of view sees is sometimes referred to as the "limit frame" in order to distinguish it from the frame as an object. Photography uses the limit frame as an editing tool. The photographer uses the camera to select and edit elements from the larger scene, or as a "lasso" (my term) to encircle disparate elements, creating emphases or connections that wouldn't have been apparent without the photographer's choices. Of course,

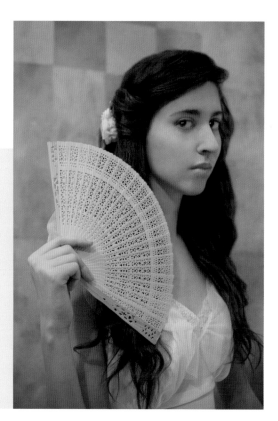

photographers might also decide to bring objects into the frame as well (as in studio tableaux photography), but this is still consistent with the concept of selection and editing.

Scale is also unique in photography; the scale of photographs is increasingly becoming a "virtual scale" because the same photograph may be seen in so many different variants—exhibition prints, web-based screen presentation, portfolio prints, and so on. In fact, it's a fair bet that probably none of the photographs in this book were created to be viewed in the sizes that they have been reproduced here. Scale sometimes seems irrelevant to photography until you see an epic Andreas Gursky or Richard Misrach print in a gallery setting.

Art in general, and photography in particular, uses a number of compositional devices to create visual interest within the frame. It is useful to be aware of these devices, but we should always remember that while good photographs are often well composed, this is a bit like saying that good writing is usually well punctuated and spelled correctly. Good composition alone can't elevate a photograph that is trite or meaningless. Conversely, some of the most powerful images in the history of the medium don't follow any of the classic rules of composition. Composition is simply a tool at our disposal, not an achievement.

The rule of thirds

The rule of thirds is so important and pervasive in Western culture that it can sometimes be difficult to find a work of art that doesn't incorporate it in some way. If you review the photos you have seen in this book so far, you'll see that over half of them use some variant of the rule of thirds.

The rule of thirds states that if we take a golden rectangle and divide it into thirds we find: voila! Nine more golden rectangles! If we place our main subject at one of the intersections, the result will dynamically draw the viewer to the subject.

The rule of thirds is especially important to photographers because so many cameras (35mm, digital SLRs) use the 2:3 "golden rectangle" aspect ratio (although the exact proportions of the classic golden rectangle are actually slightly different: 1:1.6, to be precise). The golden rule was also championed by the first master of 35mm photography, Henri Cartier-Bresson, giving it a highly respected stamp of authority for generations of photographers who followed in his wake.

The frame within a frame

This compositional device uses an object—such as a doorway, a window, or even another person—within the photograph to frame the main subject. Frames can also

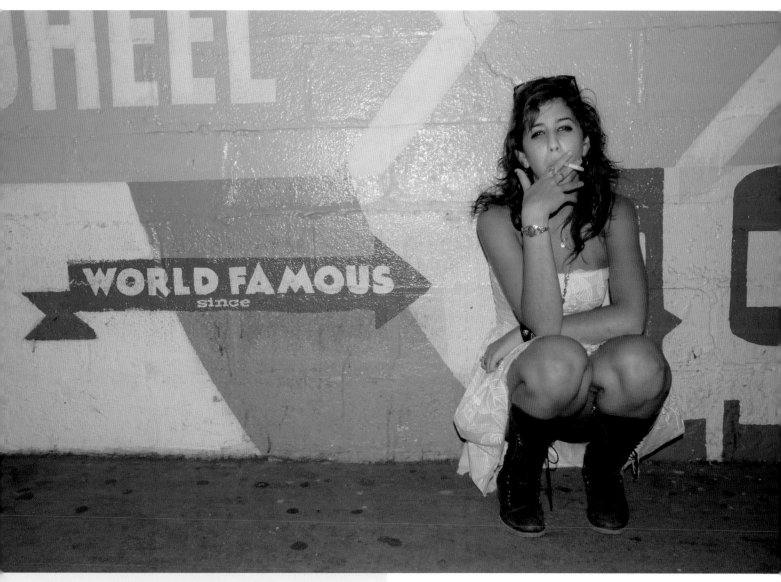

GETTING IT RIGHT

This portrait by Michelle Peralta is a textbook example of the rule of thirds. The frame is broken into thirds horizontally by the sidewalk and the stripes on the wall. The subject's head is exactly at the intersection of the upper right rectangle.

THE GOLDEN RECTANGLE AND THE RULE OF THIRDS

When the golden rectangle is divided into thirds, nine more golden rectangles are created. Placing the primary and secondary subjects at the intersections creates a balanced, yet dynamic, composition.

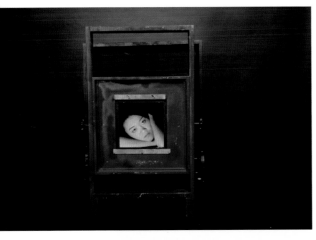

FRAMED WITH OBJECTS

This studio photo by Rachel Cerreto uses objects to reframe the main subject. Rachel used a 16 x 20 view camera (with the back removed), which was large enough for the model to actually crawl into and peer back at the photographer through the opening in the lens board.

FOUND FRAME

This photograph by Seth Mroczka frames the subject in a found frame that provides both narrative context and geographic location.

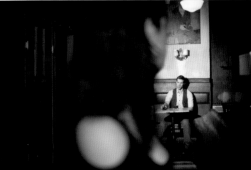

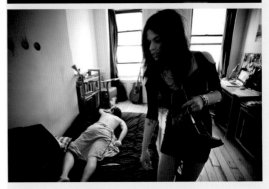

DIRTY FRAME

These photos were made as part of a class assignment that required a team of students (David Macedo, Janice Gilman, Cesar Vega, and Lupe Salinas) to work together in creating a complete photographic story. The cinematic treatment and repeated use of the dirty frame throughout was a perfect solution.

be created by including other objects in conjunction, such as a lamppost that intersects with a railing, or by shooting between two people.

The dirty frame

The "dirty frame" is a compositional device that comes from cinematography. It frames the subject with out-of-focus foreground elements in order to create the illusion that the photograph is candid and that the viewer is a voyeur.

Perspective and diagonals

This compositional device uses either receding perspective or diagonal lines within the frame to draw the viewer's eye to the subject. The diagonals can be created by actual perspective using architectural elements, the way the model posed, or even by simply tilting the camera.

The "lasso"

The "lasso" technique was widely popularized by the great street photographers of the '60s and '70s, most notably Garry Winogrand.

The lasso "throws" the camera's limit frame around seemingly disparate elements in order to include them in the same photograph. It ignores the classic figure/ground relationship and the traditional requirement to use the horizon as a grounding point for the viewer.

Layering and reflection

Layering (shooting through glass or other surfaces) and reflections can be used simply to create visual interest or to bring greater context to the subject by incorporating elements that otherwise would not be included in the frame. Layering can be a very effective tool for establishing or explaining complex relationships in space, time, or geography. Examples might be a son's reflection in a framed portrait of his mother, or shooting through the window of a diner to reflect the desert sunset that wouldn't otherwise be visible.

Symmetry and dynamic symmetry

In many ways, symmetrical compositions are the most subtle of all photographic devices. Photographs that employ either symmetry or dynamic symmetry (symmetry that is off by a subtle amount) seem to convince the viewer that the photograph is simply a recording of "what was there." Many of the world's greatest photographers—Walker Evans, Richard Avedon, and Thomas Ruff, to name but a few—have employed very simple compositions in order to focus the viewer's attention on the emotional or intellectual content of the photograph.

DIAGONALS

The frame in this photo by Michelle Watt is bisected twice on the diagonal, forming an X—first by the line of the subject's arms, and again by the S-curve of his body. Note that his face is placed exactly at the imaginary upper-left intersection according to the rule of thirds. Cropping tightly emphasizes the power of his physique, making him seem as though he is ready to burst from the frame.

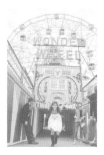

PERSPECTIVE

This photo by Michelle Peralta uses the receding lines of the railing to bring your eye to the blue arrows, which in turn point to the main subject.

LAYERING TO SUPPLY CONTEXT

This photograph uses layers to supply context (the driver's name and profession) as well as creating visual depth.

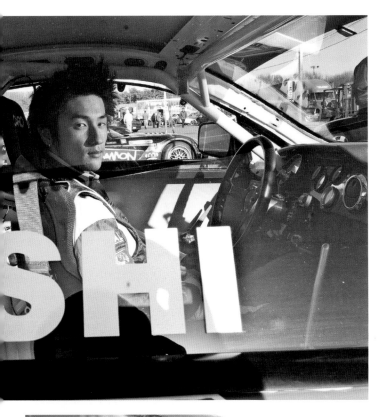

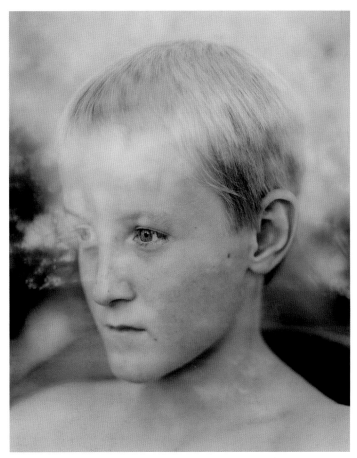

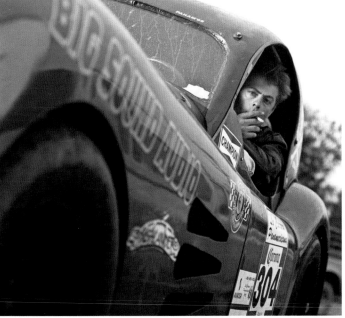

LAYERING TO CREATE VISUAL INTEREST

Jake Stangel uses a window reflection to add visual interest and to suggest the inner life of the subject.

COMBINING DEVICES

This photograph uses the dirty frame (out-of-focus foreground), diagonals, the rule of thirds (placement of the subject's head), and a "dutch angle" (a cinematic term for moving the camera slightly off the level in order to create dynamism).

Portfolio | MAKI HIROSE

When Maki Hirose was a student, he seemed to understand instinctively the importance of styling.

He was artistically ambitious, worked hard, and thought carefully about the pre-production of his shoots; he built his own sets, pulled the wardrobe himself, and watched his shoots carefully for flaws in the lighting, styling, or the pose of the models. Even though he was "just" shooting his classmates, he had high standards and understood that his portraits of women would only be as good as the effort he put into them (see this page).

After school Maki went on to assist many top professionals as a digital technician, and refined his skills in lighting, styling, and post-production digital retouching. Now, as a post-graduate professional, it's easy to see how his work ethic and attention to detail have helped him in his career (see right-hand page).

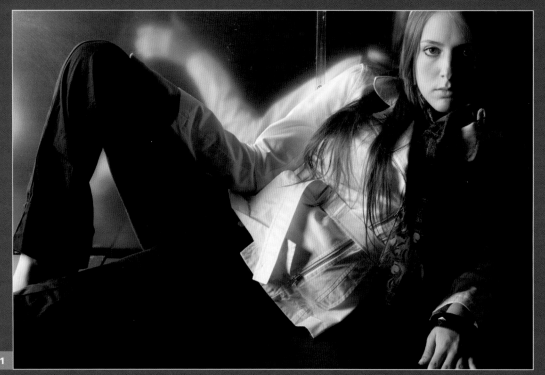

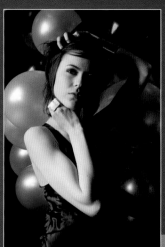

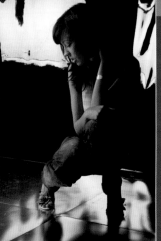

SHARP STUDENT STYLING

1 It's difficult for students to spend money on styling shoots but Maki was always clever about finding ways to make his early test shoots look as professional as possible by pulling clothes from the model's wardrobes.

2 Maki was clever about finding inexpensive ways to create backgrounds that were simple but more interesting than plain background paper.

3 Here the background was a piece of inexpensive vinyl from a discount plastics store. The white reflection is from the soft box that was used to light the main subject.

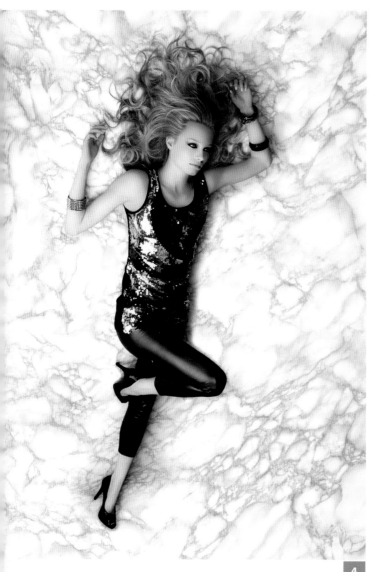

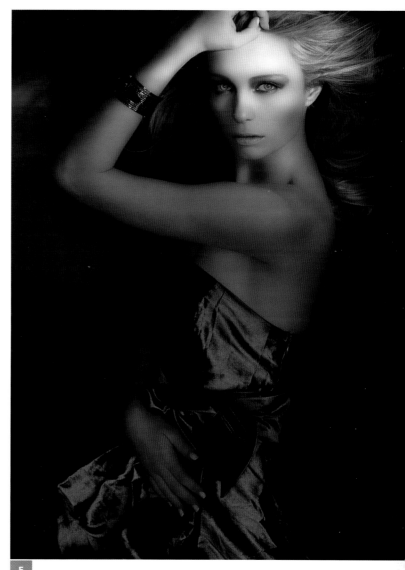

4

5

PROFESSIONAL POST-GRAD WORK

4 Here Maki creates an illusion of weightlessness through the high camera angle, distorted perspective, and the pose of the model.

5 This is a great example of simple lighting done well. One light was bounced into a silver reflector. However, much of the reflector was covered with cinefoil (a matte black aluminum foil) in order to shape the reflection to highlight the model's eyes.

METADATA 1	
Make/Model	Canon EOS 20D
Shutter speed	1/60 sec
F-stop	f/11
ISO speed rating	100
Focal length	37mm
Lens	18–55mm
Flash	Did not fire
Metering mode	Average

METADATA 2	
Make/Model	Canon EOS 20D
Shutter speed	1/60 sec
F-stop	f/11
ISO speed rating	100
Focal length	31mm
Lens	18–55mm
Flash	Did not fire
Metering mode	Average

METADATA 3	
Make/Model	Canon EOS 20D
Shutter speed	1/60
F-stop	f/11
ISO speed rating	100
Focal length	41 mm
Lens	18–55mm
Flash	Did not fire
Metering mode	n/a

METADATA 4	
Make/Model	Canon EOS 5D
Shutter speed	1/200 sec
F-stop	f/8
ISO speed rating	100
Focal length	50mm
Lens	50mm
Flash	Did not fire
Metering mode	Pattern

METADATA 5	
Make/Model	Canon EOS 5D
Shutter speed	1/200 sec
F-stop	f/8
ISO speed rating	100
Focal length	100mm
Lens	100mm
Flash	Did not fire
Metering mode	Pattern

Tutorial 23 | PROPS AND OBJECTS

While it is often said that a picture is worth a thousand words, most of those words are nouns and adjectives; stories need verbs and adverbs.

OBJECTIVE >>

☐ **To explore how props and objects can provide insight into the subject.**

exercise:

CREATE A PORTRAIT WITHOUT PHOTOGRAPHING THE PERSON

Go into a friend's home and select ten objects that you believe will provide insight into the person.

Before you photograph them, write down the reasons you have selected them. Are they old, new, personal, iconic, universal? What do you think they mean and why did they interest you? Use these notes to decide how to describe them photographically. Will you light them? If so, how? Will you shoot them so close that you can only see the details that interest you—or will you take a more objective/emotionally distanced approach?

Photograph them, and ask a disinterested third person to describe the person who owns the objects and what they imagine they mean to the owner.

This statement, paraphrased from the great critic and curator John Szarkowski, might be the single most important thing anyone has ever taught me about photography.

If we look at the epic F.S.A. photographs by Walker Evans or Dorothea Lange, what we really see are simply people, places, and things; nouns (and adjectives). The "story" is usually something we apply to the photograph using our personal knowledge. We might look at this Walker Evans portrait of Allie Mae Burroughs and think, "What a portrait of despair and desperation"—but that statement is not really supported by the information in the photograph. We know (from other sources or captions) that she is a sharecropper, and that the photograph was made to document the Depression, and we apply that knowledge to the photograph.

What we really see in the photograph is a woman, mid-thirties or so, weathered face, (but quite attractive actually), in front of a wooden structure. The clothes also give us some cues as to the era and her expression does hint at the fact that at that particular moment she might be concerned about something, but she also looks quite confident. For all we know, her car has a flat tire and she is stuck on the road next to an old barn.

The power of the photograph comes from the specificity of its description. It's not any woman, but a particular woman who really lived. On a particular day, she wore a particular dress and looked a particular way while a photographer took her picture. These are the only indisputable facts; everything else is conjecture and speculation.

Part of our job as photographers is to critically evaluate the people, places, and things that the camera describes and presents in the finished image so that the viewer has enough information to understand what we want them to understand. If we give them too much information and aren't selective enough, it becomes ambiguous. When we use props and objects to describe a person's profession or inner life, it is the specifics of the object that provide the viewer with the necessary details. A man in camouflage standing in the woods with an M16 might be a soldier; if he is holding a double-barreled shotgun he might be a hunter.

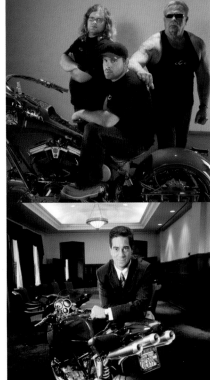

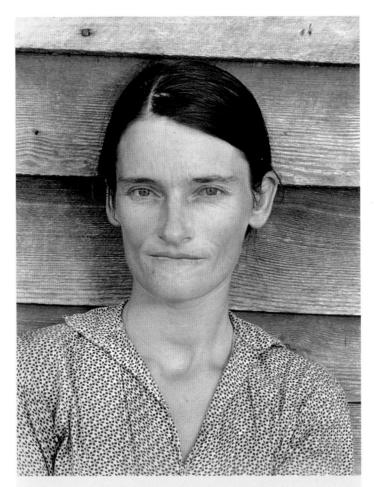

WHAT CAN A PHOTOGRAPH REALLY TELL US?

If we remove this single photograph from its historical context and the rest of Walker Evans' work, it becomes apparent that the photo doesn't tell us very much. Of course the photograph is a masterpiece, but only because the body of the work creates the context for each of the individual photographs.

◁ GUESS WHO

All of these photographs depict men and motorcycles. Which one….

- Is of a wealthy banker who keeps his prized motorcycle in his boardroom?
- Is of a family who builds custom choppers?
- Is of the legendary racer Giacomo Agostini, who has won more Grand Prix races than any other rider in history?
- Is of a collector who prizes the historical accuracy of his collection?

PORTRAIT AS FICTION OR ALLEGORY

Props and locations don't have to be real. For her senior thesis, Morgan Levy created these inventive portraits depicting children exploring new worlds. They are all shot in a studio using photographic backdrops that the artist created; all of the props and wardrobe are also two-dimensional paper prints that were cut out, to be worn or held by the models. There is no digital compositing other than what was used to create the paper props, costumes, and backgrounds.

Tutorial 24 | WARDROBE, GROOMING, AND STYLING

Anybody who has gone to a nightclub in search of romance, or dressed for a job interview, has had the experience of looking in the mirror and trying to analyze what message their wardrobe might convey about them. What the subject wears in a portrait is vitally important.

Wardrobe says a lot about a subject. It can also present formidable technical problems for photographers. One simple example is the classic problem of a bride wearing a white dress while the groom wears a black tuxedo. Colored clothes may also clash with the chosen location or background. It helps if you have options.

Be a pro

Shoots with professional models and celebrities are often easier than those with private clients or business professionals because there is inevitably a fashion stylist, as well as a makeup or grooming professional. Shoots with ordinary people can be far more difficult. Their taste in fashion might be atrocious, and quite often they simply don't understand or fail to consider how their

personal appearance will reflect on their personality or professionalism (or lack thereof) in a photograph. There may be lots of doctors who work in a t-shirt and jeans, but that doesn't mean that they should wear them for a portrait that will appear on their website or in a professional journal.

This is when you have to step in as the professional and help them understand the importance of the photo session and what they should expect. Often, simply asking them to follow a few of the simple guidelines opposite will help them to think about the fact that the photograph you are going to make requires a commitment on their part as well.

OBJECTIVE >>

■ **To appreciate the importance of clothing and styling in conveying a message.**

exercise:

TELL US ABOUT YOURSELF

Create a self-portrait that uses props or wardrobe to tell the viewer about your own passions, hobbies, and interests.

CLOTHES MAKE THE MAN

When I arrived to photograph the priest for a *Time* magazine article on faith, he was wearing "civilian" street clothes. I was lucky he was so amenable to changing into his vestments.

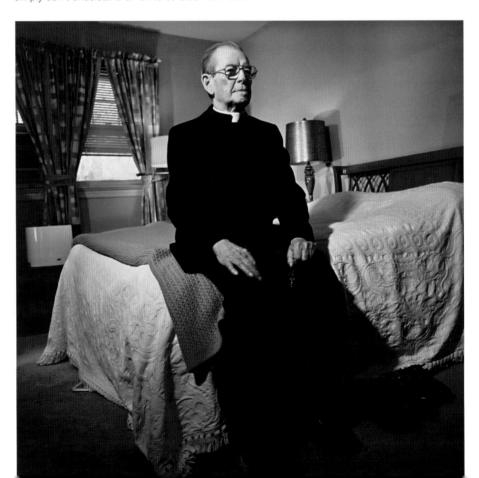

GUIDELINES

- Ask the subject what they were planning to wear.

- When photographing private subjects and there is no stylist, always ask them to bring, or have available, three changes of clothes. This is especially important with female professionals. Women tend to use a larger range of colors in their wardrobe.

- A simple and inexpensive hair and makeup option for female professionals is to suggest that they go to a salon to have their hair blow-dried the day of the shoot. The added benefit is that the stylist might suggest that someone at the salon do their makeup professionally.

- When photographing businessmen, always ask that they bring two or three additional shirts and ties with different color combinations.

- Businessmen often like to be photographed in shirtsleeves because it is less formal, but if they have been wearing a jacket all day the shirt they have been wearing will be a wrinkled mess. Having a fresh shirt to change into is important.

- Look out for wardrobe malfunctions, such as errant ties that poke out from underneath jackets or an unsightly bulge in the back of a jacket when the subject is seated (have them sit on the tail of the jacket). These simple problems can take hours to correct in Photoshop but are easy to fix on set.

- A few clamps or "bulldog" clips can do wonders for an article of clothing that might not be perfectly tailored.

- A steamer or travel iron takes up little room in your lighting kit and can save hours in post-production.

- Always carry a makeup brush and a small selection of powders for a range of complexions. These aren't a substitute for a makeup stylist but they can be used to knock shine off your subject's forehead or nose.

- Male subjects can be touchy about using makeup. Oil-absorbent pads (available at drugstores) do a great job of reducing shine. Alternatively, simply having them wipe their face with a paper towel can simplify lighting and post-production.

DETAILS TELL THE STORY

This car mechanic wears his professional grime as a badge of honor. I was intrigued but intimidated by him. I circled for a few minutes and then said, "You are obviously the hardest-working man here, you gotta let me take your photo."

PROVIDING CHOICES

These photos were shot for a private client: a doctor who also holds over 20 patents for medical apparatuses he has invented. The client uses the photographs for a variety of purposes—websites, press releases, and to accompany articles in journals—so he needs different photos for different uses. The added advantage of shooting a variety of poses and locations for the photographer is that the subject becomes increasingly comfortable with each photograph.

HAIR AND MAKEUP

Fashion photographers often insist on using their own stylists. Stylists can have a good understanding of the way particular photographers use light and they will tailor their work to the photographer's vision. However, portrait photographers will often have a hair and makeup artist assigned to them by the magazine, or the subject may insist on using someone they know.

The photographer and the makeup artist should always look at each other's work beforehand and have a discussion prior to the day of the shoot. Makeup can take hours; if the makeup artist does something awful or inappropriate (it does happen), it can set the schedule back and create tension on set as you send the subject and stylist back to do it over. Remember that you bear the ultimate responsibility for everything in the final photograph, including terrible makeup.

WARDROBE

Upon arriving for a meeting at the *Vanity Fair* offices in New York, I noticed that the reception area and hallways were jammed with racks of clothes that had been pulled by stylists for an Annie Leibovitz cover shoot featuring the actor Daniel Day-Lewis. The clothes were all variants of the same thing: black jackets and dress pants, white shirts, and black shoes. It seemed as though there were hundreds of each item from a myriad of famous designers.

When the cover hit the newsstands, it pictured Daniel Day-Lewis bare-chested, taking off a white shirt that was flowing in the wind. Some might think the stylists had gone overboard by pulling so many clothes for such a small result in the end product; but it was exactly the right shirt that caught the wind perfectly.

Tutorial 25

There are many books that will tell you to pose a person with a certain type of face or body type in a particular way. They are probably useful in terms of simply flattering the subject, but to view posing as purely cosmetic is an oversimplification of the complex interpersonal dynamics that take place during a photo shoot. Posing and psychology are really two edges of the same sword.

POSING AND PSYCHOLOGY

Just imagine how awful it is for most of our subjects: They are brought into the prepared location or (worse) led onto a bare white background. They are often intimidated and have no idea what to do. Another person, or a team of assistants and stylists, is scrutinizing them and possibly even talking about them in hushed whispers. This is when the photographer owes the subjects the courtesy and professionalism of guiding them to a pose that will help them to look their best. Even if you are shooting in their office or home, once you have set up lights and cameras they are in your world; you need to be a gracious host and a leader.

Every time the camera clicks and the strobes pop, the subject has been sent a clear signal that the photographer has made a judgment about them. They need reassurance that the judgment was a positive one. "Wow, that was great!" might be an inane comment, but it works. All of us, even supermodels and celebrities, have insecurities, and this is why fashion photographers chatter incessantly during shoots: we are reinforcing the subject's self-image and behavior. Unless you need the subject to feel awkward for editorial/narrative reasons, it is just common courtesy to give them useful feedback as you are shooting.

It's also about you

You can learn a lot by photographing your friends and classmates, but in the real world you will need to be able to quickly establish rapport with someone you have just met. Our careers depend on our ability to emotionally connect with complete strangers.

exercise:
SELF-STUDY

Before you read any further, look at yourself in a full-length mirror for a few minutes. Watch how you look at yourself.

When we look at ourselves in a mirror, we tend to adopt a stance that helps us look our best. Few people stand square to the mirror and look straight at it; most will cock a hip, or stand with one foot slightly in front. We'll turn one shoulder forward and look at ourselves over that shoulder. Women will often "bevel" (see right). We never know what to do with our hands so we fold them, put them in our pockets, or cross our arms. Notice what your body language reveals about your personality.

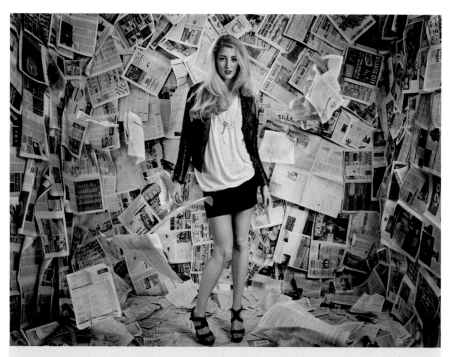

THE "BEVEL"

The "bevel," as shown in this photograph by Rachel Cerreto, is often an instinctive pose for women. It was first popularized during the '20s, when a very narrow-hipped, boyish body type was in vogue. Turning the toe and knee and hips inward slims the body visually. Young women unconsciously learn to bevel by imitating fashion models as they grow up.

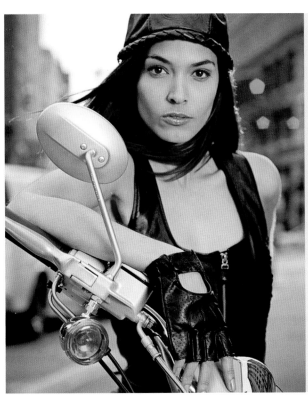

PROFESSIONAL MODELS

When working with professional models or entertainers, it is usually best to respect their expertise and professionalism. Let them adopt a pose that they come up with, then offer collaborative suggestions as the shoot progresses. The best models are smart, work hard, and are worth every penny they make. Pros often have great ideas that can inspire you to be a better photographer. Ordinary people and business professionals will need more guidance from you.

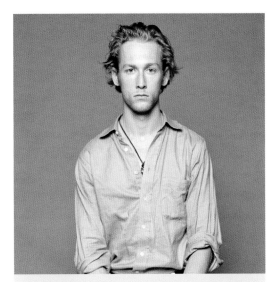

THE HOPEFULS

The "deadpan" pose is in danger of becoming a cliché in fine-art photography, but there are many times when it is completely appropriate, as in this series entitled "The Hopefuls" by Lexi Lambros on the graduating class of 2008 (young adults entering the worst job market since 1930).

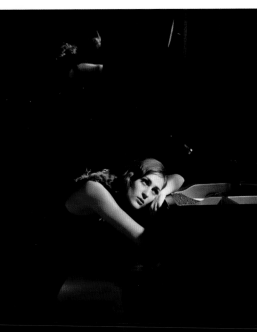

LIGHTING

In editorial/magazine photography the pose is often guided by the story: Is the subject a rising comedian (as in the photograph by Adriel Reboh) or a sultry cabaret chanteuse (as in the photograph by Michelle Watt)?

Lighting is also an important issue in posing. In the photographs of the comedian, the lighting setup is simple enough to allow the subject to express himself by playing on the large "stage" created by the photographer. The lighting of the singer is more evocative and cosmetically flattering, but it is also so specific to the pose that it "locks" the subject into position. If she raises her head the light will need to be reset, breaking the flow of the shoot. Having an assistant ready to follow her moves with the light would help.

exercise:

TURN THE CAMERA AROUND

Have a classmate or friend shoot your portrait. Give this exercise some real importance by promising yourself that, whatever the outcome, you will use the photograph on your website or Facebook page for three months. Think about what you will tell the world about yourself through body language. Note how helpful (or not) the photographer is in guiding you.

Don't cheat by doing a self-portrait; the psychology isn't the same if no one else is present.

TRICKS TO GETTING PEOPLE TO FEEL COMFORTABLE

Ask the subjects to check their grooming and wardrobe in a mirror. Watch carefully as they do this, as it will give you insight into the poses that make them feel comfortable and that they feel make them look their best.

Guide the subject by showing them a pose you might have in mind or that seems appropriate to the narrative content of the photo. If it seems forced or uncomfortable when they try it, it is usually because they have taken the suggestion too literally. Have them get up, walk around, then try it again using their own body language.

Ask the subjects directly what they dislike in other photographs they have had taken. This accomplishes two things: It tells the subject that you are on their side and want them to look their best. It also alerts you to possible problems you might not have noticed or didn't consider a problem.

Simple posing techniques can help with common cosmetic issues:

- **To alleviate a weak chin** Have them turn to the camera rather than standing square. It strengthens the jaw line.
- **Deep-set eyes** Raise the camera slightly; this forces them to look up (it also helps with middle-age jowls).
- **Balding or receding hairline** Lower the camera slightly, have the subject turn into the photo, and avoid the use of a hair light.
- **Ground the subject** Very few people are comfortable standing in an ocean of white seamless background paper. Having a stool to sit on, or the edge of a table to rest a hand, helps the subject find their place. This will also help the photographer to set lights because it limits the amount the subject can move on the set.

- **If the subject is seated, be very careful to make certain that they don't slouch** Even heads of state will slouch if you allow them to. A stool is a better platform if one's available.
- **If the subject is seated in an upholstered armchair, try putting another cushion or pillow under the chair's normal cushion** This will often force the subject into better posture.
- **Give the subject something to do** It can be something as simple as holding a pencil in a certain way. The more you can take the subject's mind off their appearance, the more natural their body language will become.
- **Give the subject a break** Most people will start to glaze over after 10–30 exposures. Being the subject of a portrait is actually a hypnotic experience. When you see their smile become a frozen grin, it's time to let them walk around or jump up and down a few times.
- **Never use the subject to set your initial lighting** Most people have limited patience and you don't want to exhaust it on preliminary tests. Get the lighting as close as possible before the subject arrives, then "tweak" it for their specific facial structure or wardrobe.
- **Don't let the subject "chimp" by looking at the back of the camera** It breaks the flow of the shoot and only serves to feed their insecurities as they scrutinize their perceived flaws. If the subject is also the client, you can review the shoot when you are confident you have something they'll like. However, on editorial shoots this is the equivalent of letting the subject read the article before it is published—poor journalistic practice.

There is no secret formula: Be attentive to your subject and alive to what you see in the camera.

In many respects, posing and the psychological dynamics of a session are really a reflection of the photographer's personality. Some photographers can never put people at ease, yet there are plenty of successful photographers with modest technical skills, but amazing rapport with their subjects. Photographers with this unique psychological skill can build a career solely on their ability to get subjects to open up.

But not every great portrait photographer is a social butterfly; one very famous portrait photographer (who shoots 20–30 magazine covers a year) is so shy that he can barely say hello to the subject or look a person in the eye—yet this emotional insecurity actually seems to encourage his subjects to open up in front of his camera. It's a mystery, but he makes it work—and his photographs owe much of their special power to his acute social anxiety.

The lesson is that, as a portrait photographer, your personality is your most powerful and idiosyncratic tool. You don't need—or want—to be like anybody else. You need to learn how to use your personality effectively.

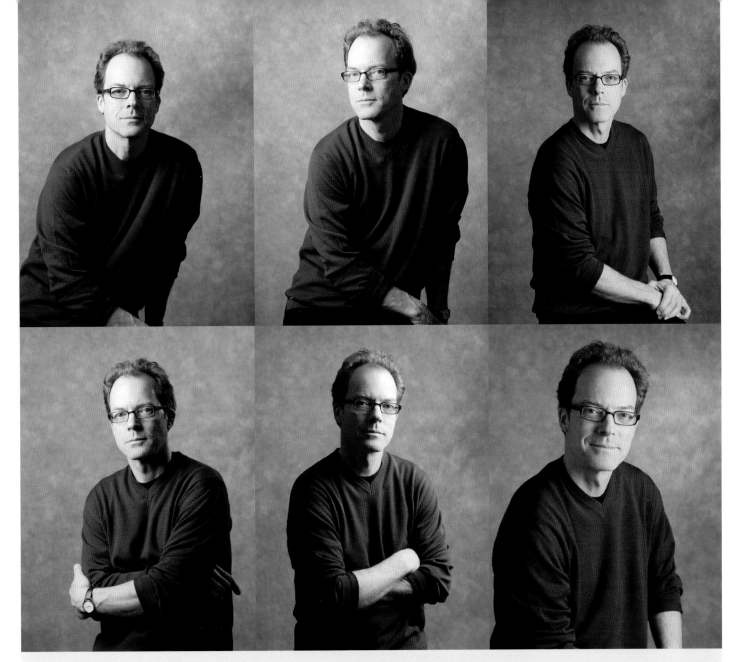

USE A STAND-IN

These photos were tests for the portrait of a Fortune 500 CEO that would appear in an official shareholders' report. Using the art director, an assistant, or even yourself as a stand-in enables you to experiment with poses without wasting the subjects' time or trying their patience. By shooting tests digitally you can show the subjects some alternatives when they arrive on set. This allows them to comment on the suggested pose in the abstract without bringing the specifics of their personal appearance into the equation.

Although the poses above all seem fairly similar and they are all flattering, there are some that seem more confident, some that seem a bit too smug, some that are too affected or guarded. Only one hits just the right note of optimism, confidence, and humility.

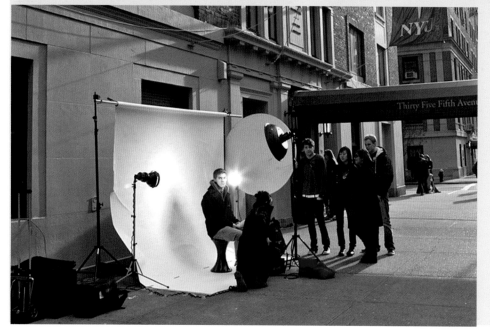

STREET CORNER STUDIO

Student Michael George created an ambitious challenge for himself by setting up a free portrait studio on a busy New York City sidewalk. He photographed everyone and anyone who walked by and wanted to have a photograph taken, delivering the finished photos by email. Two of the results are shown above.

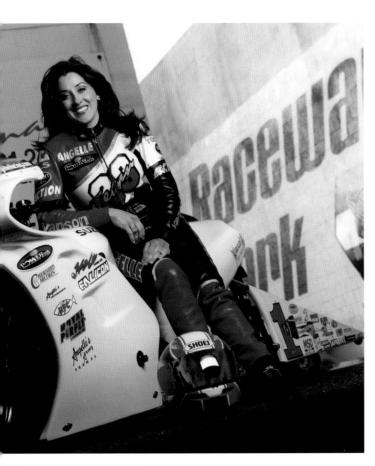

CONFIDENT AND OPEN

The pose in this portrait communicates the friendly, quiet confidence of three-time NHRA motorcycle drag-racing champion Angelle Sampey, a beautiful woman who competes—and wins—in a man's world at 200 mph (320kph).

HEADSHOTS FOR HAITI

"Headshots for Haiti" was a one-day charity event at NYU. Photo students were organized into rotating crews of photographers, assistants, and digital technicians. The students created three separate portrait studios in a large space and shot professional headshots at an affordable rate for anyone who showed up. At times there were 10–20 people impatiently waiting. The experience gave the students invaluable training, as they felt the pressure of having to quickly deal with a wide variety of technical problems, personalities, and cosmetic issues while still enjoying the safety net of having instructors and technical staff nearby in case things really went wrong. The students shot about 50–60 subjects over the course of the day and raised almost $4,000 for Haitian relief efforts.

Portfolio | KONSTANTIN SUSLOV

These photographs of surviving World War II heroes by Konstantin Suslov are masterfully crafted testaments to their subjects.

Uniforms supply the historical context, while the surrounding environment of their humble apartments tells us of their lives in the present. The low camera position and stoic poses reveal both the photographer's respect for his subjects and their pride in service. The color palette and classic lighting are just enough to suggest nostalgia without falling into the trap of cliché.

An elderly man stuffed into the uniform he wore as a young recruit is often a comic foil in films; Suslov's subjects have a dignity that reminds us that the bloody rubble of Stalingrad and the sands of El Alamein were won by a generation that is passing into dust daily to quietly join their friends and comrades.

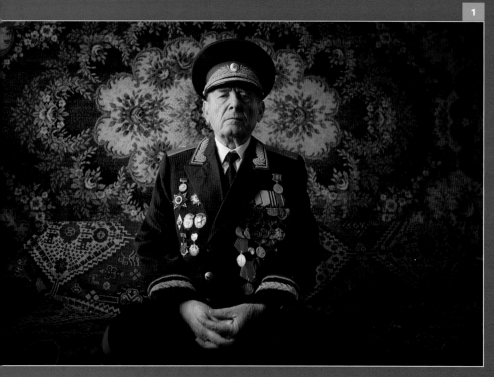

1

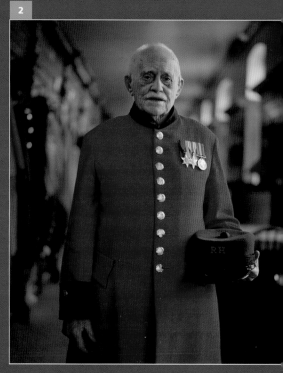

2

AVAILABLE LIGHT

1 One of the most interesting technical aspects of Suslov's portraits is that while they are all shot using only available light (he used reflectors and translucent disks to modify existing window light), the portraits are remarkably consistent in their use of light.

PORTRAYING THE HEROS

2 Although Suslov portrays all of his subjects as strong and heroic, he often found the project emotionally overwhelming: "It's not easy to sit opposite a 90-year-old man who bursts into tears while telling you of his childhood friend being ripped apart."

3 Suslov concentrated initially on Russian veterans because of his Russian descent— his grandfather was a veteran of the Great Patriotic War.

4 The project was shot with a digital camera and one lens—a 24-70 zoom, the perfect choice for Moscow's small apartments. By including his subjects' surroundings, Suslov conveys a lot about their present circumstances.

5 Because he shot everything with available light in Moscow, in the winter, sittings had to be planned and timed carefully. By 4 PM it was often too dark to shoot.

6 Wardrobe was one of the biggest obstacles. Suslov had to research and contact more veterans than he could shoot, because so few of them still had their uniforms.

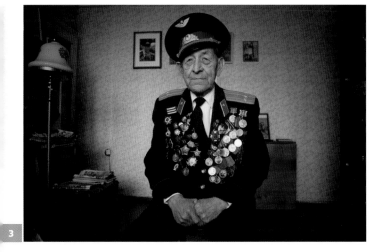

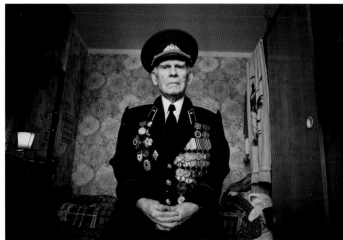

3

4

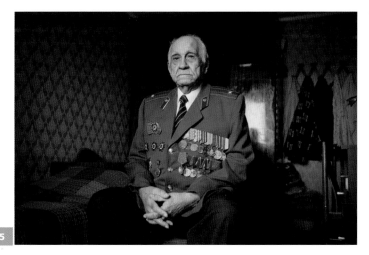

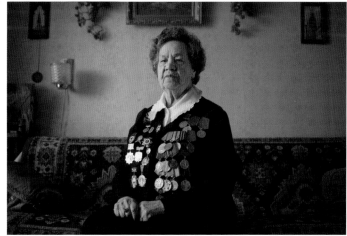

5

6

METADATA 1		METADATA 2		METADATA 3		METADATA 4		METADATA 5		METADATA 6	
Make/Model	Canon EOS 5D	Make/Model	Mamiya RZ67	Make/Model	Canon EOS 5D	Make/Model	Canon EOS 5D	Make/Model	Canon EOS 5D	Make/Model	Canon EOS 5D
Shutter speed	1/100 sec	Shutter speed	1/100 sec	Shutter speed	1/60 sec	Shutter speed	1/160 sec	Shutter speed	1/80 sec	Shutter speed	1/160 sec
F-stop	f/2.8	F-stop	f/2.8	F-stop	f/2.8	F-stop	f/2.8	F-stop	f/2.8	F-stop	f/2.8
ISO speed rating	400	ISO speed rating	400	ISO speed rating	400	ISO speed rating	500	ISO speed rating	640	ISO speed rating	640
Focal length	24mm	Focal length	27mm	Focal length	27mm	Focal length	40mm	Focal length	25mm	Focal length	32mm
Lens	24–70mm	Lens	150mm	Lens	24–70mm	Lens	24–70mm	Lens	24–70mm	Lens	24–70mm
Flash	Did not fire	Flash	Did not fire	Flash	Did not fire	Flash	Did not fire	Flash	Did not fire	Flash	Did not fire
Metering mode	Spot	Metering mode	Evaluative	Metering mode	Spot	Metering mode	Pattern	Metering mode	Pattern	Metering mode	Pattern

Looking at photographs shot by amateurs with digital cameras is pretty boring compared to the days when everyone shot with film. There is a bland sameness when we surf the landscape of Flickr. People delete the bad photographs (which were often the really interesting ones) and they shoot in JPEG format on automatic cameras, so everything has the same oversaturated palette. Everything looks similar, because most people are letting the technology do the thinking.

But digital doesn't have to be tepid: you just need to take control of it.

BEST OF BOTH

This photo by Sarah Bell is a great example of how adept modern photographers have become at using whatever technology is readily available and appropriate for the job at hand. The original photo was shot on film, which gave the photographer all the advantages of film (high resolution camera, greater dynamic range, etc.), then scanned into a digital file, which allowed the photographer to use all of the fine adjustment tools afforded by computer editing (selective color enhancement, masking, retouching, etc.), all while retaining the natural look and feel of the original scene.

chapter 5 | COMPUTER BASICS

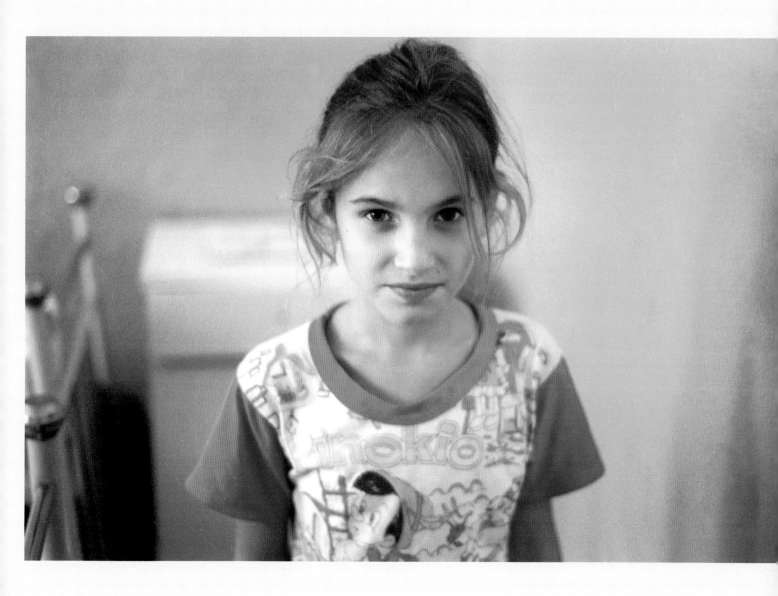

Tutorial 26 | SYSTEMS AND HARDWARE

Before you initiate a spending spree on the latest gadgets and technology, consider what it is you really need, and what you might need in the future. Then it's time to make your choice.

OBJECTIVE >>

■ **To make an informed decision about which system to use and what hardware you need.**

PC or Mac? This is the first and most fundamental decision you will make.

PC computers that use Microsoft Windows operating systems are less expensive than Macs because they use "open architecture" design. This means that any manufacturer can build a PC using readily available components, and the competition among PC manufacturers for your tech dollar is fierce. Dollar for dollar, you will probably be able to buy a lot more hardware if you build your photography career on a Windows operating platform.

So it would seem as though this is an easy decision, except… Virtually the entire creative industry uses Mac computers. Because Mac-based systems are manufactured exclusively by Apple, with no competition, they are slightly more expensive. However, this also seems to make them easier and more intuitive to use. Peripheral devices (scanners, printers, and so on) manufactured by third parties to be used with Apple products must comply with rigid standards that have been set by Apple, making the flow, use, and installation of these accessories seamless.

If you are a photography student or applying to a program in the future, the simple solution is to buy and use whatever the school uses as its primary imaging platform. Using a different operating system is possible, but frustrating, because instructors will inevitably give demonstrations using the department's common operating system. Printers, scanners, and other shared peripherals will also be set to the common system, so connecting your computer to these tools will be difficult or even impossible.

Laptop or desktop?

If you can only own one computer, a laptop is probably the best solution, because it will allow you to download shoots in the field (freeing up CF cards), and enable you to shoot like a pro, with your camera tethered to the computer (see pages 114–115).

The big downside to laptops is that their display screens are not fully adequate for critical color calibration at professional standards. Their hard drives are also too small for the massive amounts of storage that professional photographers require. The solution for many young photographers on a budget is a hybrid system, combining a laptop computer with a color-calibrated monitor and a large hard drive or RAID for storage.

You can connect the calibrated monitor to your laptop when you are doing critical work. Monitors with separate RGB adjustments can be calibrated to critical industry standards, ensuring that when you send finished files to a client, online print service, or art director, the color will appear the same on everyone's screen. A system like this will also make retouching and computer imaging easier, because you can use the

PC OR MAC
PCs (above) are less expensive, but most people in the creative industries use Macs (below).

OTHER PERIPHERALS
Technology exists to make your life easier, so acquaint yourself with some of the industry's most reliable helping hands.

Card reader There is no need to connect your camera to your computer to download images. Card readers are inexpensive ($10–30), download cards faster, don't drain the battery in your camera, and allow you to keep shooting while your files are backing up to the computer.

Portable hard drive Small, portable hard drives with 250–500 gigabytes of memory are a practical necessity for any professional photographer. They enable you instantly to back up shoots in the field and they conveniently draw their power from the computer's internal battery or power cord.

smaller screen of the laptop to hold your Photoshop tools and devote the entire display of the larger, color-corrected screen to the image you are working on.

Peripherals

The peripherals you will need will depend on your method of working and what you can afford—luckily there are ways around buying expensive pieces of hardware yourself.

Digital storage The typical laptop has an internal hard drive capable of storing 250 gigabytes. For amateurs shooting in JPEG file format, that's probably enough storage for their entire life's work. For a professional photographer shooting RAW files with a high-res camera that records 22–60 megabytes per shot, 250 gigs might not be enough to store even one or two days of shooting. You will need to put all those photos somewhere and your laptop is the most dangerous place for them to be stored. Laptops get dropped, spilled on, and stolen every day. Never—ever—use your laptop as your primary storage device.

Luckily, digital storage is a lot less expensive than it used to be. When it comes to buying your own storage device, you have several options: a portable hard drive, a large (nonportable) external hard drive, or a RAID.

Alternatively, you can store your images with an off-site storage facility. Off-site facilities from services such as Photoshelter.com are probably a little pricey for younger photographers (about $50 per month for 100 GB of memory). For working pros, the beauty of off-site storage is that your photographs are accessible from any computer in the world and can be delivered to a client 24 hours a day. An added benefit is that these services can also include web hosting with client-accessible

galleries, a very convenient way to deliver a shoot to an art director or private client.

Scanners These were an absolute necessity for any photographer a few years ago, as the industry made the transition from film to digital. Now they are a convenience, but no longer mandatory.

A high-end film scanner can cost $10,000–20,000 (or more), but chances are you only need to own something that good if you have a huge archive of images that were shot on film and need to be uploaded to a stock agency. Many university photo departments will have a few top-shelf scanners for students to use. Service bureaus are an option for pros who need great scans but don't have enough volume to justify the purchase of a dedicated film scanner.

Inexpensive flatbed scanners are often a convenient way to digitize sketches, layouts, expense receipts, and documents. Most will also include a film-scanning option that will be adequate for scanning images made on film for web use or small portfolio prints.

Printers If you are printing a lot of large exhibition prints or running a high-volume portrait studio, then a high-end, large-format printer might be a worthwhile purchase. For most photographers, however, an expensive, photo-specific printer is another item that just isn't as necessary as it was a few years ago, because websites have all but eliminated the traditional portfolio as the primary marketing tool for photographers.

That said, everyone needs to own (at least) a small printer for documents, so you might as well get something that is also capable of printing photographs sufficiently well to make contact sheets or a quick addition of a new image to your portfolio.

exercise:

REFINE YOUR DIGITAL PRINTS

Viewing an image on a perfectly calibrated screen is very different to viewing it as a print. Screens are backlit. Prints reflect light.

Try making three prints of every image, even if the first one seems perfect. Try to find a way to refine it, then make another, and another. It is amazing the difference this will make.

External hard drive Large external hard drives that require a separate power source are a very good way of storing your work at home. These can typically hold 2–4 terabytes of information. However, you will need two in order to properly back up your archive. Professionals keep one drive at their home or studio and another at a different location in case of fire or theft.

Color calibration device A properly calibrated display is an absolute must-have. A full system is probably not necessary for most students or professionals just starting out, but a basic calibration device and a monitor capable of being fully calibrated are essential for any pro delivering high-res files to a magazine or art director. If you are printing at a rental digital darkroom or university lab, you can probably rest assured that their monitors are calibrated weekly. If you are using an online print service or printing with an inkjet printer at home, a color calibration device is one of the most worthwhile investments you can make.

Photo-retouching tablet Retouching with the track pad of a laptop is a painful and clumsy process. Tablets replace your mouse or track pad with a pressure-sensitive tablet and electronic stylus, allowing you to draw and retouch your image with the freedom of a pencil stroke. They also have programmable "hot keys" that provide quick and easy access to your most commonly used Photoshop tools. They come in a range of price points and sizes, so you can easily pack a small one for location shoots. Tablets take a few days to get used to, but then they become so intuitive you'll never want to use anything else.

Tutorial 27 | DIGITAL CAPTURE FORMATS

It is important for every photographer to have a basic understanding of the pros and cons of different digital files. For our purposes, we are only going to look at the two most commonly used formats for image capture with digital cameras: JPEG and RAW.

OBJECTIVE >>

■ **To understand the pros and cons of different digital files.**

exercise:

TRY BOTH AND COMPARE

Most digital cameras can shoot RAW files and JPEGs simultaneously. When you are first learning to shoot RAW it is very instructive to shoot JPEGs as well. Try this in order to understand how the camera interprets the scene and how you can improve on your images post-processing.

JPEG

JPEG stands for Joint Photographic Experts Group, the committee that created the JPEG as a universal digital image file back in 1992.

Most point-and-shoot digital cameras only shoot in JPEG format. Prosumer-level DSLR cameras usually shoot JPEGS as the default format if you are in one of the pre-programmed, amateur settings (sports, macro, portrait, etc.); these cameras can only shoot RAW (see page 106) when they are in one of the advanced manual modes. Pro-level cameras can shoot both formats simultaneously.

JPEGS are very useful: they are capable of representing 16.7 million colors, more than the eye can discern, and they are capable of extremely high resolution, more than enough for professional reproduction. Most importantly, JPEGs are written in a universally understood file format that can be opened by any computer, even a computer that doesn't have Photoshop. So what's not to love?

Image processing and compression JPEG files are created by the camera's internal image processor; this means that as the camera takes a picture, the software in the camera decides what information is important and then writes the data to the memory card. Information that is deemed redundant or unnecessary is thrown away. In addition to this, many cameras' internal processing software automatically increases color saturation and sharpens the image before you even view it on the camera's screen. For amateurs this is great, as it means that every photo is a compact little file that looks attractive and vivid. You can save thousands of photos to a single memory card, and each of those files is small enough to be emailed. Another advantage is that because the files are small, they record to your memory card faster. But you have given up your control of color intensity, allowing the file to be modified and processed by the camera before you have even proofed it.

When you are shooting JPEGs you can choose how big you want each photo to be (the pixel dimensions), and how much you want to compress it. This is usually represented by a menu icon that looks like either a smooth arc (minimal compression) or stair steps (more compression). The more you compress the image, the more information you allow the camera or software to throw away.

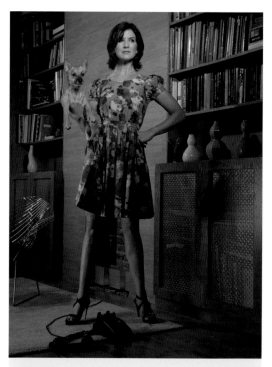

JPEG
A photo shot as a JPEG.

It gets worse when you use photo-editing software to change or work on the image. When you open a JPEG image, change it slightly, and then save it again, the image is recompressed slightly differently and even more information is thrown away. In fact, an image file can be completely ruined by simply opening and closing it several times with very small adjustments each time (if you don't make any changes, then simply opening and closing is nondestructive because the image recompresses exactly the same way).

JPEGs are lossy, as opposed to RAW files, which are compressed using lossless compression. Therefore, every single bit of data that was originally in the RAW file remains after the file is uncompressed.

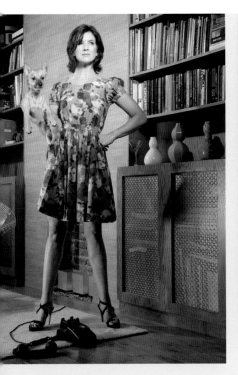

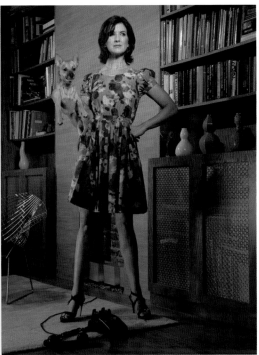

LIMITED BIT DEPTH

This photo was processed from an underexposed JPEG and the exposure corrected using the Levels Tool in Photoshop. Note the abrupt tonal transitions in the dress and skin tones: this is due to the relatively limited bit depth of JPEGs.

BAD EXPOSURE

If you expose a JPEG badly, there is little you can do to save it because much of the original information has been thrown away by the camera's image processor.

WRONG COLOR BALANCE

A photo shot as a JPEG with the wrong color balance will never look as good as a correctly balanced exposure. This JPEG has a blue cast because the camera's processor threw many of the original yellows away. You can subtract the excess blue (using Levels in Photoshop), but you still won't have the original warm colors to replace what was lost.

Bit depth JPEGs are 8-bit files. What does that mean? Digital images are stored as a series of ones and zeroes—0,1,1,0, and so on—with each string of numbers representing the brightness or luminosity of a single pixel.

JPEGS use an 8-digit binary number string to represent each shade of gray for each specific pixel—0,1,1,1,0,0,1,0, for example. If we look at all of the different ways that 0 and 1 can be combined in an 8-digit string, we find that there are 256 different combinations. Consequently, a black-and-white digital JPEG image is capable of representing 256 distinct shades of gray from pure black to pure white. Tones that fall in between the steps are rounded up or down to the next step.

Of course, our cameras are actually recording in three colors (channels) simultaneously: red, green, and blue. So now the 8-digit number string represents the levels of luminosity for each of these color channels. If we multiply 256 x 256 x 256, we get 16,777,216—the total number of colors a JPEG image is capable of representing. This is known as the "bit depth" (also referred to as color depth). The more bits that are used per pixel, the finer the color detail of the image. This figure of 16.7 million is more than enough if the JPEG doesn't require adjustment or post-processing, but it would be nice to have greater bit depth if we need to make adjustments later (known as "post-processing headroom").

If you have ever shot with color transparency (slide) film, then it might be useful to think of JPEGs as the

WHAT'S THAT LITTLE XMP FILE THAT APPEARED NEXT TO MY RAW FILE AFTER I MODIFIED IT?

When a RAW file has been modified (cropped or color balanced, for example), Photoshop creates a "sidecar" XMP file that records the changes to the RAW image and instructs the computer on how to display the image with the changes.

THE GOLDEN RULE

Never use photo-editing software to work on or adjust an original JPEG. Make a duplicate to work on and keep the original JPEG pristine.

WHO SHOOTS WHAT AND WHY?

JPEG

You're a sports photographer shooting the final game of the World Series on a bright sunny day when the light is consistent. Your motor drive is set to shoot 10 frames per second, because you absolutely can't miss a shot. When the outfielder catches the last fly ball you need to upload the image to a wire service immediately, because every second can mean thousands of dollars in syndication sales.

RAW

You're a wedding photographer, running back and forth between a dark church lit with incandescent lights to the church garden where you have strobes set up to shoot formal portraits mixed with daylight. You don't have to deliver the shoot until the bride and groom return from their honeymoon.

digital equivalent of a color transparency. The image is complete when it is processed in the camera. If it was exposed and color balanced correctly when you shot it, that's great. However, if you overexposed or made some other fundamental error, then your options and ability to refine or correct the image later are limited.

In fact, JPEGs are actually the most unforgiving format in all of photography, even color transparency film; they just seem more flexible because computers make it easy for you to help them a little in post-processing. You might not notice it, but there is always a price to be paid for editing a JPEG.

RAW files

RAW files are called "raw" because they save all the information from every photon that hit the sensor. This means that they are pretty useless until the information has been selectively interpreted or processed by the photographer.

Bit depth with RAW files By now, you have figured out that having greater bit depth is a good thing. RAW files are 12- (and sometimes 14-) bit files. The difference between an 8-bit file and a 12-bit sounds like it's only a 1.5 increase, but it's not. Because the digit string is now a 12-digit string of 0s and 1s, it can now have 4,096 "steps" between pure black and pure white. Pure black and absolute white are still the same, but the steps are smaller, allowing for more information to be captured and more flexibility in post-processing.

Compression RAW files use lossless compression, and they don't compress the file nearly as much as JPEGs. You can only fit about 25 percent as many images on the same memory card, and each image will take longer to record.

But no information is ever thrown away in a RAW file due to compression or processing. Even if you crop an image, you can always retrieve the original cropping.

You can change the way it looks on your computer screen and save the result in another type of image file (such as a JPEG or TIFF), but you can always go back, even years later, and access the original RAW image data as it was shot. In the industry, this is known as "nondestructive editing."

Processing Unlike JPEGs, where anything that is deemed unnecessary by the camera's image processor is thrown away, RAW files require you to process the image afterward using special software—which means that you decide what information is important. This gives you another level of control and creative freedom.

With RAW files you can retroactively set the white balance of the photo, even if the camera was set incorrectly when you shot it. Similarly, you can also adjust the exposure, saturation, contrast, digital sharpening, and much, much more. Completely unprocessed RAW files can look pretty bad, but with some skill they can look far better than a JPEG that was processed by the camera's internal software.

RAW files are written in a proprietary code created by the camera manufacturer. They can only be opened using special software. You can't post a RAW file to your Facebook page or send it to an online print service. You process the image, then create a duplicate in one of the universally understood formats, such as JPEG or TIFF. The duplicate image will not contain all of the information of the RAW file, only the information you decided it should contain. The original RAW file remains pristine in your archive.

If we continue the "JPEGs are like color transparency film" analogy with RAW files, then RAW files are like shooting with color negative film. You need to go into the darkroom in order to interpret and create the final image—except in this case, we are going to go into "Lightroom" (see pages 108–113).

CORRECTING FLATNESS

RAW files look terrible until you process them, because they have a completely flat tone curve (see right). Modern processing programs (Lightroom, CaptureOne, Adobe Raw Converter, or the software that came with your camera) usually apply some correction, so they might not look quite as bad as the photo shown top left. But the beauty of an image this flat is that all the original information is there. It just needs to be processed and interpreted according to your vision (see bottom left).

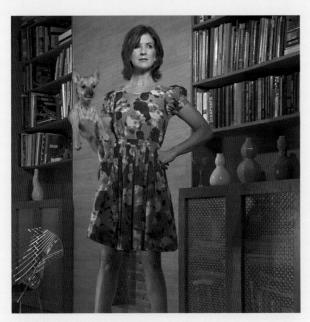

Before RAW file as the camera saw it.

Film = "S" curve Exposures made on film have an "S"-shaped curve in a graphic representation of their tonal range. Film emulsions were developed to have a "forgiving" dynamic range. This produces ideal separation of values in the middle section of the image's tonal scale, while the lowest and highest values are "compressed," respectively within the "toe" and "shoulder" ranges, thus producing an "S"-shaped characteristic curve. Because film did not respond in a linear fashion to the different levels and ratios of illumination encountered by photographers, many explored and mastered different methods of exposing and developing negatives in order to modify the tonal curve of individual images.

TONE CURVE

The tone curve shows the tonal relationship between the input values (x-axis) and the output values (y-axis).

RAW = flat curve RAW files made on a digital camera respond linearly to different levels of illumination; we call this a "flat curve." Flat curves lack contrast and appear unnatural to our eyes. However, a flat curve shows that there is no change between the input and the output values, meaning that all the information is there, and it can be manipulated digitally.

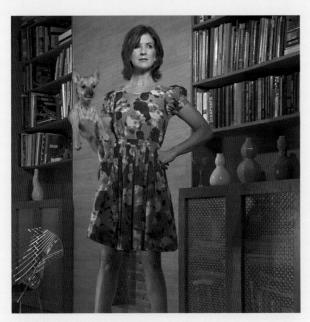

After The same RAW file after processing.

Tutorial 28 | LIGHTROOM

Adobe Lightroom consists of five modules: Library, Develop, Slideshow, Print, and Web. Here we will look at three of Lightroom's capabilities in depth: archiving (Library), processing (Develop), and its ability to shoot with a camera tethered directly to the computer.

OBJECTIVE >>

■ **To understand the basics of Lightroom Library and Develop.**

exercise:

LEARN TO MANAGE YOUR ARCHIVE

Start small and import one shoot into Lightroom, create a metadata template, and keyword all the images you import. Establishing good habits and workflow procedures in the beginning will help you manage your archive for your entire career.

Lightroom Library

Most young photographers don't understand the importance of their archive in the beginning. They just shoot, then stuff the negatives (or the digital equivalent) away in shoeboxes or binders. But your image archive is the total record of your entire creative life. It is your intellectual property. Organize it at the beginning of your career while it is still manageable. Maintain it religiously, back it up, and migrate files systematically.

Copyright protection

The very first thing to do when you load Lightroom is create your metadata presets. This template will automatically attach all of your copyright and contact information to every photograph that has been imported into your Lightroom Library. Every time you export the photograph, copy it, or upload it to a server, the information will automatically be attached. If you discover an unauthorized use of your image (it happens hundreds of times a day all over the world), you will be able to prove that you are the original creator.

It's easy to neglect this step because it's not obvious and the first thing everyone wants to do is start importing and processing images. Creating a metadata template takes five minutes and protects your images forever.

Importing photos into Lightroom

Imagine you have just completed a magazine shoot that consists of about 1,100 photographs shot in RAW file format. Before you erase any memory cards, copy the photos onto your laptop and then onto the small 250-GB hard drive that you carry on every shoot. Remember the rule: No photograph exists until it exists in two places. When you get back to your deluxe studio or palatial office, copy the photos onto your large hard drive and then import the photos into Lightroom from the hard drive or directly from your CF cards. When you insert the memory card into the card reader, Lightroom will automatically open a dialog box asking if you want to import the images, and where you want them to be copied to for storage. Remember to back the photos up to another disk on your RAID or another attached hard drive that you have designated for backup.

You have some options when you import. You need to choose which of Lightroom's preset processing recipes

THE FIVE MODULES OF LIGHTROOM

LIBRARY

Library is the very heart of the Lightroom program—where you manage your image archive. It allows you to import images, edit metadata, add keywords (very helpful for locating images later) and copyright information, create collections of images, and rate and sort images.

DEVELOP

This is where you process RAW files, correcting exposure and color balance, cropping, and making lens corrections.

SLIDESHOW

In this module, you can create slideshows and multimedia presentations complete with music. Many wedding photographers create instant slideshows of the wedding service that are played at the reception. You can also create a PDF slideshow of your work or a shoot that can be emailed to a prospective client.

PRINT

The Print module allows you to print photographs directly from Lightroom, but it does much more, because it also allows you to create custom print packages (a 5 x 7-inch and three wallet-sized for every parent of every child in a class, for example).

WEB

Within the Web module you can create a complete website for public view, as well as individual galleries that are only accessible to individual clients by password.

you want to apply (see page 111) or you can simply choose to import them "as shot," which will apply the camera settings that were used when the photograph was taken (color, light balance, exposure, etc.). In the beginning it might be useful to import them as "zeroed," with no corrections; this will show you the pure RAW file with no interpretation and help you to learn RAW image processing.

CREATING A METADATA TEMPLATE

Go to Menu bar > Metadata > Edit Metadata Presets. This will identify every photo you import into Lightroom as yours, helping to protect them from copyright theft.

WHAT'S A "DIGITAL NEGATIVE," OR DNG?

At the beginning of the Import dialog box, Lightroom will ask if you want to copy the original file to a new location or create a copy of the photo as a digital negative.

RAW files are written in a proprietary code created by the camera manufacturer for a specific model of camera. This means that special software is required to read them. Will this software still be available or supported in 20 years? Probably, but maybe not. The digital negative, or DNG, is a file format created by Adobe that "translates" RAW files into a universal code, ensuring (as long as Adobe stays solvent) that you will always be able to access the original information.

DNGs look and behave exactly like RAW files, although they use about 20 percent less disk space than RAW files on your hard drive. No information is ever lost—it's just that the code is written in a universal form. A few camera manufacturers, such as Leica, have adopted the digital negative for use as a capture format. In the future, RAW files that are proprietary to specific cameras may become obsolete and manufacturers may adopt in-camera DNG as the universal capture format.

So should you convert to DNG? It's up to you. The choice is really a matter of personal preference.

Within the Import dialog box you can also add a few keywords such as the client or magazine name, the location of the shoot, and other signifiers such as "motorcycle," "concours," or "vintage" that apply to the entire shoot. In this case, we'll select all and then click Import to bring in the entire shoot. The latest version of Lightroom also allows you to browse the shoot before you import and to select images individually if you so desire.

Editing the shoot

From our imaginary magazine shoot, there are 1,100 photos. Not every one of them is worth processing to perfection. The first step is to quickly look through them and give any photo you like a colored label. At this stage a label is better than a star rating, because it will allow you to separate different edits you might make more easily. This is also a good time to add specific keyword information. For example, if there are 30 photos of a particular person, then select those images as a group and add the name to the keyword list; now you will be able to find those photos later without looking through the entire shoot.

By using the labels, you can cull the entire shoot down to 100 photos or so. (For a wedding shoot, you might want more, but this is a feature story for a magazine.) Now you need to identify the most important photographs, narrowing them down to 20 or so best photos. Assign them star ratings according to their importance to the overall story or the overall quality of the photographs. Be careful not to give too many stars to the photos in your library. Be very selective. When your archive comprises 400,000 photos, finding a particular photo is like finding a needle in a haystack. If you apply five-star ratings to all of your photographs, then you will just create a huge stack of needles and you've defeated the purpose of creating a hierarchy.

Lightroom Develop

Once you have narrowed the shoot down to a reasonable number of images, it's time to start processing individual photos. To do this we work in the Develop module; here you can begin to process and correct your RAW files. This is where you can fine-tune color and light balance, exposure, and cropping, and reduce noise, add digital sharpening, and even correct for lens aberration. If you have 20 images that require the same adjustments, you can correct one to perfection, then copy and paste the settings for the corrections to all the other images.

Finishing off

Once you are done processing the image, there is no need to save it. Lightroom just stores it in the archive

with the settings you have applied. However, if you want to deliver the photo to a client, you have to export a copy in a more universally read format. Just select Menu > File > Export. Now you can select a file format (JPEG, TIFF, etc.) and export it. This is also where you can choose the final size of the image. If you were delivering to a private client (such as a bride), you would deliver JPEGs. A magazine, on the other hand, will do more post-processing in order to ready the image for printing, so you would need to deliver high-res JPEGs or 16-bit TIFF files.

If you want to work on the image in Photoshop, simply select Menu > Photo > Edit In > Photoshop. The image will open in Photoshop and you can work on it using Photoshop tools and techniques. When you are done, just close the image and a copy of the edited version of the image will automatically be added to your Lightroom archive with all of the Photoshop adjustments. The original will remain pristine.

You can also publish the photo to your Flickr account and Lightroom will even keep track of the comments.

This tutorial is really just a hint at the tools available in Lightroom. You can also apply selective sharpening, manipulate the contrast, eliminate noise, add film grain, heal blemishes, correct perspective, and remove spots. The best part is that you can do all of this on a single image and then copy and paste all of those improvements to the entire shoot. Lightroom will synchronize all of it. Years later, if you have changed your mind, you can access your original file and return it to all of the original settings.

"GLOBAL" CORRECTIONS

While Lightroom can apply corrections to individual areas of an image (healing blemishes, burning, dodging, etc.), it is designed to make "global" corrections that affect the entire image. "Pixel by pixel" photo editing (compositing elements from images together, for example) is done using Photoshop. The two programs work very well together.

◁ **Opening the Develop module** Select one image and then click on the Develop heading in the upper right of the screen to work on the photos in the Develop module.

△ **Assessing the RAW file** Not bad, but the photo is flat and lacks contrast. The sky is blown out and, if you look at the histogram in the upper-right corner, you will notice a lot of "clipping" in the highlights. (Clipping is when an area of the photo is either so light or dark that no detail is available.) Just a few years ago, the only solution would have been to composite the photo by stripping in the sky from a separate exposure or using a graduated filter when the photo was made. Now, however, the exposure can be adjusted on the RAW file.

▷ **Clipping** Lightroom has clipping indicators—the little triangles in the corner of the histogram. Click on these and Lightroom will show highlights that are clipping in red (right) and shadows that are clipping in blue (far right). By adjusting the exposure slider, you can "retroactively" change the original exposure. Note that in the darkened version (far right), the detail in the sky becomes visible. The small amount of shadow clipping that is still visible in the engine (the bright blue areas) is acceptable, but could be eliminated if desired.

Clipped highlights show up in red.

Clipped shadows show up in blue.

The Recovery Tool highlights information in the cloudy sky.

The Clarity Tool adds contrast to mid-tones.

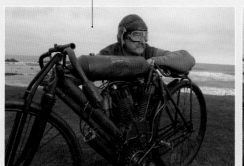

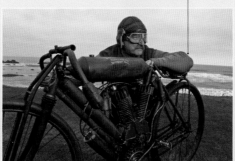

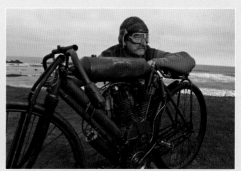

△ **Correcting exposure** Here, the overall exposure was reduced by a quarter of a stop with the Exposure tab, then the highlight Recovery Tool was used to recover even more detail in the sky. When shooting RAW files, it is often easier to recover highlights than shadows (the opposite is true of JPEGs), so it is common to overexpose a little.

△ **Increasing clarity** The Presence tab was used to increase the clarity. This is a contrast tool that applies contrast selectively to the mid-tones, making the photograph appear sharper.

△ **Increasing vibrance** Next, the vibrance was increased, a tool that selectively saturates colors without affecting skin tones as much. Note that the grass, the orange of the sweater, and the red of the bike are affected more than the subject's skin. It is also possible to control the hue, luminance, and saturation of individual colors using the HSL tab in the Develop module (see page 113).

THE ETHICS OF PHOTO MANIPULATION

Because the photograph used was shot for a news magazine, any compositing is strictly forbidden as a violation of journalistic ethics. It might seem harmless enough to simply strip in a sky, but it opens up a slippery slope of ethical issues to allow any manipulation to a photo in which new elements are added or subtracted from the original capture file. The guideline for most news organizations is that photographers can only use common darkroom manipulations—dodging, burning, and so on—to enhance a photograph. All of the steps in this tutorial fall within standard ethical practices.

▷ **Presets** Lightroom also comes with many presets, which are loaded into a menu on the left side of the screen. When you scroll your mouse over the preset recipes, the preview window on the upper left shows you what the photo will look like if you apply that particular preset. Many of them are a little gimmicky, like the Purple Glasses preset in the example, right. You can eliminate the presets you don't use, but more importantly, you can create your own by simply processing the image to your liking and then clicking on the + sign next to the presets box; a new dialog box will appear and prompt you to create and name a new preset, which is like having the ability to invent your own color film.

"SELECTIVE" CORRECTIONS

In Lightroom Develop it is possible to refine small selected areas of the image.

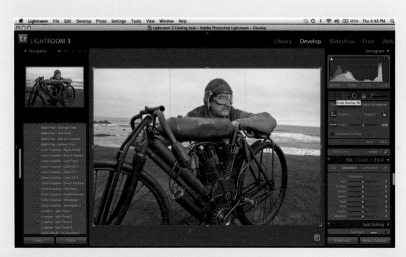

◁ **Selective Tools palette** To make "selective" corrections, click on the Selective Tools palette on the upper right of the screen—this opens a new set of tools that will allow you to work on particular sections of the photo.

Red-eye correction.

Healing/ Cloning Tool.

Graduated Filter Tool.

Cropping Tool.

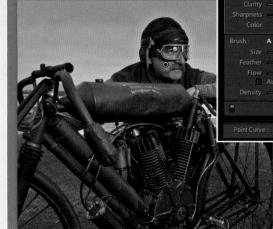

△ **Cropping the image** In this instance, a series of tools has been opened that will help facilitate cropping and straightening the image. The image has been cropped to a square, but the original cropping can always be restored. Now a graduated pale blue filter has been applied to the sky. The individual sliders can also be used to apply multiple effects within the chosen tool.

Indicates that the tool is active.

Designates an area that was altered by a tool but is no longer active.

△ **Selective dodging** By using a brush to selectively dodge, you can eliminate the effect of the graduated filter on the subject's face but retain the effect in the sky. The icons on the photos are "pins" that show where the photo was worked on. The pins become part of the photograph's metadata, allowing any of the effects to be selected, eliminated, or changed in the future. Once the brush is "put away," the pins will no longer be visible. In this case, we only used the brush to affect exposure; however, we could also have used it to sharpen or unsharpen an area selectively, or to selectively change the color balance of a certain area.

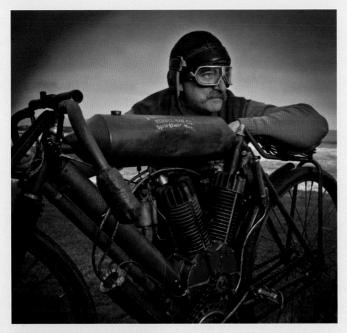

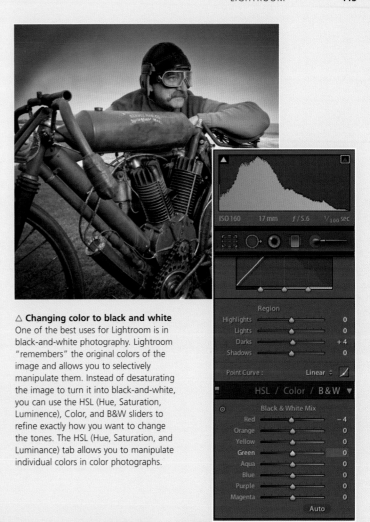

△ **Applying a vignette** The photo is a little too overworked and obvious for my personal taste, but it helps to see the effects of the tools exaggerated. It is a significant improvement on the original RAW file. At this point we could simply copy the settings (using the Copy button in the lower-left corner of the screen) and paste them onto any of the other images using the Paste button.

△ **Changing color to black and white** One of the best uses for Lightroom is in black-and-white photography. Lightroom "remembers" the original colors of the image and allows you to selectively manipulate them. Instead of desaturating the image to turn it into black-and-white, you can use the HSL (Hue, Saturation, Luminence), Color, and B&W sliders to refine exactly how you want to change the tones. The HSL (Hue, Saturation, and Luminance) tab allows you to manipulate individual colors in color photographs.

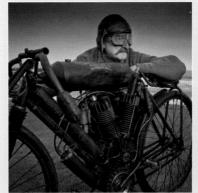

In this image, the reds were darkened and the greens lightened.

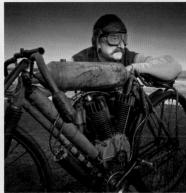

Here, the reds were lightened and the greens darkened.

Tutorial 29 | SHOOTING TETHERED WITH LIGHTROOM

While the digital display on the back of your camera is a great tool for checking your work as you shoot, that's not the way the pros do it. Most high-level portraiture is shot with the camera tethered to the computer by a USB cable.

OBJECTIVE >>
■ **To learn how to shoot with your camera tethered to your computer.**

exercise:
PLAY THE ROLE OF DIGITAL TECHNICIAN

The team on most high-level shoots includes a digital technician whose sole responsibility is to monitor and organize shots as they are imported to the computer, back them up, and then process the RAW files into JPEGs or TIFFs. Work with a couple of friends or classmates to shoot some projects as a team, trading the roles of photographer, digital technician, and lighting/grip assistant. Very few of us get to go straight to the top of the profession. Having strong digital technician skills can help get you on high-level shoots, where you will get to watch the best photographers at work.

Although there are other programs that will allow you to do this, including free software that comes with most prosumer DSLRs, this tutorial demonstrates how to shoot tethered with Lightroom.

The advantages of shooting tethered are:
■ Your camera display is a JPEG. Even if you are shooting RAW files, the instant display that your camera shows on the back is a JPEG that the camera creates as a preview. Shooting tethered allows you to see and inspect RAW files on set.
■ Shooting directly to your computer allows the photographer, the digital technician, stylists, and the art director to check the files carefully for exposure (using the histogram), critical focus, styling, lighting, and

cropping for layout as you shoot. While many people cite expense as the primary reason for the digital revolution, the ability to instantly, and critically, review each shot on set probably has more to do with the acceptance of digital imaging at the professional level.
■ By default, Lightroom will write the file to the computer (in the folder you created) while your camera writes the file to the internal memory card, giving you the photograph in two places simultaneously according to "the rule" of always having a copy of every file.

LIGHTROOM VS CAPTURE ONE

If you are assisting a professional photographer as a digital technician, the most common software in the industry is called Capture One. Capture One is quite a bit faster, which is why more fashion photographers use it. The two programs share many similarities; Lightroom is just a bit more comprehensive because of its other capabilities. If you learn how to shoot tethered using Lightroom, you'll be able to learn Capture One in an hour or two.

SELF-PORTRAIT

Shooting tethered is a great tool for fine artists working on self-portrait projects. Set your camera to self-timer and turn the computer to face you. Use a wireless mouse to trigger the camera using the "shutter release" in Lightroom, then hide the mouse from view. You'll see the image on the computer screen in seconds and be better able to adjust your pose or set lights. There is also an app available for the iPhone that allows you to view and shoot using your phone.

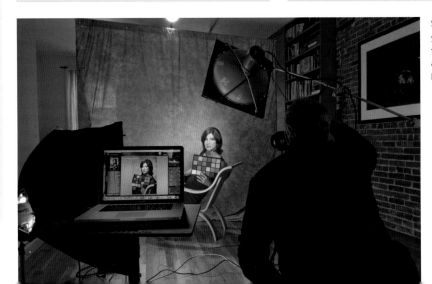

SHOOT LIKE THE PROS
Shooting with your camera tethered to your computer, as in this photo, is how the pros do it.

LIGHTROOM

Lightroom makes shooting tethered really easy. First, connect the camera to the computer using a USB cord. Launch Lightroom, and then turn on your camera.

▽ **1 Starting off** Select File > Tethered Capture > Start Tethered Capture.

▷ **2 Naming the session** This is where you choose the folder where the photos will be stored as you shoot. The default is your computer's Pictures folder, but it makes life easier to create a specific folder on your desktop for each job. Shooting to a specified session/job folder on your desktop will simplify the transfer to your archive later on. When the job is done, simply drag the folder to your portable hard drive.

Remote Shutter Release

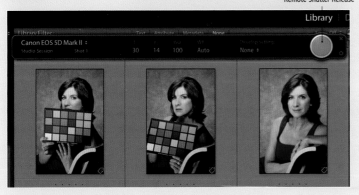

△ **3 Shutter release** Lightroom has recognized the attached camera (it will automatically recognize the most commonly used cameras) and given a control bar on the screen. The gray button on the right is the shutter release; you can now shoot without actually touching the camera if you choose to.

△ **4 Setting the white balance** Now set the white balance for the lights by shooting a color check test and using the Eyedropper Tool in the Develop module. The Eyedropper is a handy tool that allows you to select any area of the photograph that you want to be a neutral gray. Simply click on the tool to activate it, place it on the area that should be neutral, then click again. The white balance will be reset to match your selection. Here, the histogram tells us that the photo is still underexposed by about a quarter of a stop. This is fine, but it's the sort of thing you'd want a sharp digital assistant to alert you to.

Eyedropper Tool Histogram

◁ **5 Save settings** You can now save settings by creating a custom preset in the Presets menu; here it's been called HH 01. Simply click on the + sign in the Presets menu, which will allow you to create a new preset that will be applied to the entire job.

HH 01

+ sign

▷ **6 Subfolders** When you change situations or lighting setups, Lightroom can create subfolders for the new situations.

Subfolders

Tutorial 30 | PHOTOSHOP BASICS

Photoshop is a dense and complex program that has hundreds of books written about it. In this tutorial, we're only going to look at one small aspect of Photoshop: retouching portraits.

Every photographer has different rules and preferences for how they want their photos to look. In the example shown on the following pages, the model is a television host and we want the retouching to be subtle. We want to retain her age (okay, maybe we'll take five years off), but we don't want to retouch so much that a casting director is going to be shocked when she walks in.

The biggest single mistake most people make when retouching images in Photoshop is to try to do too much too fast. This is a subtle program that works best when you use it to finesse an image; many small corrections will look more natural than one big one.

Photoshop is based on the concept of "layers." It can be helpful to think of layers as acetate sheets that are placed over the original image (called the "background image"). Every layer affects each of the layers below it. If a layer has obvious mistakes or needs further refinement, it can be reopened, modified, or discarded.

When an image is opened in Photoshop, the background layer (the original image) will be locked to protect the original file. Create a duplicate layer of the background image (it will not be locked) to begin working on the image.

OBJECTIVE >>

■ **To learn how to retouch portraits in Photoshop.**

exercise:

WATCH SOME FUNNY VIDEOS

In December 2007, Matt Bledsoe and Troy Hitch created a hilarious series of video tutorials entitled "You Suck at Photoshop," hosted by the website My Damn Channel. In the series, they created a fictitious dysfunctional character named Donnie Hoyle, who retreats from his loser life into the virtual world of Massive Multiplayer Games and creating online video tutorials for Photoshop.

The web series was such a hit that it warranted a story in *Time* magazine and won two Webbies. You'll laugh, you'll cry—and you'll learn a lot about Photoshop, particularly how to composite images using Warp, Distort, and Layer effects.

STARTING OFF

Finalize your image as much as you can in Lightroom before opening it in Photoshop.

◁ **1 Refining in Lightroom** Select an image in Lightroom and get the contrast, exposure, and cropping as close to perfect as you can. To start retouching, go to Photo > Edit in > Edit in Photoshop. Lightroom will ask if you want to edit the original image, a copy of the image, or a copy with Lightroom adjustments. Choose the latter and click the box below, Stack with Original, to save the edited copy image to your Lightroom archive.

▷ **2 Opening in Photoshop** The image will automatically open in Photoshop and you can now take advantage of all its specialized tools.

RETOUCHING LINES

We all have a few lines and a 22-megapixel camera is pretty unforgiving. But the thing that's important is that we really wouldn't notice those lines in person or on video. Most of them are caused because the camera has frozen the smile.

▷ **1 Duplicate layer** First, go to Layer > Duplicate Layer. This creates a duplicate layer in order to keep the original pristine.

△ **2 Healing Brush** Now grab the Healing Brush Tool from the icons on the left side of the screen.

△ **3 Shape and Angle** Shape and angle the Healing Brush to the area you are working on—in this case, the laugh lines at the corners of the eye—so that you change the surrounding area less. The Brush menu has a circle at the bottom of the box with an arrow; rotate and reshape the circle (as the oval in the illustration) by clicking on the circle and pulling it into the desired shape and rotation. Make every change as small as possible to maximize believability.

△ **4 Don't overdo it** "When you are 20 you have the face you are served, by the time you are 30 you have the face you deserve." We don't want to eliminate her life's story, so leave some small character lines. Paint over the wrinkles, blemishes, and any sun damage with the Healing Brush, but don't go too far. There are some steps to come that will help it all blend together.

RETOUCHING EYES

One of Photoshop's most powerful capabilities is its capacity to edit small areas of an image. Here we use the Lasso Tool to select the white of the eye.

△ **1 Lasso Tool** Using the Lasso Tool, isolate the white of the eye and make a selection.

△ **2 Refine the edge** Go to Menu > Select > Refine Edge, or key in Option > Command > R to create a feathered selection. The Refine Edge Tool is intuitive, and shows you how the selection is being modified. Using a softer edge will help the selection blend.

△ **3 Desaturate reds** Go to Image > Adjustments > Hue/Saturation. Select Reds from the drop-down menu, then desaturate and lighten the red pixels to minimize the red blood vessels in the eyes. Remember the settings, because you will have to do this four times for the four different white sections, and you want them to match. This is also a great method for whitening teeth, but this model doesn't need it.

△ **4 Enhance blues** Next, select the iris of the eye. Using the same Hue/Saturation selection as before, bring up the saturation a little to pump up the blues.

◁ **5 Bloat Tool** The model's eyes are slightly different sizes (this is true of most people). You can minimize the discrepancy with the Liquify Tool. Go to Filter > Liquify—or simply hit Command > Shift > X—to open the image in the Liquify Tool. On the left side of the screen is a variety of tools that will allow you to reshape body parts, plump up lips, push in love handles, slim arms, and so on by simply pushing and pulling them with your cursor. In this case we'll use the Bloat Tool (the fourth down under the finger icon) to bring the left eye closer in size to the right. The best results are achieved by making very small moves.

RETOUCHING THE SKIN

Perhaps the thing that is the most objectionable when we view the photograph under extreme magnification is the fact that we can see the actual particles of makeup. The whole image is too sharp. The next step shows how to diffuse the image to make the makeup less noticeable and smooth the skin.

▷ **1 Copy image** First, make another copy of the entire image.

▷ **2 Apply Gaussian Blur** Next, go to Filter > Blur > Gaussian Blur to apply Gaussian Blur to the whole copy of the image. Gaussian Blur will give the impression that you are looking at the image through a soft, translucent filter. You can vary the amount of blur when you create the effect; the opacity, later on in the process.

△ **3 Blurred uppermost layer** Now the whole image (on the uppermost layer) is uniformly out of focus.

◁ **4 Erase sections** Grab the Eraser Tool from the tool palette on the left of the screen. You can specify the size, opacity, and feather of the tool the same way you did with the Healing Brush. Here, the uppermost layer is erased to expose the sharp image underneath. Use a fairly large brush with a very feathered edge.

△ **5 Expose lower sharp layer** Erase the parts of the layer with Gaussian Blur that will reveal the sharp layer below. Typically, predominant facial features (eyes, teeth, hair) should be sharp, with larger areas of skin smoothed by the Gaussian Blur filter.

◁ **6 View erased areas** By clicking the little icon with an eye in the layers stack, you can make a layer visible or invisible. Here, the background layers are turned off to make it easier to see the effects of the eraser on the layer with Gaussian Blur.

△ **7 Adjust opacity** Now you can adjust the opacity of the blurred layer. Click the Opacity Adjustment Tool in the upper right of the Layers window. A slider tool will appear. Use the slider to adjust the opacity to get exactly the effect you want.

▷ **The results** When you are through, simply save and close; the retouched version will be added to the Lightroom Library. If you compare the two, you can see that the retouched version looks better—but we haven't turned our model into a plastic mannequin.

Tutorial 31 | PHOTOSHOP: EXPERT TIPS

In this day and age, every photographer needs to be conversant with Photoshop, but there is no substitute for the practice and skills of the people who use it every day. Professional retouching has always been an integral element in the practice of portraiture.

exercise:

TAKE IT TO THE LIMIT

Photoshop is a remarkably dense program: take one image and manipulate it into 10 or 20 versions, using every tool available—it's the best way to learn the program.

Some photographers love post-production and find the computer to be the most creative aspect of the entire process. For these photographers, the profession of retouching is a viable and lucrative career option within the industry.

For more help, watch the fantastic Photoshop video tutorials by Julieanne Kost at www.jkost.com/photoshop.html

Professor Rose DeSiano has worked for years as a professional retoucher. In this tutorial she address the most common problems for portrait photographers.

Beauty retouching

The art of beauty retouching has as much to do with your observation skills as it does with your Photoshop skills. Look at your photo, really look at it—and then begin correcting everything you would want perfect about yourself on a date, big interview, or any other public first impression.

Beauty retouching requires a tremendous amount of layers and masks. As you become more familiar with Photoshop, you can modify your workflow to keep your file in a manageable state; for this tutorial, however, edited layers of each category are "grouped" together to keep organized.

BRUSH HARDNESS

Use soft brushes approximately 38 percent in hardness.

BASIC TOOL MENU

The basic tool menu in Photoshop is located along the left side of the screen. Note that most of the tools have a small triangle next to them—right-clicking your mouse on the tool will open different variations of the tool.

Learning the keyboard shortcuts will make editing your images go much faster.

Move Tool (shortcut V)

Rectangular Marquee Tool (shortcut M)

Lasso Tool (shortcut L)

Quick Selection and Magic Wand Tool (shortcut W)

Crop Tool (shortcut C)

Eyedropper Tool (shortcut I)

Spot Healing Brush Tool (shortcut J)

Brush Tool (shortcut B)

Clone Stamp Tool (shortcut S)

History Brush Tool (shortcut Y)

Eraser Tool (shortcut E)

Paint Bucket and Gradient Tool (shortcut G)

Blur Tool (shortcut R)

Dodge Tool (shortcut O)

Pen Tool (shortcut P)

Horizontal Type Tool (shortcut T)

Path Selection Tool (shortcut A)

Rectangle and Custom Shape Tool (shortcut U)

Pan and Rotate Tool (shortcut K)

3D Tool (orbit, roll, zoom, pan, and walk) (shortcut N)

Hand Tool (shortcut H)

Zoom Tool (shortcut Z)

Switch foreground and blackground colors (shortcut X)

Set foreground and background colors (no shortcut)

Edit in Quick Mask mode (shortcut Q)

COLOR REPLACE

Old, faded clothing sometimes lacks saturation; in other situations colors in one model's outfit may not complement the environment or the other model. To change the color, follow these simple steps.

1 Open your photo in Photoshop From the main menu, select Layer > Duplicate Layer to create a new layer on which you will make the adjustments. Relabel this new layer depending on what you intend to do; in this case it has been called "Red Paint"). On the duplicate Red Paint layer, choose Image > Adjustments > Replace Color.

2 Slide the Fuzziness slider to the right until you have included all of the color you want to change.

3 Click on the Results box and use the Eyedropper and the Target Color palette to select your desired final color; in this photo, changing turquoise to red. Click OK and exit the Replace Color panel.

4 Once you are back in your files canvas, create a mask (see page 124), and remove any areas in the photo where the color has changed and you do not want it adjusted.

5 While in this box, use your paintbrush, located on the toolbar on the left of the screen, to replace or remove information in the highlighted layer. Black removes the layer's information (showing the layer underneath); white replaces the layer's information after you have blacked it out.

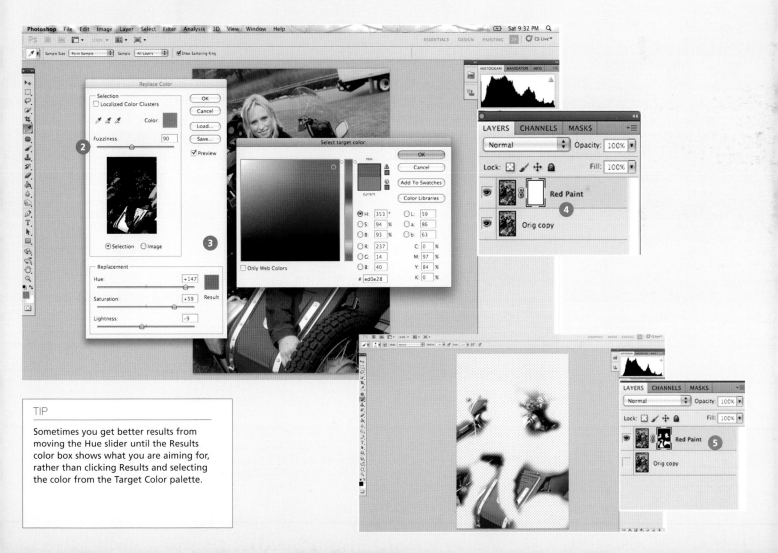

TIP

Sometimes you get better results from moving the Hue slider until the Results color box shows what you are aiming for, rather than clicking Results and selecting the color from the Target Color palette.

FABRIC WRINKLES

Wrinkled clothing is unacceptable on the runway and in the conference room. This is how you smooth wrinkled clothing out in Photoshop.

1 Using the Patch Tool, which is located in the main toolbar to the left of the screen, circle a small section of wrinkled fabric; your selection should now be activated.

2 Now slide the selection to an area of the same fabric with no wrinkles (make sure your settings for the Patch Tool are on "source" in the toolbar); your wrinkles should disappear.

> **TIP**
>
> If you get odd results, try again selecting a smaller area.

SKIN WRINKLES

Remove skin wrinkles using the Spot Healing Brush and Gaussian Blur. You can use the same layer as for removing fabric wrinkles or create a new one.

1 As when working on fabric wrinkles, create a new layer to work on the skin. Go to your original layer, then choose Layer > New Layer, then relabel the new layer "Smooth Skin."

2 Remove lines in the skin using the Spot Healing Brush method (see page 117), but take it a step further— remove every line you see.

3 Once you have applied the Spot Healing Brush Tool corrections, duplicate the Smooth Skin layer and apply Gaussian Blur to the bottom version of this layer.

4 Now make this new, blurred version brighter: choose Image > Adjustments > Brightness Contrast. Set the brightness slider to approx +5.

5 Apply a mask (see page 124) to the top original layer, and paint out all of the skin areas except those with needed detail (for example, eyelids, nostrils, lips, ears, and so on).

6 Highlight these two layers and place them in a Group (see "Creating a Group," see page 123).

HAIR

Here's how to fix all messy hairs, flyaways, or distracting gaps from odd parts.

1 Using the Spot Healing Brush, with a very, very small brush, go around the edge of the hair and remove any loose hairs or flyaways. You can also do this on the Smooth Skin/Fabric layer.

2 While on the Smooth Skin/Fabric layer, locate any areas in the hair where there is a gap or an odd part. Using the Lasso Tool, select the hair closest to this area.

3 Create a new layer: Choose your original layer, then choose Layer > New Layer, then relabel the new layer "Hair Add."

4 Copy and paste the hair selected by the Lasso Tool onto this new layer; you may want to paste it in more than once to create thicker hair.

> **TIP**
>
> Use the Refine Selection Tool to see exactly what you've selected and modify it to include exactly what you want.

5 Now move this layer over the area where there is an odd part or gap.

SKIN: TANNING

No one likes a pale model. Adding a bit of a tan can enhance the look of the whole portrait.

1 Open your image in Photoshop and choose Layer > New Layer. Now fill this entire layer with a brown tan color by clicking on the foreground box and opening the Color Picker. In the lower-right column, type in 714b34; this can be adjusted.

 2 Using the Paint Bucket Tool, fill the entire layer with this brown color.

3 Next, darken all the mid-tones by choosing Layer > New Adjustment Layer > Curves.

4 In the Curves dialog box, pull the center point of the curve down and to the right. This should slightly darken all the mid-tones in the image.

5 Create a "Group" (see below) of all your tanning layers and label it "Tan." Apply a mask (see page 124), and paint all areas other than the skin black.

CREATING A GROUP

Creating groups will allow you to apply layer adjustments (such as contrast, color, or levels) to the entire group of layers (for example, all skin layers).

1 Hold down the Shift key and click on all the layers you created during your color corrections.

2 On the upper-right side of the Layers palette, click on the menu drop-down button (four horizontal lines).

3 Select New Group From Layers.

4 Label this group; this will create a single layer with all the highlighted layers clustered within it.

TIP

If you double-click on the Group layer, you will open all the layers you had highlighted before creating a group. You can then revisit old adjustments and make new ones without affecting newer retouching work.

USING MASKS TO CHANGE BACKGROUNDS

This is a simple method for removing a model from the background of a photograph, so that he or she can be placed on an alternative background image or a simple backdrop, or to create the illusion of depth of field. This method is especially good for portraiture, as it retains soft edges of clothing and wisps of the model's hair.

1 Open the image in Photoshop.

2 While on the Layers palette, click the Channels tab to switch from the Layers to the Channels panel.

3 Select the layer with the most contrast between your model and the background. Blue is usually the best channel, with the most contrast between model and environment.

4 Duplicate the selected channel layer by dragging the layer to the icon of the dog-eared paper on the bottom of the Channels panel.

5 Adjust the levels of the new layer: holding down Command + L adjust the black input levels to anywhere from 54–150, the white from 160–230, and the gray from 1–1.8. The goal is to create the most amount of contrast between the model and the background.

6 Click on the new channel layer, hold down Command + L, and click the Layer icon; you should have a dotted line indicating the active selection.

7 Inverse your selection: choose Select > Inverse. This will create a selection that is the reverse of everything you have done.

8 With the selection still active, click the Layers tab and return to your full-color image.

9 Still with the selection active, click the Mask icon at the bottom of the Layers panel. A small black-and-white thumbnail will appear; this is your vector mask.

Click on the mask while holding down the option key; this will show you the black-and-white version of your mask. Anything black will not be cut out, so look closely at your mask and paint any black areas white using a white brush.

10 Click the Vector Mask icon (located on the lower right of the Layers palette—it looks like a circle inside a square). A white box will appear on your highlighted layer next to your images thumbnail.

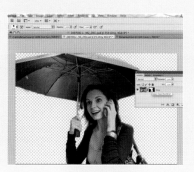

11 Your model is now cut out of the original background. This layer can be dragged on top of a new background image or a solid color, or onto a blurred version of the original, creating the illusion of depth of field.

CREATING DEPTH OF FIELD

Manipulating depth of field in post-production can help to regain some control over the backgrounds of your portraits.

1 Open the original image with the background.

2 Drag it onto the new masked version, and place the original as the bottom layer.

3 Blur the original: choose Filter > Blur > Gaussian Blur, and set Blur to approximately 5.

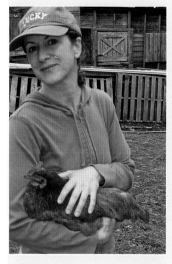

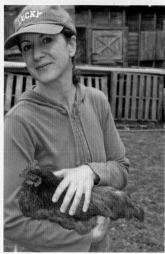

Before After

CREATING A NEW BACKGROUND

Changing the background of a portrait can transport a figure from New York to London at the click of a button.

1 Open your new background image and drag it on top of the original photo's canvas.

2 Place the new background image as the bottom layer.

So far, all of our practice has been on using one light well. In this chapter we'll begin to explore using multiple light sources effectively to define and sculpt facial architecture, light skin beautifully, and define spatial relationships between the subject and their surroundings.

ENHANCED BEAUTY

This studio portrait by Konstantin Suslov clearly shows his training and background as a fashion photographer. While the model is beautiful, the evidence of how much Suslov has enhanced her beauty with skillful lighting is hidden in the reflections in her eyes. Note the semicircular catch lights that show more clearly than any lighting diagram how her face was surrounded with light to make the photo. The artful placement of these catch lights combined with extremely shallow focus draws us into her gaze.

chapter 6 | STUDIO PHOTOGRAPHY

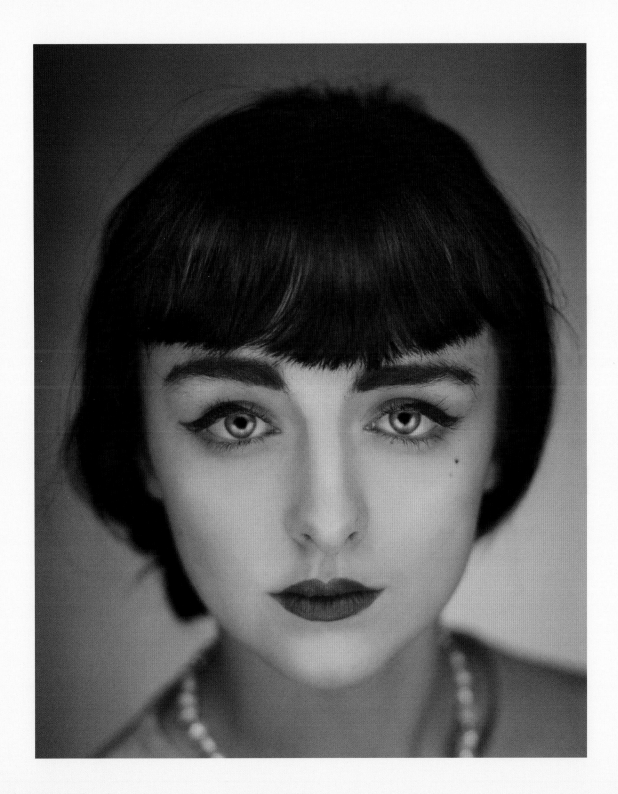

Tutorial 32 | BASIC KIT FOR THREE-POINT LIGHTING WITH ELECTRONIC FLASH

The obvious first ingredient for three-point lighting is—three lights (at least). Whether you build a kit using continuous-source lights or electronic flash is immaterial to the overall concept of three-point lighting: light is light.

OBJECTIVE >>

■ **To understand the basics of electronic flash before jumping into multiple light setups.**

exercise:

READ THE INSTRUCTION MANUAL!

We're all guilty of it: We open the box for our new camera, flash, or computer and then just start trying to work with it. But there is a wealth of information hidden in all those boring instruction manuals that will help turn down the heat on a high-pressure shoot.

KNOW YOUR GEAR

An unfamiliar flash system can be frustrating. This unit allows three heads to be controlled on two separate channels, allowing a total of 2,400 WS to be split into one 1,200 WS head and two more that can each put out 600 WS apiece. If you think before you start positioning each light, you can divvy up the power intelligently.

By now you should have enough of a grasp of the hardware to be able to interpret this tutorial for hot lights. Strobes require more hardware and a little more explanation, so we'll concentrate on those. But should you go for power packs or monoheads? That is the question. Each has its advantages; the one you choose will depend on your particular interests.

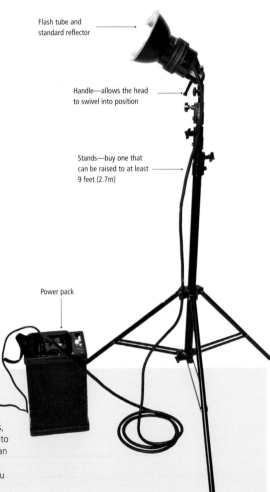

Flash tube and standard reflector

Handle—allows the head to swivel into position

Stands—buy one that can be raised to at least 9 feet (2.7m)

Power pack

Power packs

For photographers shooting primarily in a studio environment, power packs are generally the way to go. All the lights are typically plugged into the same pack, so the photographer can just reach down and turn a dial to adjust the power settings for each light.

Within a given brand, power pack strobe systems are also (generally) cheaper to purchase because there is only one pack, which holds all the capacitors (the most expensive component), and the individual heads are less expensive. Dollar for power, you can probably get more bang for your buck from a power pack + flash head system.

If an individual flash head falls over on set or needs repair, it can be quickly swapped out with a replacement. On the other hand, if your power pack fails you are sunk. Eventually, you'll really need two packs, or quick access to a spare (like a nearby rental shop).

Back when we were all shooting with medium-format cameras and ISO 100 film, photographers needed a lot more power from their lighting equipment. Portable power packs are typically capable of about 1,200–2,400 watt seconds (WS) and can split the total amount of power between three (sometimes four) separate heads that are all connected to a single power pack. On a typical 2,400-WS unit, that meant typical light setups for portraits yielded about f/8–f/16 on ISO 100 film. If you needed a lot of power from a single source, a pack could be used with a single head for a whopping 2,400 WS. Food and still-life photographers shooting with 8 x 10 cameras routinely used 10,000 WS from a single head powered by large studio power packs.

The downside of owning a strobe system that uses one central power pack is that if you need to work on location it will take longer to set up lights, and the placement of each light is limited by how far away they can be placed from each other because they are connected to a single pack. Pack-to-flash head extension cords are available, but they do come at a cost (they reduce power by a stop). Sets can also become a minefield of cords, all waiting to trip your subject or yourself. For location portraiture, this can be extremely limiting.

Monohead systems

A few years ago monoheads really weren't a great option. They just didn't have the power, and they were expensive and fragile compared to their pack/flash head

counterparts. However, modern digital cameras have made incredible strides in high-ISO noise reduction; being able to shoot at ISO 400 or even 800 means that a flash system consisting of three individual 400-WS monoheads has more than enough power for almost any lighting scenario with digital cameras, while offering far more flexibility in light placement.

The downside is that all of the controls are on the back of the head—so in order to adjust any single light, you will have to walk over, lower the light on the stand, adjust it, and reposition it. (But that's what assistants are for!)

For wedding, corporate, or architectural photographers who are constantly moving lights around to different areas within the same location, monoheads offer a significant advantage. Because each light is a self-contained unit, they can be used independently, allowing the photographer to continue shooting while assistants move available lights to the next location.

The bottom line

If you see yourself as primarily a studio photographer, you will probably do well to invest in a pack/flash head system. If you envision yourself traveling extensively and working on location, then monoheads are probably the system that will best suit your practice.

Other gear

Lighting starts with the lights, but you'll also need—or have access to—some other gear before you can begin.

Stands You need at least five stands that are at least 8 feet (2.4m) high. The extra stands are for holding reflectors, gobos, flags, and other light modifiers.

Grids A standard set of four will be sufficient for almost any situation.

Umbrellas and/or soft box Most strobe kits will come with an umbrella for each head. A 2 x 3-foot (60 x 90-cm) soft box is a great addition for individual portraits.

Grip equipment For now all you need is a small assortment of "A" clamps and a few clothespins. Some diffusion material (such as tracing paper) might be handy. Cheap foamcore or poster board is great for blocking light, creating shadows, and using as a small reflector to control the fill in a specific area.

On big shoots, grip equipment can get a lot more extensive. We'll cover this in more depth when we discuss location lighting.

Synch cords and safe synchs Again, you are totally sunk if you forget to pack a synch cord or it stops working on a shoot. Always carry at least one spare synch cord and an extra safe synch.

Beauty dish A beauty dish is a unique form of parabolic reflector that is designed to project a column of soft light. They aren't a necessity, by any means, but for certain subjects they can work wonders.

GRIPS AND GAFFERS

The term "grip" comes from cinematography. On film sets, lighting is done by a "gaffer"—this is the person in charge of setting lights. The "grip" is in charge of setting up camera dollies, and light modifiers such as flags, reflectors, and silks. A great shorthand job description for the two jobs is: "Gaffers are in charge of light. Grips are in charge of shadows."

BEAUTY DISH

This is a 20-inch (50-cm) beauty dish, the most common size. Beauty dishes rely on light "fall-off" to work well, so they need to be placed quite close to the subject.

BRIGHT COLORS

These happen to be strong-colored gels, but you can also play with subtle pale colors to bring out the tone of the subject's skin or create the effect of available light.

ACETATE GELS

Acetate gels are manufactured to be used on light sources in order to filter and change the color of the light. Brightly colored gels (such as reds and purples) are used primarily for special effects (to create a party atmosphere for example). Other gels (like the ambers and blues) are used to make one light source mimic, or mix, with another (mixing strobe and tungsten for example). Very pale gels can also be used to enhance the tone of a subject's skin.

USING GELS

This portrait uses gels for both color correction and a lighting effect. An amber/orange-colored conversion gel (the technical term is "Conversion Tungsten Orange" or "CTO") was used in a small soft box to match the color of my strobes to the tungsten lights of the television studio. Another strobe with a bright yellow filter was used to uplight the metal circle over the subject's head from behind.

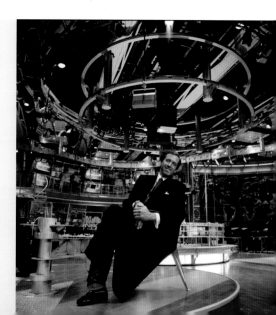

Tutorial 33 | OPTICAL SLAVES AND RADIO SLAVES

If your camera is only connected to one flash, how do all the others know exactly when to fire?

exercise:

BREAK FREE OF THE SYNCH CORD

If you have access to a set of radio slaves, it can free up a lot of new possibilities: Try lighting a location across the street or some other remote scenario where you can't be connected to the lights by a synch cord.

If you are shooting with a power pack connected to multiple heads, just plug one end of the synch cord into the power pack and the other into the safe synch on top of the camera and start shooting; all of the flash heads will go off simultaneously. If you are using multiple packs or monoheads, however, getting them to fire simultaneously isn't so obvious.

Built-in optical slaves

Optical slaves are "electric eyes" that almost all modern studio flash units have built into them. The master unit (which is connected to the camera) fires when the camera fires; the secondary flash unit "sees" the flash and then fires instantly. Because the slaves respond to the sudden flash of light, they are seldom fooled by other bright lights that might be present. High-quality optical slaves work very well, even in bright sunlight.

Power pack units have the slave built into the pack; on monohead units, the slave is built into the back of the head. In most environments they work perfectly and

they are extremely reliable. If you are a studio photographer, they are probably all you ever need. However, there are environments when you cannot rely on optical slaves.

A scenario: You're shooting a wedding. Every time one of the guests takes a photograph with a point-and-shoot camera, it sets off your flash unit and causes you to miss your shot, because your electronic flash doesn't have enough time to fully recharge.

A scenario: On monohead strobes, the slave unit is on the back of the head. This is one of the basic disadvantages of the monohead design: the slave is often pointed away from the light that is supposed to be triggering it. If there isn't a wall or other surface to bounce the light back into the slave, it won't be able to "see" the other lights. Try putting an umbrella on the head "backward" to reflect the light from the main flash onto the slave.

RADIO SLAVE WITH TTL FLASH

A new form of radio slave can be used with TTL flash units, allowing automatic flash exposure in the camera even though there is no physical connection to the camera. These radio slaves can also allow the photographer to change light ratios from the camera without having to physically touch the flash. More on these in Chapter 7.

MONOHEAD CONTROLS

The red dome on the back of this monohead is the optical slave.

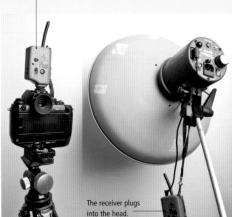

Radio transmitter.

Radio TTL receiver.

Transmitter.

The receiver plugs into the head.

Ready light—indicates the flash is ready to shoot. Pushing it will make the flash fire for testing.

Optical slave.

Plug for synch cord or radio slave.

Radio slaves

Radio triggering devices (almost) completely dispense with the old-fashioned synch cord. This is a very good thing. The design of the traditional synch cord has been around for over 50 years and was never as reliable as photographers wanted it to be.

With a radio transmitter/slave system, you are no longer connected to your strobes by the synch cord; you can move freely around the set. The range of the best units is over a quarter of a mile (400m). They also have selectable channels in order to avoid interference from other photographers who might be shooting nearby.

Most photographers will do fine with a simple transmitter and receiver set, then rely on the optical slaves of secondary flash units to synch any additional power packs or monoheads. Location and wedding photographers would do well to have a receiver available for each head, because lights often have to be placed out of sight of each other. Having multiple receivers also allows you to choose which lights you want to use by setting them to different channels.

Many of the most modern electronic flash units have receivers built into the power pack at the factory.

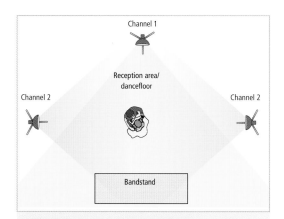

USING RADIO SLAVES FOR WEDDINGS

In a typical wedding reception scenario, having separate radio units allows the photographer to pre-position lights and then choose which lights he or she wants to trigger by simply selecting the channel on the transmitter. This enables any figure with the reception area/dancefloor to be lit as required.

CAN YOU THROW AWAY YOUR SYNCH CORD?

Not yet. Because radio slaves share frequencies with many inexpensive walkie-talkies, there are plenty of environments (construction sites, for example) where you won't be able to completely isolate your flash units from interference. If your radio slaves are firing erratically, it is probably because of another transmitter or radio in the area operating on a similar frequency. You might have to resort to a synch cord.

Radio slaves are a fantastic convenience, but you always need to keep at least two synch cords handy.

SELF-PORTRAIT USING REMOTE

This "self-portrait" was shot in the Canadian Rockies for a magazine story on adventure travel. The camera was placed on top of a mountain with a 200mm lens. My friend and I drove back and forth across the bridge while triggering the camera with a radio transmitter. The range was almost half a mile (800m).

ADDED BENEFITS

By adding a separate cord, the receiver unit can also be used to trigger the camera from a remote location. It's not unusual for sports photographers to rig as many as ten or more cameras at various positions around an important sporting event in order to shoot the action from multiple vantage points.

Remotes are also extremely useful for artists doing self-portraiture projects because it frees you from relying on the camera's self-timer. If you use a radio transmitter/slave with the self-timer, you can trigger the camera while you are in position and then simply hide the transmitter before the shutter goes off.

Tutorial 34 | INTRODUCTION TO THREE-POINT LIGHTING

Here we look at the basic principles of three-point lighting, a long-accepted and still-relevant photographic convention that allows the photographer to control contrast and emphasize the sitter's underlying bone structure.

The invention of photography is generally dated as 1839—the year that Louis Daguerre announced the invention of the daguerreotype and Henry Fox Talbot announced the calotype photographic process. However, artificial gas lighting was not widespread until the mid-19th century, and the electric lightbulb was not commercially viable until about 1880. Neither was powerful enough to be practical for early photographic applications.

This is interesting because when we look at the history of painting and portraiture before 1850 we see that it almost exclusively employed single-source lighting, either by windows or candles. The Flemish painters, in particular, with their consistent use of large windows as the predominant, or sole, light source, have loomed large as influences in photographic portraiture (in many ways the photographer's soft box is really just a portable Dutch window). It isn't until the French Impressionists that we start to see widespread evidence of multiple artificial light sources in the work of painters such as Toulouse-Lautrec, who were interested in depicting scenes of Parisian nightlife.

Of course, painters could control the contrast range of their images by adjusting how they mixed paint. Photographers needed to be able to control light itself in order to make it conform to the limited contrast

OBJECTIVE >>

■ **To learn the basics of three-point lighting.**

exercise:

STUDY CLASSIC FILM TECHNIQUES

Rent a copy of *Visions of Light: The Art of Cinematography*, an amazing documentary film that traces the history of cinematography, with interviews by some of the masters and clips from classic motion pictures. It will forever change the way you see movies or look at photographs.

THE ACCEPTED CONVENTION OF THREE-POINT LIGHTING

According to the "rules" of three-point lighting, the main light is placed to create an inverted triangle under the far side of the face from the light that "points" to the corner of the mouth, as seen here under the model's left eye.

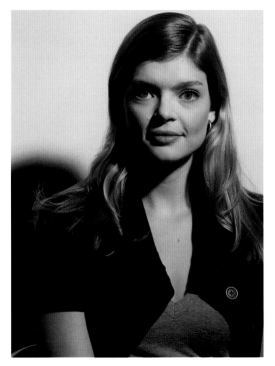

MODEL TOO CLOSE TO BACKGROUND

A typical mistake that students make is to place the model too close to the background, resulting in a shadow that is impossible to control, as in this shot.

range that early photosensitive emulsions could handle. Photographic studios were typically on the top floors of buildings in order to make use of skylights, and early movie sets that were supposed to simulate interiors were built outdoors and then covered with muslin awnings to soften the sunlight.

With the advent of sound motion pictures, exterior cinematography was no longer a viable option. By this time, however, electric lamps had become practical for cinematography so the problem of controlling contrast on a motion picture sound stage required a new solution. The answer was to use multiple light sources. Three-point lighting became both the practical solution, and the new formula, for lighting the human face.

Of course, digital photography has given us unprecedented control over contrast, so do we still need to use three lights in order to control contrast? Sometimes, but not nearly to the extent we used to. Nonetheless, three-point lighting is still the standard for virtually every professional photo shoot that involves lighting a human face, from high school yearbook photography to top-level fashion photography and Hollywood cinematography. If we think of three-point lighting in a modern context, we can see that the concept is still relevant, though the reasons for its relevance might have changed over time. Like the Dutch window, three-point lighting has become a convention.

The main light

The main light (also called the key light) is usually the most powerful light on the set. In classic three-point lighting, the main light is usually a medium–hard light source that is close in size to a human face (10–12 inches/ 25–30cm), from 6–12 feet (1.8–3.6m) away, and casts well-defined shadows.

The main light's purpose is to define the volume and contours of the face and create dimensional depth. In the classic position, it is 45 degrees to one side of the camera and higher than the subject, to cast shadows downward and to the side.

However, it doesn't have to be that way. Fashion photographers often use a larger, softer source (such as a beauty dish or soft box) directly over the camera and very close to the model, using "fall-off" to define facial structure. Cinematographers often use the main light from very oblique angles to create drama. There are no rules for placing the main light; its placement is determined by its purpose.

The fill light

In classic three-point lighting, the fill light is used primarily to control the contrast of the image by simply opening up the shadows; in essence it is "invisible," because it is not supposed to cast any shadows of its own. It is generally placed opposite the main light, at about the same height as the camera lens, and is less powerful than the main light. Because it is not supposed to cast shadows, it is usually made bigger and more diffuse by using a soft box, umbrella, bounce board, or some form of diffusion material.

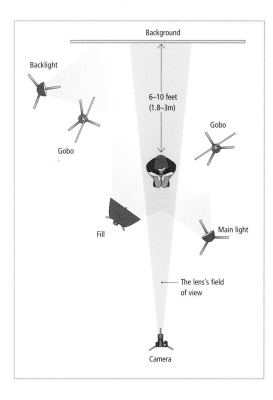

USING THE STUDIO SPACE

Many of the most common mistakes and problems in three-point lighting are caused by not using the studio space properly. When the model is moved away from the backdrop and a longer lens is used, the camera sees a small and easily controlled section of the background. This also allows gobos to be easily positioned to keep lights from interfering with each other. Dealing with each light individually as a discrete problem helps keep it simple.

LIGHTING THE BONES BENEATH THE SKIN

When lighting someone, look carefully at their underlying facial architecture to determine the size of the main light and where to place it. Think of the main light as lighting the bones underneath the skin. To use an example: Denzel Washington and Harrison Ford have very similar head shapes and bone structure, so the main light might be very similar for both actors, regardless of their ethnicity.

exercise:

THREE-POINT LIGHTING IN THE STUDIO

Using the rules and conventions of three-point lighting, try to reinvent it in as many ways as you can.

Start out by trying to emulate the classic three-point model as closely as possible. This will probably end up looking pretty close to a traditional high school yearbook photograph and probably won't be very interesting, but it will be a useful way to begin the exercise.

From there you should start trying to modify the lights by position, size, and distance. One useful exercise is to walk in a 360 degree circle around your model as you face each other. In this way the roles of each light are changed by your relative positions; the main light will become the backlight, the fill will become the main, etc.

As you move, new possibilities for variations should begin to present themselves. Experiment with these in order to explore and refine other options within the three-point exercise.

◁ **SOFT MAIN LIGHT**

Of course, the main light can also be a large, soft source as well, and can really come from anywhere. In this case the main light (and only light) is a 20-inch (50-cm) beauty dish positioned over the camera. The guiding principle for the main light is really to look at the subject's facial architecture or bone structure. The beauty dish does great things for her cheekbones and dimples, but the nasal-labial folds between her nose and lips will need to be minimized when we add the fill.

△ **SEPARATING MODEL FROM BACKGROUND**

By moving the model 6–10 feet (1.8–3m) away from the background, less of the light from the main source hits the background and we create enough distance to light the background separately. Now the main light can be optimized according to the cosmetic or editorial requirements of the shoot, because the shadow created by the main light is now falling low on the background or the floor.

LIGHTING LIGHT AND DARK TONES

Lighter objects reflect light that is both diffuse (at many different angles) and specular (only angles equal to the angle of incidence). As objects become darker, they reflect less and less light through diffusion and rely more on specular reflection to define their form. Consequently darker-skinned subjects may require a fill with a larger surface area to best define their features and skin.

Using light to define three-dimensional form The three-dimensional form of the white bowl is well defined through the light and shadow of a single direct source. The black bowl is virtually a silhouette, with a few specular hot spots.

Adding a reflector With the introduction of a reflector, the black bowl becomes more defined through specular reflection.

Increasing the amount of fill As the reflector is moved closer, the size of the reflection becomes bigger and the shape of the black bowl becomes even more defined, while the white bowl is overfilled and loses definition.

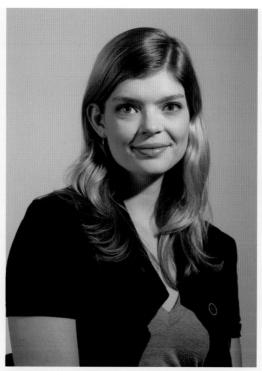

THE FILL LIGHT

Adding the fill light opens up the shadows. Note how little the tone of the white background changed with the addition of the second light. These photos show how moving the model away from the background affords maximum control over each light.

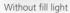
Without fill light

With fill light

LIGHTING THE SKIN

Just as you might think of the main light as lighting "bones," so you can think of the fill light as lighting "skin." To continue using Harrison Ford and Denzel Washington as examples, a larger soft box or fill (not necessarily more powerful) would probably be best for Denzel Washington. This is not because his skin is darker, but because African-American skin is actually more reflective (with greater contrast between specular glare and shadow). The bigger surface area of a larger soft box would create larger reflective highlights and better define the skin. The same solution for Harrison Ford might make him look less defined or even doughy.

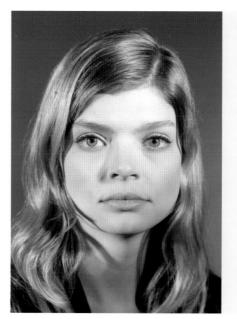

FILL LIGHT IS TOO STRONG

This photo exhibits two classic mistakes that are often made when using a fill light. The first is that the model's left eye has two catch lights (reflections) while the right eye only has one, resulting in the model looking slightly cross-eyed. The other problem is that, because the fill light is too strong, it is starting to cast a shadow opposite the main light. This particular subject has strong cheekbones and a naturally strong/wide jaw line: the lighting is exaggerating these to almost comic proportions and making her face look extremely wide. While this is probably the worst possible lighting for this particular person, a more subtle version of this basic setup might be excellent for someone with a very narrow or gaunt face.

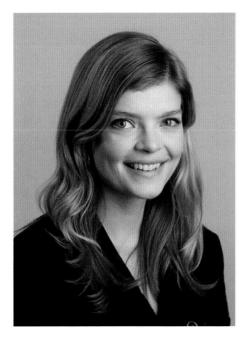

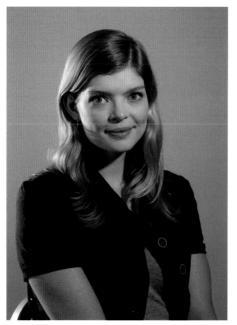

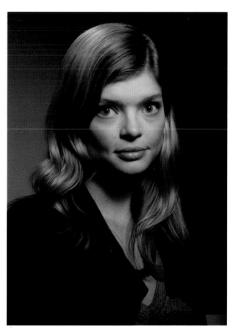

SOFT MAIN LIGHT AND SOFT FILL

In this case both the main light and the fill are large, soft sources. The main is a 2 x 3-foot (60 x 90-cm) soft box and the fill is from an umbrella. It's also interesting to compare the apparent age and weight of the model based on various light setups. She looks like a teenager here whereas other setups push her age to late twenties or early thirties.

LOW BACKLIGHT

Here the backlight is being used low as a "kicker." It looks obvious and unnatural in this studio setting, but within the proper context or narrative motivation it can be very effective. Be careful when using the backlight as a kicker or hair light, because it is often pointed directly at the lens and can create lens flare.

SOFT BACKLIGHTING

In this photo the backlight is a soft box that gives a more subtle sheen to her hair. The fill light has been eliminated.

BACKLIGHT PROJECTION ON BACKGROUND

The backlight defines space, but simply blasting a light at the background is pretty boring. Using cookies, gels, or grids to vary the color or texture of the background can add visual interest.

Here, the backlight is being projected through a type of gobo known as a "cookaloris" or cookie, to create a mottled pattern on the background. In this case, the cookie was simply cut out of a piece of black foamcore. Moving the cookie away from the wall and changing the distance of the light from the background can soften the edge quality of the shadow pattern.

USING THE BACKLIGHT ON THE BACKGROUND

Here the backlight is positioned directly behind the model and the reflector on the flash head has been removed to create a "bare bulb" light. Because this photo was shot in a small studio with a white ceiling and walls, the bare bulb is lighting the background directly as well as bouncing off the ceiling and walls to create the soft shine in her hair and additional fill to her skin. A pale pink gel was added to the main light. The traditional fill light in front was eliminated because reflected light from the room was providing so much fill already.

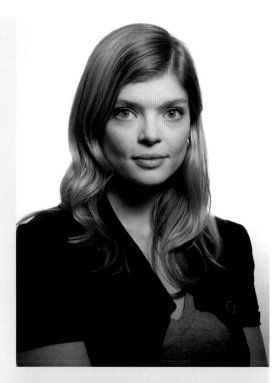

LIGHTS OF DIFFERENT COLOR

Here, the main light is a 20-inch (50-cm) beauty dish that seemed to suit this particular subject. On the beauty dish is a pale pink filter, while the fill light (a 2-foot, or 60-cm, square soft box) has a pale blue filter, a combination that seemed to complement the undertone of her skin and created a slight color contrast to accentuate her cheekbones. Remember, the lights don't have to be the same color.

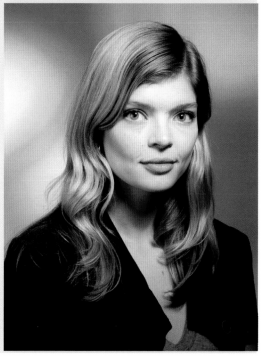

The backlight

The backlight can be placed almost anywhere. It can be used as a hair light from overhead and slightly behind; it can be used low and on the opposite side of the main light to create a "kicker"; it can even be pointed away from the subject and light the background.

In traditional Hollywood three-point lighting, lighter areas on the face are contrasted with dark areas behind, and vice versa, to create the most convincing illusion of space. The portrait of Joan Fontaine on page 140 is a great example of how the backlight creates spatial depth through contrasts of light and dark.

The key to thinking about the backlight is to realize that it is defining "space." Whether it is being used to actually light the subject (like a hair light) or the background, the true function of the backlight is to create a spatial separation between the subject and whatever is behind them.

If we think of three-point lighting in this way, we can redefine the three lights as bones, skin, and space instead of holding onto the rather antiquated idea of simple contrast control.

Putting it all together

So do you always need a minimum of three lights? No, there will be times when one is all you need and others where ten aren't enough. However, three is a perfect start if you are contemplating buying a light kit and it will get you through most situations.

The danger is to think of three-point lighting as a "one size fits all" formula. There is simply no substitute for the real skills of the photographer: Being attentive and alive to what you observe. Every person and situation is different and it doesn't matter how beautifully the subject is lit if there isn't a moment of connection created between the subject and the audience. Practice, observe, analyze your successes and your failures with equal care. The examples in this tutorial clearly illustrate three-point lighting, but none of them transcends the technical exercise to become a good photograph.

Portfolio | SAMI SCHWENDEMAN

In this portfolio, Sami Schwendeman explores the different combinations within basic three-point lighting to exploit different narrative and cosmetic possibilities.

The best photographers are always experimenting, but they also have total control of their craft. When I teach lighting I require every student to do every assignment twice. The first time they are to experiment wildly with whatever demonstration or concept we have discussed, exploring as many possibilities as they can without worrying about perfection or finesse. The second time they are to produce polished images that use the results of their experiments with purpose.

This portfolio is an example of how a particular student approached the three-point lighting. In the black-and-white photos of the young man, Sami played loosely with the basic problems of three-point lighting to suggest mood and character. In the color photographs of the women, she refined the results of her experimentation to achieve a more specific result.

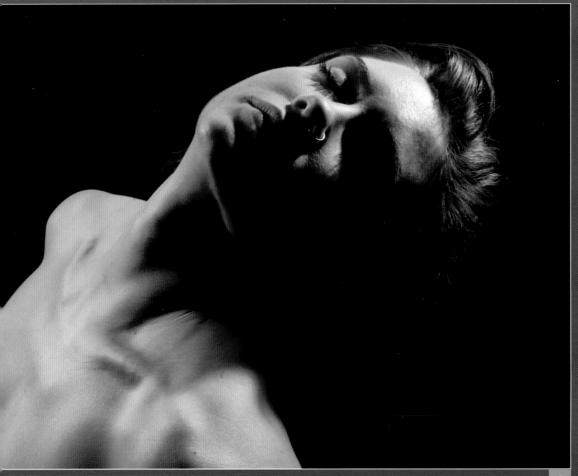

ONE LIGHT, NO FILL

1 Sami only used the backlight to create this image. There were variations that included fill and background lights, but none were as successful as this simple, dramatic solution.

BASIC LIGHTING, DRAMATIC RESULTS

2 In this "mug shot" Sami plays with how far she can take the fill light.

3 Here Sami breaks the rules again by using two hard lights of almost equal strength across from each other to cross-light her subject.

4 Here the backlight is used as a main light in the style of film noir. A weak fill light opens up the shadows on the side of the face nearest the camera.

5 Using gels can really help you understand exactly how the three lights are interacting. Here, the near side main light has a magenta filter, the far side fill has a blue filter, and the hair light is a clean white.

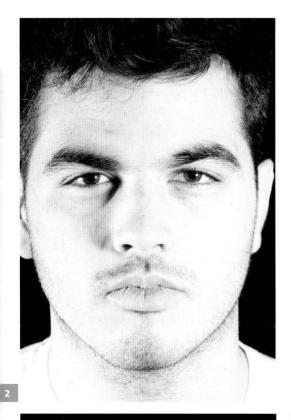

2

3

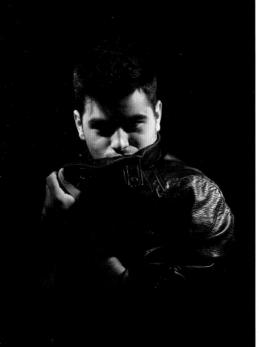

4

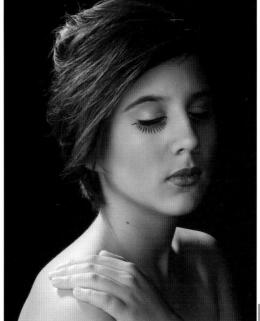

5

METADATA 1

Make/Model	Canon EOS 5D
Shutter speed	1/180 sec
F-stop	f/19
ISO speed rating	100
Focal length	40mm
Lens	17–40mm
Flash	Did not fire
Metering mode	Unknown

METADATA 2

Make/Model	Canon EOS 5D
Shutter speed	1/125 sec
F-stop	f/32
ISO speed rating	100
Focal length	135mm
Lens	135mm
Flash	Did not fire
Metering mode	Pattern

METADATA 3

Make/Model	Canon EOS 5D
Shutter speed	1/80 sec
F-stop	f/22
ISO speed rating	100
Focal length	135mm
Lens	135mm
Flash	Did not fire
Metering mode	Pattern

METADATA 4

Make/Model	Canon EOS 5D
Shutter speed	1/80 sec
F-stop	f/22
ISO speed rating	100
Focal length	135mm
Lens	135mm
Flash	Did not fire
Metering mode	Pattern

METADATA 5

Make/Model	Canon EOS 5D
Shutter speed	1/125 sec
F-stop	f/20
ISO speed rating	100
Focal length	85mm
Lens	85mm
Flash	Did not fire
Metering mode	Pattern

Assignment | COPY A MASTER

Copying someone else's work as exactly as possible can teach you a lot about lighting as well as how to style and cast a shoot.

Young photographers are often delighted to just make an image that just looks "cool," but professional photographers are craftsmen as well as artists. We need to be able to achieve specific results, reliably, consistently, and on demand. Copying the work of a master will help you really understand how they achieved the results they did, and enable you to apply them in your own work.

Start the process by analyzing how the original was created:

■ The main light comes from in front, and above. It is contrasty, it creates hard shadows, and it defines her facial structure.

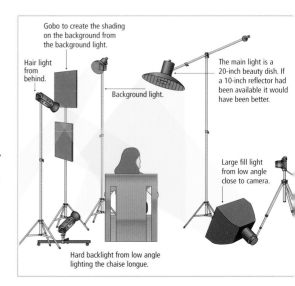

Gobo to create the shading on the background from the background light.

Hair light from behind.

Background light.

The main light is a 20-inch beauty dish. If a 10-inch reflector had been available it would have been better.

Large fill light from low angle close to camera.

Hard backlight from low angle lighting the chaise longue.

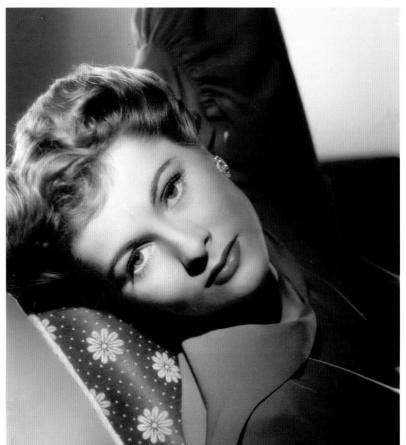

▷ **"JOAN FONTAINE", FRANK POWOLNY**

This amazing portrait is a textbook example of classic three-point lighting. It was almost certainly lit with Fresnel hot lights, but the concept is the same regardless of the technology.

△ **ORCHESTRATE YOUR INSTRUMENTS**

Plotting a lighting diagram for a photographic masterpiece will aid you in your re-creation of it and understanding of the techniques used.

▷ **THE MODERN-DAY VERSION**

This photo (right) from a class demonstration doesn't quite nail it, but it's pretty close. The model is lit with a 20-inch (50-cm) diameter beauty dish with a large grid over it to control the spill (a 10-inch/ 25-cm silver reflector with a grid would have done a better job of mimicking the harder edges created by the Fresnel in the original). The main light should also be about 6 inches (15cm) farther to the left.

■ The fill light comes from near the camera. It is a large, diffuse source that is so weak compared to the main light that it casts no shadows, which is what makes her skin look so perfect and creamy. It also lowers the overall contrast to a tonal range that the film of the time can handle. Modern films, and digital capture, have changed the nature and necessity of the fill light.

■ The hair light comes from behind at a high angle and to the left. It accentuates the shine of her hair and separates her from the background.

■ There is another light creating a mottled pattern on the background.

■ There may also be another light low and to the left, creating a highlight on the edge of the chaise she is lying on.

This sounds complex, and it is—but it is actually even more complex, because there are at least three "gobos" that are either creating shadows (on her dress, for instance), and/or shielding the lens from the forward-facing backlights.

Note also that light areas (such as the hair) are against dark areas (the wall beyond), and vice versa (the dark dress is contrasted with a light section of background).

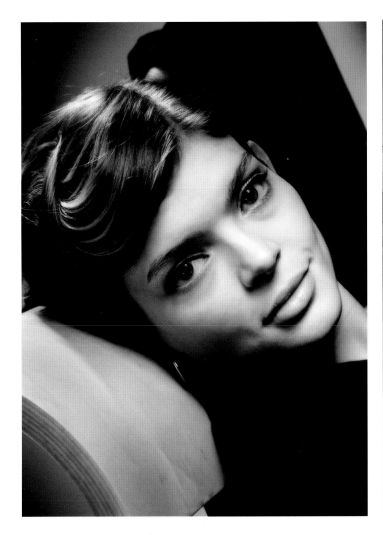

CONTROLLING CONTRAST

When shooting in a small studio with white walls, it can be difficult to achieve and control contrast because light bounces off the adjacent ceiling and walls. By using grids on all of the lights, we were able to put light exactly where we wanted it and nowhere else.

Portfolio | MEREDITH ROM

Painting students at traditional art schools have long understood the value of copying paintings by the old masters as a way of developing technique and insight into the artists' process.

This exercise can be equally valuable to photographers. Copying or imitating another artist can often help you home in on your own interests and find your own voice.

Meredith Rom did an amazing job re-creating these images by old master painters in the studio, using her fellow classmates and professors as models. In each she not only achieved the chiaroscuro effect of the original painting but also the color palette of the painter and the inner life of the original subject. Her styling for each is impeccable.

ODALISQUE, AFTER INGRES

1 All of these photographs use a large soft box to mimic the window light of the original paintings, but this particular photograph raised some unique problems. Window light comes from the sun, so there is no appreciable fall-off. This photograph was constructed in a small studio where the soft box was only about 6 feet (1.8m) from the model's back. Therefore, the light had to be carefully feathered in order to correct the significant fall-off at such a relatively close distance.

1

GIRL WITH A PEARL EARRING, AFTER VERMEER

2 In this re-creation Meredith controlled the quality of the edges of the shadows by skillfully matching the size and distance of the soft box to the contours of the model's facial structure. The fill light was also matched precisely in order to mimic the contrast of the original painting.

PORTRAIT OF A MAN, AFTER JAN VAN EYCK

3 Casting appropriate lookalike models for each photo was another challenge Meredith had to overcome for each of the re-creations, but this one was easy: The model was one of her professors.

2

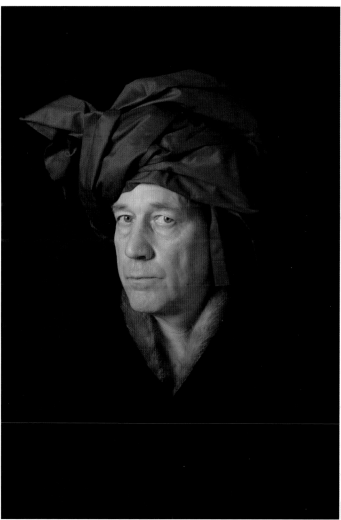

3

METADATA 1		METADATA 2		METADATA 3	
Make/Model	Canon EOS 5D	Make/Model	Canon EOS 5D	Make/Model	Canon EOS 5D
Shutter speed	1/60 sec	Shutter speed	1/60 sec	Shutter speed	1/60 sec
F-stop	f/8	F-stop	f/22	F-stop	f/16
ISO speed rating	100	ISO speed rating	100	ISO speed rating	100
Focal length	30mm	Focal length	40mm	Focal length	55mm
Lens	17–40mm	Lens	40mm	Lens	24–70mm
Flash	Did not fire	Flash	Did not fire	Flash	Did not fire
Metering mode	Pattern	Metering mode	Pattern	Metering mode	Pattern

Tutorial 35 | CONTEXT: INFLECTION, LIGHTING, AND ANGLES

In the movie *Taxi Driver*, there's a scene in which Robert DeNiro's character, Travis Bickle, looks into a mirror and recites the line, "Are you talking to me?" over and over again, but changes his tone every time he repeats the line.

This is actually a famous exercise invented by renowned acting teacher Sanford Meisner.

OBJECTIVE >>

■ To learn the power of light to change the content of a portrait.

exercise:

USE LIGHT TO CREATE MEANING

Create a series of portraits in which light establishes the meaning or emotional content of the photograph.

The idea is that the actor simply repeats the same line (information) over and over, using different inflections to change the meaning of the phrase until they have exhausted all the possibilities.

We can do the same thing with our written language:

"I'm going to the store...."

"I'm going to the store!"

"I'm going! To the store."

We learned what punctuation marks signify when we were children. The punctuation helps to inflect the phrase for the reader so they can interpret the content accordingly.

Photography is a language like any other language. It has conventions, syntax, and rules that help the viewer to understand the intention and meaning the photographer is bringing to the subject. These conventions reach deep into the history of art and visual communication and this is why it is important for photographers to have a firm grasp on the history of art. This is our lexicon.

Three-point lighting grew out of the needs of the film industry, but the language of light has continued to evolve over the history of photography as it was influenced by new equipment (flash, umbrellas, soft boxes) and materials (color photography, films with greater dynamic range, digital image editing programs, and other visual art forms such as film and painting). All of these have created a historical context for styles of lighting, as in the extensive use of ring flash by fashion photographers like Guy Bourdin in the 1980s or the dramatic, contrasty lighting of film noir in the 1950s. The "style" of the light is another powerful signifier for the viewer as to the place in history that the photograph is supposed to depict.

While photographers who are shooting a commissioned portrait, such as an actor's headshot or a wedding portrait, might simply be looking for a lighting solution that is flattering, photographers who are shooting for magazines or other media outlets are probably more concerned with the editorial content that light might bring to bear on the viewer's opinions about the subject.

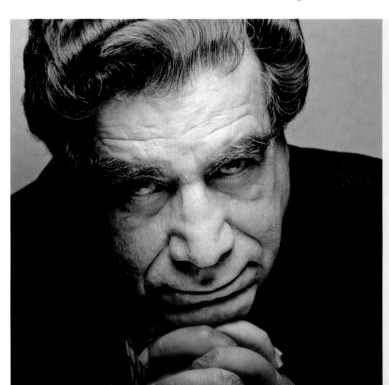

CONVEYING CHARACTER

This portrait is of Dr. Khidhir Hamza, a nuclear physicist who was the head of Saddam Hussein's nuclear weapons project. When I was hired to photograph Dr. Hamza, I was told by my photo editor to "make him look like pure evil," but within a few minutes of meeting him I knew that was an unfair characterization. He had, after all, defected, and never intended to build an tomic weapon for Hussein. This presented me with a bit of a dilemma: Should I intentionally slander him photographically— or make a neutral portrait, which would anger my photo editor? My diplomatic solution was to draw upon the history of photographic lighting to suggest a man who held more secrets than answers.

LIGHT HAS POWER

Filmmakers often talk about the "motivation of the light." In practical terms, this simply means that the lighting effect has to simulate a light source we have seen previously, like a window that might have been seen in another shot. However, light is also motivated by dramatic/editorial content. When photographers uplight a subject (like kids with flashlights telling ghost stories) to indicate malevolence, we might accuse them of relying on a cliché—but the cliché has power precisely because it is being used as a signifier to direct the viewer. Think about how the change of light influences the way the viewer reads these photographs of the same man taken with the same camera from the same position.

Rim light Putting a light directly behind the model creates a rim light around the head.

Uplight In this case the light was directly above the model but positioned to hit a silver reflector held below his face.

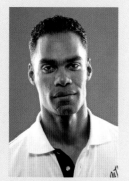

Symmetrical lighting Here two lights are bounced into large reflectors on either side. It's currently a popular look in editorial photography.

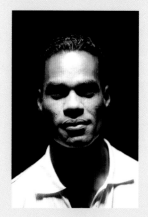

"Gangster lighting" This style of lighting was used widely by hip-hop magazines and videos in the '80s and '90s. In gangster lighting, the light comes from almost directly over the subject and obscures the eyes, making it seem as if the subject is emerging from darkness. This technique of making someone look menacing through the use of light was most famously popularized by the movie *The Godfather*. Director of Photography Gordon Willis lit Marlon Brando in such a way that the actor's eyes are always in shadow. The eyes are a window to the soul; but Willis never lets us see into Don Corleone's heart of darkness.

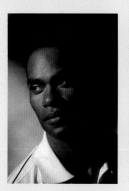

Hard side light The model is being lit with one light from the left (with another on the background). This lighting style was popular during the late 1960s.

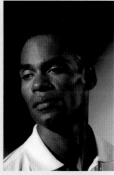

Warm and hard Here the model is lit with a hard light with a warming filter, to simulate late-afternoon sun, and a silver reflector for fill.

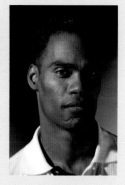

Blue filter Here a blue filter simulates a cold, early morning light.

In this case, the quality of light becomes one of the most subtle, powerful, and covert tools for the photographer to express his/her opinion.

Different lighting solutions

In all of the photographs above, the camera was kept in pretty much the same position in relation to the subject. Some of the lighting solutions might be more or less flattering to this particular subject, but that isn't what we want to concern ourselves with at the moment.

If we imagine that the subject is a pop star, are there any lighting solutions that seem to place him in different eras? Which make him seem the most contemporary, or vintage?

Do some of the lighting solutions imply different genres of music—jazz, soul, or hip-hop?

Are there some lighting solutions that make him seem less, or more, approachable?

If we imagine he's an athlete, are there some that make him look slight and slim (like a marathon runner) and others that make him seem more powerful (like a sprinter or a boxer)?

Are there some that seem as if they might have been shot on location using an available source such as a window, while others imply a studio setting?

Do any imply a particular time of day or situation? How does the color of the light change the context?

Individual lighting solutions

Lighting is as integral to a photographer's identity as his or her fingerprints. When we talk about a photographer's "style" of lighting, it can sound as though we are discussing something as superficial as a clothing choice—but it is much deeper. Light defines a photographer's universe.

SOFT LIGHTING STYLE

New York-based professional Martin Adolfsson uses soft main lights consistently to establish a signature lighting style that concentrates our attention on the person in front of the camera instead of the photographer.

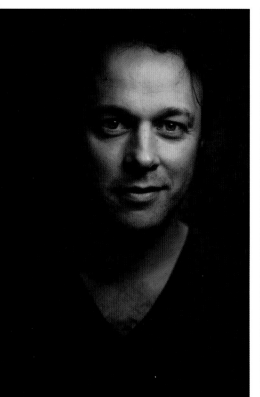

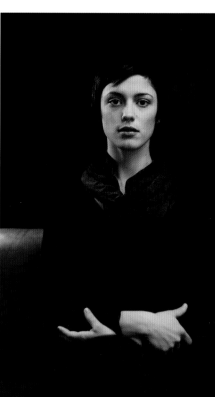

Small, close source
Here Adolfsson uses a very small source very close to the subject, creating soft shadows with strong fall-off.

Grids and reflectors
A small, close source is used right over the camera as the the main light. A narrow grid is used for the backlight/kicker. Fill is from a reflector held below the model.

Large, soft source
This portrait uses a large soft source as the main light, a smaller soft box as a backlight/kicker, and a reflector to supply fill.

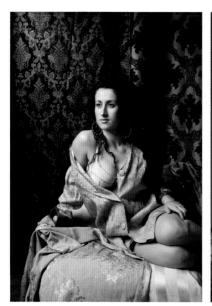

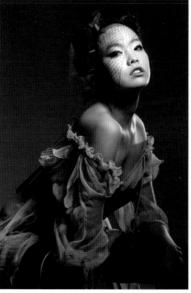

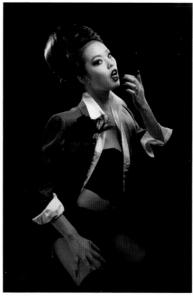

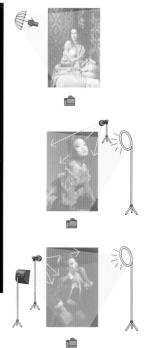

Basic but effective Michelle Watt uses one umbrella from the side for this portrait of a classmate. Her brilliant styling also elevates her work from the norm.

Controlled spill The main light used here is a beauty dish with a large honeycomb grid to control spill. A low back light/kicker separates the model from the background by defining her shoulder and collarbone.

Red filter In this photograph the soft box fill light has had a red filter added to create a sexier ambience.

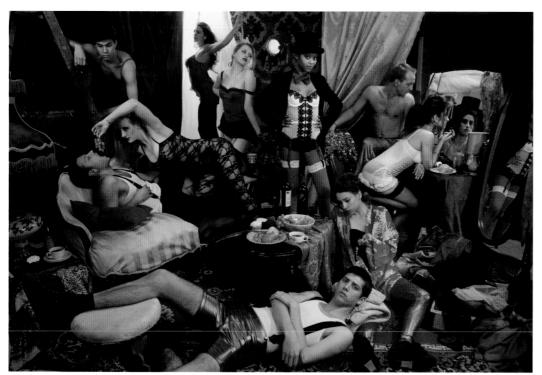

LIGHT AND STYLING

Student Michelle Watt uses light to create a scene reminiscent of a 1930s European bordello in an unused classroom, using borrowed props and her friends as models.

◁ **Effective use of available resources** This shoot was comparatively easy to accomplish while she had access to the school's facilities. The classroom/studio location was less than 50 feet (15m) from the equipment checkout cage. She had a virtually unlimited supply of lights and equipment at her disposal. The props were all borrowed from the drama department. The entire shoot took about 6 hours to stage. Imagine trying to accomplish the same thing after graduation. To do the same shot as a portfolio test shoot out of school would have cost well over $5,000 in equipment, transportation, and props and studio rentals.

Shooting portraits on location requires precise pre-planning and engages a greater, or different, set of photographic skills than studio portraiture. You must balance the importance of the background against the importance of the subject. You must describe enough of the environment to give the sitter context while still engaging and directing the sitter for maximum emotional impact.

When shooting an environmental portrait or working on location, you are combining the skills of a portrait photographer with the skills of an interior design photographer or a cinematographer, because the location/environment has to be lit and described as appropriately as the main subject. At this point, we are stepping into the realm of advanced lighting and production techniques for portraiture.

MIDDLE-EASTERN LOCALE

In his "Portraits from Jaffa" series, Bar Am-David examines the Jaffa district of Tel Aviv where Arabs and Israelis live in relative harmony. The subject's occupation is made obvious by his uniform, but the location of the photograph is suggested by a myriad of details: the color of the walls and the quality of the light.

chapter 7 | LOCATION AND ENVIRONMENT PHOTOGRAPHY

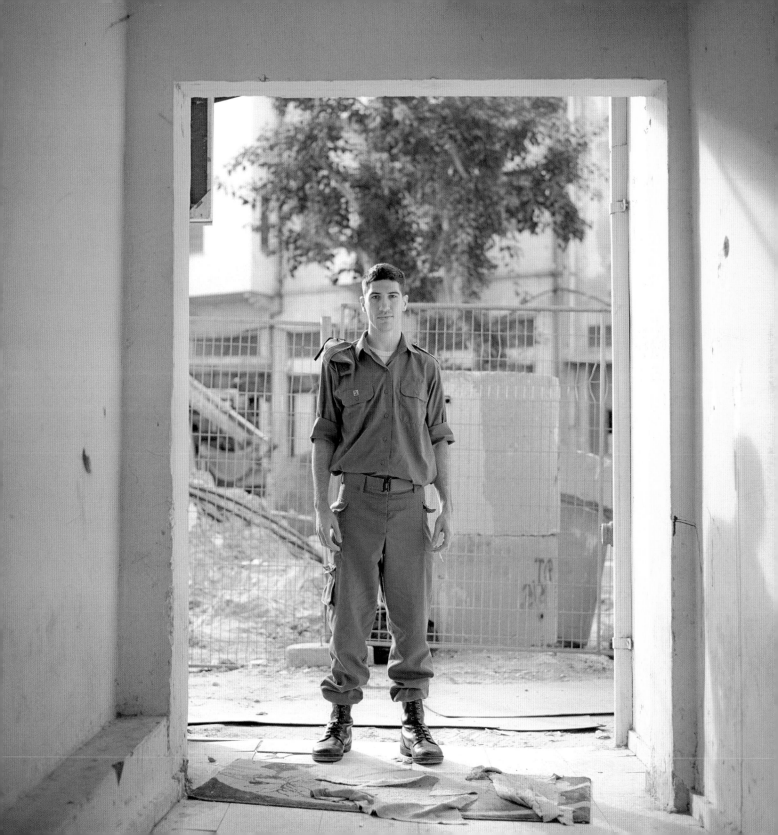

Tutorial 36 | PRE-PRODUCTION AND PLANNING

Things get confusing, hectic, and crazy very quickly when you are on location. Making sure everything is tightly organized beforehand gives you a solid foundation to start from.

OBJECTIVE >>

■ **To get organized before you head out the door.**

exercise:

ANALYZE ANOTHER PHOTOGRAPHER'S DECISIONS

Every photograph has a backstory. Find a photograph you like in a magazine or a book. With as much detail as possible, try to dissect every step the photographer had to make. Write it all down from beginning to end: wardrobe, location, lighting, lens choice, etc. Try to put yourself in the photographer's position and imagine why every little choice was made. How do those choices influence the content of the photograph?

Predict the future!

It sounds silly, but we predict the future all the time. Every time we go out to dinner or make a trip to the ATM, we are predicting the future. When we drive somewhere in our car, we have a mental road map planned, otherwise we would never get to our destination. The more information we have, the more accurate our predictions are likely to be.

Shooting on location requires a different kind of pre-planning than most studio shoots because you are—essentially—taking the studio with you. Simple things, like finding an electrical outlet or not having a three-prong adapter, can become a time-consuming distraction to the overall shoot.

Scouting helps

In my early career as an architectural photographer, I scouted every shoot with the architect to discuss what he or she wanted accomplish. The value of this was immeasurable. Scouting tells you what time the sun comes through a window and where it will fall, and this allows you to schedule the shoot around the optimal light. Scouting tells you what kind of ambient lighting the environment has (incandescent, fluorescent, etc.), where the outlets are, what kinds of props are available, whether the furniture is shabby or fantastic.

In the case of portrait assignments, scouting allows you to find out about the subject through their environment and possibly meet them. Is that CEO you have been assigned to shoot for a magazine a weekend triathlete, a backyard gardener, a chef? If you are photographing a wedding, does the church offer some fantastic settings? Are there places that are off limits or require special permits?

But the real advantage of scouting is psychological; scouting helps you predict the future with greater accuracy and allows you to previsualize more effectively. Top athletes, skiers, and racecar drivers previsualize the

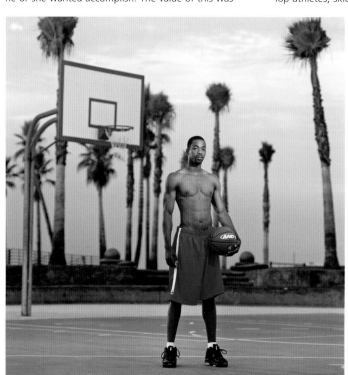

DAWN SHOT

This portrait of NBA star Rafer Alston for *ESPN* magazine had to be shot just after dawn, so that the sun would light the trees while the basketball court was still in the shadow of the neighboring buildings. My assistants and I arrived at 4 AM to pre-light and set up the shot; Alston arrived at 5:30 AM. Two battery-powered units in soft boxes are lighting him, while a small Vivitar 285 lights the backboard. Shooting later in the day might have been possible, but would have required more powerful lights and access to AC current, and the empty court would have been in use so crowd control would have been a nightmare.

race before they compete, forming a very complete and extremely detailed mental picture of the race course and how they imagine the event will unfold. Before every shoot we do something similar when we imagine what we will try to achieve; the difference is in how disciplined we are in our approach. Scouting relieves pre-shoot jitters because you have a clearer idea of what to expect, boosting your confidence. It also helps you determine when you need to rent extra gear.

Scouting tools Always carry a compass, a small point-and-shoot camera, and a pocket-sized sketchbook. A PDA with a video or still camera is also helpful.

The value of a compass should be obvious: it allows you to locate yourself on the earth, but paired with software such as focalware (http://spiraldev.com/focalware/), it can also help you to predict the future.

This is an app for the iPhone that accurately predicts the position of both the sun and the moon for any location in the world and for any date or time in the future. Focalware is currently only available for the iPhone, but other companies make similar applications for other handheld devices.

Having a sketchbook for drawing a floor plan of the location can help you to mentally pre-light the shoot with your assistants.

If it's impossible to scout, then it is often helpful to ask your contact at the location if there are any photographs of the site and/or subject available by email, or online through a website.

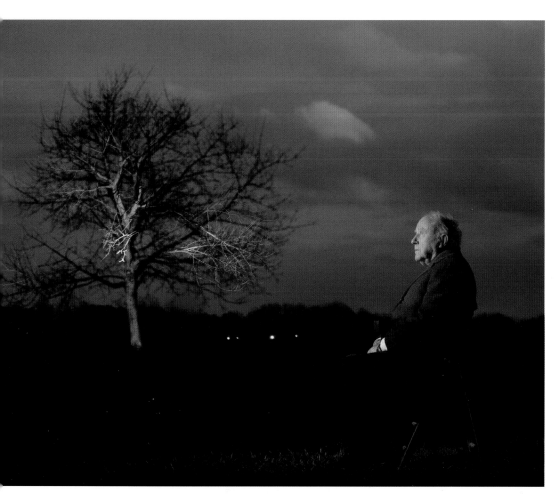

JOHN ARCHIBALD WHEELER, PHYSICIST

This photograph probably involved the most research, planning, and pre-production of any photograph in my career.

The location had to be close to Wheeler's office at Princeton University and I would only have access to him from 3:00–3:30 PM. The tree needed to be so remote that there were no streetlights nearby, yet still be easily accessible to an elderly subject. The photograph had to be made in the late fall because the tree had to be bare of leaves. However, because Wheeler was over 90 years old at the time, I had to be careful not to expose him to the elements for too long.

Two exposures were made on one sheet of 4 x 5 film: The first exposure was made in the afternoon with Wheeler sitting in the chair. He is lit with a very powerful battery-powered flash unit at $\frac{1}{500}$ second at f/32. This exposed Wheeler correctly but underexposed the existing daylight by almost 4 stops. The second exposure was made after Wheeler had left. When it was dark enough, the camera was refocused on the tree (which is about 50 feet/15m beyond the subject's position). The shutter was opened for a two-minute exposure while I walked into the scene (wearing all black clothing) and painted the tree with a mixture of flashlights and small flash units. This is why the tree is sharp where it is lit, and out of focus where it is dark.

Tutorial 37 | LIGHTING ENVIRONMENTS AND INTERIORS

When lighting a portrait in which the sitter is given context by a surrounding interior space, we are always balancing the importance of the environment against the importance of the sitter. It's usually the background that tells us whether the face we are looking at is a doctor, lawyer, saint, or sinner.

Lighting and photographing interiors is very complex, and worthy of an entire textbook of its own, but there are a few simple strategies that can make shooting a portrait in an interior space much simpler.

First, break the big, confusing problem into smaller, manageable problems:

- First light the space.
- Then light the face.

This seems backward, of course, because we are there to shoot a portrait, and most young photographers make the mistake of using nothing more than the leftover "spill" from their portrait lights to describe the room. The environment is treated as an afterthought.

This is a mistake for two reasons:

- The room/environment is actually the more difficult problem to solve and often supplies more information to the viewer.
- Because the room is the more difficult problem, it usually takes more time. The room is patient and has nowhere to go, so you usually have the luxury of being able to light the space more thoughtfully.

OBJECTIVE >>

- **To use the location to supply context.**

COLONEL DONALD HOCUTT, EXECUTIONER, PARCHMAN STATE PENITENTIARY, ALABAMA

I knew this would be the lead photo for an article in *Esquire* on capital punishment so it was composed to be a double-page spread with the subject on the left and the gas chamber on the right. The hinge of the gas chamber door was positioned to fall in the "gutter" between the pages and some extra room was left at the top to allow for the addition of text for the article's title: "The Last Face You'll Ever See."

In this particular instance I was working alone with a 4 x 5 camera and a lot of gear. Colonel Hocutt arranged for some inmates to carry my equipment the 400 yards (365m) to the location. It was blazingly hot and I noticed that everyone was glistening with sweat, which inspired me to use the silver reflector as the main source.

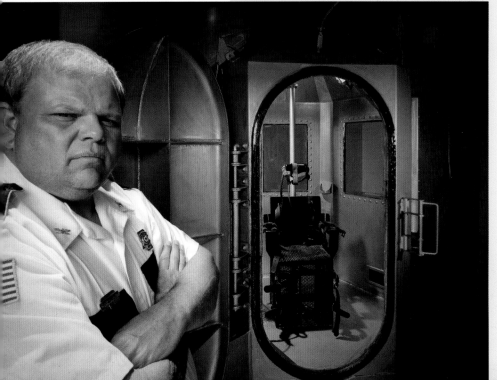

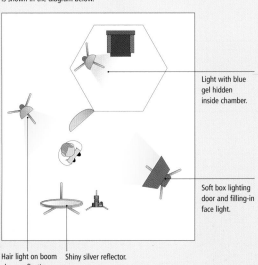

The lighting setup for the image, left, is shown in the diagram below.

Light with blue gel hidden inside chamber.

Soft box lighting door and filling-in face light.

Hair light on boom above reflecting onto shiny board.

Shiny silver reflector.

INTERPLAY OF LIGHT AND SHADE

Paul Warchol is one of the top architectural photographers in the world. This photograph is a great example of how he uses light and contrast to keep your eye moving through the photograph. Note that the brightest part of the photograph is also the farthest away.

Light the space: A rule of thumb approach

Most young photographers set up two lights (usually with umbrellas) on either side of the camera and simply blast light into the scene. Of course, the problem is that the intensity of the light falls off with distance—so the back of the room gets darker and darker. It's like peering into a tunnel with a flashlight.

However, if we look at photographs by masterful interior design photographers and cinematographers, we can see that they actually create planes of light by placing lights deep in the scene (just barely out of the view of the lens) and shooting the light across the room. This creates a series of overlapping planes of light, which draws our eye into the space and invites us to visually explore the room. It also brings out the texture of fabrics and objects.

Let's look step by step at how an interior can be improved by positioning lights deep in the room. The photos overleaf were shot with a wider lens than the final focal length to make it easier to see the process, but it's not a bad idea to "light wide" because it will point out any problem areas more easily. Using hot lights will also help you to learn the technique.

First, turn out all the lights in the room. This will make it easier to see the effect of your lights without confusion.

Having lights this deep in the scene creates its own problems, like lens flare, unwanted reflections, and

SAFETY, ETIQUETTE, AND A FEW PRACTICAL TIPS

- Lights, including the modeling lamps of electronic flash, can get hot enough to scorch paint and fabrics, and even set off sprinkler systems if they are too close.
- When plugging in, with either hot lights or flash, try to break up your load on the circuits.
- Private residences usually carry about 20–30 amps per line. Run lights by heavy-duty extension cords from other rooms instead of plugging everything into the same room.
- Never plug into an outlet/line where a computer is plugged in and in use. If the circuit blows, the project the person was working on might be lost.
- When you are shooting in someone's residence or business, you are a guest. It is inevitable that you will have to move furniture or knick-knacks. Smart assistants will use their camera phones to record where things went before they are moved.

- Don't drag light stands across floors; pick them up. Turn off hot lights and modeling lamps when moving lights; the filament is very fragile when the lamp is lit.
- Never, ever, stand on someone's furniture with shoes on.
- Lights reflecting in windows or pictures can often be hidden by changing the angle of the picture (with a rolled-up ball of gaffer's tape behind a picture, for example), or by using a gobo (in the case of a window) between the light and the reflection.
- When shooting with flash, it can sometimes be difficult to isolate which light is causing a reflection or flare. Turn off all of the lights and then turn each one on in turn. This will usually help you spot the problem.
- When packing, look carefully for equipment that might be left behind. It's unlikely that you would leave a lens behind, but a good compact flash card might be a few hundred dollars and is easy to lose. Even worse, it might have the entire shoot on it.

exercise:

ANALYZE HOW OTHER PHOTOGRAPHERS USE LIGHT TO DESCRIBE SPACES

Study interior design magazines such as *Elle Décor* and *House Beautiful* and try to work out how the photographers have used light to describe the interior environment.

Watch a few low-budget feature films (turn the sound off, so you don't get involved in the plot). Cinematographers are masters at depicting space through the use of light while hiding lights from the camera. Big-budget movies are often shot on sound stages with elaborate lighting grids so they're far less useful for showing solutions that are practical for photographers.

Light a few different interiors (without people), using nothing more than simple scoops and light stands. Improvise grip gear with nothing more than foamcore boards, cinefoil, and clamps.

uncontrolled spill. These problems can be time-consuming to solve. It's a good idea to allow an extra hour or two to pre-light any environmental portrait: You don't want the subject to be pacing impatiently while you grapple with solutions.

Now light the face

Most of the people we photograph are very, very busy. Very few of them have much experience in front of the camera, and they really don't have many "takes" in them. For these reasons it's always best to avoid using the final subject to test your lighting; instead, use your assistant, grab a bystander, or even shoot a test with yourself as a stand-in.

This can create its own problems—for example, when the assistant is 6 feet 4 inches (1.9m) and has bleached blonde hair down to his waist and the subject arrives and is a 5 feet 2 inches (1.5m) balding middle-aged man (that's why actors have stand-ins)—but even then, it's better to at least have the lighting blocked out.

Once the background is lit, you are pretty much home free. In a pinch you can always go to a simple solution for the face like a soft box or umbrella. Just be mindful of new problems that might arise in the background (lights reflected in windows or flare, for example) as you "tweak" the camera position and lighting for the actual subject.

COMMON MISTAKE
Here, the lights were set up on either side of the camera, and only slightly in front of it, at the front of the room. The fall-off of light has resulted in the back of the room being at least 1–2 stops darker than the front, despite the natural light flooding through the sheer drapes.

HOW TO LIGHT A ROOM
Long, narrow rooms, like this, are one of the most difficult problems: Look for niches and adjoining doorways to hide lights where you can.

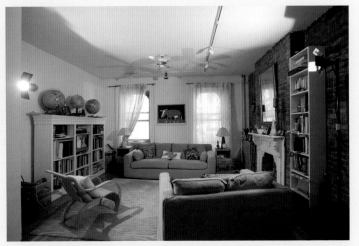

△ **1** Start by simply placing two lights as deep in the room as you can, staggering them in space. One should angle slightly to the back of the room (the light on the right of the scene), and one slightly back to the camera (the light on the left). The light angled toward the camera might also be used to slightly backlight the portrait subject if you desire.

△ **2** Note that the light on the left is flaring into the lens; we have to flag this by putting a gobo slightly out of frame, between the light and the camera.

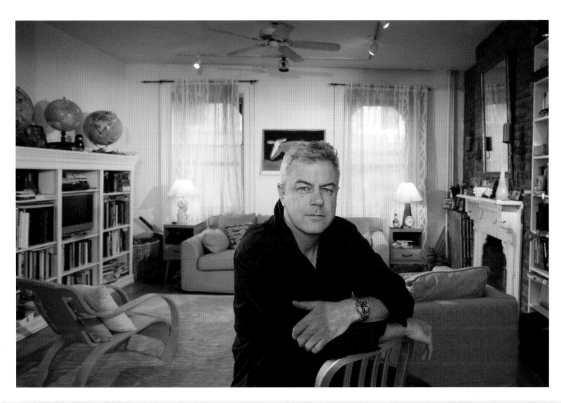

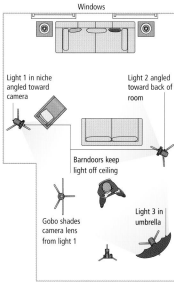

Windows

Light 1 in niche angled toward camera

Light 2 angled toward back of room

Barndoors keep light off ceiling

Gobo shades camera lens from light 1

Light 3 in umbrella

BRINGING IT ALL TOGETHER

Add an umbrella for the subject and you are almost done. Turning on the room lights provides a little necessary fill and helps preserve the original ambience of the scene. Use yourself as a stand-in if you are working alone.

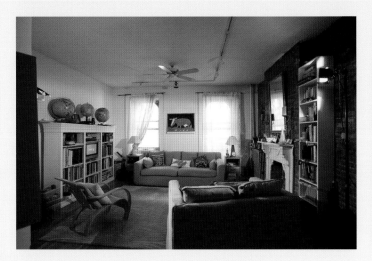

△ **3** Shade the lights from areas you don't want to be lit (like the ceiling) using barndoors or gobos. Barndoors create a soft-edged shadow because they are close to the lamp; this makes the edge of the shadow easy to hide in the angle where the wall meets the ceiling. Note the addition of the gobo on the left.

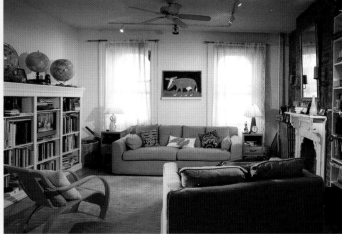

△ **4** At this point the light looks pretty good, but a bit contrasty. Now we can either fill with another of our lights or simply turn on the room lights and tighten up the frame to our final cropping.

Assignment | CHANGE CONTEXT THROUGH LIGHTING

We tend to be very influenced by our first impressions of people and environments. It can be hard to imagine how lighting can drastically change our perceptions. This assignment has four goals:

■ Transform a familiar environment through lighting.
■ Supply editorial context to the subject through lighting.
■ Collaborate and work together.
■ Start pre-planning before going on a real location.

Students were challenged to shoot a portrait of an "evil librarian." The class was told to put together a list of all the equipment that would be necessary to shoot on location in a nearby library, with the proviso that they wouldn't be able to return to the photo department to check out more equipment.

One student was assigned to be the photographer, one served as the digital technician, another was cast as the librarian, and everyone else pitched in as assistants.

The location was less than 50 feet (15m) from the equipment checkout cage. Over the course of the shoot, students made five trips to the equipment cage to get items they had forgotten. Had they been real photographers working on a real assignment, this lack of planning would have been pretty embarrassing.

△ **SEPARATING SUBJECT AND BACKGROUND**

Moving the subject away from the background helps a lot and gives us more control over the lights. It also adds much needed visual depth to the scene.

△ **START POINT**

They started out by making a fairly common mistake—using the same lights to light both the background and the subject. The background is full of hot spots and the subject looks like he's been stood up next to a wall for a firing squad. The lighting is boring and flat. The "evil librarian" context is provided by nothing more than the subject's pose.

RED GEL AND UPLIGHTING

Lighting the background with a red gel and uplighting the subject might be a cliché, but it does start to communicate the idea by using commonly understood visual cues.

GREEN GEL BACKLIGHT

The green gel backlight made him look more sinister but the students also thought it looked too "Christmassy."

PROPS

The students had the idea that an evil librarian would destroy books so they ripped up some magazines and threw them into the frame.

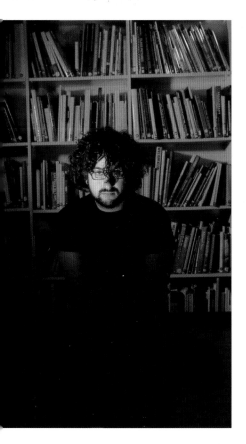

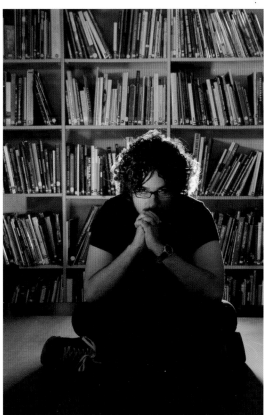

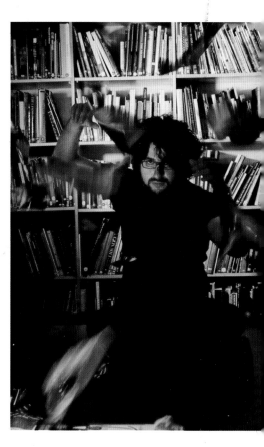

Tutorial 38 | MIXING FLASH WITH AVAILABLE LIGHT

Lighting with flash outdoors is confusing for most young photographers; in fact, it's really easy once you fully understand a few basics.

OBJECTIVE >>

■ **To learn to use available light to your advantage.**

OUTDOOR EQUIPMENT

A couple of handy items can make working outdoors a lot easier and they don't have to cost a fortune.

Before we go into the theory and practice, let's quickly look at some options on lighting gear to use in the field:

Studio strobes (either monoheads or power pack units with heads)

Can you take studio strobes outside? Of course. The only problem is finding an AC power supply. If you can plug into a nearby building with a long (heavy-gauge) extension cord, then go for it. Several manufacturers make portable batteries that allow you to plug studio strobes in, and many new cars have built-in power inverters with three-prong power outlets in the dashboard.

Battery-powered electronic flash

There are several options for battery-powered lighting. Some are nearly as versatile and powerful (and almost as cumbersome) as studio equipment; others are much more portable.

Studio-like units Studio-like battery-powered pack and head units are made by a variety of manufacturers. They consist of a flash head connected to a separate power back that looks and behaves like a standard studio pack; the difference is that it has a rechargeable DC battery that can be quickly swapped out. The power output of these systems typically ranges from 600–1,200 WS. The

best thing about units like these is that all of the advanced light modifiers from the manufacturer (soft boxes, reflectors, beauty dishes, etc.) will also fit, enabling true studio-quality lighting in the field. These units come complete with modeling lights to aid you in placing lights (although using the modeling lights will affect battery life).

The versatility of these systems is matched by their price. A single flash/pack like the one in the photo will be about $3,500 (before you add on the cost of extra batteries, light modifiers, and so on). Consequently, these units are most often used for high-end fashion and editorial work.

Flash units with a lightweight battery pack Made by manufacturers like Lumedyne and Quantum Instruments, these workhorse units are prized by wedding photographers. They consist of a simple (lightweight) reflector/flash head, connected to a battery pack/flash generator weighing about 5 pounds (2.2kg) that is light enough to be carried on a shoulder strap. Power output is typically about 150–200 WS, just powerful enough for using outdoors in combination with sunlight. Using light modifiers will require a bit of ingenuity (for example, try taping grids on) and dedicated adapters for soft boxes. With special cables,

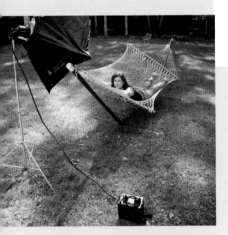

Battery-powered pack and head units Although you sacrifice some of the portability of smaller options, battery-powered pack and head units are powerful and very versatile.

AC adapter This adapter allows you to turn any exterior lightbulb socket (porch lights, construction sites, etc.) into a plug-in AC power source. It's one of the handiest devices you can buy for your lighting kit and costs less than $1 at any hardware store.

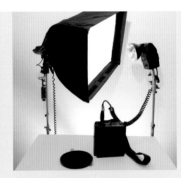

Lightweight battery-powered units For most outdoor portraiture assignments, battery-powered units like these Quantum Q flashes represent an ideal balance of power, portability, price, and versatility.

Camera-mounted flash units Small flash units powered by AA batteries, such as this Vivitar 285HV, are a great addition to your basic lighting kit. Note the additional optical slave mounted to the bottom and the stand/umbrella adapter.

TYPICAL OUTDOOR SCENARIO

This sequence demonstrates how to take a well-balanced portrait photograph outside. It shows how you can use flash to achieve dramatically different light effects.

▽ **Meter reading** A check of our light meter reveals that the exposure for the sun alone would be f/16 at $\frac{1}{125}$ second (ISO 100). But if we remember the "sunny 16 rule" (see page 49), there isn't any need to even take a light reading.

The "sunny 16 rule" actually gives us a range of equivalent exposures:

$\frac{1}{125}$ second at f/16

$\frac{1}{60}$ second at f/22

$\frac{1}{250}$ second at f/11

$\frac{1}{500}$ second at f/8 (assuming the camera will synch at that high a shutter speed. Only leaf shutter medium-format cameras will synch at that high a shutter speed with standard flash unit).

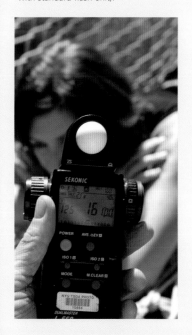

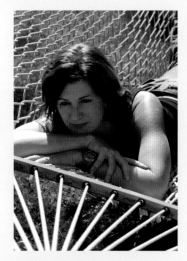

△ **Shot taken metering only for available light** Of course, this looks terrible: our subject's face is completely in shadow. In this typical situation, the sun is harsh and backlighting our subject. Excellent: we are going to use it to our advantage and turn it into a flattering backlight that will separate the subject from the background. Now we can light the subject with flash. Positioning the flash with a light modifier (a soft box in this case) to light her to her best advantage.

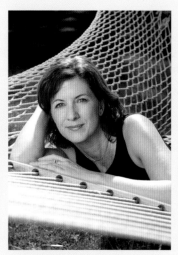

△ **Available light plus flash** Once the flash is added, she looks a lot better, and we've retained the use of the existing sunlight as a backlight. We are now using two-point lighting, because the sun is serving as our secondary light source. However, there are still places where the sun is in danger of "clipping" (overexposing) the highlights on her shoulder and arm.

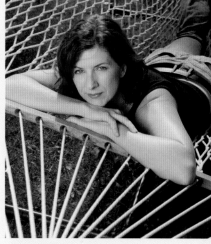

△ **Faster shutter speed** Raising the shutter speed to $\frac{1}{200}$ second (the maximum for this camera/flash combination) subdues the sun even more.

▷ **Smaller aperture** If the flash is powerful enough, we can increase the power to the flash and stop down the aperture even more ($\frac{1}{200}$ second at f/22), effectively overpowering the sun and making an outdoor photograph shot at noon look as if it was shot indoors. In fact, if we could access a higher shutter speed we could completely eliminate the sun's effect. We would also be able to use a less powerful flash. This ability to use high shutter speeds to control the intensity of the sun relative to the flash was one of the primary reasons that medium-format cameras with leaf shutters dominated fashion and portrait photography until recently.

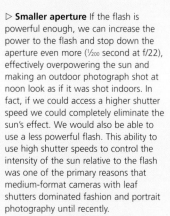

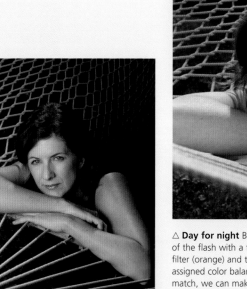

△ **Day for night** By changing the color of the flash with a tungsten conversion filter (orange) and then changing the assigned color balance of the photo to match, we can make the sunlight look like moonlight.

SHUTTER SPEEDS

This sequence illustrates how the shutter speed is used to control the amount of ambient sunlight while the aperture and power setting of the electronic strobe influence the intensity of the flash exposure.

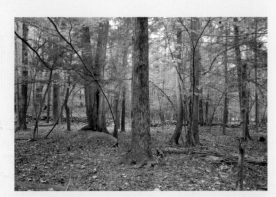

◁ **4 seconds @ f/22** There is a flash unit hidden behind the center tree, but at f/22 the flash isn't very powerful and has almost no impact on the surrounding trees.

▷ **2 seconds at f/16** At an equivalent exposure of 2 seconds at f/16, we start to see the effect of the flash on the trees closest to the flash.

◁ **1 second at f/11** The flash is so powerful that it is in danger of overexposing the trees that are closest.

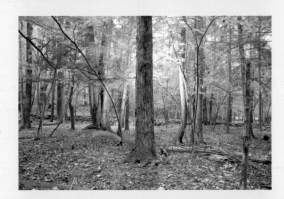

▷ **½ second at f/8** Trees that are 6 feet (1.8m) away are already overexposing, but the central tree (which is shaded from the flash and illuminated by only the available light) looks exactly the same. The flash is starting to cast shadows on the foreground.

◁ **¼ second at f/8** While leaving the f-stop at f/8, the shutter speed is raised to ¼ second, underexposing the ambient light slightly. With an artificial light source hidden behind the tree, the forest starts to look like dusk.

▷ **1/60 second at f/8** Raising the shutter speed to 1/60 second, (while leaving the f-stop at f/8) underexposes the ambient sunlight drastically and makes the scene look as if it was shot at night, even though all the photos were taken at 9:00 AM.

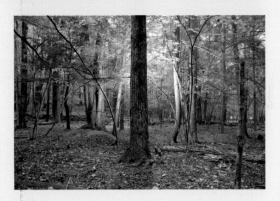

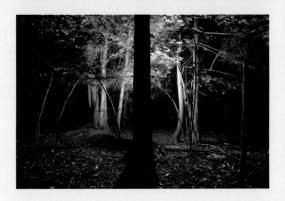

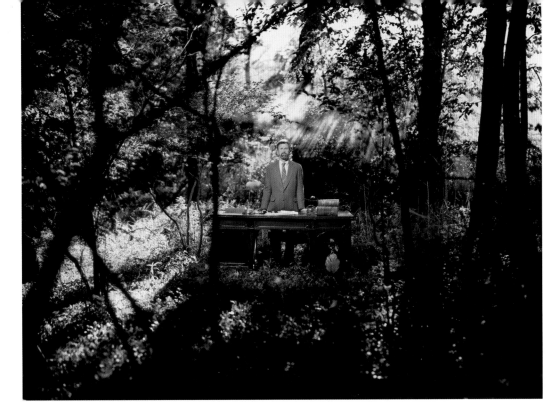

PORTABLE GAS GENERATOR

If you need a lot of power and you are deep in the woods, portable gas generators can supply massive amounts of AC current to power studio strobes. This particular photo of a lawyer who is an environmental activist was shot with an 8 x 10 camera for *Town & Country* magazine. In the spirit of complete overkill, we turned the woods into a photo studio with about 10,000 WS of studio strobes and a fog machine. Two portable generators (weighing 75 pounds, or 35kg, each) supplied AC power in the remote location. Three assistants carried the props and over 300 pounds (135kg) of gear across a stream. Why on earth would we do such a thing? Because photography is more fun when you challenge yourself!

SAFETY FIRST!

In the unlikely event that you ever need to do something like this, remember that AC generators require a surge protector between the generator and the electronic flash or you run the risk of having your electronic flash being damaged by current surges from the generator.

some models can also take advantage of cameras that have TTL capability.

Small camera-mounted flash units (non-TTL) with adapters

adapters Because these inexpensive, small, simple flash units have no cords, AA flash units are easy to hide on location shoots; they are great for use as a hair or accent light. They are almost powerful enough to use outdoors in direct sun. In the shade, or on an overcast day, they are powerful enough to use with a small umbrella or soft box. With the addition of a separate high-voltage battery pack, they can recycle very quickly. The power output is easily regulated in one-stop increments and they even have a "zoomable" Fresnel incorporated into the design to change the angle of coverage.

As fantastic as they are, using small flash units well requires quite a bit of ingenuity: a knowledge of how slaves work, how to adapt light modifiers, etc. Because they have no modeling lights, they are also difficult to previsualize. So some students struggle to use small flash units well. However, once students are introduced to the basics of lighting theory with studio equipment, using small flash units effectively becomes much easier.

What's the exposure?

This is often confusing because you are actually determining two exposures at the same time: the available light exposure and the flash exposure.

The available light exposure This is the exposure that is determined by the prevailing light source. This is most commonly the sun, but could be any preexisting, continuous source beyond your direct control.

The flash exposure The exposure of the flash is completely independent of the shutter speed. The flash component of the exposure is determined by the distance to the subject, or the power setting of the flash, and the aperture setting of the camera. As long as the shutter speed is high enough to keep the ambient exposure from overexposing, we can easily fine-tune the ratio of flash to ambient light.

Combining flash with slow shutter speeds

The single biggest mistake most young photographers make when they are first learning to use flash is that they mistake the highest synch speed available as the only speed they can synch at.

Most modern cameras can synch at up to $\frac{1}{200}$ second. However, as the forest photos demonstrate, they will synch at any shutter speed that is slower as well. This gives us very precise control over how much of the available light we wish to include, especially in situations where there isn't an overpowering amount of available light (cloudy days, interiors, shade, for example).

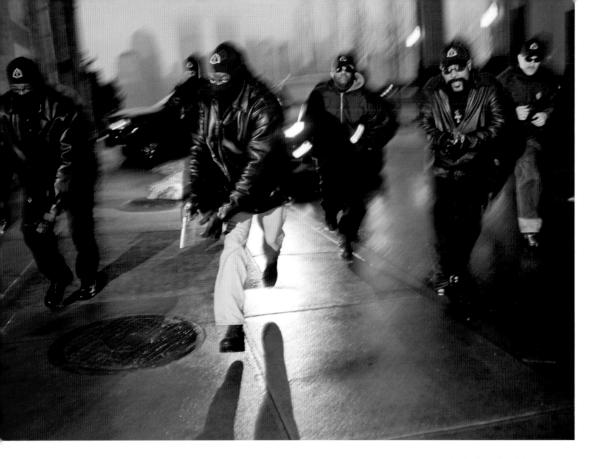

▽ **MIXING FLASH WITH AVAILABLE LIGHT INDOORS**

This photo of a bounty hunter was shot with nothing but a Vivitar 285HV. This small flash was all I could carry on a fast-moving photojournalistic shoot. By shooting at ⅛ second at f/5.6, the exposure includes the light from the neon signs as a light source, imparting a red cast to the scene.

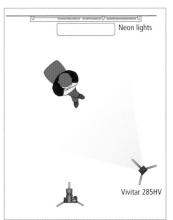

Neon lights

Vivitar 285HV

△ **FLASH COMBINED WITH SLOW SHUTTER SPEED**

In this case I wanted the bounty hunters to look as though they were chasing me. By shooting on a gloomy day, I could shoot at a very slow shutter speed (⅟₁₅ second) and add three small flash units to the scene. Because the light from flash units is so short in duration (about ⅟₁,₀₀₀ second), the figures are frozen when the flash goes off but blurred during the ambient exposure. I was running away as the photo was being shot, so the camera movement makes the background blurry as well.

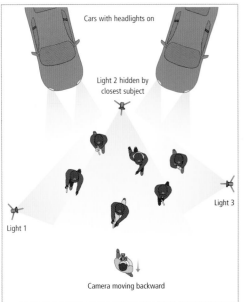

Cars with headlights on

Light 2 hidden by closest subject

Light 1

Light 3

Camera moving backward

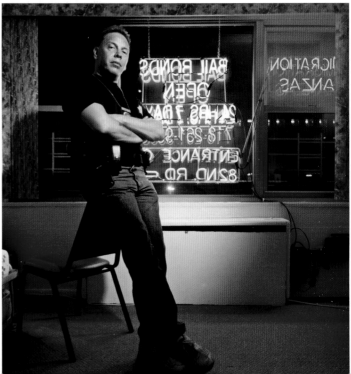

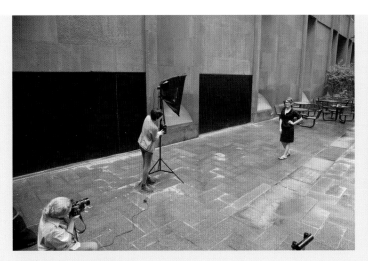

OVERCAST WEATHER

Overcast weather or shade can give you more control when working with the lower power output of location flash units running on DC batteries.

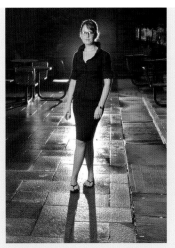

Backlight plus humidity Here, Aileen Mitchell employs a backlight to use the rain-soaked sidewalk and the humidity in the air to her advantage.

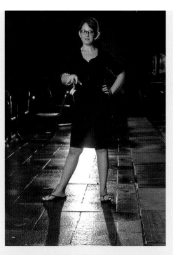

Backlight plus gel Using a strong gel on the backlight enhances the "day for night" effect.

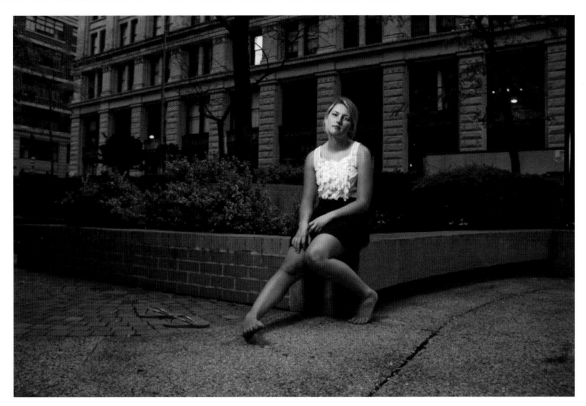

Small soft box

SHOOTING AT DUSK

Erica Sutton used a battery-powered Lumedyne with a soft box to isolate her subject in this portrait. Shooting at dusk enabled her to expose at $1/_{30}$ second at f/4. If she had wanted more of the available light, all she needed to do was move her shutter speed to $1/_{15}$ second; changing to $1/_{60}$ second would have made it look like night.

Tutorial 39 | WORKING WITH WIRELESS TTL FLASH

Wireless Through-The-Lens (TTL) flash units might be the most important innovation in lighting equipment since the invention of electronic flash.

OBJECTIVE >>
■ **To learn to get the most out of small flash units.**

exercise:

DO YOUR RESEARCH

Two excellent resources for a more thorough understanding of wireless TTL are the Strobist website http://strobist.blogspot.com/, and Joe McNally's book entitled *The Hot Shoe Diaries: Big Light From Small Flashes*.

What is TTL flash?

On digital cameras, "Through-The-Lens" flash units work by sending out a pre-flash a split second before the shutter opens. This pre-flash is reflected by the scene and returns to the camera through the lens. The camera reads the amount of light that has been reflected from the subject and makes a (very quick) calculation on the amount of light that will be needed for the second flash to make the actual exposure correctly. Then the camera's shutter opens and the second flash goes off. This is the flash that will actually make the exposure.

The duration of the second flash (not the camera's shutter) varies according to the amount of light that is needed. When enough light has been produced to make a proper exposure (within limits), the flash stops emitting light. For subjects close to the flash (very little light necessary) the flash duration might be as short as $1/20,000$ second; for subjects that are farther away (requiring more light), it can be as long as $1/1,000$ second.

TTL flash has been around for many years and works remarkably well in most situations. Of course, for older TTL flashes to work, the camera and the flash needed to be physically connected by a dedicated series of electrical contacts built into the hot shoe of the camera.

Wireless TTL Modern TTL flash units incorporate an infrared slave unit into each of the individual flash units. This means that a small "on-camera" flash can be used to trigger another (or many) secondary flash units. In theory, there is no limit to the number of flash units that can be used. If all of the units are "dedicated" (made to communicate with the camera and with each other), then the unit that is on the camera can be designated as the "master" control unit. The master unit can then be used to control all the remote/slaved units. It can even be used to set the ratios between different units without any need for the photographer to walk over and set each unit individually. The remote/slaved units also send out infrared signals back to the master unit on the camera. All the equipment talks to each other, at the speed of light, and it all works with the automatic settings of your camera. Simply amazing.

Learning to work with any particular manufacturer's wireless flash system requires time and patience. In order to really understand all the possibilities and use them

well, you will need access to a set of wireless flash units for a few days, and a few hours of study with the manufacturer's instruction manual. Because they are so automatic and (usually) work so well, it can be twice as confusing when they don't behave as expected. A wireless TTL system isn't something you should buy or rent the day before a big job and imagine you can learn overnight, even if you feel confident using studio lights.

However, for photographers who have to do great lighting "on the fly" without an assistant, a wireless TTL system might be the most worthwhile investment one can make. For wedding photographers, photojournalists, and sports photographers, they open up an amazing range of creative possibilities. With some ingenuity and knowledge, they enable studio-quality lighting to be packed in a camera bag.

How can a small flash unit powered by AA batteries create enough light to be used outside and overpower the sun?

Modern wireless TTL flash units have a feature called "high-speed synch," which allows them to synch at any shutter speed. Using the high-speed synch feature allows you to shoot at any shutter speed (it works by pulsing the flash so that it fires multiple times very quickly as the shutter is traveling across the sensor). This means you can shoot at $1/8,000$ second at f/4.0 (ISO 100), which effectively underexposes the sun by two stops according to the "sunny 16 rule."

The gear

Building a wireless TTL system starts with buying one or two TTL flash units that are dedicated (designed to interface) to your camera. If you work primarily indoors, that may be all you'll ever need.

Pocket Wizard Flex transmitters and receivers The Pocket Wizard Flex units are radio transmitter/receiver units that attach to the hot shoes of the Speedlites and convert the (somewhat unreliable) infrared signal into a very dependable radio signal.

The Pocket Wizard system had some problems when it was initially launched, but the manufacturer has continually supplied easy-to-install firmware updates. My system works beautifully now and the range of the units is vastly improved over the infrared system. Best of all, the whole system works reliably outdoors.

USING WIRELESS TTL

Wireless TTL flash systems can produce sophisticated results with a minimum amount of equipment.

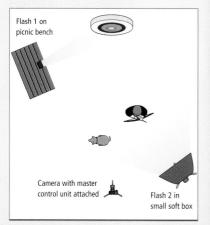

Flash 1 on picnic bench

Camera with master control unit attached

Flash 2 in small soft box

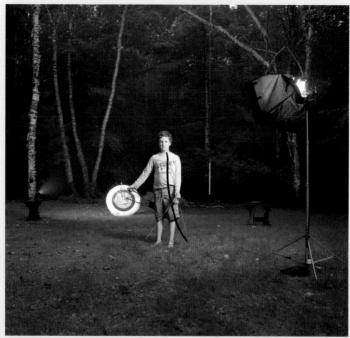

◁ **Pre-production** Wireless TTL flash systems require as much practice, study, and thought as any other lighting tool. This shot has been carefully planned. Note the small light in the back that is lighting the archery target.

▽ **Results** High-speed synch allowed this photograph to be shot at $1/640$ second at f/4.0. This underexposes the background and gives more prominence to the dog, boy, and target that are being lit by the flash units. With conventional flash systems, the highest synch speed available on this camera (a Canon 5D Mark II) is $1/200$ second.

Setup Once the two flash units were in position, a master control unit atop the camera was used to control the ratio between the two flashes.

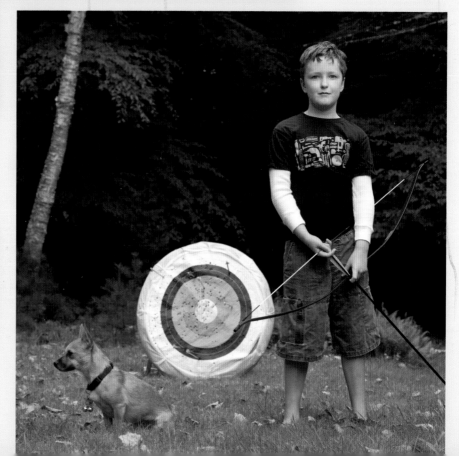

DO I NEED A WIRELESS TTL FLASH SYSTEM?

Not every photographer needs a wireless TTL flash system. Students who aspire to careers as fashion and still-life photographers are typically uninterested, because wireless TTL flash systems seem much more complicated and amateurish than studio flash systems. However, students who are aspiring photojournalists often want to run out and buy a complete system.

A system like the one in this tutorial will cost a little over $2,000. The great thing is that you can build it over time, using a lot of equipment you may already own, beginning with nothing more than a Speedlite (which every photographer needs), an off-camera cord, a light stand, and an umbrella.

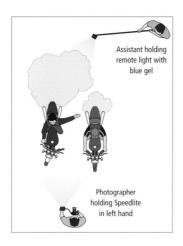

Assistant holding remote light with blue gel

Photographer holding Speedlite in left hand

WORKING WITH AN ASSISTANT

If you are working with an assistant there are even more possibilities. In this photo, the assistant is across the pit (just out of frame in the upper right corner) holding a slaved flash unit with a blue gel to backlight the smoke. Wedding photographers often employ the same technique, using an assistant as a living light stand to put the second flash where it is needed and avoiding the amateur look of "flash on camera."

COMPLETE WIRELESS SYSTEM

This photo shows two battery-powered Speedlites and a command module. The photographer controls the lights from the camera by attaching the command module to the camera's hot shoe. Each light has a wireless transceiver that allows them to communicate with the camera, ensuring perfect exposure using the camera's TTL flash metering mode.

Basic kit

The specifics of wireless TTL vary a bit according to the manufacturer but the theory is the same. A very basic kit would consist of two flash units—one for use on the camera as a master and the other as a slave. Because I almost never use flash on camera, I've also added the ST-E2 (the small device in the middle of the photo left) as a command module for this Canon System. The ST-E2 is actually a small flash unit that transmits an infrared pulse, but no visible light. It is used on the camera's hot shoe as the "master" and the other two units are designated as slaves with assigned "zones." The ST-E2 is used to set the ratio of light output between the two zones. It's not a necessary accessory, but I prefer it because it's smaller and lighter than having a complete flash unit on the camera.

Wireless flash systems rely on those little red windows on the front of the flash. This is how the flash units are able to communicate (like the remote on your TV). It works perfectly, as long the units can "see" each other or the infrared signal is able to bounce off nearby objects or walls. The Achilles heel of wireless TTL flash is the fact that they require each of the units to be able to see each other's infrared signal. If you frequently work outdoors or need to hide lights within a scene, this can create significant problems.

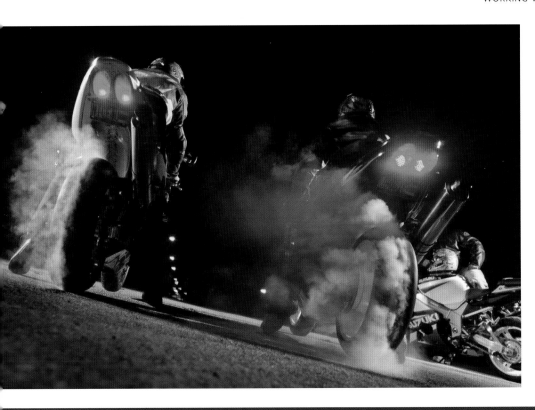

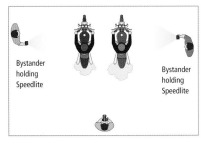

FAST RESPONSE

For this *MAXIM* story on illegal urban drag racing, I often rode along with the racers on my own motorcycle because it was the only way I could keep up with them. I couldn't carry anything more than a small camera bag strapped to my bike. For this photo I asked two cooperative spectators on the sidelines to hold the two Speedlites I used to light the photograph. Wireless TTL units set up quickly and work well with the automatic features of modern cameras, enabling photographers to respond rapidly to fluid situations.

GRIP GEAR AND LIGHT MODIFIERS

All my grip gear and lights pack into a small camera bag. The two light stands and the soft box are carried in a separate bag with a tripod. In addition to all the gear in the photo, I carry a small high-voltage battery that helps speed up the recycle rate of the flash and a very small 6 x 9-inch (15 x 22.5-cm) soft box that attaches with Velcro strips.

WHAT'S IN THE PHOTO?

- Two Canon Speedlites with Flex Transceivers (1)
- One Canon ST-E2 with a Mini TT1 Transmitter (2)
- One 16 x 20-inch (40 x 50-cm) soft box (3). There's a special adapter that allows it to be used with the Canon Speedlites. The adapter allows any of the larger soft boxes to be used as well.
- Two off-camera TTL cables (4). These are for connecting the flash directly to the camera if need be. These can also be "daisy chained" together to create one long cord.
- A collapsible flash bracket (5)
- A Lowel Tota-Clamp (6). This allows a light to be securely attached to any convenient shelf, pipe, tree limb, etc.
- Two stand adapters (7). These allow the Speedlites to be mounted on light stands.
- Gaffer's tape (8). Carry a roll in every equipment case.
- Two sample swatch books of gels (9). These are free at most lighting supply stores and are large enough to cover the flash unit. Just tear them out of the swatch book. Note the blue gel taped to the front of one of the flash units.
- A few "A" clamps
- Two sheets of Cinefoil (10). This is the black stuff in the photo that looks like black aluminum foil, which is exactly what it is. Cinefoil, or "black wrap," is remarkably handy for fashioning an impromptu "cookie" like the one in the photo, or creating a snoot to narrow the spread of a light. Cinefoil is one of the most versatile light-shaping tools you will ever use. Carry a large roll in your main kit and a few spare sheets in your camera bag.

Assignment | ENVIRONMENTAL PORTRAITURE ON LOCATION

SUGGEST TIME AND MOOD

Kate Mclane and Erin Erwin collaborated as photographer and assistant for this portrait. A sympathetic club owner let them use the location for a few hours before opening. Gels were used on the lights to create a palette that suggests 1950s Havana.

With a friend or classmate, shoot an environmental portrait, trading the roles of photographer and assistant. The portrait should use the surrounding environment to clearly define the person's profession, enhance the visual appeal of the photograph, or provide insight to the viewer.

Teaming up with a friend or classmate is of vital importance when doing portfolio-quality work on location. Lighting gear is heavy and cumbersome. With the possible exception of photojournalists, very few top pros work alone. The more you can collaborate with your friends or classmates, the better your portfolio will look.

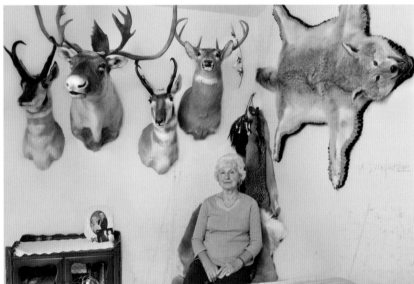

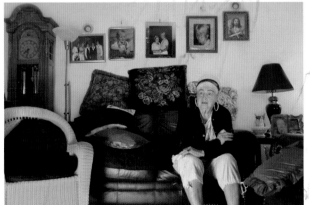

TELL A STORY

Marissa Singer's senior thesis, "When I Was Your Age," depicted older women in homes filled with artifacts from their youth. Marissa used continuous-source lighting in order to work alone and to see the effect of the lights more easily.

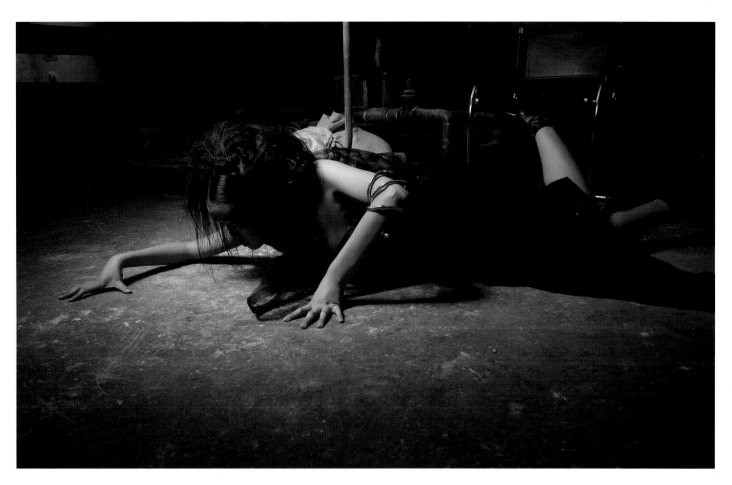

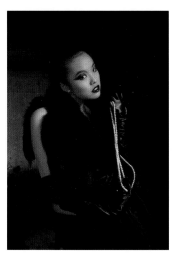
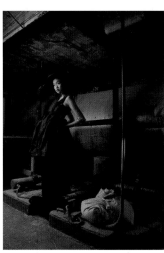

MODERN AND EDGY

These photos are a great example of three strong students teaming up on an environmental lighting assignment to help each other. In this series Michelle Watt, Adriel Reboh, and Jade Andreson used the same model for a class assignment. The location was the boiler room of a campus dorm. Note the placement of the lights staggered deep in the scene to create depth. Oops! The light stands are visible. That's what Photoshop is for…

Portrait photography is a big field. No one photographer can hope to be an expert in all of the different areas of specialization, but the more important issue might be that each area of specialization rewards a different kind of personality. Skill sets are also very different according to specialization. Wedding photography requires a different kind of diplomacy than editorial photography, if only because the client is also the subject. Celebrity and corporate photography require careful lighting and pre-production planning, while photojournalists have to be able to drop into any situation and be prepared to improvise.

The following interviews present a broad overview of the careers of six photographers in very different areas of specialization.

"JEFFERSON AIRPLANE," ART KANE

This photograph by Art Kane was shot for the cover of *LIFE* magazine in 1968. As one of the pioneers of editorial/conceptual portraiture, Kane researched his subjects extensively in order to create images that provided visual cues that were specific to, and evocative of, his subjects.

Jefferson Airplane was one of the music groups that defined the "Acid Rock" genre of the late 1960s. The band members are posed in Plexiglass boxes that were built for the shoot as a subtle reference to the sugar cubes that were often used as a way to administer LSD at the time. The factory in the background was eliminated by manual retouching (predating Photoshop by 40 years) for the final version.

chapter 8 | INTERVIEWS

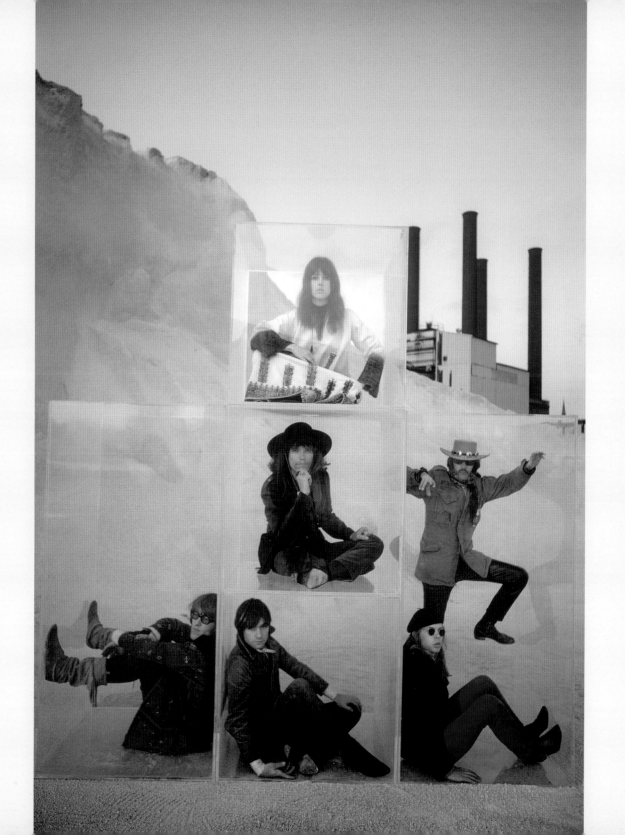

Art Kane | THE PORTRAIT AS CONCEPT

April 9, 1925: Born in New York City.

1943: Wins scholarship in Art of Military Camouflage right after high school.

1944: Deployed with 603rd Engineer Camouflage Battalion, also known as the Ghost Army unit (23rd Special Troops), which also included future fashion designer Bill Blass and abstract painter Ellsworth Kelly.

1950: Graduates Cooper Union with honors.

1953–56: Studies with Brodovitch at The New School.

1950–52: Editorial designer at *Esquire*.

1952–57: Art Director, *Seventeen* magazine—the youngest ever appointed.

1957–59: Art Director, Irving Serwer advertising.

1959: Starts shooting full time.

1960: Opens his first studio in Carnegie Hall building.

1962: Exchanges portraits with the yet-to-be-infamous Andy Warhol, an illustrator he had often hired.

1963: First use of extreme wide-angle lens in fashion—Diana Vreeland at *Vogue* is initially horrified.

1967: Writes and directs a film, *A Time To Play*, for U.S. Pavilion at Expo.

Until 1990: Shoots wide variety of campaigns worldwide.

February 22, 1995: Dies.

www.artkane.com

Before there was Annie Leibovitz, Mark Seliger, or Chris Buck there was Art Kane. While Arnold Newman might rightly be considered the originator of the conceptual portrait, Art Kane was the brash innovator who brought it into the modern era.

One of photography's greatest roles is as a mirror that both reflects, and creates, the society of its time. Art Kane didn't simply document the popular culture that surrounded him; he was one of its primary inventors. From 1960 to the mid-1980s, it was virtually impossible to pick up a magazine without seeing Art Kane's photo credit. His contribution to editorial photography is inestimable.

Jonathan Kane is Art Kane's son and a magazine photo editor, musician, and photographer in his own right.

MJ: I was in junior high when I first became aware of your father's work; I really don't know that much about him, aside from seeing his work all over the place when I was growing up. He might have been the first photographer I became aware of from just seeing his photo credit everywhere. I do know that he was an art director before he became a photographer.

JK: That's right; in fact he was quite a celebrated art director at the time. He was the youngest art director of a major American magazine at the time (*Seventeen*), he's in the hall of fame at the Art Directors Club, his signature is still on their wall, and he had a wall full of awards for art direction before he became a photographer. *[Art Kane would win 38 awards from the New York Art Directors Club over the course of his career.]*

While he was working as an art director he went back to his alma mater, Cooper Union, to study photography with Alexey Brodovitch. Many of his most famous photographs were shot for that class.

MJ: It is interesting to consider his photographic career in light of his background as an art director. It was probably a very natural transition for him to work conceptually, because that's what art directors do. They come up with visual concepts to illustrate ideas. Working as an art director probably trained him to become the photographer he was.

On a completely different topic ... In my research I came across a cryptic reference to the fact that your father served in the U.S. Army during WWII as part of a top-secret "Ghost Army." What was that about?

JK: (Laughing) That was Art Kane's first big adventure and a funny story. During his basic training the Army put out a call for "creative types" to take part in a top-secret project. My Dad volunteered for the assignment and it turned out that they wanted artists to come up with concepts to deceive the Germans on the landing site for the invasion of France. Two of the other people that they recruited happened to be the fashion designer Bill Blass and the painter Ellsworth Kelly. The team experimented with different ways to create a fake army in northern England in order to confuse the German reconnaissance planes. They tried making tanks and trucks out of plywood, but it was too expensive and heavy. Then, being New York kids who had all grown up watching the Macy's Thanksgiving Day Parade, they hit upon the idea of balloons. So they created hundreds of inflatable tanks and artillery pieces that could be easily transported and assembled anywhere. That was the Ghost Army.

MJ: I know that story! That was one of the primary reasons the Germans moved most of their tanks to the Pas de Calais and left Normandy under-defended. Amazing.

One of my favorite photographs of your father's is the portrait of Sonny and Cher. They seem to be both swimming and flying. They are

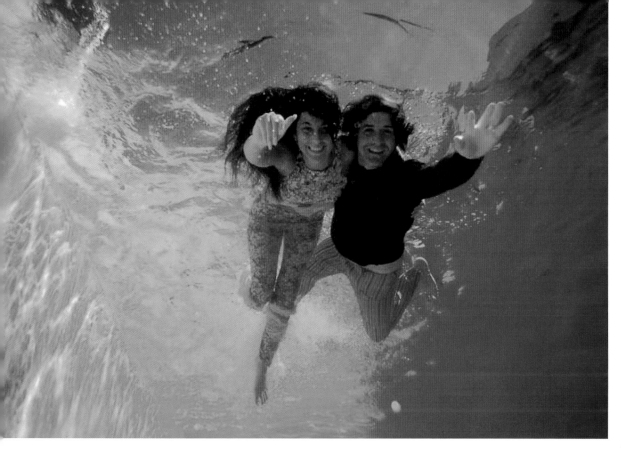

"The interior of a camera is like outer space."

Art Kane

"It starts with concepts. I consider myself a conceptual photographer. I want to communicate the unseen elements in a personality."

Art Kane

SONNY AND CHER, MCCALLS MAGAZINE, 1966

This shot required many takes because the water distorted Sonny and Cher's features.

happy and in love. For me it completely encompasses who they were in American culture at that time.

JK: Absolutely, and you know Art Kane was a vicious editor of his own work. All of his shoots were done on transparency film and he threw away anything that wasn't up to his standards. On most of his shoots, there are only ten or fifteen select frames that are still around.

The Sonny and Cher session is one of the few where almost the entire shoot still exists. Most of the photos are really typical; late-afternoon light, them on the back of a motorcycle looking all lovey-dovey. The photos are okay, and I'm sure the magazine would have been happy, but that wasn't enough for him, so in his typical way he pushes the envelope and says, "Let's try something different," and they all jump in the pool.

MJ: But he had to have planned for it. He had to have an underwater housing for the camera.

JK: Oh yeah, he had a scuba tank and weight belt so he could stand on the bottom of the pool. But I agree with you. That's one of those Art Kane photos where all the elements came together, fashion, celebrity, lifestyle, rock stars, the conceptual thing; it's all there in that picture.

MJ: One thing that is interesting to me is that your dad was a rock star photographer when that meant being a rock star yourself. He and David Bailey probably personify what we think of photographers of that era, but as I did my research I realized that he was older than the people he was shooting.

JK: That's true, he was in his forties when he was shooting rock stars, but he was also an example of the modern way that we extend youth culture into middle age. It's common now to see men and women in their forties and fifties who still dress and act young, but it was pretty unusual then.

MJ: Yeah, I always think of your father as "forever hip."

JK: He was, but what's interesting is how he used the wisdom and experience of his age to bring credibility to the youth culture that he saw as valid and vital. He really helped shape it into what we know today.

MJ: So tell me a story: Probably the most famous Art Kane photograph is his portrait of the rock band, The Who. How did that happen?

JK: Most people think The Who commissioned that photograph, because it was used for the album cover and as the poster for the movie, *The Kids Are Alright*. It was actually shot ten years earlier. It was originally commissioned by *LIFE* magazine and licensed later for the album and movie poster.

LIFE asked my father to shoot a cover story on "The New Rock," and the story included a bunch of musicians: Janis Joplin, The Cream, Jefferson Airplane, and a few others.

My dad researched extensively for every shoot. When he knew he was going to shoot someone, he listened to every album, looked at fan

> **"I need an assignment, I love an assignment. I love discipline. Discipline creates freedom."**
>
> *Art Kane*

THE WHO, LIFE MAGAZINE, 1968

In the history of rock photography there are few images more iconic and influential than Kane's portrait of The Who.

magazines, he'd learn everything he could. In the case of The Who, he noticed that they wore Union Jacks in their clothing, Peter Townshend and Roger Daltrey had jackets and shirts made from Union Jacks. They were clearly branding themselves as a British rock band.

So he took that a step further and had a huge flag made from several smaller Union Jacks. He shot some of the band in the flag on a plain white backdrop at his studio in Carnegie Hall. It was good, but not great. Then he remembered a photograph by Cartier-Bresson of a vagrant asleep in Trafalgar Square, so he decided to reference that. He had a location scouted—Carl Schurz Park, up near Columbia University—that

had the right elements and looked a lot like the location in Trafalgar Square. They all jumped in a cab, he wrapped them up in the flag and told them to pretend to be asleep. Most people think it was shot in London, but it was right here in New York.

MJ: You mentioned the Jefferson Airplane shoot as well and that was an unusual photograph for the time. There's a lot of production value there, a set was built, and I guess he flew out West to shoot them; it's in the desert…

JK: Actually, no, I went on that shoot when I was a kid. That was shot in Long Island City in

Queens, NY. Those white cliffs you see in the background are piles of gypsum. It was shot next to a factory that made sheetrock.

You're right, though; it was done at enormous expense. They had to have those Plexiglass cubes made, and that was not cheap. But Art Kane was a very persuasive guy and was probably considered the king of editorial photography at the time. The Airplane were also at the height of their popularity. I think everyone involved was pretty sure that the photograph would end up as the cover, so he got his way and the magazine paid to have the set built.

Part of what my dad knew about Jefferson Airplane was that they were considered an "Acid Rock" band. The cubes were meant to reference the sugar cubes that people used as a way to take LSD and as a reference to the "Windowpane" acid that was around at the time.

MJ: I would never have guessed that was shot in Queens, and the white powdery hills beyond do look like mountains of drugs. All available light?

JK: Yes, most of my dad's work was shot with available light. The photo of Jim Morrison in the closet of Morrison's hotel room at the Chateau Marmont, there's a little lighting in that one.

MJ: That was the same assignment?

JK: Yes.

MJ: That's remarkable—of the photographs we've talked about, three of them are from that assignment. That's an amazing batting average.

JK: Yes, there were two big shoots on musicians and youth culture, one for *McCall's* in 1966 and the other for *LIFE* magazine in 1968. Most of the iconic music photographs—Dylan, Cream, Janis Joplin, the Rolling Stones, Frank Zappa—they all came from those two assignments.

MJ: You have a unique perspective on this: you're not only your father's son, but you are also a photographer and photo editor. If it's possible, can you take a step back and assess your father's career objectively?

JK: His contribution to the way we think of editorial photography today was profound. We've talked exclusively about his portraits, because that's the focus of your book, but of

course he was also doing a ton of fashion work and other assignments.

I think that Helmut Newton, Guy Bourdain, Avedon, Hiro, and Art Kane personify what we think of when we think of fashion photography from the 1960s through the '80s. He was also an innovator in the area of photo-illustration, combining images through layering, that predates Photoshop by decades. I sometimes think he doesn't get enough recognition for that work, which was incredibly forward. No one else was doing anything like it.

The amazing thing is that his work hasn't lost an iota of its power—it's still as fresh as the day he created it.

> **"Part of being a photographer involves being a detective, images come out of investigation."**
> *Art Kane*
>
> **"Performance shots are a waste of time. They look like everyone else's."**
> *Art Kane*

JIM MORRISON AT THE CHATEAU MARMONT, LIFE MAGAZINE, 1968

Given our modern perspective on technology, it might be natural to assume that having the image of a woman who appears to be Marilyn Monroe on the TV screen was pre-planned and set up, however this photo was shot before VCRs and DVD players were commonplace. Kane's work is a great example of a photographer who made luck part of his plan.

Richard Renaldi

TIMELESS STRANGERS

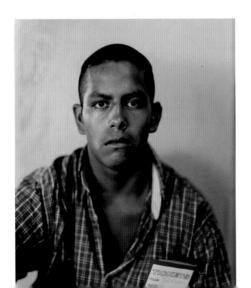

1968: Born in Chicago.

1986–1990: Received BFA in photography from New York University.

2002–2011: Solo exhibitions of his photographs throughout the United States, including the Gallery at Hermès and Yossi Milo Gallery in New York, and at Jackson Fine Art in Atlanta. His work has been exhibited in numerous group shows, including Strangers: The First ICP [International Center of Photography] Triennial of Photography and Video (2003).

2006: First monograph, *Figure and Ground*, published by the Aperture Foundation

2009: Second monograph, *Fall River Boys*, released by Charles Lane Press

www.renaldi.com

Many photographers take photographs in order to engage with the world. There is nothing passive about being a photographer; they stroll the sidewalks, observing and looking, but for what? They often don't know, until their eyes fall upon something they don't understand or someone they want to know.

But why is it necessary to make a photograph? This is like asking why it is necessary for a composer to hear their work performed. The photographic act sharpens their observational skills and makes the exchange concrete. It changes the experience from voyeurism without consequence to active participation with real stakes at risk. When it all goes well, the reward is seldom what they expect and better than they could have hoped for.

Richard Renaldi drives the rural routes of America and wanders the city streets, taking photographs of strangers with his 8 x 10 camera over his shoulder looking for … what? He takes photographs of people he doesn't know, without fully understanding why, but trusting in the photographic act to peel back the veneer of the stranger to reveal the person, and the people we are, underneath.

MJ: Part of the reason I wanted to talk to you is because I think what you do is one of the hardest things any photographer can do, which is to photograph an ordinary person, a stranger, and make the photograph in such a way that it engages another stranger (the viewer). What makes you want to do this?

RR: I'm just drawn to certain people. I use the camera as a social extension; it's a way of engaging with people. When I studied photography and then worked in the field, I saw that a lot of attention was given to fashion and celebrity photography and I was never interested in that. I was drawn to real people and I wanted to make my art about real people.

The type of work that I do … leaves the viewer with questions about the subject's story. There is no narrative in still photography because it's just one still frame, but I think there is an implied narrative, or a narrative that the viewer creates.

MJ: One thing that I find interesting is how specific the people in your photos are: they're each unique, they're not archetypes.

RR: That's true, but when I'm out there, driving around or walking the streets with my camera, I'm doing my own casting. There are people I'm drawn to that I want to photograph, people that I might ordinarily stare at, or even flirt with. That's almost a subtext of portraiture, because there's often a level of flirtation.

I like people with character and there are certain places where you find that and others where you don't. I'm interested in rural and urban America, but not in suburban America. But, having said that, I think that you can find interesting subject matter anywhere.

MJ: Tell me about the 8 x 10 camera.

RR: My partner Seth had an 8 x 10 camera that he was no longer using, so I took it out to Madison Avenue just to try it out. I liked the way it slowed the shooting process down. I just fell in love with the amazing level of detail I got out of the negative, and the enlargements just took everything to a whole other level.

MJ: You're still printing analog?

RR: Yes, I don't print myself anymore, but all my prints are still done with an enlarger and using chemical processes.

MJ: I think sometimes that that's one of the problems I often find with digital, especially with younger, student photographers. Every tool we use creates a distinctive tool mark on the finished product. Traditionally, photographers have chosen to use certain tools because there's a unique character to the tool/camera that we find suits the work. Sometimes I worry that we've lost, or are in danger of losing, the individual personalities of what a Leica or an RZ 67 is, or the particular fingerprint of a certain film or paper. When everyone is using the same tools, then everything can start to look the same.

RR: That's true, but that means you just have to try harder to distinguish yourself within that.

In terms of the specifics to the 8 x 10, I don't think it's the camera, but I do think that when the camera is on a tripod there's a different dynamic between the photographer and the subject. There's a different gravity, and an implication of greater importance because it takes more time compared to a snapshot with a small camera that takes $\frac{1}{60}$ second. There's a different level of engagement, but you can still get it with a small camera. I also carry a digital SLR with me when I shoot and what I get from it is different, but I'm still interested in those photographs.

MJ: Shooting 8 x 10 color neg is really expensive (with processing, almost $20 per exposure). How many frames do you typically shoot of a subject?

RR: One or two, that's it. You learn to be very decisive. But you do have that big beautiful ground glass to preview your image. Still, there are other things that are left to fate, like the gesture of the subject.

MJ: Tell me about the "Touching Strangers" project.

RR: When I was shooting some of the bus traveler portraits that are in the *Figure and Ground* book, there were a couple of occasions where the portraits were of a group of subjects who didn't know each other. Instead of asking one person if I could take their portrait, I had to ask a group. I found it challenging to have to orchestrate that and I was interested in how the dynamics of the portrait were changed when two strangers were posed together.

My idea in "Touching Strangers" was to ask two or more people, who don't know each other,

▷ **MIKE, LAUGHLIN, NEVADA, 2004**

Renaldi photographs are simple and direct, which makes them accessible to a wide audience. However, the photographs are full of subtleties that reveal the photographer's careful attention. Note the placement of the foot on the white line, how the subject's face is framed by the mountains beyond, and the way his hat interacts with the horizon line.

◁ **JAIME, DENVER, COLORADO, 2005**

In his bus traveler series, Richard traveled across America photographing at Greyhound stations throughout the country. The photographs reflect a unique cross-section of American society and made use of the fact that his subjects had nowhere to go, and nothing to do besides killing time by posing for his lens as they made their own journeys.

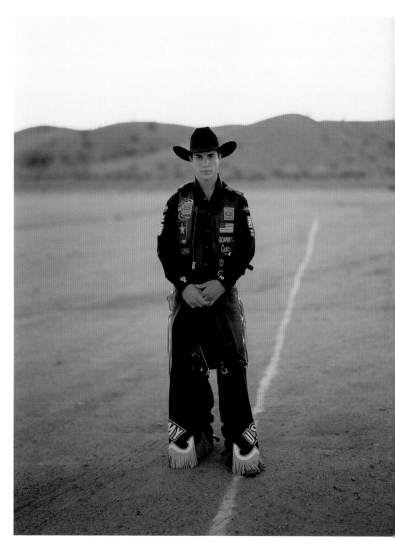

to be in a portrait together and ask them to touch each other. They started out very tentative, but as the work progressed I've become more involved; I've learned how far I can push people and the photographs have gotten more intimate. It creates these (I think) honest moments of bringing people together to perform this moment of contact for me and my camera.

MJ: So, it's almost a performance piece that you are orchestrating?

RR: Yes, and the pictures reveal these levels of discomfort, or comfort, depending on who the

people are. I was, to a certain extent, inspired by how we are fraying apart in our culture because of technology and online social networking.

It takes a certain leap of faith on the part of my subjects to consent to do this and it also forces the viewer to ask the question, "What would my reaction be if someone asked me to do it?"

It's also interesting because, without the background information of how I get people to pose together, the photographs create a fiction about the relationships between the people. There's an implied relationship. I hope the work challenges a number of social taboos.

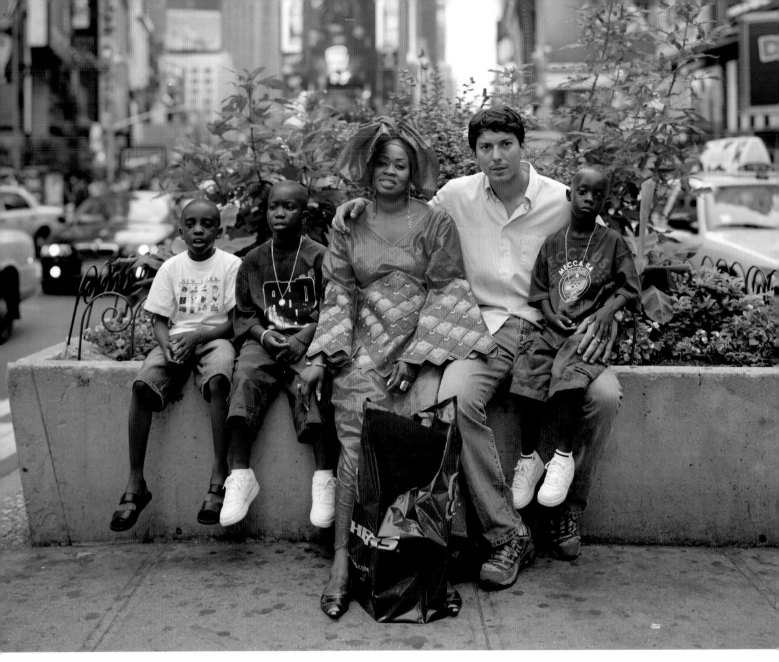

MJ: Do you get nervous?

RR: Oh, I get very nervous, it's like asking someone on a date. It can take a few minutes to build up my courage. When I'm out shooting the first person of the day it's hard, but then it gets easier.

MJ: I'm always terrified approaching strangers. It's easier for me when I'm on an assignment;

then I can be pretty fearless, because I can explain who I'm shooting for and what the story is about. One of the first assignments I give my freshman students is to go out and shoot 25 portraits of strangers and you can just watch the blood drain from their faces. They hate that assignment.

RR: That's a great assignment, but I can see why they would hate it.

MJ: How do you approach people?

RR: I'm pretty straightforward, I just walk up and introduce myself, tell them what I'm doing. I get everyone's name and address so I can send them a print later. I'm very direct, and I think that's a

◁ **CHEIKH, ALIOUN, GRACY, TERRY, PAPE, NEW YORK, 2007**

In his "Touching Strangers" series, Renaldi organizes group portraits of people who didn't know each other prior to Renaldi's introduction. The result is an emotional moment that is simultaneously fictive and authentic.

▷ **CRAIG, FALL RIVER, MASSACHUSETTS, 2006**

In his latest book Richard photographed young men in the community of Fall River, Massachusetts, a town where dwindling employment opportunities are challenging their traditional rites of passage into manhood.

lot of why the photographs look the way they look and why people react the way they do in my photographs.

MJ: How were you able to create a career as a fine artist?

RR: I've always been a project-based photographer, and I always have four or five projects I'm working on at the same time. I did a project on Madison Avenue that came to the attention of Christopher Phillips (Curator at the International Center of Photography, and NYU faculty member), and some of that work was included in the ICP Triennial in 2003. From that I got a show at Debs & Company and another at Yossi Milo Gallery (both prestigious private galleries in New York City's Chelsea art district).

MJ: Are you able to make a living as an artist?

RR: It has peaks and valleys, but yes, and I do get the occasional commission. I just did a pretty huge ad campaign for Microsoft that I shot in 2007 and 2008, where I traveled to 17 different countries.

MJ: Did you shoot that on 8 x 10 as well?

RR: Yeah, it was pretty amazing experience. They let me shoot exactly the way I normally shoot, but it was strange because I was shooting with a huge crew. Normally I work alone, but on the Microsoft job I'd be shooting and then turn around and suddenly be aware that there were 18 people standing behind me.

MJ: Did that affect you?

RR: Surprisingly, not really.

MJ: How did you start Charles Lane Press?

RR: I got my feet wet in publishing when I published my first book, *Figure and Ground*, with Aperture in 2003 and I found that I loved the process of putting together a book. I had been shooting in Fall River, Massachusetts, since 2000, and by 2008 I felt like I had enough work for another book. I approached Aperture again, but the timing wasn't right for them. I wanted to go ahead and do it, so I just took the money from the Microsoft job and created Charles Lane Press with Seth.

Fall River Boys was our first book, the first Charles Lane Press imprint. Then we published a book by another photographer, Alison Davies. Next year we'll be publishing two more books by other photographers.

It's a way of giving back to the community for us, and I love photography books, so it just seemed like a natural progression for me. The photographers we publish aren't in the mainstream. I think we're trying to publish work that wouldn't get out there otherwise.

MJ: Isn't that kind of similar to why you make the portraits you make?

RR: It is, and it goes back to your first question about why I make the pictures I make. It's because we live in a culture that celebrates youth, beauty, and surface, but that's not the reality for most of America. Most of this country, once you get out of the cities, is pretty poor. That's what the *Fall River Boys* project is about; it's about coming of age in an area where there are pretty limited economic opportunities.

MJ: Those are the guys we hire to fight our wars.

RR: That's right, I feel like the people I photograph are people whose stories aren't told, and those stories need to be told.

Emily Shur

CELEBRITY PHOTOGRAPHER

1976: Born in New York, NY.

1998: BFA, Tisch School of the Arts, New York University. Group exhibitions (selected): Sasha Wolf Gallery, NYC; National Portrait Gallery, London; Directors Guild of America, Los Angeles. Lectures: Art Center College of Design, Pasadena; Loyola Marymount University, Los Angeles; School of Visual Arts, NYC.

1998–2001: Freelance photo editor working at various magazines.

2001–2005: Working as a photographer in New York for magazines such as *Entertainment Weekly, Interview, GQ*.

2005: Relocated to Los Angeles.

2005–present: Living in Los Angeles, currently shooting for magazines, record labels, and multiple advertising clients including *Esquire, Fortune, Rolling Stone, Entertainment Weekly*.

www.emilyshur.com

Emily Shur is living the dream of many young photographers, working for the top magazines, photographing celebrities, and doing great work. She's exactly where she wanted be, but it wasn't easy to get there, and it isn't easy to stay there.

MJ: So tell me your story; you got out of school and then what?

ES: I did an internship at *SPIN* magazine when I was a student. When I graduated I worked in various photo departments for a few years at different magazines, mainly *Rolling Stone*. Then I went to *Newsweek* as a freelance photo editor, which was great because I was only there a few days a week and that allowed me to start doing my own shoots.

MJ: You're actually unusual because you never assisted for anyone. That's great, but doesn't it put you in the position of having to make it all up from scratch as you go along?

ES: Well, yes. I learned a lot from being a photo editor. That job really helped me to decide what I wanted to do and what I didn't want to do. But ... I feel like everything I know about being on set, lighting, and all the technical stuff I really

TONY CURTIS

This portrait of a Hollywood legend is lit simply, using just enough fill from the photographer's lights to keep the existing sunlight from obscuring his eyes with the shadow from his hat brim.

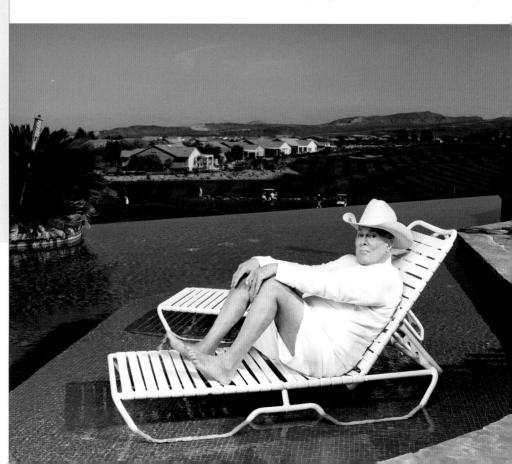

just taught myself by trial and error or trying to emulate images that I admired.

MJ: Tell me about your early shoots. You worked a lot for *Interview* early on …

ES: Yes, *Interview* was great because, even though they didn't pay anything, they really did make every attempt to help as much as possible with production and put together a great-looking shoot. Working with great stylists, hair, and makeup people taught me a lot about how to elevate my images and it got my foot in the door shooting entertainers and celebrities. The celebrity world is a tough nut to crack, but once you've shot a few, people are less hesitant to hire you.

MJ: How does your office work now? Do you have a team of stylists and assistants that you work with regularly?

ES: It's pretty low-key for me and I like it that way. I work out of my house. I have freelance stylists, digital techs, and assistants that I like and I work with regularly. My first assistant has been working with me for a couple of years now. I have two or three digital techs I work with.

MJ: What about stylists? When you shoot female celebrities, especially, I would think that pulling clothes and arranging for hair and makeup would be a big deal.

ES: I have people I like, but there is a little dance that goes on because celebrities often insist on using their own people for hair and makeup. I'm fine with that; there are other battles I'd rather win, and I want the subject to feel comfortable on set.

In terms of wardrobe, often the magazine will assign someone or I'll suggest someone I like, then we (stylist, photo editor, art director, and photographer) will all discuss the direction of the shoot and the stylist will pull clothes based on that. When the wardrobe arrives, the stylist and I go through the racks together and edit things before the celebrity shows up so we can suggest our favorites first. There are times when that doesn't work and we'll all have to compromise to find clothing that works for everyone. At that point, we have to go to the other racks.

MJ: Is there always a publicist on the set? Is it a problem working with them?

ES: Most of the time a publicist is present, but sometimes the celebrity will just show up with an iced coffee in their hand and be like, "I'm here, what do you want me to do?"

I'm fine either way. I get on well with the publicists and we all understand what we're there to do. I don't want to make a picture that pushes too far or asks someone to do something they're not comfortable doing. I think the subjects respect that.

MJ: But not all celebrity photographers will do that. I like Martin Schoeller's work a lot but it's not all flattering.

▷ **AMY POEHLER**

For her series of portraits of Amy Poehler, Emily posed the actress as various movie icons. Emily's use of research combined with her knowledge of lighting and styling cues enabled her to exploit some of the most iconographic images from popular culture to her advantage.

▷ ▷ **AMBER TAMBLYN**

Pose, wardrobe, and a lighting setup that is a skillful mix of available light with flash make the actress look beautiful, ethereal, and timeless.

ES: That's true, and you happened to pick one of the photographers I most admire. I think the fact that he gets people to pose for photos that may not be typical celebrity portraits is a sign of how much respect they have for him and the integrity of his work.

MJ: But there is an aspect of one hand washing the other, right? ... Are your photographs helping to establish the celebrity's brand and identity?

ES: For sure, but often that's when it's the most interesting because that's when it's the most collaborative. Those are the people who understand photography; they want to do something interesting. They have an affinity for photography and respect it for the art form that it is. They're not just trying to get it over with.
 And even if it's just a woman who's really beautiful, who knows how to pose and knows her best angles, well, that's helpful too. I try to appreciate the whole spectrum of how the collaboration can go. It doesn't help them, or me, to have bad pictures out in the world.

MJ: Amy Poehler seems like she went completely over and above the call of duty for what she was willing to do for the photos.

ES: She was amazing, and that is one of my all-time favorite shoots as well as one of the lowest-budget shoots I've ever done. It was so minimal. We did that totally bare bones, everyone was working for free ... She was the opposite of high-maintenance and a joy to work with. She made that shoot.

MJ: So there is a give and take between what they want, and what you want, because as photographers we want to make great pictures—but I'm sure there are a lot of starlets out there who just want to look hot.

ES: Absolutely, and you know, sometimes that's just what the shoot is. As I'm sure you know, the actual photography is often the smallest part of the whole process. Most of it is reading people and really listening to them. I'll meet someone and know immediately, "Wow, this is going to be a fun day," or I'll know, "This is what they're willing to give me. They just want to look hot, so I am going to make the best picture I can of them looking hot."

You have to know when you can push and when you can't. I can tell when someone is adventurous and when they aren't.
 Not everyone can do this kind of photography. There are definitely compromises that you have to make, but I love to photograph people who love to be photographed. I've always wanted to take pictures of people who were performers. I'm such a huge fan of television and movies. I love entertainers and I really do respect what they do.

MJ: Yeah, there is a part of the process that is about being a fan and being interested in the subject ... If you build your career around what you love, it's always enjoyable and an adventure.

ES: Exactly, I was an only child and both of my parents worked, so I watched a lot of TV as a kid, and I still go to the movies all the time ... It's easy to write off celebrity photography as superficial but it's not when it's done well, by people who do it well. It's really creative, and you get to work with some of the best people in their field. It's a real privilege.

MJ: Tell me about working with Michael Cera. Your photographs seem to reinforce his on-screen persona—how deliberate is that?

ES: Actually, in person he's exactly the same, very soft spoken, and quiet. I've photographed him a few times and like him a lot. He's one of the people who understands the process and he's always eager to collaborate.

MJ: Tell me about research and pre-production. Do you research people you don't know?

ES: Absolutely, I do a lot of Internet searches and I'll watch interviews they've done, but the most useful thing is to look at other portraits of them. It gives me a sense of what they're up for and how animated they are. If they don't seem very animated, then I know I'll have to build the shoot around lighting and other technical aspects instead of counting on getting a "moment."

MJ: Let's talk a bit about the technical stuff. You were shooting 4 x 5 for a long time. How are you doing your shoots now? How did the digital switch change things?

◁ **MICHAEL CERA**

Emily has done several photo sessions with Michael Cera. Unlike many other stars, who demand star treatment, Cera is easy to work with. This photo was shot on a street near Emily's home as they walked through the neighborhood looking for locations.

▷ **THE AIRBORNE TOXIC EVENT**

Emily's portraits of musicians always seem to respect the drummer as much as the lead singer. The palette of this photograph is all earth tones, which makes the very few white objects pop in contrast.

ES: I kept shooting film until recently, and I still shoot film for all my personal work. For my celebrity and music work I had to give in and start shooting digitally. When the budget allows I work with a digital tech and a medium-format Hasselblad camera with a Phase One back.

MJ: You rent the digital camera?

ES: Yes, it all comes as a package with the digital technician: the camera, the on-site computer. They do everything, the color calibration, the file processing. It took me a while to make the switch, and at this point in the industry having a great digital technician has really become as integral to the whole shoot process as having a great first assistant....

When the budget is tight I shoot with a Canon 5D Mark II and I use Capture One software to do the color correction and process the files myself.

MJ: Tell me about shooting musicians and bands.

ES: Music photography is probably the hardest thing I do. They're not actors so they sometimes aren't interested in performing for the camera, and their image is usually something they've cultivated pretty carefully. Once in a while, I get to do something conceptual, but most of the time it's about helping a band achieve the image they've set for themselves.

MJ: Ah-ha! Yes, of course, actors make a living by pretending to be someone they're not, while musicians are all about the authenticity of their persona ... I always think it must be like shooting the board of a Fortune 500 company. You might want to put the short guy in the front because he's short, but suddenly you realize that he's just an accountant and you've offended the CEO because you stuck him in the back. It seems like you have to be really sensitive to the internal politics of the band. I notice that in all of your band photographs they're democratic, you've found a way to give everyone equal stature.

ES: With band shoots I just try to keep it loose while structuring the composition of the photo, so the people are just visual elements in the frame. Sometimes, someone will step in and let me know how they like to be positioned, either emphasizing a certain member or insisting that no one gets emphasized. That's fine; my job is to make a good picture within the parameters of what they need.

MJ: What do you think is the biggest misconception about what you do?

ES: People think that because you're photographing glamorous people you must be living a glamorous life. They don't think about the red-eye flights, waking up at four in the morning, getting to the set hours before talent to set up, etc. It's really hard work. You sweat and get dirty.

You can't do it for the glamour or the money. There isn't much glamour and there are other areas of photography where you can make a lot more money. You have to do it because you love it.

Kristen Ashburn | PHOTOJOURNALIST

1973: Born in King of Prussia, Pennsylvania.

1997: BFA, Tisch School of the Arts, New York University.

2003 and 2005: World Press Awards.

2003 and 2006: National Press Photographer Awards.

2003: Marty Forscher Fellowship for Humanistic Photography.

2004: Canon Female Journalist of the Year award.

2004: Featured speaker TED (Technology, Entertainment, Design) Talks.

2006: Getty Foundation Grant.

2007: Pictures of the Year award.

2007: Emmy Nomination for "Bloodline: AIDS and Family" multimedia project.

www.kristenashburn.com

Photojournalism may be the most difficult career in photography, both financially and psychically. Even in the heyday of the great picture magazines, the path of the photojournalist was never easy. But at least David Douglas Duncan and his contemporaries could be assured that their photographs, etched on Tri-X by light filtering through the haze of battle, would be seen by the public. The photojournalists of today are no less brave, the stories no less important, but it is increasingly difficult for stories to get the exposure they deserve.

Kristen Ashburn is a true believer in photography's ability to move the viewer and inspire social change. In a person with less passion, energy, and drive it would be easy to dismiss this as naive idealism, but Kristen has built a reputation as one of the world's foremost photojournalists by skillfully balancing her lofty ideals with pragmatic activism and dogged hard work.

It is the privilege of the photojournalist to witness the beautiful, tragic, and moving moments that shape our time. With the privilege of witness comes the responsibility to testify, to use the photographs' descriptive power to supply evidence beyond fact. Kristen's photographs are testimonies written with light, inflected with the photographer's compassion and intelligence.

MJ: Let's start from when I met you in the darkrooms at NYU. You were printing photographs of the Romanian orphans which, in itself, was an amazing project for someone in their junior year. Tell me about that work first.

KA: I was a young photographer trying to figure out what I wanted to do and I had always admired the work of photojournalists. The act of documenting our collective history felt important to me, and that feeling led me to want to be a photojournalist. It seemed like a noble path.

While in college I saw the pictures and footage, like everyone else, of what was happening in Romanian orphanages after the '89 revolution. A family friend, Monica McDaid, who was a schoolteacher in England, had also seen the news about the orphan crisis. She organized a bunch of truck drivers who volunteered to drive supplies to Romania. Once they got there they found horrific conditions: Children kept four to a cot, open sewage, rat infestation, no electricity, it was beyond imagination, really. The news stories didn't prepare her for what they would see. That was the start of her relief effort and her organization called The Romanian Challenge Appeal.

I signed on as an aid worker for her the summer after my freshman year. It was my first real international travel. My role was to work with the children first, photographer second. I had to shoot clandestinely because, by that time, Romania was aware of the negative press and didn't want anyone, including aid organizations, to document what they were seeing. Over the years I kept going back during my summer and winter breaks to volunteer and I kept shooting. I was acutely aware of my role and how involved I was as a volunteer, but I kept my objective distance as a photographer. I would only photograph once the job was done, during the in-between moments.

Toward the end of my work with the organization, during my senior year at NYU, I organized an art and photography auction to raised money for the Romanian Challenge Appeal. It was then that I used my photography not only to raise awareness but also to raise funds. After working so closely with the children, it was impossible to sit back and not try to do more to help. In a way, this set a pattern for how I approached other projects I've worked on. I've crossed the line into activism on a few occasions.

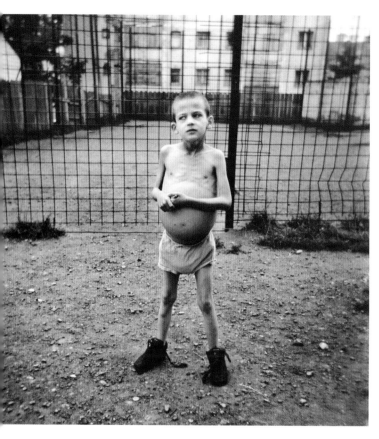

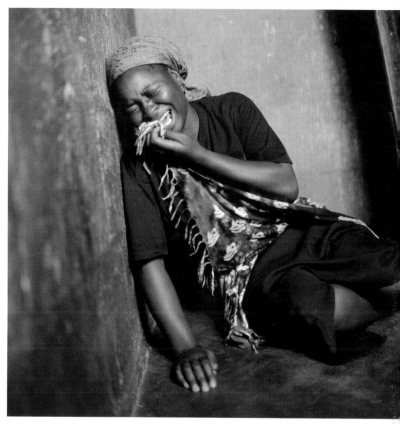

MJ: You worked for the fashion photographer Steven Klein after school.

KA: Actually, I first worked as a printer at a great lab, MV Labs, in New York City. It was later that I met Steven through the lab. When Steven needed a studio manager, he asked me to come work for him.

MJ: Working for such a high-level fashion photographer seems like an odd detour. Did that influence or change your work?

KA: Not visually, but to see a highly functioning photographer work was amazing. His level of commitment was incredible to witness and his energy and constant production was prolific.

It was during those years working with Steven that I was able to think about and research my next move. I was making money and saving it so that I could eventually quit my job and pursue my own photography.

I began to follow articles dealing with the AIDS pandemic in the *Times* and the *Village Voice*. The *Voice* had just won a Pulitzer for their work on the topic. The story was so large and so reaching that I couldn't understand why more wasn't being done to cover it. I decided that would be my next story. I wasn't sure where it would lead me, but I was willing to take the leap. If I was going to spend my time and money to work independently, I wanted to make sure the story was something I could completely commit myself to.

MJ: And that trip launched the "Bloodline: AIDS and Family" project? You funded it all yourself?

KA: At first, but then grant money and resale of the work funded trips. My first trip I spent almost six weeks between Botswana and Zimbabwe. When I returned to the States I contacted Robert Pledge, of Contact Press Images, who I had met while working at MV Labs. I showed him the

◁ **ROMANIAN ORPHANAGE SERIES**

The term photojournalism implies the objectivity and necessary skepticism required of a journalist, but all photographs are edited versions of truth. The simplicity of Kristen's work forces the viewer to examine his or her own humanity and empathy without calling undue attention to the photographer's role in how the information has been filtered or interpreted.

△ **AFRICAN AIDS PANDEMIC**

The heartbreaking situation in Africa is well publicized now, in no small part because of Kristen's work—proof that one determined person can make a difference.

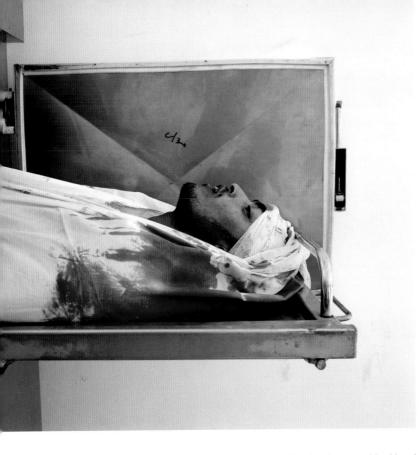

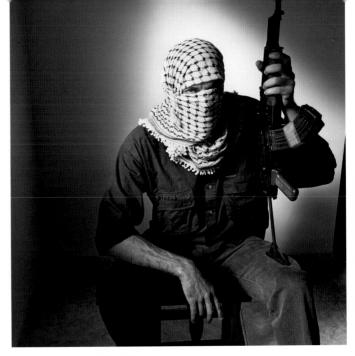

FAME IN THE AFTERLIFE

In Kristen's portraits of living Shaheeds, her subjects are always masked to conceal their identity. She was only able to photograph their faces after they had died. This is oddly appropriate, since the goal of a Shaheed is not to achieve fame in life but in their death.

work and asked him to help edit it. He agreed and once he saw the work he agreed to help get it published. He's very generous to young photographers that way.

It was really through his guidance that I was able to make the leap into the professional photography world. He sold the story to magazines and encouraged me to apply for grants and awards. That was the year I won the first of my World Press Awards. All thanks to Robert's encouragement.

MJ: One of my favorite projects of yours is on the suicide bombers in Palestine. How did that project come about?

KA: I think I was working on a project on Israeli settlers at first. This led me to better understand the Intifada and what was really happening in the West Bank and Gaza. I began spending more time in Gaza, which was a very tricky area to work in because the Israeli government had locked down the area. I had a friend who I trusted with contacts there, he connected me to a reliable fixer he had used in the past. *[A fixer*

is a local contact hired by photojournalists to help translate, travel in dangerous areas, and negotiate with the local authorities and population.]

I kept seeing all these posters and billboards memorializing Shaheeds (martyrs) on almost every street corner. I wanted to understand the culture of what these Shaheeds meant to their community. I started by going to the families of the Shaheeds and interviewing them. I just did portraits and interviews to gain a broader perspective of what these peoples' deaths and actions meant to their families and friends. From there I was able to gain access to men and women who were training for suicide missions.

It was an unnerving experience. I was taken to places … secret places. My guides took great lengths to make sure I wouldn't know the true identity of the subjects. It was fascinating, and risky. After talking to them for a while, hearing their voices, I became a little more relaxed. There was this strange mixture of fear and comfort. Fear because I could only see their eyes and I knew what they most wanted to accomplish in death, and comfort because I knew I was sitting

across from another human being, even if they happened to be wearing an explosive belt

MJ: As photojournalists go, your work is far more portrait-based. I also think that visually it's diabolically simple, and I mean that as a compliment. There's very little of the traditional action and visual tension that we normally associate with photojournalism. What is it about the portrait that serves your work?

KA: Because of the influence of the decisive moment and Cartier-Bresson, there's a history of photojournalists capturing life in this very designed and composed way. I never put much energy into that. I was more interested in the story. Not that there's anything wrong with that style: it can be beautiful and poetic, and it's an important way to see. It's just not always me. Maybe the story always felt stronger than the style and forcing a style took me further away from the truth of the subject.

You're so drilled on aesthetics in school: How to compose a frame, think about the foreground, the background. It was overwhelming to me. Not

that I didn't try. My first camera was a Leica that I saved up for ages for … I truly love the purity of that camera and the approach.

Then I switched from working with a Leica to working with a Rollei. It was a little disorienting at first, because everything is reversed, but I was interested in the simplicity. With the Rollei I could just point at the subject and shoot …

I experimented with a bunch of cameras over the years, the Mamiya 7, the Fuji 6 x 9, Rollei, Leicas, but most of my work was done with the Rollei. In a way, it's a reflection of my weakness as a photographer; my lack of interest in the technical aspects of photography.

I'm trying to perfect my skills with digital now, although my recent work in Haiti was shot with the Rollei. I tripped my second day there and almost fell into a pile of bodies. It was pretty disturbing. I damaged the lens on my digital camera, which forced me to use the 10 rolls of 120 black-and-white film I brought with me. It wasn't much, but I shot the whole story with it, which worked out because that camera has this ability to record all the subtlety of the scene. It forced me to slow down and really look. There was so much happening, but when you stopped and took a few more minutes to look, you could see under, or through, the rubble in a way. Bodies emerged through the chaos and the rubble everywhere.

I'm impressed with work I've seen other people do digitally so I've taken up the challenge of relearning photography digitally. As you know, it's more like shooting slide film so you have to be a lot more careful with the exposure. You just don't have the same latitude you have with film. I'm happy with the results I'm getting from my digital camera and I like working with it.

My newest project on albinism is all shot digitally. I just bought an 85mm f/1.2 and I'm excited by how the lens renders the subject. But ultimately I want the person, or the situation, to speak for itself. The camera is just the means to the end.

MJ: Falling into a pile of bodies brings me to another point I wanted to talk about; in our lives as photographers we see things that most people don't see … Is there a psychic toll from the work? Does it change you? And in a way, don't we do it in order to be changed?

KA: Well, yes, it has to, how could it not? We're still human at the end of the day. Each situation

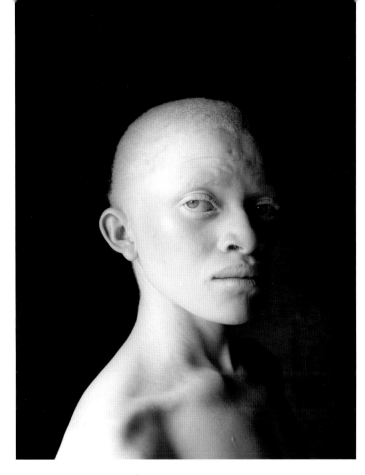

ALBINISM

While working in Malawi on her AIDS project, Kristen became aware of the unique medical and social problems of albinos living in equatorial Africa. However, in this case Kristen's social concerns were somewhat secondary to her attraction to the unique physical beauty of albinos. One interesting aspect to the project is that unlike her other work, the subjects need no surrounding environment, wardrobe, or narrative, to supply context. They wear their story on their skin.

affects you differently, but as I've matured I think I've found a way to cope and process my feelings better.

I think the Romanian orphan project was the most difficult for me to process, because it was my first experience, and you know, what's that expression—"The first cut is the deepest"? Landing in that situation, seeing how systematically abused these children were … it just opened up a window into how barbaric we can be to each other. Crossing that threshold was probably the most significant for me.

It's interesting, on my first trip to Africa people would ask if they could see other work I'd done. I had my computer with me so I'd show them the Romanian work. It was amazing. No matter how poor the people were, no matter how dire their own situation was, the Romanian photographs always shocked them. The idea of housing children like animals was beyond anything they could imagine.

Nothing surprises me any more, but it's been an education. As awful as it can be, I have also

had so many positive experiences. I can meet someone in an African village in the morning and find myself eating dinner and staying the night in their home that night. People have opened up their world to me. There's incredible generosity out there, so that balances it out for me a bit.

MJ: I'm curious, now that you are shooting digitally with the Canon 5D Mark II and having produced your "Bloodline" multimedia piece, are you interested in shooting video?

KA: Absolutely, I've been fortunate enough to be a little ahead of the curve on that. I have always collected audio on all of my stories and later collected video as well. As powerful as the still image is, there are limits to what you can translate and communicate to the viewer. Sound is a powerful component of our experience. It's a no-brainer; we'll all have to become conversant with it as we move away from the old models of magazine stories on paper pages. It's just another challenge I'll have to master. It's all about the story.

Karen Cunningham

FAMILY PHOTOGRAPHER

1969: Born in Princeton, NJ.

1991: BFA Tisch School of the Arts, New York University.

1991–1996: Photojournalist. Clients included *New York Daily News*, *New York Times Magazine*, *Vibe*, and *The Village Voice*.

1996–2004: Karen Cunningham Fine Art Printing. Master black-and-white printer using traditional gelatin silver techniques as well as gum-bichromate, platinum, hand coloring, custom toning. Clients included *New York Times Magazine*, *National Geographic*, and *Vanity Fair*, Mark Seliger, Amy Arbus, David La Chapelle, Patrick Demarchalier.

2004–present: Karen Cunningham Photography Boutique Wedding Studio.

Fine Art Group exhibitions:

2009: The Barn Gallery, Massachusetts.

2006: Kala Art Institute, artist in residence, San Francisco, CA.

2001: PS122 Gallery, NYC.

1999: Harper Collins, NYC.

1999: Throckmorton Fine Art, NYC.

1998: Artspace, Virginia.

www.karencunningham.com

Wedding photographers are some of the best photographers in the field and they seldom get the respect they deserve.

Weddings are challenging, requiring the photographer to have skills in photojournalism, still life, architecture, and interiors, as well as studio and location portraiture. A wedding is an event, a fast-moving freight train that won't stop while you load film or fumble with lights. The pressure can be intense: guests will make requests for candid photos just as you are setting up for a very important formal portrait, churches and clergymen will restrict your access during the ceremony, the wedding cake will come out just as you have sat down to take your only break in a grueling day. This is hard work: 12-hour days are common. It requires diplomacy and a genuine interest in the event; outstanding people skills are mandatory. It's not easy, but the challenges are also what make wedding and family photography one of the best educational and rewarding experiences available for young photographers.

Karen Cunningham has had a few different, and very successful, careers in photography, as both a photojournalist and as a custom printer for an amazing roster of A-list photographers. It all adds up to a savvy woman who brings skill and dedication to every assignment.

MJ: So you've gone through some career moves and changes. How did you settle on shooting weddings as a career?

KC: I started out as a photojournalist. I went to the former Yugoslavia in '91/'92 at the start of the war on my own to cover the diaspora of refugees from the former republics. When I returned, I freelanced for the *Daily News* and the *New York Times* as well as *People* magazine. I liked the work for several years, but found the lifestyle of journalism incompatible with my lifestyle. The compensation was poor and left me with little time to pursue my own artwork.

I started a custom printing service by accident. Edward Keating, who worked for the *New York Times*, asked me if I knew any good printers for a book he was working on at the time. I volunteered. I had worked as a printer at a high-end black-and-white lab all through college. The lab was started by Andy Warhol and Peter Beard and serviced high-end fashion and editorial photographers such as Patrick Demarchelier, Bruce Weber, and Annie Leibovitz.

After the job I did for Eddie, Kathy Ryan, editor of the *New York Times* magazine, called me to ask if I would print for them. It was through the *Times* magazine that I printed for Gilles Peress, James Nachtwey, Antonin Kratochvil, Eugene Richards, and many others, but as digital became the dominant medium, silver-print work declined and I felt I had to rethink things.

Weddings were a good fit for me because I was always interested in the social dynamics I observed when I was shooting news stories, and weddings are all about social dynamics.

One of the big draws for me was the lifestyle of the wedding photographer. There's a wedding season, and I work really hard during the season, then I have big blocks of time when I'm free to work on my personal art. Unlike a lot of photographers—like you, for example—I've always considered commercial photography as my day job. My creative outlet is in my printmaking *[Karen is also an accomplished printmaker who exhibits her photo-etchings]*; weddings give me the time to make my art.

MJ: Because you're primarily working on weekends when you're shooting weddings?

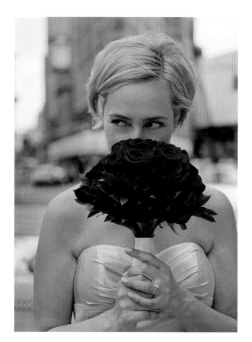

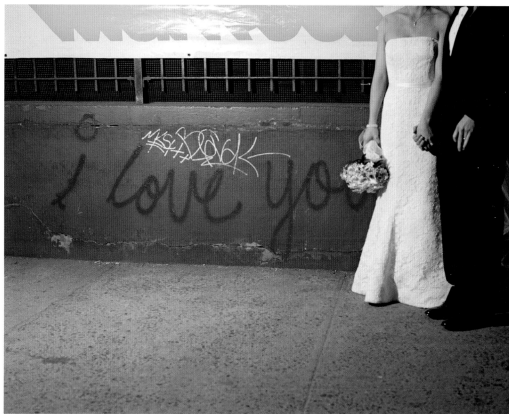

BEGUILING BRIDE

While this photograph looks simple, it packs a lot of relevant information for the bridal couple; featuring the bride, the engagement ring, the bouquet, the location, the dress and hairstyle, as well as her flirtatious glance to the groom.

▷ STAY ALIVE TO THE SCENE

Karen's background in photojournalism is most evident in the "off moments" she often discovers in the course of shooting weddings.

KC: It's actually a solid five- to six-day-a-week job during the season, but yes, during the winter I have some time for myself to make art.

Weddings were also a good fit for me because it combined a set of skills I already had. I'm really good at flattering reportage, and environmental portraiture.

MJ: So take me through your gear: you used to shoot film, now you're shooting with…?

KC: Nikon D300s, and I chose them primarily because of the size. I'm 5 feet 4 inches (1.6m) and weigh 115 pounds (52kg). I have to carry those cameras all day. The D300 was the best combination of quality with portability. I have two Nikkor 17–55mm f.2.8s and that's pretty much all

I shoot with. I do have a 105mm that I'll use occasionally, but I'm very "Cartier-Bresson": I like the 50mm perspective. I like the equipment and technique to be simple.

MJ: And for lighting?

KC: I use a Nikon flash set to TTL on the camera and shoot in manual mode on the camera, so I'm controlling the exposure manually by using the aperture and shutter speed in combination to create different mixed light and shutter drag effects. My assistant has a Lumedyne on a stick (mounted to a monopod) that's triggered by a Pocket Wizard connected to the camera. We have a fairly elaborate sign language that we use to communicate across the room, so I can tell him how to set the power and where to point it.

MJ: You don't set up stationary room lights?

KC: Less so now that I'm shooting digitally. At ISO 800, the files are still super smooth and I have all the ambient light I need. A lot of high-end weddings these days hire lighting designers, so I want to make sure I'm not overpowering the existing light.

MJ: When you were working as a printer, you were able to dig through the contact sheets of some of the world's greatest photographers. What did that teach you?

KC: It was great; I got to work with the best photographers in the world. From the photojournalists I learned how to approach a subject and tell a story. I also learned their palettes. Antonin [Kratochvil] is very dark, big expanses of shadows, whereas others were really open and light.

From the fashion photographers I learned more about lighting: how you can use contrast to add some age and maturity to someone who is

really young, or how you can project an emotion onto your subject by just using light skillfully.

I also learned a lot about how to get people to pose with their whole bodies: You know, you'll do a portrait and then you look at the person's hands and then realize they have a clenched fist because they're nervous. Fashion photographers taught me to look past just making a flattering portrait of someone's face and to look at the whole body. I'll tell people to shake out their hands and other things to get them to relax their whole bodies … I'll get them to move around and then shoot just as they stop.

One thing I learned from working for fashion photographers is that models really work hard! There is nothing easy about what they do.

MJ: Absolutely, and they are smarter than anyone gives them credit for … I used to be so concerned about being ultra-professional that I never flirted with models as I was shooting, but now I realize that even they need a little bit of help, and they know that the flirting isn't serious.

KC: And with untrained subjects that's even more true: you have to let them know they're doing a good job. They need the positive reinforcement and they can't ever feel as though you're judging them. Even if the lighting isn't quite right, I'll start shooting just so the subject doesn't think it's something about them. Then my assistant and I will make adjustments as we're shooting.

MJ: So take me through the day … I haven't shot many weddings but what I remember was that there was this great long list of about 75 pictures I was expected to get: Mother with bride, father with bride, grandparents, bouquet being thrown, etc. Do you have a script of shots?

KC: I don't do that. I have an itinerary of what's going on over the course of the day. I allow one hour for all the formal portraits. I spend 20 minutes with just the couple and then 20 minutes with the family, the extra 20 minutes I'll use to fill in anything I might have missed. I try to never do more than 10 to 15 portraits of all the family combinations, which requires the family to come up with a realistic list, that is just what they really want for the family portraits.

I make a list of everyone's names and I have them all memorized before I get there. I address everyone by name, never their title like "Mom" or "Maid of Honor." I think that's important.

MJ: That's an amazing skill and strikes me as very, very important.

KC: Well, I type up the list for my assistant and once I've done that then it's in my head, but that's also part of my emphasis on being "the family's photographer" … Little things count; like my assistants and I never shout out to each other or to the family, because I want to reinforce that idea of being the family photographer.

MJ: One thing that scared me about shooting weddings is that it seems like there's often a disconnect between what I shoot and what people remember. It's this great day for them, but maybe they don't notice how tacky the banquet hall is, that kind of thing.

KC: Yes, but that's often a very positive thing as well. They often look through the proofs and say, "Wow, I didn't see that!"

One thing that's interesting to me, as a woman who has a certain awareness of her own style and appearance, is that I realize that we seldom really see ourselves. We tend to look at ourselves in the mirror from the one angle that we think makes us look good. So I'll ask the subject specific questions about what they might feel uncomfortable about. Later, when we're reviewing the shoot I'll gently bring up the idea of retouching certain pictures and just explain that, because modern cameras and lenses are so good, any woman would have to be 12 years old to look flawless without retouching, which is really true.

MJ: Right, and a lot of "flaws" are actually caused by the way the camera records things, like the extremely short exposures of flash lighting.

KC: And formal wear. Most people don't dress formally very often and you have to carry yourself differently. Strapless dresses and tuxedos require a different posture and presence than a t-shirt and jeans. Look at pictures of the Royal Family sometime. They really know how to do it!

MJ: Tell me about your workflow.

◁ **GO WITH
THE FLOW**

Unlike many wedding
photographers, Karen lets
the subjects relax, relying
on psychology, location,
and composition to carry
the photograph.

▷ **SPECIFICS MAKE
IT SPECIAL**

A photo of the bride
and groom kissing is
de rigueur in a wedding
album, but Karen gives
it a fashiony taste of
New York.

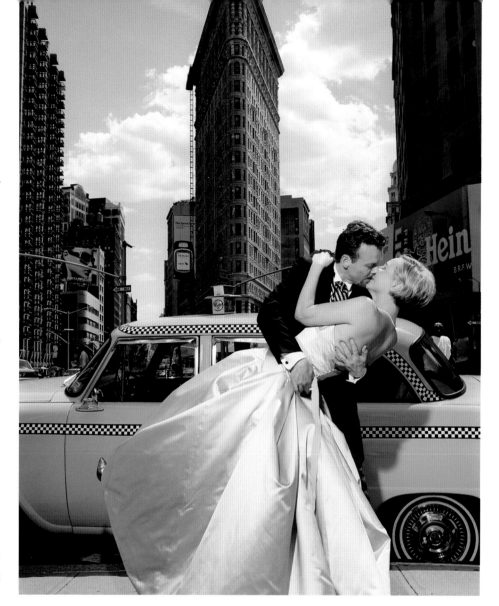

KC: My assistant downloads the cards and backs
them up to an external hard drive during the
wedding, but none of the cards are erased until
all of the files have been loaded into the desktop
computer back at the studio and backed up
again. Then we load them into Lightroom and
I do 90 percent of what I need in Lightroom.
Occasionally I'll go into Photoshop to use the
"liquefy" tool to slim someone's arm or something,
but Lightroom does almost everything I need.

 Then I upload the shoot into a web gallery for
the client to look at, and have a "proof" album
made. Most young couples are comfortable
looking at the photos online but sometimes
parents and grandparents aren't as computer-
savvy, so the proof album is important.

MJ: So what's the appeal of this for you? I mean
I know there was an economic imperative, but
why weddings?

KC: There was an aspect of shooting weddings
that held the same satisfaction I had as a printer,
because I was helping someone else realize their
vision. I liked being in that position as a collaborator,
but I also had the autonomy that I enjoyed when
I was a printer. I'm the art director, the editor, and
the photographer of the story …

 I love observing how people interact. But
also, as a woman I'm fascinated by the fashion
component of weddings and how the women
present themselves to the public and to their
husband. The wedding dress started out 300
years ago as way of presenting a dowry and was
a symbol of a family's wealth; in many respects,
it still is.

 I heard a famous wedding dress designer on
a TV show advise brides to look at the wedding
aisle as a fashion runway. That comment made
me think about how we live in a society where
style and beauty is actually a route to power, with
celebrities for instance. These brides, especially in

New York, want to present themselves as stylish.
It's exciting and fascinating to record.

MJ: And that's interesting because the family is
commissioning you, which is very different from
someone like an editorial photographer. In your
case, you are entrusted with carrying their
projected image forward.

KC: Um yes, but it has more facets than that.
Part of it is simply recording, telling the story of
what happened that day, and they also want
great portraits of people who are important to

them. But I think the most important aspect is
about creating something concrete, a document
of all the planning that they have put into the
event over the course of a year. A wedding day is
ephemeral. My album is one of the few concrete
things that they take away from the day. There's
a certain satisfaction in that.

Sarah Wilson

1977: Born in Durham, NC (raised in Austin, Texas).

1996–2000: Photography, NYU Tisch School of the Arts, Department of Photography and Imaging.

1999: Intern for James Evans in Marathon, Texas.

2000–2001: Awarded the Daniel Rosenberg Traveling Fellowship to complete project about the Cajun area of Southwest Louisiana.

2000: Solo show of Louisiana Project at NYU's Gulf and Western Gallery.

2000–2003: Assistant to photographer Mark Jenkinson.

2000–2004: Project about the town of Jasper, Texas, in the aftermath of the brutal murder of James Byrd, Jr.

2004: Published *Jasper, Texas: The Road to Redemption* (University of Texas Press). Exhibited in six cities in Texas, and showed in New York's White Box Gallery.

2005: Stills photographer and field producer on Keith Maitland's film, *The Eyes of Me*, a documentary following four blind teenagers at the Texas School for the Blind and Visually Impaired.

2006: Volunteered as prom night photographer for the Texas School for the Blind, and has volunteered every year since.

2008: Awarded the PhotoNOLA Review Prize for "Blind Prom."

2009: "Blind Prom" shown at Foley Gallery in New York, New Orleans Photo Alliance Gallery, and Lishui International Photography Festival, China.

Currently working as editorial photographer for magazines such as *The New York Times Sunday Magazine, Texas Monthly, Time, The Atlantic Monthly, Mother Jones,* and *Der Spiegel.*

www.sarahwilsonphotography.com

THE BREAKTHROUGH PROJECT

In the past, the concept of "the extended project" or photographic thesis was usually reserved for graduate students working toward an MFA. Now, almost every undergraduate class in photography relies on each student completing some form of extended project for every class.

From a teacher's point of view, extended projects bring real intellectual rigor to the classroom and teach students to build a consistent artistic process and a coherent identity. Most important, extended projects require a strong work ethic that helps students break free of "the lucky shot" mentality.

However, there is something inherently artificial about any project that starts at the beginning of a semester and is expected to be complete by the end. Students, under the pressure to perform, will often choose to work on an idea that isn't motivated by an inner creative need, but something that is less ambitious and can be completed within the constraints of the class schedule. Real projects, by real artists, evolve much more organically.

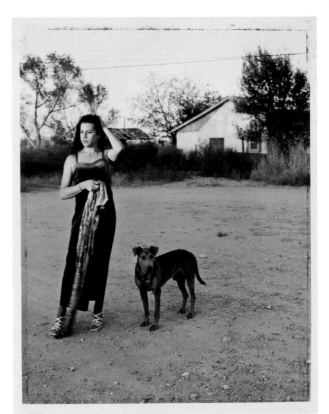

FREDDIE GONZALEZ
Freddie Gonzalez, a transvestite who was well accepted in the small town, and worked as a waitress at the local pizza shop.

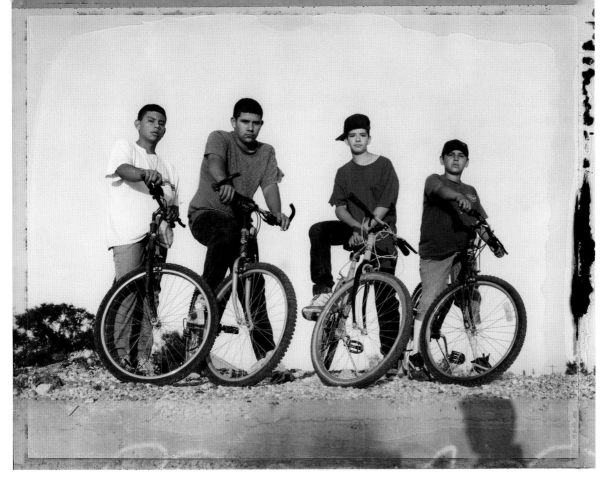

Sarah Wilson was a student that came to my attention as a freshman at NYU. She was funny, smart, and creatively ambitious. These qualities, combined with a strong work ethic, should have made her a standout, but she just couldn't seem to find her focus.

In the summer between her junior and senior year Sarah went to the small town of Marathon, Texas, to intern with local photographer James Evans. She came back knowing what she wanted to do with her life.

Since then she's gone on to shoot many more projects, including stories on the racially motivated murder of James Byrd, Jr. in the small town of Jasper, Texas. Most recently she has been working on a new extended project,

"Blind Prom," at the Texas School for the Blind and Visually Impaired in Austin, while balancing a busy career as a contributing photographer for *Texas Monthly* magazine and shooting a variety of commercial assignments.

MJ: So, we know each other way too well [*Sarah was my assistant for three years*], but tell me about the Marathon, Texas, pictures. What was different about working there? What did it do for you?

SW: I had the opportunity to go assist a photographer there. Marathon is a small town of about 400 people in the West Texas Desert and I had just come from being in New York for three years. I grew up in Texas, but I had never lived in a town that small. Going from New York to Marathon I was suddenly in a community that I could really sink my teeth into. Within two weeks I knew everybody's name and I could wave to everyone as I drove by.

It was a place I could really get a handle on; the story of this community just unfolded itself to me very quickly. It felt like I was in a sitcom about a small town and I was another one of the characters in the story. It was very accessible to me; I could meet everyone and also be part of the community. Asking to photograph someone was nowhere near as scary as doing a portrait project in New York City. It was more open. It was the perfect place to do a first portrait project.

MJ: And the town seems almost like a Twin Peaks kind of town. I mean, I don't know too many small towns that have a town drag queen. It seems very typically Texas, but also very liberal at the same time.

SW: (Laughing) I know. There are great characters. There's a real mix of people. In that little pocket of West Texas, there are a lot of real progressive people and some real traditional cowboys.

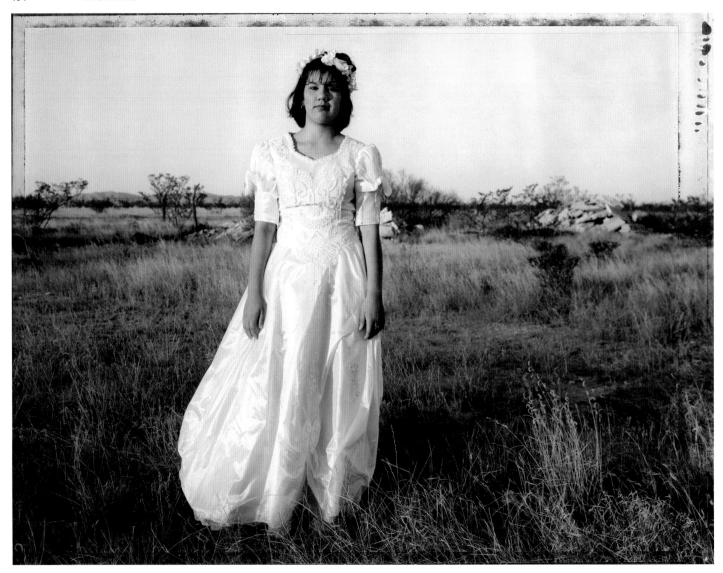

MJ: Tell me about shooting 4 x 5, what did that do for you? It wasn't really your medium before this.

SW: No, not at all. I had been playing and shooting with a lot of cameras, but I didn't have a real solid idea for what I wanted to do with photography before I did this project. I learned a lot from the photographer I was working for and he had a 4 x 5 field camera I was able to borrow.

I remember we were on a road trip assignment for a magazine and we saw an awesome exhibit in El Paso by the photographer Max Aguilera-Hellweg about Texas border towns that he shot on 4 x 5 Polaroid pos/neg. They were these beautiful portraits of these really interesting characters in the Mexican and U.S. border towns that he had shot for a story in *Texas Monthly*. There was one I remember of a kid with an inner tube on his head because he was getting ready to cross the Rio Grande into the

U.S., and other pictures of barbers, the town prostitutes, just amazing people. I also loved the clarity and crispness of that film. I went back to Marathon the next week and knew what to do.

MJ: I know Aguilera-Hellweg's work well. It's amazing. I used to borrow that particular portfolio to show in class. It was just 8 x 10 prints mounted in a handmade book constructed from cardboard and plain brown wrapping paper, then tied together with a piece of twine. It was a

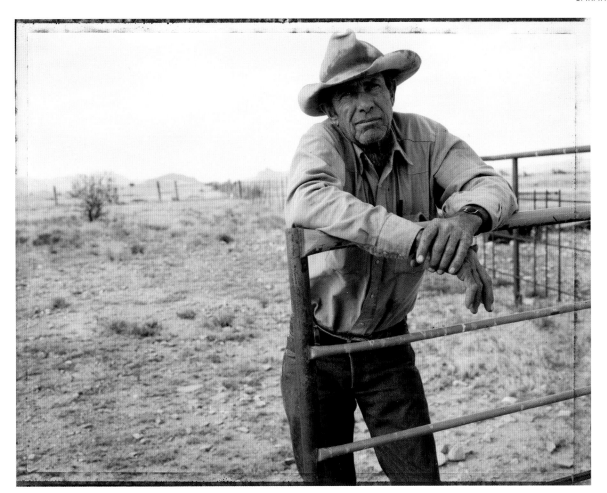

◁◁ **BRENDA**

This portrait of a young woman with her Quinceañera dress (a celebration of her 15th birthday) blowing in the breeze combined with the long shadows of the late afternoon light speaks volumes about both the culture and landscape of rural Texas.

◁ **IKE ROBERTS**

Shooting with the limited depth of field of a large-format camera can make it difficult for the subject to stay in the plane of focus. In this portrait, Sarah helps the subject by allowing a pose that feels natural, but also locks him into position.

fantastic low-tech presentation device that completely launched his career as a magazine photographer.

SW: I actually called him after I saw that work, he was really nice and we talked for a long time. It was pivotal moment for me. Suddenly what I wanted to say was all right in front of me. I went back to Marathon and made it happen.

MJ: The beauty of that Polaroid pos/neg film was that you had something you could hand to someone after you took their picture, like a thank you. It helped them understand what you were trying to do, it was great for establishing rapport with the subject.

SW: Yes, and that 4 x 5 was so much fun. I remember photographing this rancher, Ike Roberts, and I can tell he's thinking, "What is this girl doing? And why is she putting so much effort into a picture of little ole me?" Using the 4 x 5 camera is a really formal way of photographing someone; it takes time and it's like you're really honoring them. You're taking a real portrait, not just a snapshot.

MJ: Part of what makes you special is your amazing ability to just charm everybody. People really like you, and it's so apparent in all of the pictures. How do you approach someone?

SW: I really bend over backwards to make people comfortable. I feel like a therapist; in fact, if I weren't a photographer that's what I'd probably

do. It's all about having empathy and the ability to really put yourself in their shoes. I could probably be happy sitting on a couch and just listening to people, but the great thing about being a photographer is that you get to go into their world. I feel like when I photograph someone I completely immerse myself in their life.

MJ: I think the pictures reflect that. It's like the interaction between you and the person is the real reward. I think you're genuinely interested in everybody you photograph, that's a gift in itself.

SW: Yes, coming away from a situation, sometimes it's not about the photography so much for me, it's about the moment I got to share with someone I didn't know yesterday.

Eventually you may want to make photography a career. This means that you will have to make some hard choices: If you try to be everything to everyone, then you can often find yourself becoming nothing to anyone.

One way to approach this problem is to clearly define your audience; who do you want to work for—families, magazines, record companies? Or do you want to exhibit and sell your work in galleries? These are all distinct markets requiring different approaches. A portfolio that works in one area of specialization will probably fail in others. You'll need to take a hard look at what you have done, what you enjoy, and what you are good at, as well as aspects of your work that need more development. It might be better to fail at what you enjoy doing than to succeed at something you hate.

chapter 9 | GOING PROFESSIONAL

Tutorial 40 | FINDING A JOB IN THE INDUSTRY

The first thing to consider when embarking on a career in photography is that not everyone should become a professional photographer.

FOOT ON THE LADDER
Working as an assisstant is a great way of getting into the industry and learning from professionals.

Life as a working photographer is difficult. Most photographers will tell you that the biggest problems are financial. As a freelance photographer you are a small business owner; unless you are extremely successful, you will probably run the entire business by yourself. That means you will be responsible for providing your own health insurance, setting up your own pension plan, finding clients, servicing clients, delivering jobs, invoicing, charging sales tax, paying vendors and assistants, buying supplies, paying income tax quarterly, and creating websites, portfolios, and all your other promotional materials as well as shooting and making photographs.

These are formidable obstacles. If you love being a photographer, if you just live to make photographs, then all the difficulties are more than worth the sacrifices. When you love your job and you are having fun, it doesn't seem like work; you are just doing what you have always dreamed of doing.

But there are other difficulties that are perhaps more subtle about pursuing a career in photography. One of the biggest is the fact that there is no clear career path. You will be making up the rules as you go along. This is a creative field, and that means you will have to be a creative businessperson.

Loneliness and lack of stability is another psychological issue. People who enjoy the camaraderie and routine of a busy workplace can find it difficult to work alone. As a photographer you will have to be able to set your own goals and assignments on a daily basis. Being a self-starter is a mandatory part of the job description.

The great thing is that if you love photography but don't want to become a photographer, there are many other career paths within the industry: photo editing, retouching, curating, working in or owning a gallery, retail equipment sales, studio and equipment rental, or studio management, to name a few. All of these options can be very satisfying and allow you to work in the field and pursue your personal art work while (possibly) offering greater stability and benefits without the headaches of being a professional photographer/entrepreneur.

Starting out

There is no set path for a professional photographer to follow. However, there are various common ways of getting into a career in photography.

Internships The most important advice for an intern is:

Be quietly impressive, and make yourself indispensable.

This means that when you are at your internship you should be aware that the job is not about you. No one cares about the fight you had with your boyfriend or the club you went to last night. No one wants to hear your plaintive sigh when you are asked to sweep up the studio at the end of the shoot. No one has the time to explain things in the middle of a shoot: Write your questions down and wait until the equipment is being packed up. Better yet, take the first assistant out for a beer at the end of the day and then ask him or her to explain everything. Networking with your peers is essential.

Being an intern is about doing whatever task you are assigned to as best you can. Interns who are quietly impressive are the ones who can step up to fix the computer glitch or volunteer to take the lunch order. They search the location at the end of the shoot to make sure no equipment has been left behind. They look for places to be helpful, but don't get in the way.

Be on time every day. People might not notice punctuality, but you can be certain that they will notice it every time you are late.

Dress appropriately; the most common complaint on intern evaluations from supervisors is about interns who either show up dressed like slobs or as if they are going on a date. This also means that you should dress appropriately for the task at hand. Don't wear a skirt and high heels for a location shoot in the woods; don't wear a ripped T-shirt and hiking boots when you are assisting on a CEO portrait for an annual report.

The surest way to get offered a job when your internship is over is to become so indispensable/valuable that your internship employer has no choice but to hire you, because they can't imagine how they can run their business without you. One student who successfully turned her internship into a job said: "Dependability is what gains you the best reputation. Being passionate about your work will become evident without effort, and the fruits of that passion, paired with dependability, will be your greatest accomplishment."

Camera/lighting assistant While there are many successful photographers who have never worked as an assistant, they are usually the exception, not the rule.

Working as an assistant is the traditional apprenticeship, and there are many advantages to assisting an established photographer for a couple of years.

As an assistant you get to watch a professional at work. This means you can watch how they run their business, how they think through an assignment, and how they produce shoots. Assisting is best viewed as a continuation of your education, not a job. If you are smart and can find a job working for a great photographer who is a willing mentor, you will learn more about professional photography in a year as his/her assistant than you will in four years of college (though college teaches you other things).

Photographers who are willing mentors will ask to see your work regularly, take an active interest in your career, and may even let you use their equipment or studios to create new work for your portfolio. This is a privilege you can earn by making certain that you are sharp and have your head in the game on every shoot you work on with the photographer.

However, if you treat assisting as a paycheck, you will discover that you are in a low-paying job that offers no opportunity for advancement. Hardly a formula for success.

Photo assistants love to gossip about how difficult and overbearing certain photographers can be. Remember that it can take months or years for a photographer to cultivate a new client and that a single client might represent 25 percent or more of the photographer's annual income. The photographer is expected to produce perfection every day, and that is a lot of pressure. Your job is to support him or her, not to whine and complain. You will expect nothing less from your assistants in the future.

Digital technician Working as a digital technician/assistant may be one of the best new jobs in photography and offers a new path into the industry.

The job of the digital technician is to process, store, and back up digital files as they are downloaded from the camera's memory card and/or monitor the quality of the files as they are written directly from a camera that is tethered to the computer.

On set, the digital tech has a very high profile, working very closely with the photographer and art director. The job involves a very high level of organization, responsibility, and technical knowledge; consequently, it also offers higher pay than that of the traditional camera/lighting assistant. The downside is that if you make a mistake it is also very noticeable and possibly catastrophic. Digital techs are expected to be perfect, every time and in every way.

Tactics for job hunting

For most students, the first impulse is to send an email with a resumé attached. Then they wonder why there was no response. How do you know it was received or read? How many emails do you get every day that are junk mail?

A tactic that is far more effective is to send an actual letter, printed on your letterhead, with a resumé and a small print of one of your favorite photographs. Send it by regular mail. This ensures that it will be delivered and, almost certainly, opened.

If you narrow your job search to the ten photographers you really admire and want to work for, then you can tailor your cover letter to them. Explain your interests and tell the photographer specifically why they are the person you want to work for (don't be too flattering).

A resumé is important, but the most useful thing to include is a small example of your work that includes your name and phone number. Photographers are interested in photographs and tend to remember things visually. If you send a striking image it might get pinned to the wall over his or her desk, while your resumé will probably be thrown away or filed in a drawer. The photograph should reflect your best work, something you take genuine pride in. Don't try to second-guess what you think they will like.

Follow up on your letter with a phone call five to seven days later. Don't be pushy; just ask politely if they received the letter and say that you hope to be considered if any appropriate openings arise. If this doesn't work, go down your list and find ten more prospects to repeat the process.

Always send a handwritten thank-you note by mail. Old-school courtesy goes a long way these days.

exercise:

DESIGN A LETTERHEAD

You are a creative person so everything about your resumé should convey this. Spend time designing a letterhead. Once again, it should reflect you.

AGENTS AND REPRESENTATIVES

Many young photographers imagine that with the right agent their career will skyrocket. However, most agents aren't interested in signing a photographer that doesn't already have an extensive client list and is billing less than $200,000+ a year. Agents take 25–40 percent commission on creative fees for every shoot (including established accounts) and will also require you to contribute to fees associated with agency promotions and websites.

Having a good agent can be fantastic. When you are busy shooting, they are busy selling your services and promoting new business. But it is important for young photographers to have the experience of marketing themselves as well. When you sit down with your portfolio and interview a potential client, you witness their reaction to your work firsthand. You are also establishing a personal relationship that may last for many years or even decades. When your agent sends your portfolio by messenger and then calls to tell you the client's reaction, the information has been filtered. And if you and your agent decide to part ways the agent is the one who has established the personal relationship with the client.

Signing with an agent is great if you are with the right person; miserable and painful to end if you made the wrong choice. Think carefully before you sign the contract.

Tutorial 41 | DEVELOPING YOUR OWN STYLE

When we hear photographers talk about "style," it often sounds pretty superficial, as if it's a decoration we sprinkle over "content." Too often, style is considered to be a "look" based on a photographic technique such as using soft-focus filters, HDR, or other photographic devices.

OBJECTIVE >>

■ **To define yourself and your own visual identity.**

exercise:
YOUR FAVORITE PHOTOGRAPH'S QUALITIES

Write down five important qualities that your photographs must have in order to be "good" photographs. Write them with a grease pencil on your bathroom mirror. Look at them every day as you brush your teeth. Leave them there for a month, then erase and think of five more. Do this for a year.

Twenty years ago, it was all the rage to process color transparency film as a negative (cross processing), and then print the photos with the skewed color that resulted. It looked cool; go back and look at some old issues of *Rolling Stone* and you'll see hundreds of examples. The modern equivalent is the incredible overuse of HDR. These are techniques, but they are not to be confused with style, because when everyone can use the same techniques to create a style then everyone becomes interchangeable. In fact, this is the antithesis of style. To base your work on a technique is dangerous, because any reasonably competent photographer can master and imitate a technique very easily. Basing your style on technique puts you in the category of being a technician instead of being a creative professional. Stylish techniques are fads that are a pretty sure way to have a career that flashes and dies quickly.

Why is it that many older photographers are closing their studios? Surely it can't be simply because they couldn't adapt to shooting digitally (although that may be the case for some). Irving Penn, Richard Avedon, and many others have had brilliant careers that transitioned into the digital age without problems. They were not made irrelevant by digital imaging, any more than great writers have been made irrelevant by word-processing programs. The difference is that their unique way of seeing and interpreting subject matter could not be imitated, although tens of thousands tried. In fact, both Penn and Avedon used techniques that were very easy to imitate (what could be simpler than a plain white background?). However, their unique vision, their ability to interpret and present their subjects, was inimitable. This was what enabled them to be relevant and vital until their dying days.

Style is akin to the unique quality of someone's voice or how they express themselves. When we apply this more accurate definition to photographs, the word "style" takes on a much deeper meaning because it reflects an idiosyncratic and unique interpretation of the object or person the photographer is describing.

Most of what we refer to as "style" is actually a consistently constructed interpretation of reality as it is presented through the work of a particular artist. This is a much bigger idea than technique. This goes to the core of who you are as an artist, what you believe reality to be, and how you define your existence. Style is a big issue.

So what is style?

It starts with being interested in the subject. Successful photographers have a deep interest in what they photograph. They are experts in their fields. Great fashion photographers are not just people who take pictures of pretty women in fashionable frocks: they are students of fashion, they follow the trends, they keep their ear to the beat of popular culture. They can tell the difference between a couture dress and a cheap knock-off from a block away. Process begins with being very, very interested in what you are shooting; this is what will allow you to bring a unique perspective, expertise, and real insight to your subject.

Writers are not defined by their ability to spell or punctuate. Their process and the quality of their thought define them. Techniques and tools do not define photographers. We are defined by the way in which we choose to move through the world and how we describe the things we see.

So what makes a "good" photograph? For some people a good photograph is all about clarity:

"There is nothing more mysterious than a fact clearly described."
Garry Winogrand

For some it is all about ambiguity:

"Photography deals exquisitely with appearances, but nothing is what it appears to be."
Duane Michals

The way we define simple words (good, photograph, style, time, light, art, life) influences the way in which we make our photographs.

Style is branding

For both professional and fine-art photographers, style and branding are similar problems:

"Simply put, a brand is a promise. By identifying and authenticating a product or service it delivers a pledge of satisfaction and quality."
Walter Landor (brand strategist and guru; founder of Landor and Associates)

If someone tells you that they have just purchased a new BMW, you will have an instant idea about what qualities the car will have, even if they haven't told you whether it was an SUV, a sports model, or a luxury

sedan. All BMW models share common qualities and features. This is the essence of a brand.

If someone tells you they have just purchased three prints by three different photographers—Gregory Crewdson, Ryan McGinley, and Cindy Sherman, for example—you will also have an instant idea about what the photographs might look like without knowing the specifics of the individual images.

As a young photographer, creating a visual style doesn't necessarily mean that you should always photograph the same thing (BMW doesn't only make sports cars), but rather that your sensibility and process should be consistent throughout your work. What we have seen in the preceding chapter of case studies is that photographers might work on many different projects and genres, but their visual identity remains

consistent. Real style cuts across subject matter and technique; it is putting your fingerprint and brand on everything you do.

When a potential client looks at your website or portfolio, they shouldn't see the same picture over and over; instead, they should see many photographs that show your creative process and tell them what idiosyncratic qualities and insights you will bring to their project.

exercise:

YOUR FAVORITE PHOTOGRAPHER'S QUALITIES

Look at the websites or portfolios of your favorite photographers. Write down the consistent qualities in their work that you enjoy. These are the compass points to your own identity. Add them to the words you have written on your mirror.

DEVELOPING A VISUAL IDENTITY

Sarah Wilson's later professional work is an excellent example of a photographer who has developed a signature visual identity over the course of her professional career, proving that consistency doesn't mean shooting the same photograph over and over.

Though the photographs are more demanding and the lighting technique more challenging, it is easy to see that her underlying approach is consistent. All of her photographs carry the stamp of her visual style, which has much more to do with her sincere interest in her subjects than a superficial visual artifice.

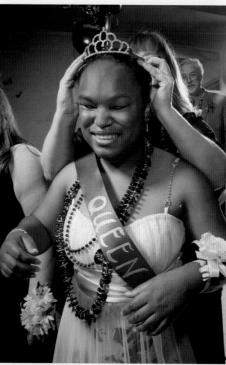

◁ ◁ **MARLON FORWARD, JASPER, TEXAS, 2004**

In one of her first professional assignments Sarah created a series of photographs about the town of Jasper, Texas, where James Byrd, Jr., a black man, was chained to a pick-up truck and dragged to his death by three white men. Marlon Forward was six years old when he discovered the mutilated body.

◁ **QUEEN BRITTANY, 2005**

In her "Blind Prom" series, Sarah photographed teenagers at the Texas School for the Blind as they participated in a high school ritual that has come to represent one of the milestones in the lives of American teenagers. Here Sarah uses a full-frame digital camera and fluid location lighting technique (an assistant holding a portable strobe as a floating light stand).

Tutorial 42 | YOUR PORTFOLIO

Printing a portfolio makes you consider your work as a coherent whole.

exercise:

START SMALL

Make small 3 x 5-inch (8 x 12-cm) reference prints of your favorite images. Tack them on a wall you see daily. Look at them carefully and try different arrangements to see how they work when they are viewed sequentially.

In our digital age, photographs are largely ephemeral. This can make them seem valueless. We toss them up on Facebook or Flickr, our friends give them a "thumbs up," and they are done.

Printing an actual portfolio makes you think much more carefully about your work. Pictures that look good on a computer screen can look pretty terrible as prints. Making prints exposes a lot of technical flaws and forces a constant reevaluation of your work and goals. Printing represents an intellectual and monetary investment in a particular image. It forces you to stand by what you have created in a more significant way.

While websites are great, if you are reading this book you probably aren't in a position to be getting assignments for magazines or advertising yet. Chances are you are just trying to get your foot in the door as an

assistant to a great photographer. A portfolio is a better tool for a young photographer trying to get a job as an assistant (though websites are also indispensable). A portfolio is a tangible object that you can bring on a job interview that will give a prospective employer a sense of your skills and interests. It is a conversation piece, and it can help you or hurt you. No one can resist looking at a portfolio full of amazing photographs that are beautifully presented, but a portfolio that is slipshod clearly tells a prospective employer that you really aren't serious. If you are sloppy with your own work, how can you be expected to care about theirs?

Portfolios also tell you about the photographer you are interviewing with: Do they seem to care about your work? Do they seem to enjoy photography? It's just as hard (or easy) to get a job assisting a great

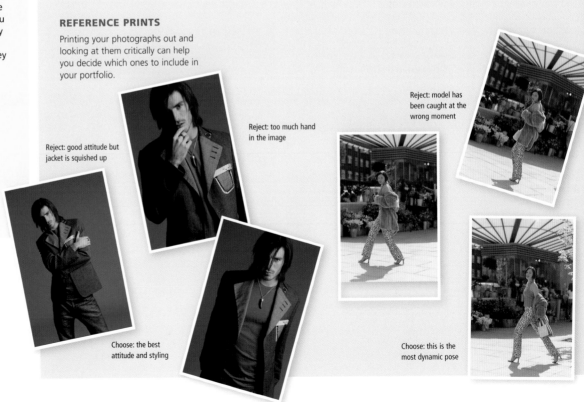

REFERENCE PRINTS

Printing your photographs out and looking at them critically can help you decide which ones to include in your portfolio.

Reject: good attitude but jacket is squished up

Reject: too much hand in the image

Reject: model has been caught at the wrong moment

Choose: the best attitude and styling

Choose: this is the most dynamic pose

photographer who will be a mentor as it is to get a job working for a hack. Assisting isn't a career; it's an apprenticeship. It pays to work for someone who respects your aspirations as much as their own.

Make some reference prints

Select 40 of your favorite images and make small 4 x 6-inch (10 x 15-cm) prints of them. Lay them out on a table and look at them critically. Try to imagine that another photographer has created them, and you are seeing them for the first time.

Bear in mind that there will be many times when you will not be present when a prospective client is viewing your portfolio. Make it speak for you clearly.

If you don't have 40 images yet, then read ahead— but postpone the actual process of making the portfolio until you do.

Be ruthless

We all have pictures we are emotionally attached to. This doesn't mean that they should be in our portfolios.

We have to be ruthless at this point and eliminate any photograph that doesn't contribute to the strength of the overall portfolio. Editing should be as painful as killing puppies. That really great exercise you did for your still-life class? Kill it. That picture of your old girlfriend whom you still miss? Kill it. The one great landscape that you were so proud of because it looks like a postcard? Burn it.

If you loved doing that one great still life, then maybe you should create 40 more and build a still-life portfolio. Don't include it in your portfolio just to show that you can light something. No one cares.

Portfolios and websites are the primary marketing tools of photographers. They can also be traps. We create our best work by experimenting with a free and open mind; that's how we build a great portfolio. But when clients hire us, they want us to create more of the same; that is the value of your "brand." The work you present in your book/website is what you will get hired to do. If you fill your portfolio with work that is competent, dull, and uninspired, you can get stuck doing it for ever. If you are looking for work as a photographer's assistant, then a dull uninspired portfolio will probably land you a job assisting for a dull, uninspired photographer.

To paraphrase the legendary photographer/art director Henry Wolf, "If you wouldn't want it to be shown at your funeral, then it doesn't belong in your portfolio."

Cull the runts of the litter to improve the breed. Try to whittle the original 40 images down to 25.

Assemble a dummy portfolio

Buy a cheap photo album or sketchbook at an art supply store and experiment by tacking the images into the book with an easily repositioned adhesive like a glue stick or double-stick tape. Find an order for the images that seems to make sense. Most photographers will base a book on grouping together similar images. That might work, but just as often it can mean that the photographs will just roll along one after the other and water down the impact of your best photographs. Try some other tactics as well:

- Try thinking of the sequence as a drum or guitar solo.
- Try to find an order that makes every turn of the page a surprise.
- Try finding a rhythm that feels like breathing, or your heartbeat.
- Remember to use double-page spreads and blank pages to help establish the rhythm.
- Go crazy: make it scream, shout, cry, and weep. It should be as alive as you are.

You are in a creative field. You should make your portfolio a reflection of your creative persona. Don't fall into the trap of making your portfolio feel like a salesman's sample case because "that's what people want to see." The common mistake for young photographers is to create a book that is too conservative.

Live with the little sketchbook mock-up for a week or two before you buy an actual portfolio. The mock-up will help you make a better decision about the scale and orientation of the book you purchase.

Buying a book

Once you have created an edit and order for your images, you can start shopping for a portfolio. You might be tempted to print a bound photo book through a service like Lulu.com or Apple's book service. These are great services, but not for your portfolio at this stage.

At this point in your career you want a portfolio that can evolve and be quickly changed as you create new work. Portfolios that allow you to slip photographs into acetate sleeves or use screw posts to hold photos printed on double-sided paper are a better alternative for the time being.

Printing your portfolio

Now is the time to really perfect your printing. Every print that isn't spotted, color corrected, and impressive is like wearing a shirt with coffee stains to a job interview.

Professional or fine-art photography is a business based on perfection. Your book should be as perfect as you can make it. Your clients/employers will expect you

▽ **Style statement** Show an art director that you mean business and exude style by having your name embossed onto the cover of your elegant leather portfolio.

▽ **First impressions** A smart presentation doesn't start or end with the portfolio: send or present your portfolio in an appropriately stylish case.

to make amazing, perfect photographs and your portfolio should instill confidence in your ability to deliver. Remember that "a brand is a promise."

When your book is done, you can show it to your friends or your teachers. Listen to their criticism, ignore their praise.

Take your portfolio out to play

You'll never know how your work will be received until you take it out and get some reactions.

Drop-offs Virtually every magazine, gallery, or museum has at least one day a month that is an open drop-off day; this means that anyone can bring in a portfolio and drop it off to have it looked at. This is not a guarantee that it will be reviewed, or that anyone will comment on it, but it's good practice to take your book somewhere at least once a week because it creates the pressure to keep perfecting your work as an ongoing exercise.

The etiquette of portfolio drop-offs is simply to drop off and pick up. The people viewing your book have no obligation to comment, so if you get a complimentary note or an invitation to come in for a meeting, you should view it as very positive feedback.

Portfolio reviews Most large cities have a few annual photo festivals where photographers can pay a fee (usually $250–500) in order to have their portfolios and projects reviewed by a panel of professional photo editors, art buyers, agents, book publishers, and gallery directors. While the price of admission might be steep, this can be a great way to have face-to-face meetings with top professionals and make valuable contacts.

FLEXIBILITY

At this point in your career you want a portfolio that can evolve and be quickly changed as you create new work. Portfolios that allow you to slip photographs into acetate sleeves or use screw posts to hold photos printed on double-sided paper are the best choice for the time being.

ARRANGING PHOTOS AS SPREADS

The order in which your photographs appear in your portfolio and how they are presented can make a big difference, so give this some careful thought.

This portfolio by Blaine Davis shows a range of wor that includes both studio and location photographs while still exhibiting a consistent identity.

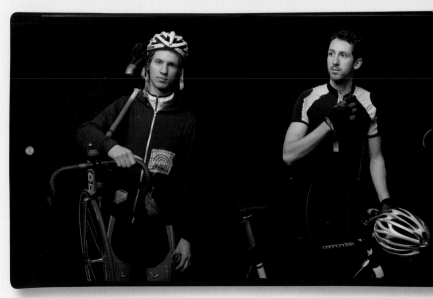

△ **Multiple-image projects** Many assignments will involve making a number of pictures that create a coherent whole. Your portfolio should prove your ability to deliver a five- to ten-page story.

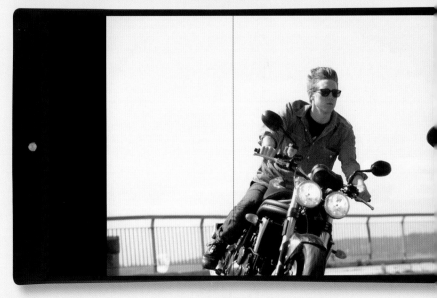

△ **Create contrasts** Seeing this dynamic image right after the quiet photo of the man sitting in bed is a great contrast that makes both images stronger.

△ **Mix it up** Using double-page spreads will keep the book looking lively. If you shoot a lot of horizontals consider buying a portfolio that uses the landscape format.

SAY "THANK YOU"

When someone has taken time out of their busy day to look at your portfolio (whether you were present or not), they deserve the simple courtesy of a thank-you note.

△ **Overall appearance** When the pictures are all laid out, check that the spreads maintain a consistency that will give the correct impression that you're confident in what you're doing.

EQUIPMENT LIST

Every photographer is different and has different needs; this is the basic kit that I take on virtually every shoot. It represents what, over years of magazine photography, I've learned I can carry (with an assistant), transport on a plane with reasonable excess baggage charges, or fit in a car.

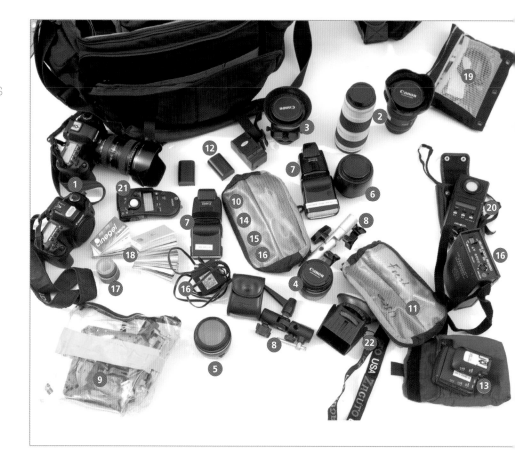

Bag 1: Camera, lenses, etc.
- Two cameras: one full frame, one APS chip (1)
- Lenses: 16–280mm focal lengths covered with three zoom lenses plus a 1.4 x teleconverter (2)
- 24mm tilt and shift lens (optional) (3)
- 24mm f/1.4 (optional) (4)
- 50mm f/1.2 (optional) (5)
- 85mm f/1.8 (whatever your favorite focal length happens to be, you should have one fast-prime lens in that focal length) (6)
- 64 gigabytes-worth of memory card storage
- Digital storage device for downloading/backing up memory cards when no computer is available (optional)
- Two battery-powered TTL flash units that are dedicated to your camera system with TTL cables for using the units off camera (7)
- Two stand adapters that allow battery-powered units to be mounted on stands (8)
- Grip kit for wireless TTL flash units (9)
- One small soft box or light modifier that clips directly to dedicated flash units
- Spare cables for tethering camera to computer (10)
- 16 AA batteries (11)

- Spare batteries and chargers for cameras (take two as they are easily lost) (12)
- Pocket Wizard Flex triggers for TTL flash (these also work for studio flash so they are a backup synch system for studio/battery strobes as well) (13)
- Spare synch cable (14)
- Electronic cable release (15)
- Cables for using Quantum batteries with dedicated Canon flash (16)
- Multi-tool (be sure to move this to checked luggage when flying)
- Small roll of gaffer's tape (17)
- Swatch books from lighting gel manufacturers (18)

- Camera filters: Black net diffusion, a very mild diffusion, polarizer (19)
- Color meter (20)
- Light meter (21)
- Expolmaging disk for custom white balancing
- Zacuto Viewfinder for shooting video clips and inspecting digital previews on the camera's LCD screen (22)
- Sensor cleaning kit
- Lens cleaning kit

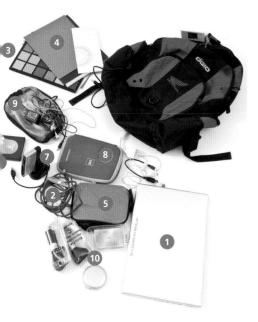

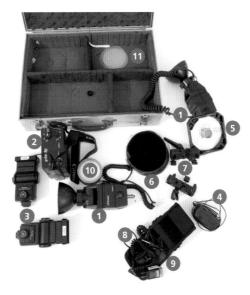

Bag 2: Computer/film
- Macbook Pro with power cord, plus spare power cord (1)
- Two sets of USB cables for tethering the camera to the computer (2)
- Collapsible diffusion disk
- Collapsible reflector (white/silver)
- Macbeth color checker (3)
- Gray card (4)
- Power inverter (this allows you to power strobes or a computer using a car's cigarette lighter) (5)
- Portable hard drive of 250 gigabytes (6)
- Card reader for downloading memory cards (7)
- Surge protector power cord (8)
- Small toolkit and multi-tool (move to checked luggage before flying) (9)
- Makeup kit: A brush, a small assortment of powders, a pack of oil removal pads (10)
- Small roll of gaffer's tape

Bag 3: Battery-powered flash
- Two Quantum Q Flash units (150 watts per second) (1)
- Battery for Quantum flash (2)
- Two Vivitar 285s with optical slaves (3)
- Chargers for battery-powered flash units (4)
- Dedicated soft box ring for Quantum (allows the use of any of my three soft boxes with a Quantum) (5)
- Extra set of grids (these can be taped onto the Quantum reflectors) (6)
- Stand adapters (7)
- Two plug-in optical slaves (8)
- A few clamps (9)
- Gaffer's tape (10)
- Diffuser disks for Quantum flash units (11)

Bag 4: Plug-in (AC) flash
- Four 400 WS monohead flash units with custom-made cables (these can also be run off the Quantum batteries) (1)
- Two AC slave unit flashes (these can be screwed into any lightbulb socket and work as electronic flash; they have in-built optical slaves) (2)
- Radio slave system with one transmitter and three receivers, plus spare cords for each (3)
- Five power cords (one is a spare) (4)
- A few 15-foot (4.5-m) extension cords (5)
- Set of grids (6)
- Spare modeling lamp (7)
- Two spare fuses for monoheads
- One small kit of electrical connectors (three-prong adapters, an adapter that allows a plug to be used in a lightbulb socket, three spare PC cords, cube taps, etc.) (8)
- Small grip kit of clamps, clothespins, Lowel Tota-Tatches, etc. (9)
- Three rolls of gaffer's tape (black, yellow, gray) (10)
- Small assortment of gels stashed in the lid (11)
- Two optical slaves (12)
- Soft box speedrings (13)
- Standard parabolic reflectors (14)

Bag 5: Light stands and grip equipment
- Four heavy-duty 11-foot (3.3-m) light stands (1)
- Three medium 9-foot (2.7-m) light stands (2)
- One small 4-foot (1.2-m) boom (3)
- One Matthews knuckle (this can turn a spare light stand into another boom) (4)
- Large (4 x 5 foot/1.2 x 1.5-m) soft box with silver interior (5)
- Medium (2 x 3 foot/60 x 90-cm) soft box with white interior (6)
- Three 25-foot (7.5-m) extension cords (7)
- One roll of cinefoil (a.k.a. black wrap) (8)
- A roll of assorted gels (about 40 different colors) (9)
- 20 feet (6m) of light rope or clothesline (10)
- Two umbrellas that have never been used, but are still carried on every shoot just in case (11)

Bag 6: Tripod
- Tripod (1)
- Monopod with ball head (2)
- A mediumweight 9-foot (2.7-m) light stand (3)
- 16 x 20-inch (40 x 50-cm) soft box with an adapter for use with small TTL flash unit (4)
- One lightweight extension cord (5)

Bag 7: Small personal bag
- Job file with contact info, permits, and plane tickets, etc.
- Receipt file
- Lumix point-and-shoot camera (1)
- Film point-and-shoot camera (2)
- Camera battery charger (3)
- Zoom H4n digital sound recorder (useful for taking notes on stories when I am assigned to be both the writer and photographer) (4)
- Spare microphone (5)
- Mini tripod (6)
- Compass (7)
- Sketchbook
- Small flashlight (8)
- Three sets of earplugs (useful in factories, racetracks, and other noisy environments—the extras are for art directors and assistants) (9)
- iPhone with sun plotting and depth-of-field calculation programs (10)
- 4-gigabyte emergency memory card (11)
- 250-gigabyte hard drive
- Small roll of gaffer's tape
- Spare light meter (12)
- Novel or other relaxation tool (13)
- Spare contact lenses, aspirin, and a few band-aids
- Power bar, apple, or other portable food

TAKE A PHOTO BEFORE YOU UNPACK
If you are working as an assistant on location with a new photographer, take a photo of each case with your camera phone before you start unpacking his or her gear. It will help you repack it exactly the same way and most pros will appreciate the effort.

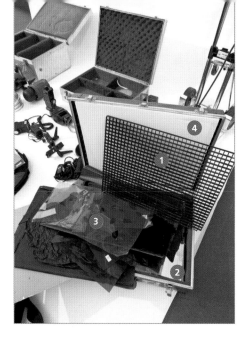

Bag 8: Optional grip/lighting equipment

This kit is not carried on every shoot. It is specific to certain highly stylized portraits (especially fashion)

- Beauty dish with grid
- Grid for 16 x 20-inch (45 x 50-cm) soft box (1)
- 16 x 20-inch (45 x 50-cm) mirror (2)
- Two 12 x 12-inch (30 x 30-cm) mirrors
- More gels (3)
- Gobos: 16 x 20-inch (45 x 50-cm) foamcore—four white for use as reflectors and four black for use as flags/gobos/negative fill cards (4)
- Lightweight muslin backdrop

WOW, LOOKS LIKE A LOT OF GEAR DOESN'T IT?

It all packs up onto one easy-to-manage folding luggage cart. The switch to digital means that this is "traveling light" compared to the days when it was five power packs and eight flash heads, as well as a complete medium-format camera system.

Certain things are redundant. This is because it allows the use of any of the kits independently of the others. If I know I am only shooting indoors, I will leave Bag 3 (battery-powered flash) at home. If I suddenly have to move fast and light, I can just grab the tripod bag and the camera bag and still have a wireless TTL flash system with two Speedlites, a soft box, and a light stand.

However, if all of the cases are combined, there are a total of 12 flash units at my disposal, more than enough for almost any situation I am likely to encounter. On assignments that require more lighting (like automotive shoots), I rent more equipment as necessary.

Once you have found a system that works for you, the equipment should always be packed and repacked exactly the same way. This ensures that if something is missing, or has been moved, it will be obvious with just a glance into the case.

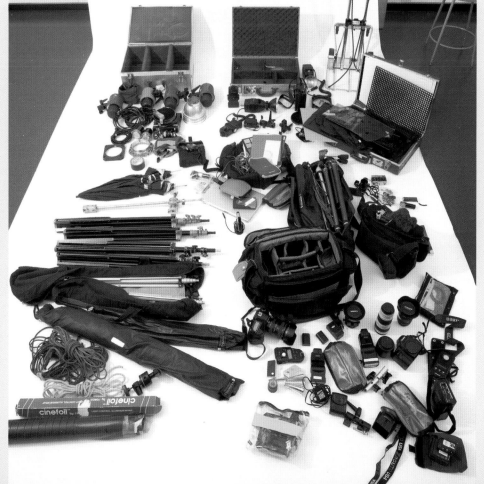

PHOTOGRAPHERS' PROFILES

Here are short profiles of the iconic historical and contemporary photographers referenced throughout the book.

Max Aguilera-Hellweg
(http://maxaguilerahellweg.com/)
Max Aguilera-Hellweg is a top editorial photographer. While on an assignment photographing a story on open-heart surgery, Hellweg was so moved by the experience that he enrolled in medical school and successfully completed his medical residency. He has since returned to photography and filmmaking.

Nobuyoshi Araki (b. 1940)
(www.arakinobuyoshi.com)
One of the world's most prolific and controversial photographers, Araki has produced well over 350 books of his photography. Araki is a photo-diarist who sees and portrays the world entirely from his subjective point of view. Among his most notable portrait projects were his intimate, erotic, and heartfelt photographs of his wife, which were published as a (limited edition) monthly magazine that unflinchingly chronicled her life and eventual death.

Diane Arbus (1923–1971)
(http://diane-arbus-photography.com/)
Arbus might be the most controversial figure in the history of photography. Lay people typically characterize Arbus as a photographer of freaks and fringe members of society, while most photographers understand that this is a superficial view of her work. Arbus was a photographer who was genuinely interested in other people and their stories; it's just that some

people had more interesting stories than others. People who had faced adversity, because of their race, physical appearance, or sexual orientation were inherently more interesting to Arbus. "They've already passed their test. They're aristocrats." Because Arbus was more interested in her subjects than technique her photographs are frontal, simple, and characterized by the high level of detail afforded her by the Rollei and Mamiya medium-format cameras that became synonymous with her work.

Eugene Atget (1857–1927)
From about 1897 to 1927 Eugene Atget prowled the streets of Paris on an almost daily basis; documenting the city's street life and architecture with an antiquated (even for the time) camera in order to create a record of historical landmarks while earning a modest living by selling prints of his work to artists as reference sources for paintings.
 Bernice Abbott (then a young photographer's assistant working for Atget's neighbor, Man Ray) befriended Atget and became a devoted fan of his work. After his death she arranged the purchase of his entire archive by the Museum of Modern Art.
 Atget's collected photographs of Paris are now regarded as one of the masterworks in the history of photography.

Richard Avedon (1923–2004)
(www.richardavedon.com)
Richard Avedon might rightly be considered the greatest portrait photographer who has ever lived. As the preeminent superstar/fashion photographer of his generation he had unprecedented skills, resources, and technique at his disposal. Yet his approach to portraiture became increasingly more basic and minimal

during the course of his career. Over time he systematically pared away all the conventions and visual crutches that photographers traditionally use to create interest and context in the photograph, until, finally, there was nothing left but the person standing before his camera. Every photograph was a challenge to find the purest emotional essence of his subject.

David Bailey (b. 1938)
(www.david-bailey.co.uk)
David Bailey's early photographs of 1960s British pop culture and Carnaby Street fashion icons, such as the Rolling Stones, Penelope Tree, Jean Shrimpton, and the Kray twins defined and created the swinging London scene of celebrity chic.
 While Bailey is probably best known for his personal life, which includes many romantic affairs and marriages to some of the most iconic beauties of the 20th century, his photographic work for British *Vogue* defined the editorial and visual identity of the magazine and created a cultural revolution.

Guy Bourdin (1928–1991)
(www.guybourdin.org)
One of the quintessential fashion photographers of the 1970s, Bourdain's work was characterized by strong color and erotic (sometimes violent) undertones. His highly conceptual approach often played with the ways in which the camera could confuse two-dimensional elements within three-dimensional depictions of reality.
 Though Bourdain died in 1991 his work has achieved a cult status among many younger photographers.

Alexey Brodovitch (1898–1971)
Legendary art director, photographer, and teacher. Brodovitch served as the

Art Director for *Harper's Bazaar* from 1938 to 1958. He was responsible for discovering and mentoring many of the 20th century's greatest photographers including Robert Frank, Art Kane, Richard Avedon, Diane Arbus, Hiro, Garry Winogrand, and Irving Penn.

Chris Buck (b. 1964)
(www.chrisbuck.com)
Conceptual portrait photographer living in the U.S. and working primarily for magazines. Buck is best known for his very funny photographs of celebrities.

Clayton Burkhart (b. 1966)
(www.claytonburkhart.com)
American fashion/editorial photographer and filmmaker currently living and working in Paris. Burkhart's work is most notable for his fearless use of color.

Henri Cartier-Bresson (1908–2004)
(www.henricartierbresson.org)
French photographer who revolutionized the medium through his use of the small camera. Bresson is often regarded as the father of modern photojournalism due to his "decisive moment" approach, which defined his photographic sensibility and became the standard for generations of photographers who followed. Simply put, the decisive moment is the moment in which the narrative and factual elements of the photograph coalesce with formal and compositional elements to create a synergy of both meaning and visual interest.

David La Chappelle (b. 1963)
(www.lachapellestudio.com)
American photographer and film director whose exuberant, shocking, and grotesque style of portraiture

mirrored the excesses of Reagan-era America.

Gregory Crewdson (b. 1962)
(www.whitecube.com/artists/crewdson/)
Crewdson draws on the collective iconography/history of film and cinematography to create implied fictions. By creating scenes that are devoid of narrative context or continuity each photograph represents a moment of ambiguity that compels the viewer to create and imagine a story that is unique to the viewer's personal history and point of view.

Crewdson also employs traditional Hollywood techniques to create his elaborate tableaus. Months are spent in pre-production, casting, and planning for each shot. Sets are often constructed and elaborate lighting employed.

Patrick Demarchelier (b. 1943)
(www.demarchelier.net)
Demarchelier is a fashion photographer who is defined by his deep insights, historical perspective, and profound respect for fashion and couture as a valid art form. In many ways he is better understood if viewed as a photographer in the documentary tradition (à la Walker Evans). His work just happens to reflect his epoch through a singular aspect of his era's popular culture; an aspect that is (arguably) no less valid than another photographer's images of sharecroppers, roadside architecture, or any of the other traditional subjects associated with the documentary genre.

David Douglas Duncan (b. 1916)
Duncan is best known for his career as a combat photographer, working first during World War II as a U.S. Marine in the Pacific Theater, and later as a *LIFE* magazine photographer during the Korean and Vietnam Wars. He was also a great friend of Pablo

Picasso and published seven books of his portraits of Picasso.

Walker Evans (1903–1975)
American photographer best known for his work for the Farm Security Administration (FSA) documenting the effects of the Great Depression. Much of Evans's work from the FSA period uses the large-format 8 x 10-inch camera.

The persuasive power of Evans's work lies in his seeming invisibility as the photographer, and his trust in the camera's descriptive abilities to allow things to speak for themselves.

William Eggleston (b. 1939)
(www.egglestontrust.com)
American photographer living in Memphis, Tennessee, considered to be one of the pioneers of color photography. He was the first color photographer honored with a solo exhibition at the Museum of Modern Art.

Lee Friedlander (b. 1934)
(www.fraenkelgallery.com/#s=0&p=0&a=10&mi=222&pt=1&pi=10000&at=1)
Friedlander first came to prominence as one of the "Social Landscape" photographers of the late 1960s (along with Winogrand, Arbus, and others).

Friedlander's early photographs were like nothing that had come before, constituting a wholly new approach to documentary photography that was unapologetically subjective. His dry, ironic wit and deadpan style were reflective of an emerging American youth culture that was growing increasingly suspicious of the American consumerist dream.

Many of his compositional innovations are now commonly accepted conventions. He embraced the flaws he saw in amateur snapshot photography—cropping off people's heads, including himself in shadows and reflections, and using very deep focus—to create juxtapositions between disparate objects.

Robert Frank (b. 1924)
(www.pacemacgill.com/robertfrank.html)
Widely regarded by many to be one of the most important photographers of the 20th century. Robert Frank's publication of *The Americans* created a new standard for photography that discarded the popular myth of the photographer as an objective observer and established the photographer's function as a social critic.

Andreas Gursky (b. 1955)
(www.matthewmarks.com/artists/andreas-gursky)
German photographer Andreas Gursky creates large-scale, color photographs distinctive for their incisive and critical look at the effect of capitalism and globalization on modern life.

Gregory Heisler (b. 1954)
(www.gregoryheisler.com)
One of the most successful portrait photographers alive with over 70 *Time* magazine covers to his credit.

Lewis Hine (1874–1940)
As a social activist Lewis Hine used photography to rewrite the child labor laws in the United States through his documentary portraits of children working in factories under harsh and dangerous conditions. Later, he was also commissioned to photograph the construction of the Empire State Building.

Pieter Hugo (b. 1976)
(www.pieterhugo.com)
South African fine-art photographer Pieter Hugo has produced four books of his portrait-driven work that documents the unique cultural and social issues that affect the continent. His extremely successful book, *The Hyena and Other Men*, which depicts Nigerian men who keep hyenas as pets, brought his work to the attention of a worldwide audience.

Edward Keating (b. 1956)
(www.edwardkeating.com)
Ex staff photographer for the *New York Times*. Winner of two Pulitzer Prizes, currently represented by Contact Press Images.

Steven Klein (b. 1965)
(www.stevenkleinstudio.com)
While Klein is easily pigeonholed as a fashion photographer, this really doesn't do justice to the breadth and intellectual complexity of his work. His photographic and multimedia collaborations with Madonna, Brad Pitt, Christian Bale, and Lady Gaga have helped to reinvent portraiture for the 21st century as they use the public personas of these celebrities to confound the viewer and recontextualize their subjects; the result constitutes a new form of collaborative conceptual art.

Markus Klinko and Indrani
(www.markusklinko-indrani.com)
The photographic duo of Markus Klinko and Indrani began as a result of their (past) romantic relationship as they each pursued different careers (Swiss-born Klinko was a classical harpist, Indian-born Indrani worked as a fashion model while studying fine art).

In 1995 they began to collaborate as a photographic team shooting cover art for albums and celebrity portraiture for magazines. Their theatrical flair made them an instant success. The reality-TV show "Double Exposure" follows their career in a semi-comedic style as it documents the high drama and real pitfalls of their life in photography's fast lane.

Antonin Kratochvil (b. 1947)
(www.antoninkratochvil.com)
Czech-born photojournalist Kratochvil works in a style very closely associated with the "decisive moment" tradition of Cartier-Bresson. Kratochvil's work is highly expressionist in its use of composition, light, and shadow.

Annie Leibovitz (b. 1949)
(www.contactpressimages.com/
photographers/leibovitz/leibovitz_bio.
html)
For a decade Leibovitz was chief photographer with *Rolling Stone* where she refined the elements that became her artistic signature: The use of bold primary colors, high production value, and cleverly constructed conceptual contexts that summarized the public personas of her famous subjects within the confines of a single image.

Her later and current work for *Vanity Fair* and *Vogue* is more thoughtful and multidimensional, often revealing the inner conflicts between her subject's public visage and their more complex, and private, inner life.

Matt Mahurin (b. 1959)
(www.mattmahurin.com)
Mahurin is a photographer, illustrator, and director who creates highly conceptual, often disturbing images for magazines and commercial clients. His music video for Metallica's "Unforgiven" is considered a landmark that transcends the music-video genre.

Sally Mann (b. 1951)
(www.gagosian.com/artists/sally-mann)
Sally Mann is best known for her haunting large-format photographs of her children that were published as the book *Immediate Family*. Her most recent work, *What Remains* (Bullfinch Press, 2003) and *The Flesh and the Spirit* (Aperture, 2010), continues to be deeply personal, exploring themes of death and decay.

Ryan McGinley (b. 1977)
(http://ryanmcginley.com/)
Ryan McGinley's career was launched when his photographs depicting exuberant youth were featured in a retrospective at the Whitney Museum in 2003 entitled "The Kids Are Alright." Since then his work has been embraced by many magazines and commercial clients worldwide.

Duane Michals (b. 1932)
(www.pacemacgill.com/duanemichals.
html)
Michals is best known for his photo sequences that incorporate text and images to create surreal and disquieting moments. As a portrait photographer he is best known for his conceptual portraits of surrealist artists such as Joseph Cornell and René Magritte.

Richard Misrach (b. 1949)
(www.fraenkelgallery.com/#s=0&p=0
&a=21&mi=222&pt=1&pi=10000&at
=1)
Richard Misrach is one of America's foremost landscape photographers, though his work is really about man's intervention and destruction of the natural landscape. Working with an 8 x 10-inch camera and color film he produces extraordinary prints that are epic in scale.

James Nachtwey (b. 1948)
(www.jamesnachtwey.com)
For the past three decades, Nachtwey has devoted himself to documenting wars, conflicts, and critical social issues, working across the globe. When certain stories he wanted to cover—such as Romanian orphanages or famine in Somalia—garnered no interest from magazines, he self-financed trips there. He is known for getting up close to his subjects, or as he says, "in the same intimate space that the subjects inhabit," and he passes that sense of closeness onto the viewer.

Arnold Newman (1918–2006)
(www.arnoldnewmanarchive.com)
Arnold Newman's portraits of artists, world leaders, and writers are so iconic that his work is virtually the dictionary definition of environmental portraiture.

Helmut Newton (1920–2004)
(www.helmutnewton.com)
German-born fashion photographer best known for his highly erotic, often fetishistic, photographs of women.

Irving Penn (1917–2009)
(www.pacemacgill.com/irvingpenn.html)
As one of photography's most prolific practitioners, Irving Penn was really three great photographers rolled into one; a great fashion photographer, a brilliant portrait photographer, and the most celebrated still-life photographer of his time.

His sensibilities in still life are mirrored in his studio portraits, which are typically very close and rely entirely on bold composition and a dramatic connection between the subject and camera/viewer.

Gilles Peress (b. 1946)
(www.magnumphotos.com/Archive/C.
aspx?VP=XSpecific_MAG.Biography_
VPage&AID=2K7O3R13C8UA)
A member of the prestigious Magnum Photo Agency, Peress is a French photojournalist of international renown. Best known for his reportage during the Iranian Hostage crisis, which was published as the book *Telex Iran: In the Name of the Revolution*, and his coverage of the war in Bosnia, published as *Farewell to Bosnia*.

Platon (b. 1968)
(www.platonphoto.com)
Platon is an English-born photographer who lives in New York, though his career takes him all over the world. Platon's work is deceptively simple and bold. He often employs wide-angle lenses and hard, direct lighting to create photographs of world leaders and celebrities that—while not traditionally flattering—provide the viewer with a new and unique perspective of his well-known subjects.

Richard Prince (b. 1949)
(www.gagosian.com/artists/richard-
prince/)
Prince is a controversial artist who rephotographs and appropriates found imagery (created by others) and in doing so recontextualizes the original meaning of the photograph. His most famous image is a rephotographed image of a cowboy (originally created by Sam Abell for the Marlboro cigarette campaign) that set an auction record for a photograph in 2008, selling for $3.4 million.

Eugene Richards (b. 1944)
(www.eugenerichards.com)
American-born photojournalist closely associated with Magnum. Richards' approach is traditional black-and-white photojournalism that focuses with a heart-rending clarity of purpose on the disenfranchised and largely forgotten segment of the American populace that struggles daily with poverty, drug addiction, and mental illness.

Thomas Ruff (b. 1958)
(www.davidzwirner.com/artists/18/)
German photographer Thomas Ruff's early portraits reflected his influence by his teachers, Bernd and Hilla Becher, in that they were typologies; deadpan photographs of faces photographed without inflection by the photographer in order to draw attention to similarities and differences.

Sebastiao Salgado (b. 1944)
(www.amazonasimages.com)
Brazilian social-documentary photographer and photojournalist. He is particularly noted for his social-documentary photography of workers in less-developed nations.

August Sander (1876–1964)
(www.augustsander.de)
August Sander's monumental portrait project "People of the Twentieth Century" depicted the German

people of the Weimar Republic. This remarkable body of work has had enormous ramifications on the subsequent history of photography, influencing virtually every great portrait photographer who has emerged since.

Sander's photographic approach and purpose was to create a series of photographic archetypes through portraiture; each subject was a unique individual who also served as a symbol that represented a greater cross-section of the population. This approach influenced later generations of German and European photographers (the Bechers, Andreas Gursky, Thomas Ruff, etc.) and gave rise to the photographic typology as a formalized conceptual construct.

Martin Schoeller (b. 1968) (www.martinschoeller.com) German-born photographer Martin Schoeller now lives and works in New York. He is best known for his extreme close-up portraits of his subjects that are all lit and shot the same, whether the subject is a movie star, a president, or a derelict, in keeping with the "typological" approach to portraiture.

Schoeller is a remarkably versatile photographer who also shoots in more traditional and conceptual modes as well.

Mark Seliger (b. 1959) (www.markseliger.com) Mark Seliger rose to fame through his love of music, as reflected in his early photographs of musicians for *Rolling Stone* (where he eventually became a contract photographer, shooting over 125 covers.) He is currently a contract photographer with Condé Nast shooting portraits for *Vanity Fair*, *GQ*, *Vogue*, and others.

His love of music continues; he is also a practicing musician and front man for the band Rusty Tracks.

Cindy Sherman (b. 1954) (www.metropicturesgallery.com/index. php?mode=artists&object_id=4) American photographer best known for her conceptual self-portraits. Sherman's earliest self-portraits were based on black-and-white film stills in which she cast herself as various roles. In the early 1980s she began to work in color and established herself as one of the most interesting and original photographers of her generation.

Stephen Shore (b. 1947) (www.303gallery.com/artists/ stephen_shore) A pioneer of early color photography, Stephen Shore was heavily influenced by the work of Walker Evans. He is best known for his book *Uncommon Places*, a series of color photographs of rural landscapes and vernacular architecture made while traveling across America photographing with an 8 x 10-inch camera. *Uncommon Places* is widely considered a pivotal book in the history of color photography.

Eugene Smith (1918–1978) (www.smithfund.org/public/ aboutfund/overview) One of the seminal photojournalists of the 20th century, Smith was a demanding perfectionist, a quality that led him to have numerous fights with his editors at both *Newsweek* and *LIFE* magazines where he served as a staff photographer.

His photo essay on the city of Pittsburgh was originally supposed to be shot over three weeks. Smith spent three years there.

Smith's greatest work might be his photographs that documented the Chisso Chemical Company's illegal dumping of heavy metals into the water supply of the Japanese city of Minimata and the attendant medical problems faced by the populace there. In the course of his reportage representatives of the company attacked Smith, permanently damaging the vision in one eye.

John Szarkowski (1925–2007) Szarkowski is best remembered as the Director of Photography at the Museum of Modern Art where he emerged as one of the 20th century's most important critics and thinkers.

Szarkowski was also an accomplished photographer in his own right, having published two books of his own photographs before accepting the position at MOMA. His experience as a practitioner gave him a unique insight into the motivation and methodology of other photographers. At an time when most art critics questioned whether photography could even be considered an art form, Szarkowski contended that photographs were a new and unique art form, that required criteria that were specific to the unique qualities of the medium.

He championed the work of photographers (Arbus, Friedlander, Winogrand, Eggleston, and others) who broke with the traditions of painting and literature to form a wholly modern aesthetic based on the intrinsic veracity of the photograph and the camera's unprecedented descriptive characteristics.

Szarkowski was a gifted writer with a unique ability to reveal the mysteries and meanings of photographs to the layperson without insulting the intelligence of the viewer or diminishing the photographer's intention.

His influence was so profound that his contribution to the current landscape of photographic culture is simply beyond estimate.

Bruce Weber (b. 1946) (www.bruceweber.com) Bruce Weber is renowned for his photographs of fashion and celebrity portraiture, but most particularly for his black-and-white photographs of men that epitomize and celebrate the male physique.

Edward Weston (1886–1958) (www.edward-weston.com) American photographer best known for his large-format black-and-white still-lifes and nudes; which often looked very similar.

Garry Winogrand (1928–1984) Garry Winogrand was the definitive New York street photographer. As one of the "Social Landscape" photographers, Winogrand's work also embraced the "snapshot" aesthetic that was popular during the 1970s. Winogrand often viewed the implied figure/ground relationship of the camera's limit frame as an artificial constraint, leading him to tilt the camera at odd angles in order to incorporate and juxtapose different elements. His photographs of American culture were defined by wry wit and an unbridled visual energy.

GLOSSARY

angle of view The area seen by a given focal length/format combination.

angle of coverage The maximum angle that a lens can project as a circular image. The rectangle that the recording medium (film or digital) selects from this circular projection determines the actual angle of view.

aperture The opening of the lens through which light passes. This word is often used interchangeably with the term "f-stop."

Aperture Priority An automatic exposure mode in which the photographer chooses the preferred aperture and the camera automatically sets a corresponding shutter speed. This mode is often abbreviated as AV, or "Aperture Value."

archival The chemical, software, and storage properties that allow photographs to be preserved for future generations. Photographic prints that are pH neutral, printed on stable media (such as paper), and use long-lasting inks are said to be archival under proper storage conditions.

archive A collection or database of photographs.

autofocus An internal camera function that selects an area of the frame to be perfectly focused. This can be accomplished by either analyzing the contrast of the area (passive autofocus) or reading a reflected light beam that has been transmitted by the camera (active autofocus).

Automatic Exposure (AE) Any exposure mode in which the camera's light meter is choosing some

combination of shutter/aperture or both.

AV Stands for Aperture Value; see Aperture Priority.

available/ambient light The light that exists in a scene prior to the photographer introducing an additional light source. Also referred to as "existing light."

banding Occurs when a smoothly stepped or graduated grayscale has been altered, resulting in a series of visible steps. This term is used interchangeably with "posterization."

barrel distortion Occurs when a lens renders straight lines (usually at the edge of the frame) as slightly curved outward, like parentheses. Some lenses, such as fisheye lenses, have barrel distortion as an integral element of the lens's aesthetic and optical design.

bit The smallest amount of information a computer can process; represented as "0" or "1" (binary format).

bit depth The number of bits used in a digital image to determine the gray value of any single pixel. Eight-bit images have 256 steps from absolute black (no shadow detail) to absolute white (no highlight detail). Twelve-bit RAW files can represent 4,096 steps from absolute black to absolute white. These additional steps can help alleviate the posterization that can occur when post-processing an image before converting it to an 8-bit (per color channel) file for printing or electronic transmission.

bounced light Any light that is reflected off another surface.

built-in meter A meter that measures the light reflected from an object or scene as it passes through the actual lens of the camera. Also referred to as "TTL" metering.

bulb This shutter setting opens the shutter for as long as the shutter release is depressed.

camera obscura Latin for "dark chamber." This term means any darkened room with a small hole to allow light to enter and project an image (inside the room) of the scene outside the room. All cameras are essentially just tiny rooms with the addition of a lens (to help gather light more efficiently) and a recording medium (film or sensor) to preserve the image.

CCD Stands for Charge-Coupled Device. This is one form of digital sensor.

chrome Shorthand term for a photograph shot with transparency or slide film.

circles of confusion As a lens focuses individual rays of light, the ray forms a point on the focal plane. Areas that are out of focus show up as indistinct blobs, or "circles of confusion." As the lens is either focused or the aperture is made smaller, the circles become smaller and smaller until they can be regarded as "sharp."

CMOS Stands for Complementary Metal-Oxide-Semiconductor. This is a type of sensor used in digital cameras.

color management The synchronization of color spaces combined with a calibration of

displays so that all devices (like monitors and printers) display the same range and gamut of color.

color temperature A numerical description of the color spectrum of light, usually expressed in degrees Kelvin.

compression A way of reducing the (stored) file size of a digital image or file. Compression has advantages for faster electronic transmission and simplified storage. Compression may be "lossless" or "lossy." Lossless techniques, like RAW files, reduce the stored file size without loss of original data. Lossy techniques, like JPEGs, actually discard some information in order to achieve very highly compressed and small file sizes that transmit quickly and take up less storage space.

daylight film Color film that is balanced for and designed to be exposed in sunlight.

dedicated flash A flash unit that is made to interact with a specific camera and allows the flash's output to be controlled automatically by the camera's internal meter for optimum exposure. Also known as TTL flash.

depth of field The distance, or range, between two points (far and near) that will be rendered as sharp in the final image.

diaphragm A mechanical iris that controls how large the lens opening, or aperture, is and how much light is allowed to enter the camera.

diffuse Light that is scattered and emitted from many different angles, resulting in softer-edged shadows.

dpi Stands for dots per inch; the resolution of a printed image.

dynamic range The ability of any given capture medium to record extremes of highlight/shadow detail within a particular scene. Some media, such as color negative film, are able to record scenes with extreme dynamic range. Other media, like color transparency film and digital sensors, are extremely limited in the range of highlight and shadow detail they can record in a single image.

electronic flash A tube filled with gas that creates a powerful and short-duration burst of light when it is electrified. This term is used interchangeably with "strobe."

emulsion A light-sensitive and flexible coating of gelatin with silver halide particles in suspension that is applied to acetate-based film.

exposure latitude The amount of overexposure or underexposure that a given capture type (film or digital) can tolerate without a significant loss of quality.

Exposure Value (EV) A shorthand number that can indicate the complete range or combination of shutter speeds, ISO, and f-stops available within a given lighting scenario. Many older cameras like Rolleis and Hasselblads used an EV setting that "linked" the shutter speed and aperture to a given EV setting, allowing the photographer to simply turn one knob in order to access any of the shutter/aperture combinations available. While few photographers or cameras use EV in this way anymore, it is still used as a way to describe a certain light level with one simple number. For example, an EV of 6 translates to ⅟₁₅ second at f/2.0 at ISO 100 or 1 second at f/11 at ISO 200.

fast Can refer to: Film or sensor speed—ISO 1,000 is "faster" than ISO 100; Aperture—f/1.4 is a bigger lens opening, therefore, it is "faster" than f/8.0; Shutter speed—⅟₁,₀₀₀ second is "faster" than ⅟₁₅ second.

fill A diffuse light source (no distinct shadows) that reduces the contrast of a scene by lightening the shadow areas.

film speed A numerical designation to describe film's sensitivity to light. The universal designation is now "ISO" (International Organization for Standardization); however, older cameras and light meters may use ASA (American Standards Association) or DIN (Duetsches Institut fur Normung) as a designation.

filter A piece of glass, plastic, acetate, or gelatin that is placed over the lens (or light) in order to selectively absorb or transmit a selected part of the light or spectrum.

flare Light that reflects or scatters inside the camera or lens, resulting in either loss of contrast or undesirable pinpoints or streaks of light.

focal length The distance from the lens to the focal plane when the lens is focused to infinity. Long focal lengths result in greater magnification (telephoto lenses) and short focal lengths result in less magnification (wide-angle lenses).

focal plane The plane at which a lens focuses light inside the camera.

focus The point at which light rays reflecting from the scene converge to form a sharp image. Also, the act of adjusting the lens in order to form a sharp image.

f-stop A ratio that equals the focal length of the lens divided by the diameter of the lens aperture (or opening). In theory—and practically speaking—any lens set to the same

f-number transmits the same amount of light as any other lens set to the same f-stop regardless of focal length. This term is often used interchangeably with "f-number" and "aperture setting."

gamut The range of colors capable of being recorded or reproduced within a medium or color space.

gigabyte (GB) One billion bytes.

gobo A board that "goes between" the light source and an object. It is used to control the shape of the emitted light.

gray card A device used by photographers to measure the luminance and/or color temperature of a scene. Photographic gray cards reflect 18 percent of the light falling on them and correspond to a theoretical scene with equal amounts of lights and darks.

ground glass On older cameras, this was an actual piece of glass that had a texture on one side allowing the photographer to focus on the glass. Newer cameras use plastic screens, but the term is still used interchangeably to refer to the image viewed "on the ground glass." All SLR-type cameras use a ground glass as a focusing/viewing device. When the lens projects an image onto a ground glass (as opposed to viewing through another type of optical viewfinder) the photographer can clearly see the effects of focus and depth of field. Other types of optical finders project everything as sharp and crisp (though they might not be in the final photo).

highlight Bright or light areas of an image.

histogram A graph that shows the distribution of tones in a digital image ranging from black to white. While it looks like a smooth scale most of the

time, it is actually a representation of each of the 256 steps from absolute black to absolute white (in an 8-bit JPEG). When a histogram has gaps (like a comb with broken teeth), it is an indication that tonal information has been lost and will likely result in a print or file with visible banding or posterization.

hot shoe A slot with built-in electronic contacts on the top of the camera that allows accessories like flash units to be mounted to the top.

hyperfocal distance A way to extend the useful depth of field for a given lens and f-stop combination. It is the distance setting that produces the greatest depth of field for any given aperture setting.

incandescent light Light created by a substance that has been electrically heated to create light. Technically, any black body light source is incandescent, but the term is most commonly used to describe ordinary household lightbulbs.

incident light meter A light meter that measures the light falling on the surface, rather than the light reflecting off the surface of an object.

infinity The distance at which all reflected light rays from an object become (effectively) parallel for a given focal length of lens. Also, the farthest focus setting on a lens.

ISO Stands for "International Organization for Standardization." A numerical designation that indicates the relative sensitivity of a film or sensor to light.

Kelvin temperature In photography, Kelvin temperature is used to refer to the spectrum of light emitted by various light sources.

key light The primary, or main light in a three-point light scheme.

light meter A device with a photoelectric cell that is capable of measuring the amount or color of light in a situation.

long lens Any lens whose focal length exceeds the diagonal of the capture format, resulting in a narrower field of view and a magnification of the image. Commonly referred to as "telephoto" (135mm is one example).

macro lens A lens that is capable of extremely close focus. Sometimes referred to as a "micro lens."

manual exposure An exposure mode in which the photographer chooses both the shutter speed and f-stop.

megabyte (MB) One million bytes.

megapixel (MP) One million pixels. Megapixels are a common form of referring to the absolute resolution that a digital camera is capable of. However, megapixels are just one of the factors that determine overall image quality.

midtone An area of medium brightness.

noise All electronic instruments produce a certain level of background "noise" due to the electrical current that is passing through the instrument. One common example is a stereo that—without music playing—will produce an audible humming sound (noise) as the volume is turned up. When music (signal) is added the background hum is still there but it becomes negligible compared to the volume of the music. Digital sensors also have a certain level of noise that is inherent to the sensor except that in this visual medium the noise is evident as colored speckles (that look like the grain of high speed film). Proper exposure (adding signal) makes the noise less visible.

normal lens A lens whose focal length is approximately the same as the diagonal of the capture format. This results in an angle of view that approximates the human eye. For example, a 50mm lens on a 35mm film camera or a 33mm lens on a typical digital camera with a 1.5 conversion factor.

open up To increase the exposure of a photo by lowering the shutter speed, enlarging the aperture, or increasing the ISO. Also, to decrease the overall contrast of a scene by introducing "fill."

palette A range of colors that an artist/photographer uses consistently in his or her work. Also, a panel or box that appears in imaging software that contains tools.

pan Following motion with the camera to record the relative movement of an object.

photoflood A form of incandescent bulb that is made specifically for photographic use and has a color temperature of exactly 3,200 degrees Kelvin.

photo montage A composite image created by combining individual photographs or parts of individual photos.

pincushion distortion A lens defect that causes parallel lines in an image to pinch toward the middle, like backward parentheses. Most commonly found in zoom lenses at the long end of the zoom range.

pinhole A tiny opening that can allow light rays to form an image without a lens in a camera obscura.

photosite The individual photoreceptors that together make a digital sensor.

pixel A picture element. Digital photographs are actually composed of millions of picture elements, each displaying a distinct tone or color. When viewed at normal distances and magnifications, these individual elements merge to form the illusion of a smooth and continuous tone image.

pixels per inch (ppi) The pixel resolution of an image. It is important to remember that pixels have no real "size" until a size is assigned to a digital image (although your camera and imaging program might assign one by default).

plane of focus When a camera is focused on a given object a "plane of focus" is created. Most of the time the plane of focus is flat and perpendicular to the axis of the lens. If you point a camera at a wall (with the lens perpendicular to it and the back parallel) the entire wall will be sharp, even though the edges of the wall are physically farther away than the center. Some cameras (view cameras) and/or lenses (tilt and shift lenses) are capable of tilting or swinging the plane of focus, resulting in an effect of greater or less depth of field than would otherwise be possible.

plug-in An upgrade or addition to a software program that gives it additional capabilities.

polarizing filter This filter absorbs reflected rays of light from non-metallic surfaces that are vibrating at certain select angles to the filter. The effect is that the amount of reflection can be controlled and selected by the photographer.

posterization See banding.

primary colors The three colors that can be combined to create all other colors. In the additive color system, three different colors of light (red, green, and blue) are combined to create all other colors (including

white). In the subtractive color system, three different colors of pigment or ink (cyan, magenta, and yellow) are combined to create all other colors (including black).

prime lens A fixed focal-length lens that cannot zoom or change its angle of view (for example, a 24mm or 135mm lens).

profile A color-space profile is the data that accompanies an image or file and informs a digital device how to display the color gamut for the image. A paper profile is data that accompanies a certain paper type and allows the printer to perform optimally with that particular paper.

reciprocity law The relationship between the shutter speed and f-stop, which states that if one is increased it must be balanced by a decrease in the other. For example, $\frac{1}{15}$ second at f/2.0 is functionally the same exposure as $\frac{1}{30}$ second at f/1.4. Both settings allow the same amount of light to reach the film/sensor.

reciprocity law failure This occurs when the reciprocal relationship between lens opening and shutter speed no longer applies, such as very long exposures and/or very short exposures. An exposure of $\frac{1}{30}$ second at f/1.4 is the equivalent of $\frac{1}{15}$ second at f/2.0. In theory, the reciprocal law should hold that a one-minute exposure at f/64 is still the equivalent exposure. However, when shooting exposures longer than one second on traditional photographic film, the reciprocal law starts to break down and the exposure is not equivalent. This is called reciprocity law failure, often incorrectly referred to as reciprocity.

A rule of thumb is that at exposures longer than one second, the photographer should increase his/her exposure by half a stop. Exposures longer than 30 seconds should be increased by an entire

stop. However, this does vary with different films. Reciprocity law failure can also cause color to be rendered inaccurately with certain films.

reflected light meter Reflected meters measure the light that a scene is actually reflecting. The light meters in cameras are all reflected light meters.

resolution The ability to render and differentiate fine details/the degree of detail available in a photographic image. Also, the number of data points within a given linear measurement of a digital image (for example, 300 ppi). In digital images, this is the total number of pixels available to represent a photograph. Resolution commonly refers to the photosites available in a camera's digital sensor (such as 6 megapixels); however, this is misleading because the quality and size of individual photosites—together with lens quality—is ultimately as, or more, important in the resulting visible optical resolution than simply the total number of pixels.

reversal The process of making a negative into a positive. The word is commonly used to refer to slide film (reversal film).

short lens A lens whose focal length is shorter than the diagonal of the rectangle of the capture format, resulting in a wide field of view (a wide-angle lens, like a 20mm).

shutter A mechanism to control exactly how long the film or sensor is exposed to light.

Shutter Priority An autoexposure mode in which the photographer selects the shutter speed and the camera sets the appropriate f-stop to produce a correct exposure. Many cameras use the abbreviation "TV" (Time Value) for this setting.

slave An optical electric sensor that can trigger an electronic flash when it detects a burst of light from another unit.

slow Can refer to: Film or sensor speed—ISO 100 is slower than ISO 400; Aperture—f/5.6 is a smaller lens opening, therefore it is slower than a lens set to f/1.4; Shutter speeds— $\frac{1}{15}$ second is slower than $\frac{1}{60}$ second because the duration is longer.

spot meter A reflected light meter with a very small angle of view.

stop The aperture setting of a lens. Also, the change in exposure by a factor of two. A one-stop increase in exposure doubles the amount of light hitting the film/sensor. A one-stop decrease halves the amount of light hitting the film/sensor.

stop down To reduce the size of the aperture/a larger f-stop number; for example, stopping down from f/2.8 to f/8, thereby reducing the amount of light hitting the film/sensor.

strobe See electronic flash.

surrogate focus A technique used in candid photography to help remain inconspicuous and minimize the amount of time the lens is pointed at the subject. The photographer focuses on another object that is approximately the same distance away as the subject, then recomposes quickly on the actual scene to be photographed.

synchronize or "synch" To electronically connect the camera's shutter to a flash unit so that the shutter is fully open when the flash fires. Focal plane shutters cannot synch at very high speeds, so it is important to know the highest synch speed of your particular camera.

telephoto Photographers use this term to refer to any lens that has a focal length longer than the diagonal of the capture format and projects a magnified image. Technically speaking, a telephoto lens is a specific lens design that allows the effective focal length to be longer than its actual size, resulting in a more compact package than would otherwise be possible.

transparency An image on a transparent base that allows the image to be viewed by transmitted light rather than reflected light. This term is used interchangeably with "slide" and "chrome."

Through-The-Lens (TTL) meter Usually used to describe a type of light meter that reads the light being transmitted through the lens of a camera.

TTL flash A flash unit in which the duration and power of the flash unit is controlled by a meter in the camera to ensure proper exposure.

tungsten Technically, this is simply a metal that is heated to create incandescent light, but the term is commonly used to refer to photofloods or quartz halogen lamps yielding a precise color temperature of 3,200 K. Tungsten or "Type B" films are made to be exposed under lighting that has a color temperature of 3,200 K. This is also a preset color temperature in the white balance menu of digital cameras.

TV (Time Value) See Shutter Priority.

variable maximum aperture A lens in which the ratio between the maximum f-stop and the focal length of the lens changes as the focal length changes.

vignette Underexposure at the corners of the rectangle resulting in the image having an almost circular quality in extreme examples. Vignetting is a common problem with inexpensive zoom lenses, especially at short focal lengths; however, many photographers like the effect.

white balance The setting on a digital camera that corrects and balances the camera to a particular light source, ensuring that white objects will be rendered without a color cast.

zone focus Setting the camera to a preselected distance and depth of field in anticipation of a photograph.

zoom lens A variable focal length lens (for example, 18–55mm).

CONTACTS AND RESOURCES

PHOTOGRAPHY MUSEUMS

Aperture Foundation
www.aperture.org
547 West 27th Street, 4th floor
New York, NY 10001
(212) 505-5555

California Museum of Photography
www.cmp.ucr.edu
University of California Riverside
3824 Main Street
Riverside, CA 92501
(951) 827-4787

Center For Creative Photography
www.creativephotography.org
University of Arizona
Tucson, AZ 85719
(520) 621-7968

Center for Fine Art Photography
www.c4fap.org
400 North College Avenue
Fort Collins, CO 80524
(970) 224-1010

**Florida Museum of
Photographic Arts**
www.fmopa.org
200 North Tampa Street, Suite 130
Tampa, FL 33602
(813) 221-2222

**George Eastman House,
International Museum of
Photography and Film**
www.eastmanhouse.org
900 East Avenue
Rochester, NY 14607
(585) 271-3361

**International Center
of Photography**
www.icp.org
1133 Avenue of the Americas
New York, NY 10036
(212) 857-0000

**Los Angeles County Museum
of Art**
www.lacma.org
5905 Wilshire Blvd
Los Angeles CA 90036
(323) 857-6000

**Museum of Contemporary
Photography**
www.mocp.org
Columbia College Chicago
600 S. Michigan Ave
Chicago, IL 60605
(312) 663-5554

Museum of Modern Art
www.moma.org
11 West 53rd
New York, NY 10019
(212) 708-9400

New Museum
www.newmuseum.org
235 Bowery
New York, NY 10002
(212) 219-1222

Photographic Resource Center
www.bu.edu/prc
Boston Univeristy
832 Commonwealth Avenue
Boston, MA 02215
(617) 975-0600

**San Francisco Museum
of Modern Art**
www.sfmoma.org
151 Third Street
San Francisco, CA 94103
(415) 357-4000

PHOTOGRAPHY BOOKS

Berger, John, *Ways of Seeing*
(Penguin, 1990)

Berger, John, *Selected Essays*
(Vintage, 2003)

Cotton, Charlotte, *The Photograph as
Contemporary Art* (Thames & Hudson,
2004)

Edwards, Steve, *Photography: A Very
Short Introduction* (Oxford University
Press, 2006)

McNally, Joe, *The Hot Shoe Diaries:
Big Light From Small Flashes* (New
Riders, 2009)

Newhall, Beaumont, *The History of
Photography* (Museum of Modern
Art, 1937)

Ritchin, Fred, *After Photography*
(W.W. Norton, 2008)

Rosenblum, Naomi, *A World History
of Photography* (Abbeville Press, 2008)

Shore, Stephen, *The Nature of
Photographs* (Phaidon, 2007)

Szarkowski, John, *Looking at
Photographs: 100 Pictures from the
collection of the Museum of Modern
Art* (Museum of Modern Art, 1976)

Szarkowski, John, *The Photographer's
Eye* (Museum of Modern Art, 1980)

Willis, Deborah, *Reflections in Black: A
History of Black Photographers 1840
to the Present* (W.W. Norton, 2000)

PHOTOGRAPHY FILMS

*"American Masters" Richard Avedon:
Darkness and Light* (1983)

Annie Leibovitz: Life Through a Lens
(1983)

*Contacts, Vol. 1: The Great Tradition
of Photojournalism* (1988)

*Contacts, Vol. 2: The Renewal of
Contemporary Photography* (1992)

The Genius of Photography, BBC TV
series (2007)

*Henri Cartier-Bresson: The
Impassioned Eye* (2003)

*Visions of Light: The Art of
Cinematography* (1992)

PHOTOGRAPHY MAGAZINES

American Cinematographer
www.theasc.com

Black & White Magazine
www.bandwmag.com

Digital Photo Pro
www.digitalphotopro.com

Lenswork
www.lenswork.com

Outdoor Photographer
www.outdoorphotographer.com

Popular Photography
www.popphoto.com

View Camera
www.viewcamera.com

PHOTOGRAPHY BLOGS AND
WEBSITES

www.aphotoeditor.com
Created by Rob Haggert, this is an
invaluable site with a wealth of links
and useful information.

www.americansuburbx.com
Excellent source for reviews and essays
on photography.

www.cinema5d.com
Invaluable resource for learning about
emerging video capabilities with
modern DSLRs.

www.dpreview.com
Up-to-the-minute news and reviews on new cameras and technology.

www.magnumphotos.com
World-famous photo cooperative.

www.mediastorm.com
One of the pioneering sites for multimedia-based photojournalism.

www.modelmayhem.com
Social networking site for photographers, models, and stylists.

www.pixelpress.org/afterphotography
Fred Ritchen's thoughtful blog on the future of imaging and journalism.

www.the-digital-picture.com
Excellent in-depth reviews and testing of lenses, cameras, etc.

http://strobist.blogspot.com/
Great practical advice on lighting with small wireless TTL flash. Lots of do-it-yourself projects.

www.viiphoto.com
Photo cooperative with a focus on photojournalism.

www.ypu.org
Young Photographers United. International social network for emerging photographers.

CAMERA MANUFACTURERS

Canon
www.usa.canon.com

Hasselblad
www.hasselbladusa.com

Leica
http://en.leica-camera.com/home/

Mamiya
www.mamiya-usa.com

Nikon
www.nikon.com

Olympus
www.olympusamerica.com

Panasonic
www.panasonic.com

Pentax
www.pentaximaging.com

Rollei
www.rollei.com

Sigma
www.sigmaphoto.com

Sony
www.sony.com

CAMERA ACCESSORIES

Adobe
www.adobe.com
Distributor of Photoshop, Lightroom, Illustrator, etc.

Apple
www.apple.com
Manufacturer of Apple computers and Aperture imaging software.

Bron Imaging Group
www.bronimaging.com
Distributor of Broncolor, Kobold, and Visatec lighting, Sinar cameras.

Dynalite Electronic flash
www.dynalite.com

Eizo
www.eizo.com
Manufacturer of high-end calibratable color monitors.

Hasselblad USA
www.hasselbladusa.com
Distributors of Hasselblad cameras and Imacon Flextight scanners.

Mac On Campus
www.mac-on-campus.com
Offers student discounts and educational partnerships/opportunities to photo students on MAC group products.

Mamiya America Corporation
www.macgroupus.com
Distributers of Mamiya cameras, Profoto lighting, Indura tripods,

Pocket Wizard, Sekonic light meters, Xrite color calibration devices, Toyo view cameras.

OFF-SITE DIGITAL STORAGE

Amazon S3
http://aws.amazon.com/s3/

Barracuda Networks
www.barracudanetworks.com

Iron Mountain
http://digital.ironmountain.com

Photoshelter
www.photoshelter.com

PRINT SERVICES

Adorama
www.adoramapix.com

Lulu Books
www.lulu.com

Whitehouse Custom Color
www.whcc.com

PHOTO SHARING WEBSITES

DropShots
www.dropshots.com

Flickr
www.flickr.com

Fotki
www.fotki.com

Photobox
www.photobox.co.uk

Photobucket
http://photobucket.com/

WORKSHOPS AND PORTFOLIO REVIEWS

www.cpw.org
Catskill Photography Workshop, Woodstock NY

www.eddieadamsworkshop.com
Free four-day workshop in New York's Catskill Mountains with some of the world's greatest photographers and editors.

www.fotofest.org
Portfolio reviews and networking in Houston, Texas.

www.mainemedia.edu/workshops
Maine Media Workshops.

www.newyorkphotofestival.com
Portfolio reviews and networking, NYC.

www.powerhouseportfolioreview.com
Sponsored by Powerhouse publishing, NYC.

www.santafeworkshops.com
Santa Fe Workshops.

ANNUAL PHOTOGRAPHY PRIZES/COMPETITIONS

Arnold and Augusta Newman Foundation Prize for Portraiture
www.arnoldnewmanarchive.com/Prize.html

CAFÉ (Call For Entry)
www.callforentry.org
Free updates on competitions, and grants for the arts.

The Camera Club of New York
www.cameraclubny.org/competition.html

Photo District News
www.pdnphotoannual.com
Various competitions over the course of a year in different categories Including wedding photography, advertising, landscape, etc.

INDEX

ACKNOWLEDGMENTS

AUTHOR ACKNOWLEDGMENTS

Author acknowledgments are a bit like Oscar acceptance speeches: They go on too long, someone important is always forgotten, and no one cares except for the parties involved.

I realized at the outset of this project that no single photographer can hope to know or represent the entire genre of portraiture, so the entire premise for this book depended on the contributions and expertise of my colleagues, students, and all of the photographers from around the world who answered our call and submitted work for publication in this book in order to better represent the true breadth of the subject.

Many thanks to Haakon Harris, Julia Pencakowska, Konstantine Suslov, Martin Adolfson, Bar Am-David, and all of the other European photographers who contributed. I hope to meet you all some day and, if we do, the drinks are on me.

Many other wonderful photographers also submitted work that we simply did not have the space to include; please accept my apologies, this should not be viewed as a critique on the quality of your work, but simply a reflection on the realities of publishing.

Thanks to the entire faculty and staff at NYU's Tisch School of the Arts, Department of Photography and Imaging for all of their understanding, friendship, and support over the last 25 years.

I also need to send a special thanks to Professor Rose Desiano at the University of Pennsylvania for her Photoshop tutorial section. My passion and expertise lie in the camera and shooting. The most important qualities any teacher can bring to a classroom are credibility and a passion for the subject, attributes I believe Rose evidenced in her tutorial.

Thanks to my editorial/photographic assistants Daisy Briceno and Corinne Rappone who helped me prepare all of the demonstration photos for the book.

Thank you to Jackie Palmer, Sarah Bell, Kate Kirby, and Victoria Lyle at Quarto Publishing for the design and visuals of this book, your confidence in my ability to pull this project off, and for hammering my rambling prose into something coherent.

I can hear the orchestra playing me offstage. Gotta write fast …

Thank you to my family for your patience and understanding.

And finally, thank you to all of my students past, present, and future—it's been a blast.

PICTURE CREDITS

Quarto would like to thank the following for supplying images for inclusion in this book:

(t = top, b = bottom, l = left, r = right, c = center)

p9, 20 Megan Fingleton
p11l Dorothea Lange
p11tr, 11br, 12b Getty
p15 Emily Walker/flickr
p16 Rachel Ceretto
p21t Nick Carillicchio
p21b, 75, 142–143 Meredith Rom
p22 White House Press Office (WHPO)
p23b, 188–191 Karen Cunningham
p23t Grigphoto/iStockphoto
p25 Haakon Harris (www.harriss.no)
p30 Henri Cartier-Bresson/Magnum Photos
p32tr Aaron Lee Fineman
p33t Kevin Link
p35tl, 35r David Macedo
p44 Andrea Bejarno
p52, 53tl Sasha Arutyunova
p53bl, 53cr Blaine Davis
p58t, 58b Erin Erwin
p60bl, 62bl Sam Heesen
p60bc Andres Vargas
p60br Alexandra Shabti and Mike Finkelstein
p61tl Daisy Briceno
p63 Inzajeano Latif (www.inzajeano.com, info@inzajeano.com)
p64–65 Julia Pencakowska (http://juliapencakowska.com)
p69 Universal/The Kobal Collection
p76t David Macedo
p77t Janice Gilman
p79 Goshka Gajownik (www.goshkaphotography.com)
p80 Samantha Adler
p81 Michelle Peralta
p82tl Rachel Cerreto
p82bl Seth Mroczka
p82t, 82c, 82br David Macedo, Janice Gilman, Cesar Vega, and Lupe Salinas
p83 Michelle Watt

p84 Michelle Peralta
p85tr Jake Stangel
p86–87 Maki Hirose
p88tr, 88br Morgan Levy
p88 Walker Evans
p92 Rachel Cerreto
p93tr Lexi Lambros
p93bl, 197 Adriel Reboh
p93br Michelle Watt
p96 Michael George
p98–99, 127 Konstantin Suslov (www.konstantinsuslov.com, konsus@gmail.com)
p100 Sarah Bell (http://sarahbell.viewbook.com)
p138–139 Sami Schwendeman
p140 20th Century Fox/The Kobal Collection/Frank Powolny
p146 Martin Adolfsson (www.martinadolfsson.com)
p147 Michelle Watt
p149 Bar Am-David (www.photography-bar.com, bar_amdavid@yahoo.com)
p163tc Aileen Mitchell
p163b Erica Sutton
p168l Kate Mclane and Erin Erwin
p168t, 168b Marissa Singer
p169 Michelle Watt, Adriel Reboh, and Jade Andreson
p172–175 Art Kane (www.artkane.com)
p176–179 Richard Renaldi
p180–183 Emily Shur
p184–187 Kristen Ashburn
p192–195, 201 Sarah Wilson
p198 Samantha Adler

All other photographs are courtesy of Mark Jenkinson.

All other images are the copyright of Quarto Publishing plc.

While every effort has been made to credit contributors, Quarto would like to apologize should there have been any omissions or errors—and would be pleased to make the appropriate correction for future editions of the book.